# Movements of modernity

# Movements of modernity
## The case of Glasgow and Art Nouveau

William Eadie

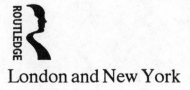

London and New York

First published 1990
by Routledge
11 New Fetter Lane, London EC4P 4EE

Simultaneously published in the USA and Canada
by Routledge
a division of Routledge, Chapman and Hall, Inc.
29 West 35th Street, New York, NY 10001

© 1990 William Eadie

Typeset by
NWL Editorial Services, Langport, Somerset TA10 9DG

Printed and bound in Great Britain by Mackays of Chatham PLC, Kent

*British Library Cataloguing in Publication Data*

Eadie, William
   Movements of modernity: the case of Glasgow and Art
   Nouveau
   1. Scottish decorative arts. Art Nouveau style. Glasgow school
   I. Title
   745.0922

*Library of Congress Cataloging in Publication Data*

Eadie, William, 1948–
   Movements of modernity: the case of Glasgow and Art
   Nouveau/
   William Eadie
   p.     cm.
   Includes bibliographical references.
   1. Art Nouveau–Scotland–Glasgow.   2. Art, Modern–19th
   century–Scotland–Glasgow.   3. Art, Modern–20th
   century–Scotland–Glasgow.   4. Glasgow School of Art.
   5. Mackintosh, Charles Rennie, 1868–1928 – Influence.
   I. Title.
N6781.G55E26   1991                               90–8293
709'.414'.4309034 – dc20                            CIP

ISBN  0-415-03243-1

# Contents

# Acknowledgements

This book is the result of a three-year period of research carried out in connection with the Department of Sociology at Glasgow University. The topic was originally suggested to me by David Frisby, and to him is due the main credit for stimulating me in my attempts to elucidate the assumptions, the achievements, and the inadequacies of current work in this particular field. When constructive criticism and helpful suggestions were required, he provided me with both intellectual stimulation and supportive friendship. I would also like to thank Simon Frith and Harvie Ferguson for their critical responses to the PhD thesis which formed the basis for the greater part of this book. A number of people helped to provide me with access to important material. Pamela Robertson gave me extensive use of the Mackintosh Archive in the University of Glasgow. Ian Monie allowed me to use some of the rarer contents of the Glasgow School of Art library. Brian Blench kindly furnished me with a copy of Talwin Morris's unpublished paper on the Glasgow Four. My thanks are also extended to the staff of the Glasgow School of Art library; Joseph Fisher and the staff of the Glasgow Room in the Mitchell library; and the staff of Strathclyde Regional Archives. In all cases, I could not have wished for more courteous and patient assistance. Finally, I would like to take this opportunity of expressing my warm appreciation to David Freckleton for the countless occasions when he shared his extensive knowledge of architecture and the arts with me. Our discussions together formed one of the strongest motivations for carrying through this work. The responsibilities for the final product, of course, remain entirely mine.

The author wishes to thank the following for giving permission to quote material in this volume:

Hunterian Art Gallery, University of Glasgow, for selected material from the Mackintosh Archive.

*Acknowledgements*

Glasgow Art Gallery and Museum, Kelvingrove, for sections from Talwin Morris's unpublished essay *Concerning the Work of Margaret Macdonald, Frances Macdonald, Charles Mackintosh and Herbert MacNair: An Appreciation.*

The Glasgow School of Art for passages from Annual Reports and Prospectuses.

# Introduction

In its initial stages, the Art Nouveau venture involved a symbolic return to origins. This focused upon two fundamental categories, namely, *nature* (the origins of life), and *history* (the origins of culture). The fascination with the *historical evolution* of architecture, which connects Mackintosh in Scotland with Wagner in Vienna, encompassed a deeply rooted preoccupation with the beginnings of vernacular forms. This reflected, in turn, intensified concern over the perceived erosion of the traditional functions required of architecture. In confronting a plethora of meaningless historicist styles, Art Nouveau attempted to establish a new form-language capable of universal application. In setting out to redefine the social role of the artist in the future from its vantage point of a difficult-to-grasp present, it expressed the kind of high ideals which later came to characterize modernism. Art Nouveau employed abstraction in its endeavour to create imagery that was distanced from immediacy and the (socially) real. In the early stages, it demonstrated how much it had come to view with suspicion the depictions of social history furnished by traditional naturalism. Also, Art Nouveau confronted technical forces of production through the understanding that these were reflective of nature, as that which operated via the mediating forces of human culture. Technology was perceived as being objective, and thus external to subjectivity: but it was also apprehended as providing the potential for an enhanced human life process. The central dialectic of Art Nouveau is represented by two opposed trends – (a) escape into an aestheticized world of stylization; and (b) the aestheticization of social reality through intensified determinacy over artistic *and* technical means towards this end. In other words, Art Nouveau embodied escape into the domestic interior and the world of the self, but it also desired *escape from* a self that had been constituted through a redundant past history. It is, I would stress, in direct relation to this schema, that the Scottish movement can best be understood.

In this book I address the issue of the social possibilities attaching to the emergence of an avant-garde in Glasgow in the 1890s. I offer a case study of this avant-garde within the context of an analysis of early European modernism. There is, as yet, no coherent *theory* of Scottish Art Nouveau. The 'orthodox' view continues to be that Mackintosh (invariably the main focus of attention) was not capable of articulating a theory of architecture. In my view, this is to condemn Mackintosh for failing to match up to what commentators, usually with an overt bias towards the history of architectural *works*, have decided he ought to have been. Consequently, the assumption is that a unique genius, capable of producing work of greatness, should, ideally, have had a transparent understanding of every issue with a greater or lesser bearing upon his practical and conceptual experience. The absurdity of this position exposes the continuing reductionism which has plagued a subject area colonized by art history with its characteristic 'techniques' of analysis. The outcome has been that the small amount of extant written material by Mackintosh has been deemed of negligible value. This has allowed the 'experts' comfortably to return our attention to the works which they alone are supposedly capable of explaining, and which are alleged to hold the key to the understanding of the man. I try to show that a great deal can be learned about the avant-garde to which Mackintosh belonged when this material is related to other contemporary material, and when the endeavour is guided by a theoretical understanding of what Art Nouveau as a widespread cultural phenomenon involved. The inherent objectivity of Art Nouveau works themselves is reflective of forces that are always *beyond* the intellectual and technical resources of their creators. Art Nouveau practitioners were *struggling* with issues which affected, not only the means of the production of their creations, and the technical methods for their execution, but also the objective outcomes of their ostensibly 'subjective' innovations.

Unlike Thomas Howarth, whose 1952 monograph on Mackintosh has long since achieved near-classic status, I consider the movement around Mackintosh to represent a significant instance of Art Nouveau as such. Howarth argued that Mackintosh was a modernist *per se*, and not actually an exponent of Art Nouveau style. In this particular context, the question of how Art Nouveau should be understood needs to be addressed, in order that its relationship to modernism be clarified. This, in turn, has implications for the perception of Art Nouveau in relation to the debates surrounding post-modernism. For example, to what extent was Art Nouveau seeking unified coherence in its productions, and to what degree could it embody the kind of alienations and dislocations which at the present time preoccupy the architects of Deconstruction? Alternatively, how does

rationality articulate with irrationality and the uncovering of repression in Art Nouveau? In adopting an art history perspective, Howarth abstracted Mackintosh from the socio-cultural situation of which he was a part. One crucial result of this was that Mackintosh could not be meaningfully related to either (a) the group of Art Nouveau designers centred on the Glasgow School of Art, and the group of architects who shared certain ideals and who employed a similar form-language in their work; or (b) the European Art Nouveau movements. By separating Mackintosh from these contexts, Howarth was unable to explain the interweaving of artistic and technical, decorative and functional, concerns, in Mackintosh and in his avant-gardiste associates. It is argued here that Art Nouveau cannot be properly understood unless this particular process of interweaving is acknowledged as having had a central role to play in the whole endeavour.

Empirically, I demonstrate that a system of ideas existed within and through certain institutions in Glasgow, and that this helped to provide the basis for a new mentality. In the sphere of architecture, the seeds of anti-historicism were being sown; the Art School was attempting to unite art with technical skills and with architecture; the University was disseminating aesthetic theory; in the press, popular discourse was describing the potential for the beautification of the environment. The avant-garde mentality which emerged out of this configuration of cultural forces was new in a number of respects. It was clearly progressivist to insist, as Mackintosh did, that architects and those who worked in the industrial production of design should, from the outset, be artists. Architecture signified the means for a transformation of values through a modern visual ideology which took the fusion of art and science as its paradigm. The achievement of the new mentality was to conceive of artists leading the way in the practical sphere, and becoming involved in the task of supplying the needs of a massified society. What was perceived as fundamental was the need for cultural meaning, for *form*. In terms of the search for a meaningful visual language which could symbolize the relations of objects to their true contemporary totality, freely invented abstract forms became increasingly non-representational of the shapes of nature. The artist's estrangement from the practical was to be overcome within a new form of the unification of art and technology. The main issue here was not merely one of welcoming the large-scale manufacture of well-designed goods. The designs that industry produced were to be free from commercial domination which reflected economic imperatives alone. The latter was seen to be perpetuating a plethora of redundant ideas and images. I argue that the true significance of the views on beautiful products for living becoming independent of

3

their designer, which Mackintosh was expressing in 1902, needs to be understood in the light of the ideas on the relationship between art and the machine which were formulated by Hermann Muthesius at this time. The unadorned designs which Mackintosh was producing, involved shape and proportion made possible by a knowledge of artistic principles combined with knowledge of enhanced functionality. These were undoubtedly conceived against a vision of rational standardization within a society that had engendered mass cultural education. From its inception, Art Nouveau had striven for a deeper perception of the potentialities of new forms. It wished to posit meaning through a synthesis of cultural forms and, crucially, through overtly synthetic (artificial) form. In the Scottish context, the static neutrality of crystalline geometric form in late Art Nouveau has its philosophical counterpart in Patrick Geddes's desire for modern technological society to manifest the 'static perfection' of art through the unification of the world. The significance which Glasgow Art Nouveau attached to the interpenetration of intellect and emotionality lay with the insight into the essential contrast between beauty in nature, and beauty in art, respectively. In being apprehended as having enduring qualities, art was to be utilized, on the basis of knowledge of its underlying principles, for the composition of symbolic forms that were universally comprehensible. The rationalism inherent with Glasgow Art Nouveau engendered an architecture capable of expressing ideals through an economy of means. The importance being attached to simplicity in design was rooted in the fundamental desire to combine analysis with synthesis, knowledge with imagination, through a comprehensible form-language.

# Chapter one

# The dialectics of modernity and modernism

'Modernism' is usually understood as a distinctive mentality and range of activities fundamentally preoccupied with the disruptive renewal of perception in a society which engenders routinized experience. The term 'modernity', historically, carries with it proliferating meanings which none the less centre around the theme of 'the deformations of a one-sidedly rationalized everyday praxis' evoking 'the need for something equivalent to the unifying power of religion'.[1] Max Weber argued that the internal relationship which subsisted between the modes of rationality peculiar to the West, and modernity – understood as the rationalization of everyday existence and the corresponding dissolution of traditional life patterns – was a necessary one. The disintegration of religious world views which portrayed a 'meaningful cosmos' had resulted from the emergence of new cultural spheres around empirical science, autonomous art critical of ancient classical artistic models, and secular legal and moral conceptions grounded in rationalist principles. Georg Simmel described how economic and political forces encouraged, with economic growth, technical development and a 'practical materialism' commensurate with industrialism. These, in turn, had brought about 'the increased externalization of life'.[2] With everything subordinated to material interests, the technical side of life came to dominate the inner, subjective dimension of personal values. The intense desire to escape from the constant unrest, fragmentariness, and complexity of modern life lay at the heart of the modernist experience, and for many this escape assumed an aesthetic character as they sought release in 'the artistic conception of things'.[3] Simmel gave concrete historical and psychological content to the concept of modernity by illustrating how specific socio-cultural trends are connected with the inner needs and responses of individuals. The essence of modernity, he claimed, is psychologism, 'the experiencing [*das Erleben*] and interpretation of the world in terms of the reactions of

5

our inner life and indeed as an inner world'.[4] Simmel viewed modern art as having the potential for both the embodiment of modernity and the resolution of its contradictions. This is because modern art, unlike naturalism, overtly *stylizes* real life by capturing 'the impression of the supra-temporal, the timeless impression'.[4] A significant example given by Simmel of this reaction against naturalism in art is the 'Scottish School' of painters (the 'Glasgow Boys').[5]

Among recent theorists of modernity, Marshall Berman dates the beginnings of a modern sensibility from the sixteenth century and the advent of a world market. Berman detects three historical phases of such a sensibility: firstly, up to around 1790; secondly, throughout the nineteenth century; and thirdly, in the twentieth century with the expansion of modernization. In the second of these phases the actual experience and language of modernity gave rise to classical visions of modernism which both celebrate and denounce the unprecedented objective social transformations facilitated by the advent of the capitalist world market. *Modernity*, Berman informs us, is the *experience* undergone within the modernization process which, in turn, engenders modernism. As experience within the dynamism of capitalism – with its oscillations of construction and destruction – it is experience of an essentially contradictory nature, at once of both exhilaration and fear, elation and despair, emancipation and ordeal. The nineteenth-century public, claims Berman, 'can remember what it is like to live, materially and spiritually, in worlds that are not modern at all. From this inner dichotomy, this sense of living in two worlds simultaneously, the ideas of modernization and modernism emerge and unfold.'[6] Economic 'development' has operated to transform the subjective life of individuals. As well as providing the means towards the emancipation of the individual self from the rigidities of fixed social status, narrow morality, and restricted imaginative range, economic development also engendered, at one and the same time, insecurity, disorientation, frustration and despair. For Berman, modernisms are characterized by their ability to appropriate the ambiguities and contradictions of modern life as fostered by capitalist 'development', and give expression to the dramatic tensions which such processes create within individuals. The classic examples of such modernisms are to be found with thinkers such as Marx and Nietzsche in the nineteenth century, whose 'self-ironies and inner tensions were a primary source of their creative power'.[7] The dialectical nature of the experience of modernity has, with their twentieth-century successors, increasingly given way to a shrinking of imaginative range with 'rigid polarities and flat totalizations'.[8] Modernist art, despite its manifesting brilliant creativity, no longer connects with any common life, since it is not capable of being adequately incorporated *via*

thought. However, it is possible, Berman believes, that 'going back can be a way to go forward: that remembering the modernisms of the nineteenth century can provide the vision and courage to create the modernisms of the twenty-first'.[9]

When claiming that Berman's book had reopened the contemporary debate on modernity, Perry Anderson outlined a number of difficulties with Berman's position. Fundamentally, Anderson considers modernism as a notion to be 'the emptiest of all cultural categories'[10]designating no describable object in its own right at all and completely lacking in positive content. Modernism, says Anderson, as a specific set of aesthetic forms,

> is generally dated precisely *from* the 20th. century, is indeed typically construed by way of contrast with realist and other classical forms of the 19th, 18th or earlier centuries ... modernism too needs to be framed within some more differential conception of historical time.[11]

If modernism is treated in this way, that is, periodized within the history of capitalism, it becomes strikingly apparent that its geographical and spatial distribution is uneven, with major areas of the world having failed to generate any significant modernist momentum. Berman's reading of modernism as a whole, according to Anderson, 'establishes no distinctions either between very contrasted aesthetic tendencies, or within the range of aesthetic practices that comprise the arts themselves'.[12] Because the 'decisive' currents of modernism in the first decades of the twentieth century – symbolism, expressionism, cubism, futurism or constructivism, surrealism – engendered doctrines and practices peculiar to themselves, but which were antithetical to each other, the possibility of defining the classical modernist bearing towards modernity in terms of one characteristic disposition or sensibility is precluded. 'Much of the art produced from within this range of positions already contained the makings of those very polarities decried by Berman in contemporary or subsequent theorizations of modern culture as a whole.'[13] This range of incompatible aesthetic practices from the beginning of the twentieth century was unified *post hoc* into 'a portmanteau concept whose only referent is the blank passage of time itself'.[14]

Such criticisms do not, however, lead Anderson to reject the possibility of establishing a meaningful category for the analysis of modernism as an historical phenomenon. He concedes that European modernism in the early twentieth century manifests certain unifying characteristics. A common adversary for modernist movements was found in the official academicism which reflected the

persistence of the *anciens régimes*. This gave unity to a wide span of new aesthetic practices: insurgent art forms could measure themselves against the cultural values represented by academicism, but they were at the same time able to articulate themselves in terms of the latter:

> The classical stocks of high culture still preserved – even if deformed and deadened – in late 19th-century academicism, could be redeemed and released against it, as also against the commercial spirit of the age as many of these movements saw it.[15]

The latter points to a further unifying dimension, namely, the uniform detestation of the capitalist market as an organizing socio-cultural principle by 'every species of modernism'. It was 'in the space between a still usable classical past, a still indeterminate technical present, and a still unpredictable political future' that European modernism flowered at the beginning of the twentieth century. Cubism, futurism, constructivism were to derive a powerful imaginative stimulus from 'the energies and attractions of a new machine age', but the interest here reflected a conception which was conditioned by 'the abstraction of techniques and artefacts from the social relations of production that were generating them'.[16]

Anderson argues that 'a *conjunctural* explanation of the set of aesthetic practices and doctrines subsequently grouped together as "modernist"' should be attempted, which 'would involve the intersection of different historical temporalities, to compose a typically overdetermined configuration'. 'Modernism' is thus to be understood as 'a cultural field of force *triangulated* by three decisive coordinates': the codification of a highly formalized academicism in the (visual and other) arts leading to the emergence of oppositional cultural forms; the still incipient emergence within official regimes of state and society of the key technologies or inventions of the second industrial revolution and the lack of mass consumption industries founded on these; and thirdly the imaginative proximity of social revolution and utopian cultural radicalism.

As well as Berman and Anderson, a significant contribution to the recent debate on modernity has been made by Habermas. The context for Habermas's analysis of Nietzsche's articulation of aesthetic modernity lies with his acknowledgement of 'the autonomous art that emerged in modern Europe (together with art criticism institutionalized since the eighteenth century) as the product of a [cultural] disintegration and the result of a process of rationalization'.[17] Eighteenth-century Kantian idealist aesthetics, in separating aesthetic pleasure (founded on perception of the beautiful and the sublime)

from other 'empirical' forms of satisfaction involving the useful and the desirable, allows art to emerge 'with its own proper claim, *along with* science and technology, law and morality'. The result is an institutional differentiation of art within 'three cultural value spheres, which are also separated from each other institutionally in the form of functionally specified systems of action'.[18] Forms of argumentation have developed with Western art criticism which 'specifically differentiate it from the forms of theoretical and moral–practical discourse'. However, Habermas stresses, the 'locus of directed and cumulative transformations' is not to be found with the discourses about works of art, but rather with the works of art themselves which, through their inner logical differentiation of specifically aesthetic content, radically uncouple the potential for non-routinized, unconventional modes of experience which can elicit the decentring and unbounding of subjectivity and transform relations between self and world:

> The ever more radical uncoupling of this potential for experience, the purification of the aesthetic from admixtures of the cognitive, the useful, and the moral is mirrored in the reflections of the early Romantic period (especially in Friedrich Schlegel), in the aestheticism of Baudelaire and the symbolists, in the programme of *l'art pour l'art*, in the surrealistic celebration of illumination through shock effects ... [19]

With the decentring of subjectivity comes a heightened sensitivity towards

> what remains unassimilated in the interpretive achievements of pragmatic, epistemic, and moral mastery of the demands and challenges of everyday situations; it effects an openness to the expurgated elements of the unconscious, the fantastic, and the mad, the material and the bodily – thus to everything in our speechless contact with reality which is so fleeting, so contingent, so immediate, so individualized, simultaneously so far and so near that it escapes our normal categorical grasp.[20]

Two relevant questions to raise at this stage would be (1) to what extent does the decentring of subjectivity, as facilitated by the experiences made possible with such movements as symbolism and aestheticism, lead to evidence of the heightened sensitivity which Habermas describes, manifesting itself with Art Nouveau? And (2) what might an empirical study of Art Nouveau reveal about the attempt actively to apply such a heightened sensitivity to the integration of the artistic with the cognitive, the useful, and the ethical?

9

German *Jugendstil* certainly reflected the need for a surrender to unconscious powers; late Art Nouveau, with its form-language of geometric abstraction, appeared against a background of innovative theorizing about psychology and aesthetics. In opposing eclectic-historicism and the demarcations separating the various styles, and in seeking out the 'motives' behind architectural appearances, Art Nouveau elicited reflection upon the fundamental conditions of architecture and its relationships with the political, social, and ethical infrastructures.

In his critique of Habermas's position, Peter Bürger[21] argues that the increasing differentiation of the separate cultural spheres – science, morality, art – and the contrary drive for the reintegration of these spheres with the 'life–world', is more contradictory than Habermas's theory of modernism concedes. In Bürger's view, Habermas, in claiming parallel developments towards autonomy and specialization by the three spheres, misconstrues their relative structural and social differences. Cognitive-instrumental rationalization has a primary position in the modernization process. Autonomous art carries with it the idea of its self-transcendence, writes Bürger, but this is not true of science in the same way because science betrays no impulse for its reintegration with everyday life. Again, an empirically grounded examination of Art Nouveau – as an artistic movement which attempted to confront the separated spheres of art and rationality with a view to achieving their integration on the level of the practical – can surely prove its value for the illumination of the kind of issues covered by these debates. In setting the scene for such an analysis, let us begin by examining Nietzsche in connection with Habermas's critique: the latter has the virtue of elucidating what Nietzsche himself owed to rationality. Importantly, we find in Nietzsche, the kind of tensions which were central to Art Nouveau: the tension between artistic and scientific concerns, art and morality, tradition and revolution, discipline and abandonment, and individualism and collectivism.

### Nietzsche and Worringer: two exemplary instances of an Art Nouveau world-view

If a central aspect of Nietzsche's work were to be pinpointed in demonstrating his relevance to Art Nouveau as a 'classical' modernism, it would have to be the challenge being posed to divisions which fragment knowledge and experience, and, more specifically, to the traditional antithetical relationship between scientific and imaginative–symbolic experience. The relevance of Nietzsche's critique of historicism follows from this challenge. In writing about contempor-

ary architecture Nietzsche finds that its symbolism no longer provides access to a reservoir of deeply profound meaning. In volume one of *Human, All Too Human* (1878) he states that 'we no longer understand architecture....We have grown out of the symbolism of lines and figures.' This gives way to a brief examination of how ancient architecture expressed meaning:

> Everything in a Greek or Christian building originally signified something, and indeed something of a higher order of things: this feeling of inexhaustible significance lay about the building like a magical veil. Beauty entered this system only incidentally, without essentially encroaching upon the fundamental sense of the uncanny and exalted, of consecration by magic and the proximity of the divine; at most, beauty *mitigated* the *dread* – but this dread was everywhere the presupposition.[22]

The contemporary beauty of a building is 'something mask-like', that is to say, a mere surface phenomenon. Historically, claims Nietzsche, the human intellect has introduced a symbolic language of *feeling* into architecture through bestowing a particular significance 'into the relations between lines and masses which is in itself quite unknown to the laws of mechanics'. In other words, a language of signification emanating from linguistics has operated to limit the potential for the realization of more comprehensive symbol systems capable of expressing the distinctiveness of architecture. Neither music nor architecture could in themselves be considered as *immediate* languages of feeling capable of speaking directly to the inner world and appearing to spring *from* the inner world. For this to be supposed by the *intellect*, an age would have to have dawned in which symbolism had conquered 'the entire compass of the inner life'.

One central manifestation of the trend reflected in twentieth-century aesthetic modernisms such as expressionism and surrealism towards the use of abstraction explicitly involved the drive to signify, through artistic means, 'something of a higher order of things' and even the 'proximity of the divine'. 'I believe that the increasing abstract significance in art is one phase of mankind's contemporary advance in spiritual apprehension', Sheldon Cheney revealed in 1934 when demarcating the field of expressionism as he understood it. The real point of liberation for art from 'emotional–interpretive equivalents of living, as too often in the works of Tchaikovsky or the Impressionists', is to be found with abstraction which affords experience of an unexplainable harmonious order.[23] In 1937 Hilla Rebay spoke of the 'cosmic inner order' of paintings which had eschewed objectivity and representation: 'Abstraction is merely a forerunner of

the achievement of pure art and entire freedom of creation in painting. Objective inspiration can go no further than abstraction.'[24] Paul Eluard, in passionately representing the inspirational qualities of surrealist painting and poetry, declared that all surrealists were 'animated by the same striving to liberate the vision, to unite imagination and nature'.[25] Human beings had to be aware of their supremacy over nature in order to guard themseves against it and conquer it. Imagination, which lacked the 'imitative instinct', was 'a universe without association, a universe which is not a part of a greater universe, a godless universe, since it never lies, since it never confuses what will be with what has been'.[26] What is the relationship of this modernist mysticism to an equally modernist belief in the powers of reason and logic? One of Nietzsche's readers, namely van de Velde, argued in 1902 that the sole criteria for *modern* design were to be found in reason and logic, and that 'the essential character of beauty is the perfect accord of the technical means, form, and purpose'.[27] This particular formulation contains the essence of the Art Nouveau desire to resolve the traditional conflict between (subjective) creative imagination and scientific objectivity.

Art appropriates the mythic symbols of religion in order to preserve the core of the latter and represent it in ideal terms, Richard Wagner declared in his *Essay on Religion*. In illustrating the influence of Wagner on the young Nietzsche, Habermas has this to say:

> An aesthetically renewed mythology is supposed to relax the forces of social integration consolidated by competitive society. It will decenter modern consciousness and open it to archaic experiences. This art of the future denies that it is the product of an individual artist and establishes 'the people itself as the artist of the future'.[28]

Under the sway of this thinking, Nietzsche, in *The Birth of Tragedy* (1871), described how 'the state and society and, quite generally, the gulfs between man and man give way to an overwhelming feeling of unity leading back to the very heart of nature.'[29] At this point in time, Nietzsche was 'echoing Hegel in contrasting the unity of Greek culture with the fragmentation that is characteristic of modernity'.[30] In 1886 Wölfflin would argue that the 'few periods in history that created a style were those that were able to experience and understand their collective feelings'.[31]

Poets, Nietzsche explained in *Human, All Too Human*, had to be in many respects backward-looking creatures, in order that they could provide bridges to dead or dying religions and cultures and to 'quite distant ages and conceptions'.[32] But in discharging short-lived palliatives, poets only really hindered passionate *practical* attempts

to achieve a real improvement in the conditions of life. In *The Gay Science* (1882) the conception of art's real power as consisting in its ability to create illusions is juxtaposed to the achievements attributable to science. These include 'the insight into universal untruth and mendaciousness'.[33] Art is made a countervailing power to science ('science is expanding, the most scholarly of us are on the point of discovering that they know too little'),[34] the purveyor of aesthetic phenomena which make a life burdened by the honesty rendered by science bearable. Enthusiasm for what he called 'pure' science had already been pinpointed by him as a 'true' cultural element. The young Nietzsche, in analysing the roots of cultural decline, bewailed the separation of art and philosophy which had brought about a modern situation where artists could not simultaneously *think* and *feel*.[35]

In pouring scorn on the art of 'decadence', and Wagner's 'sick' music in particular, Nietzsche insists that nothing is more modern than 'total morbidity', 'decrepitude' and 'the over-excitability of the nervous machinery'.[36] Such ambiguous, inflated, oppressive art, full of 'vague longing' and 'spongy desire', has deprived music of its world-transfiguring character. Only life-affirmative values can guarantee the future, and these, Nietzsche came increasingly to believe, are only possible through an art rooted in the energetic and ecstatic Dionysian principle of the polymorphous (and the unity of man with nature) as against the Romantic ideal of the unity of humanity in a transcendent deity. It is the Dionysian which liberates the individual from everyday existence and the 'curse of identity'. This is achieved through the succumbing of the subjective to the point of a self-oblivion capable of being engendered by the Dionysian states. In the realm of aesthetic illusion, where the arbitrary, surface appearance, the superficial and simplified, are the basis of a creative life – since art manifests the *phenomenal* character of reality – the decentred subject is freed from conventional pragmatic experience. Values are created, posited, by innovative artists, and this value-positing aesthetic productivity dictates the laws of value appraised by the spectator. Nietzsche is thus able to imagine modern art as 'the medium in which modernity makes contact with the archaic'.[37] This medium necessarily takes on an abstract form. As John Sallis points out, 'Dionysian repetition has nothing to do with images, much less with copies in any ordinary sense.' 'The figure of Dionysus announces itself in an imageless manifestation. Presumably this is why it must occur as music, assuming that music is the only art without images.'[38]

For Nietzsche the decadence of modern culture signifies the disintegration of all genuine values and their replacement with illusions: 'viewed from any position, the *illusory nature* of the world in which we believe to live is the most certain and secure thing which

13

our eyes can still catch hold of.'[39] This Schopenhauerian notion of modern experience as illusion will reappear in Worringer's *Abstraction and Empathy* (1908) in the context of a thoroughgoing attempt to establish the basis for a radical reorientation of aesthetic standards. However, within Nietzsche's theory of modern power lies the premise that behind the outward appearances of a rationalized world, lies concealed a naked pathological transsubjective will to power which subjugates the wills of individual subjects. In *On the Genealogy of Morals* (1887) he illustrates how the violence exerted by the modern state on the individual in the name of discipline, and the implementation of apparently universal normative assumptions, is paralleled by the violence which the individual unleashes upon him or herself in creating a centred subjectivity, a *formed* self. The 'secret self-ravishment' which imposes form on the subject is a kind of 'artistic cruelty' which gives birth to 'all ideal and imaginative experience'.[40] This is artistic cruelty because *form* is being imposed on vital, instinctual life. In portraying the antithesis between life and form in this way, Nietzsche helps to prepare the ground for Art Nouveau, which, in its initial organic/vitalist phase, would attempt to engender a form-language which taught that this antithesis could be transcended. The Nietzschean influence is apparent also where Art Nouveau's attack on historicism is concerned, although he was certainly not the first to articulate such a critique. The whole of modern culture is, Nietzsche insists, essentially *internal* and this inner world is 'chaotic'. Modern consciousness suffers from a surfeit of historical knowledge, and the resultant inability to look to the future has debilitated life's 'plastic power'.[41] The arbitrary contents of the consciousness conditioned by historicism reveals hollowness and a total lack of what is essential to life. The will to power is thus perverted, distorted, by being inverted into a sphere of inwardness.

At the core of the will to power lies the power for the potential creation of meaning within a world of appearances. This, as Habermas explains,

> is at the same time a *will to illusion*, a will to simplification, to masks, to the superficial; art counts as man's genuine metaphysical activity, because life itself is based on illusion, deception, optics, the necessity of the perspectival and of error.[42]

Consequently, since art is creative existence, all is reduced to the aesthetic dimension: it is only as an aesthetic phenomenon that the world and human life can be justified because the aesthetic is at odds with the 'truths' about the world which are, in actuality, illusions, worn-out metaphors. Justification of the world through aesthetic ac-

tivity is made to appear indistinguishable from the imprinting of meaning on the world through language and its metaphorical – and thus symbolic – structures. This is what Nietzsche understood by what he (in 1873) called 'Being within the whole',[43] which is also being outside of oneself.

Habermas has argued that 'Nietzsche owes his concept of modernity, developed in terms of his theory of power, to an unmasking critique of reason that sets itself outside the horizon of reason.'[44] Implicitly, this critique appeals to 'criteria borrowed from the basic experiences of aesthetic modernity'. For example, taste is enthroned by him as the 'organ of a knowledge beyond true and false, beyond good and evil'.

> But he cannot legitimate the criteria of aesthetic judgement that he holds on to because he transposes aesthetic experience into the archaic, because he does not recognize as a moment of reason the critical capacity for assessing value that was sharpened through dealing with modern art – a moment that is still at least procedurally connected with objectifying knowledge and moral insight in the processes of providing argumentative grounds. The aesthetic domain, as the gateway to the Dionysian, is hypostatized instead into the [absolute] other of reason. The disclosures of power theory get caught up in the dilemma of a self-enclosed critique of reason that has become total.[45]

How was Nietzsche's 'capacity for assessing value' 'sharpened through dealing with modern art'? What represented modern art in Nietzsche's time? The most obvious answer to this question is the 'new' music of Wagner which Nietzsche was clearly experiencing, and which he initially supported and later denounced (for extra-musical reasons). From at least 1860, the year in which Brahms signed a manifesto opposing the 'modernist' music of Liszt and Wagner, the latter was viewed as the art of a movement intent on making a headlong drive into the future. Wagner's 'music dramas' can be considered as a prime source for Nietzsche's experience of the 'inner logic' of avant-garde art, for example, the careful structuring of a variety of leitmotifs, not to mention the use of dissonance, particularly with *Tristan und Isolde* – long considered the 'source work' for musical modernism – which Nietzsche described as being full of 'rhythmical ambiguity'[46] (he considered this to be symptomatic of dissolution). He enthused about the 'psychological knowingness and precision', the clarity, and the 'sublime and extraordinary adventure of the soul' in the orchestral prelude to *Parsifal*.[47] These latter comments illustrate tellingly that, even where Nietzsche was rejecting

Wagner ideologically, he was still benefiting from the 'inner logic' of his actual works. As we shall see, according to Adorno, Art Nouveau originated in Wagner's music.

The counter-authority to reason, which Nietzsche appeals to in his attempt to escape modernity, for Habermas turns out to be 'experiences of self-disclosure of a decentred subjectivity, liberated from all constraints of cognition and purposive activity, all imperatives of utility and morality'.[48] Habermas views Nietzsche as splitting off the moment of reason that 'comes into its own in the logic proper to the aesthetic–expressive sphere of value' manifested with avant-garde art from any connection with 'theoretical and practical reason' and pushing this moment 'into the realm of metaphysically trans-figured irrationality'.[49] Aesthetic judgement is 'stylized' as 'value appraisal' and this, in turn, provides 'criteria for a critique of culture that unmasks science and morality as being in similar ways ideological expressions of a perverted will to power'.

> But Nietzsche cannot admit of the theory of power as a theory that can be true or false. He himself moves about, according to his own analysis, in a world of illusion, in which lighter shadows can be distinguished from darker ones, but not reason from unreason. This is, as it were, a world fallen back into myth, in which powers influence one another and no element remains that could transcend the battle of the powers. Perhaps it is typical of the ahistorical mode of perception proper to aesthetic modernity that particular epochs lose their own profile in favour of a heroic affinity of the present with the most remote and the most primitive: the decadent strives to relate itself in a leap to the barbaric, the wild, and the primitive.[50]

This description helps to set the key for an empirical examination of Art Nouveau when the 'ahistorical mode of perception' is seen to manifest itself in this movement's attempts to oppose historicism. The factor of relating to the primitive is relevant here also when it is acknowledged that the Art Nouveau venture focused upon a symbolic return to natural and cultural *origins*. For Habermas, the logicality which is developed in avant-garde works of art is interconnected with theoretical and practical reason. In extending his view to an elucidation of Art Nouveau it can be stated that here art is made increasingly subject to rational logic through its being oriented towards empirical ends. This leads to efforts at *deducing* the nature of new work on the basis of enhanced knowledge of pre-determined principles of form (held to underpin, for example, construction, function) and of materials. Art Nouveau architecture illustrates logical

determinations being made about space and its deployment. These formal constituents, however, in their unity maintain also their autonomy. As van de Velde recognized, the promise of the emancipation of rationality from its confinement within an empirical means–ends nexus depended squarely upon the ability of artists to impose coherent aesthetic form on the objects within the modern life-world.

Such ideas as Simmel was expounding on aesthetics and modern experience around the turn of the century were, on Wilhelm Worringer's account, to influence deeply his *Abstraktion und Einfuhlung* published in 1908.[51] In this work, however, it is the formulations of the Viennese art historian Alois Riegl which are most overt. Riegl (1858–1905) was, along with Franz Wickhoff (1853–1909), developing a new view in Vienna of art history which brought, in Carl Schorske's words, 'the late liberal, non-teleological sense of flux so common in *fin-de-siècle* culture'.[52]

> In order to appreciate the unique forms that every age produced, one had to get at what Riegl called the society's *Kunstwollen*: the intention and purpose of art in every culture. This produced not progress and regression, but eternal transformation – an appreciation of plurality in art beyond any single apriori aesthetic standard.[53]

In asserting the role of the powers of will and mind for the proper understanding of artistic representations, Riegl was profoundly influential for those modern art movements seeking an alternative to naturalism. But in his work he succeeded in re-evaluating art forms hitherto considered 'minor' by the side of fine art. In this respect he was not original, since Heinrich Wölfflin, in the 1880s, suggested 'like Semper before him, that the tendency of each age could best be read in the smaller-scale decorative arts'.[54] August Endell, the Munich Art Nouveau architect, was heavily influenced by Wölfflin's psychology of architectural form, which argued that the general feeling for form which motivated artistic creation was of greater importance in the generation of architectural forms than factors such as purpose, materials, or climate. Riegl insisted that 'anonymous, unselfconscious patterns were the surest markers of an epoch's energies.'[55] With his reformulation of cultural history Riegl called into question the legitimacy of traditional claims about antiquity and High Renaissance as representing the greatest achievements of art production.

With Worringer, Nietzsche's insight into human language as an umbrella used to obstruct awareness of a hostile universe, and his in-

sistence – so important for Simmel – that subject interacts with object through aesthetic modes of relationship capable of resolving contradictions, are developed for a comprehensive theory of abstraction. Worringer's work represents a classic attack upon what he himself considered a limited orientation, namely, the 'subjectivist' 'theory of empathy' formulated in the writings of Theodor Lipps. According to Worringer, this theory held that aesthetic experience, as self-enjoyment, found its gratification in naturalism and the beauty of the organic, with the latter *objectifying* self-enjoyment. However, art's beginnings do not manifest naturalistic constructs, Worringer maintains, but ornamental–abstract ones which reveal aesthetic need pressing towards empathy-shunning linear–organic forms. The urge to abstraction appears as the counter-pole to the need for empathy, and it stood

> at the beginning of every art and in the case of certain peoples at a high level of culture remains the dominant tendency, whereas with the Greeks and other Occidental peoples, for example, it slowly recedes, making way for the urge to empathy.[56]

The latter involves a dimming of instinct through the development of intellectual reflection and rationalistic cognition, and its precondition is 'a happy pantheistic relationship of confidence between man and the phenomena of the external world'.[57] Such a relationship, facilitating 'a happy, world-revering naturalism' in art, and anthropomorphic pantheism in religion, has been the result of 'innate disposition, evolution, climatic and other propitious circumstances'.[58] Worringer writes of the urge to abstraction being the outcome of 'a great inner unrest inspired in man by the phenomena of the outside world'.[59] Natural models played only a secondary role in the genesis of the work of art. What was primary was an 'absolute artistic volition' which made itself 'the master of external things as mere objects to be made use of'.[60] Primitive man stood lost and spiritually helpless within the external world, experiencing 'only obscurity and caprice in the interconnection and flux' of phenomena. Hence he was motivated by an intense urge 'to divest the things of the external world of their caprice and obscurity in the world-picture and to impart to them a value of necessity and a value of regularity'.[61]

> The primal artistic impulse has nothing to do with the rendering of nature. It seeks after pure abstraction as the only possibility of repose within the confusion and obscurity of the world-picture, and creates out of itself, with instinctive necessity, geometric abstraction. It is the consummate expression, and the only

expression of which man can conceive, of emancipation from all the contingency and temporality of the world-picture.[62]

Following Riegl, who had asserted in his *Stilfragen* that the historical evolution of the arts demonstrates peoples at a low level of cultural development employing the regularity of an abstract geometric style, Worringer argues that a 'causal connection must therefore exist between primitive culture and the highest, purest regular art form'.[63] Moreover, abstract form is not the result of reflection and calculation. It appears as a purely instinctive creation, a mode of expression not requiring the 'intervention of the intellect'. Worringer ignores the implications which arise from an acknowledgement that Palaeolithic art is eidetic (apparently representational) and that symbolic, geometric form characterizes the *later* Neolithic period. He gets round this 'problem of origin' (which, anyway, offers artificial distinctions) by emphasizing the significance of flattening of imagery as an abstract principle. The dynamic underlying the striving for abstraction, and the innate disposition towards regularity, is the more forceful where mankind has failed to enter into 'a relation of friendly confidence with the appearance of the outer world'. The simple line which developed in geometrical regularity offered the strongest possibility for happiness in the face of the disquietude created by the 'obscurity and entanglement of phenomena'. The law and the necessity embodied in pure abstraction – as the highest absolute form – effaced the final trace of connection with, and thus dependence upon, a capricious organic life. Mechanical forces, through geometric forms, have, claims Worringer with the aid of a description from Lipps's *Aesthetik*, 'been taken out of the natural context and the ceaseless flux of the forces of nature, and have become visible on their own'.

The essence of Worringer's argument is that in the West, the development of rationalistic–sensuous cognition has inhibited *instinct*: the latter manifested historically with the human fear of feeling lost in the universe. By contrast, the civilized peoples of the East, who opposed the rationalistic picture of the world presented by Western intellectuality, 'remained conscious of the unfathomable entanglement of all the phenomena of life'. Their instinct for the relativity of reality stood 'above' cognition, whereas with primitive peoples this instinct was 'before' cognition.

The happiness they [Oriental peoples] sought from art did not consist in the possibility of projecting themselves into the things of the outer world, of enjoying themselves in them, but in the possibility of taking the individual thing of the external world out

of its arbitrariness and seeming fortuitousness, of eternalizing it by approximation to abstract forms and, in this manner, of finding a point of tranquility and a refuge from appearances. Their most powerful urge was, so to speak, to wrest the object of the external world out of its natural context, out of the unending flux of being, to purify it of all its dependence upon life, i.e., of everything about it that was arbitrary, to render it necessary and irrefragable, to approximate it to its *absolute* value.[64]

Absolute forms, therefore, represent the only, and the highest, forms of regularity, created with 'elemental necessity', with which human beings can confront the vast confusion of the world-picture. What then connects the primitive experience with the modern?

It is as though, Worringer stresses, 'the instinct for the "thing in itself"',[65] that is, the individual material object, were the most powerful in primitive man. Riegl had already argued that the early civilizations of antiquity perceived external things as 'confused and obscurely intermingled' and that 'through the medium of plastic art they picked out single individuals and set them down in their clearly enclosed unity'.[66] As Worringer explains, humanity's primal need was to represent the sensuous object artistically in such a way as to free it from 'the unclarity imposed upon it by its three-dimensionality'. Such representation involved the suppression of *space* (which links objects to each other, gives them a temporal value, and imparts a confusing relativity in the world-picture) and *depth* (which contradicted apprehension of the object as an absolute value, that is, as a closed material individuality/enclosed unity). Space is 'a mere perceptual form of the human understanding'; the apprehension of depth relations requires that the subject/spectator *constructs* the object's physical reality from familiarity with the object through optical perception. This appeal to limited subjective experience, says Worringer, contradicted all need for abstraction. Antique art admitted from the outset that surface or plane dimensions of space (height and width) were indispensable for the rendering of any notion of material individuality whatsoever. The instinct for the 'thing in itself', the individual phenomenon, is blunted and dimmed through 'Increasing spiritual mastery of the outside world and habituation to it'. After thousands of years of the evolution of human rationalistic cognition, however, the feeling for the 'thing in itself' reawakens as 'the ultimate result of scientific analysis' and 'the final resignation of knowledge'. 'What was previously felt instinctively has finally become a product of thought', the 'ultimate product of cognition'. 'Having slipped down from the pride of knowledge, man is now just as lost and helpless *vis-à-vis* the world-picture as primitive man.' The deepest and

ultimate essence of all aesthetic experience, Worringer insists, is the need for self-alienation, and the impulse towards the latter is strongest and most intense in the urge to abstraction, which is 'an urge to seek deliverance from the fortuitousness of humanity as a whole, from the seeming arbitrariness of organic existence in general, and in the contemplation of something necessary and irrefragable'.[67]

The feeling for the 'thing in itself' and the need for self-alienation are clearly apprehended as being essential elements in a determination which ultimately leads to the shedding of everything that is extraneous to the aesthetic process. As we saw, Nietzsche found the 'aesthetic phenomenon' to be possible only when the subject loses itself, transcends itself as a subject, and becomes decentred. Such formal characteristics as placing emphasis on the flatness of (patterned) picture surface through the suppression of depth and the illusion of three-dimensionality, stress what is intrinsic to works of art that eschew representation. They are capable, not only of eliciting self-estrangement, a sense of distance, and contradictory interpretations, but also intensified tactile (or haptic) experience. But what happens when the 'thing in itself', as a material object external to the sphere of fine art, becomes also 'the picture' – that is, when artistic criteria are applied to objects with a function within the life-world? Simmel argued that the appreciation of objects only became aesthetic as a result of 'increasing distance, abstraction and sublimation'.[68] When objects were beautified through artistic form and appearance they took on a unique individual existence which intensified objectification and engendered aesthetic satisfaction.

Principles of abstraction had already been operationalized through being applied to rooms, buildings, furniture, etc., by Art Nouveau practitioners before Worringer's book appeared. It was through these avenues that the problematic of the 'thing in itself' was already being confronted by Art Nouveau; that is to say, not merely through the stylization of objects, but by employing modes of abstraction 'capable of forming a whole for the imagination' (Worringer), – a completed form. A heightened awareness developed of the potential for unifying experience *vis-à-vis* objects by enhancing the significance of the relationship between creator, phenomenon created, and examiner. In following from the recognition of redundant symbol systems the Art Nouveau preoccupation with the 'thing in itself', the *real* object as manifestation of 'life and truth' (van de Velde), could appropriate from thinkers such as Riegl and Worringer the notion of abstraction being able to preserve a 'tactile nexus of representation'. This was a way of confronting the problem, elucidated by Riegl, that experience founded on the optical engendered delusion. Describing relations that have been reduced to the plane (transformed depth

relations), Riegl claimed that here lay the source of perception of the sense of touch. In enhancing the 'reality' of their objects through aesthetic design capable of dissolving three-dimensional spatial volumes, late Art Nouveau practitioners sought the sources for an *objectivity* which transcended conceptual frameworks and the *appearance* of past forms. Art Nouveau was thus a practical project which submitted symbolic cultural categories to 'empirical risks' (to paraphrase Marshall Sahlins)[69] by transforming the empirical through radical innovation into a new language of imagery for the general experience of everyday life (an important example would be the rooms – with white on white and black on white reducing the sense of three-dimensionality – which resulted from the new concepts of spatial structuration made possible by abstraction).

Appearing as it did between late Art Nouveau and early modernisms such as cubism, Worringer's work marks a fundamental attempt to provide comprehensive theoretical justification for art's unique ability to establish coherence in the face of an arbitrary and fragmented world of relativism. In his work we can discover the *combination* of two conceptual orientations which, with twentieth-century aesthetic modernisms, would become separated. These can be termed *formalist* and *mystico-spiritual* respectively. In acknowledging the nature of this combination we can begin to better understand the mentality behind Art Nouveau. The former of these orientations deals with what it takes to be the basis for specifically aesthetic experience – namely, what Clive Bell would term 'significant form' ('lines and colours combined in a particular way, certain forms and relations of forms').[70] We can see where Worringer is providing philosophical and psychological justification for a trait that has characterized the greater part of modernist painting, that is, symbolic images overtly flattened in appearance. However, this trait was already in existence prior to the turn of the century with the symbolism of Gauguin, Renaud, and Denis. More interestingly for our purposes, is that the new language fostered by late Art Nouveau manifests such characteristics in a variety of objects from its furniture to its architecture. In Vienna, Otto Wagner's *Wilhelminen Hospital* (dermatology ward) of 1910–13, and his *Austrian Postal Savings Bank* of 1904–6, incorporate overtly two-dimensional façades which mediate perception of volumes through the employment of lines (in the former, through the use of strips of blue ceramic tiles). Wagner discovered in the new psychological–aesthetic theory the basis for a rationalist functionalism: 'Completely objectionable is every restless and robust line or one that actually makes the form three-dimensional, thereby producing uncertainty and uneasiness in use.'[71] In work by Josef Hoffmann from this period, the reduction of plastic

values to surface qualities illustrates the fundamental tendency towards anti-historicist Abstraktion. In describing Hoffmann's *Purkersdorf Sanatorium* (1903–5) Ezio Godoli notes that 'articulation of volume is transformed into a two-dimensional expression of thin linear strips – in black and white squares – that mark out the edges', and that these 'frame the apertures in place of traditional jutting cornices'.[72] Writing of the architectural work by Mackintosh which was discussed in German art journals, Eckart Muthesius describes Mackintosh as being 'less interested in the need for perspective representation than in the delicate, careful structuring of space'.[73] Metal discs, marble, different types of wood, mirror, and ceramic-glazed tiles – the use of a variety of materials by Art Nouveau practitioners for expressive purposes illustrates their concern to heighten haptic experience in the spectator.

Along with concern for form, Worringer demonstrates the metaphysical conviction that art is rooted in a human need to experience 'spiritual' reality (or reality in a spiritual form). This orientation can subsequently be witnessed with diverse and conflicting aesthetic modernisms: with expressionism and its notion of qualities essential to the human make-up; in cubism where visual reality is rendered as manifestly thematic and conceptual; with dadaism which was obsessed with abstract creative 'ideals' underpinning the production of art objects; and in surrealism where privileged access is claimed to unconscious states which connect to 'primitive' impulses in Worringer's sense. Like Nietzsche's assertions about the role of language in human cultures, Worringer's claims about artistic form as that which reflects deeply rooted human needs, leads to the acknowledgement of a primal drive towards the creation of security and coherence. Here Worringer represents one significant articulation of the philosophy underpinning the late Art Nouveau endeavour with its attempt to reconcile subject with object which, as we shall see, was of fundamental importance for the Scottish movement under Mackintosh. Worringer's text also reveals some of the roots of the essentializing mentality which later came to characterize modernism as a whole. The means towards coherence – geometric abstraction – signified the need to employ a visual language of sublimity in confronting the harsh and often hostile realities of an industrialized society. In addition, the hope of a union of art and science seemed possible, since geometry was also the language underlying science, the means for rationally understanding the structure of the physical universe.

Baudelaire, in fusing the aesthetic experience of modernity with the historical, had found that the art of modernity embodied *both* 'the transient, the fleeting [or fugitive], the contingent' *and* 'the eternal and the immutable'.[74] Worringer discovers that in imparting neces-

23

sity and eternity to things, and thus wresting them from temporality and arbitrariness, the artist must 'suppress every element of the organic' (the natural model) by approximating it to pure linear regularity. However, this solution of employing plane relations and outline has, says Worringer, more of the character of expediency than strict consistency of artistic volition. The transition from this to pure geometric crystalline abstraction (with lines 'drawn absolutely straight'), notwithstanding its historical referents (the strict proportionality of elements dominated by a unity of unbroken outlines with ancient Egyptian art; the de-organicization apparent in Northern Celtic art), reads like a description of the movement from *Jugendstil* to *Sezessionstil*. It is through the purest abstraction that Baudelaire's 'relative, circumstantial element [of beauty] ... contemporaneity, fashion, morality, passion', the 'mysterious beauty' which human life unintentionally imparts to modernity,[75] is to give way to the basis for a 'tranquillizing consciousness' (Worringer) in the face of the increasing disintegration of experience described by Simmel.

It was from Otto Wagner that Josef Hoffmann learned clarity of stereometric form, that ornamental elements are accessories, and that large surfaces, space, compactness, simplicity of volume, involved geometric shapes. 'The geometric interpenetration and optical clarity of the visual square', commented Wagner's contemporary Dagobert Frey in 1919, 'have become the aesthetic experience of our time.'[76] This was true, not only of Germany/Austria, but of locations as far apart as the USA (Frank Lloyd Wright in Chicago) and Scotland (Charles Rennie Mackintosh in Glasgow). The geometric style, as applied by Hoffmann and Moser to the works produced by the Wiener Werkstätte in what has been referred to as its 'severe period', raised important implications for the issue of the possible mass-production of WW creations. In drawing the contrast between the WW and Walter Gropius's Bauhaus in Weimar and Dessau (1918–32) W. G. Fischer makes the point that many of the former's designs can be viewed as 'a brilliant anticipation of the Bauhaus idea'.[77] Fischer acknowledges the potential inherent in 'constructional' Art Nouveau for large-scale reproduction. The intention of the Bauhaus was to create the kind of good-quality prototype designs that could subsequently be mass-produced '(world revolution permitting) to adorn the homes of the emancipated proletariat'.[78] Despite the factor of the WW remaining faithful to the concept of individually made, unrepeatable objects, from a stylistic point of view the architectonic logic and the geometric form-language (*Konstruktiver Jugendstil*) contained the potential for the kind of reproduction which Mackintosh clearly had in mind. Says Fischer, 'one has only to think of the baskets and vases in white-painted, perforated sheet

24

metal, ready for mass production, which look like a curtain-raiser to the great formal drama played out by the Bauhaus and De Stijl.'[79]

In a letter written to Hoffmann in 1902 on the subject of the setting up of a craft workshop as an offshoot of the Vienna Secession,[80] Mackintosh demonstrated, not merely his own wholehearted welcoming of mechanization, but also his ability to project forward in time to a stage where artistic quality and mass production could merge, thus allowing even the poorest-off members of society to acquire genuinely beautiful products of design: but by that stage, products that were the result of the machine rather than the handicraftsman. Mackintosh's expressed views point beyond the WWs costly luxurious designs, as well as its own tension-filled relationship to mass-production which perpetuated the limited equation of quality with small-scale production. Clearly, he was able to acknowledge that machine-made goods did not necessarily have to be plain or ugly: that machine techniques need not violate integrity of design. Under Mackintosh, the Glasgow Art Nouveau movement signified the attempt to rationalize art and integrate it within objective society at the same time as it emphasized individuality, creativity, spontaneity, and experimentation, notwithstanding the mechanization, standardization, and, above all, routinization of life under capitalism which it confronted.

The mentality of Mackintosh was to a considerable extent moulded by the milieu in which the potential for mass-produced examples of industrial art was being acknowledged in Glasgow, and which reached a peak with the East End Industrial Exhibition of 1890–91. Mackintosh's stress upon the ideal nature of art and the charismatic status of the individual artist capable of spontaneity, represented an expression of art's autonomy, at the same time as it acknowledged that autonomy as having become exhausted. Thus he wished to integrate art fully with functionalism in confronting technology. Both of these strains – the aesthetic (detached/hedonistic) and the functional (practical/disciplined) – articulated *dimensions* of the capitalist division of labour. Furthermore, with Mackintosh 'astringent rationalism' is the complement of 'fervent instinctualism', and this takes place within a position of critical estrangement from the segregated utilitarian and aestheticized elements of turn of the century capitalistic culture. It is this critical estrangement, with the 'moment of spontaneity' that it facilitates, which perceives that concrete institutional interrelationships between artistic and non-artistic forms of production have been compromised through the autonomy status bestowed on a non-practical art on the one hand, and the lack of (artistic) spontaneity obtaining within the technological status quo on the other.

Chapter two

# Modernism as avant-gardism

This chapter attempts to construct the basis for a sociological perspective on Art Nouveau. Instead of focusing exclusively upon individual producers and their respective work, a sociological approach needs to locate Art Nouveau as a coherent *cultural phenomenon* which took shape at a precise point in historical time. In doing this it must demonstrate what actually was new and exceptional about Art Nouveau in its time. For historiographical purposes, the 'newness' of Art Nouveau requires to be distinguished from what was not new, that is, what was stable and inherited from the past. However, the 'newness' also has to be meaningful in terms of a present which embodied discontinuities with the past, but which itself imposed restrictions on 'newness'. If the socio-cultural context for Art Nouveau is to be elucidated as a complex structure which has attained significant stability through time, then the best means for analysing Art Nouveau as a phenomenon in tension with this stability, is through the use of a concept of Art Nouveau as involving the shared ideas and activities of specifiable homogeneous groups of exponents. In confronting archival material, the sociology of Art Nouveau requires the kind of clarifying concepts which deal with rifts in the cultural relations between groups, more specifically, with the relation of Art Nouveau as avant-garde to traditions and established institutions. We will begin by examining the criteria whereby avant-gardism as such can be adequately specified. Subsequently, with the help of certain social theorists, it will be shown in what ways Art Nouveau can be legitimately judged to have been avant-gardiste.

### Peter Bürger and the importance of aestheticism for avant-gardisme

According to Peter Bürger in his *Theory of the Avant-Garde*, the historical avant-garde artistic movements in the early twentieth century,

such as dadaism and surrealism, represented a break in the development of art in bourgeois society. The avant-garde was opposing art as an institution: an institution embodying the ideological concept of an autonomous art, and which functions according to that concept or principle:

> Art as an institution prevents the contents of works that press for radical change in a society (that is the abolition of alienation) from having any practical effect. That is not to say, of course, that art as institutionalized in bourgeois society cannot assume tasks relating to the elaboration and stabilization of the subject, and have functions in that sense.[1]

Importantly, in this respect of opposition, the avant-garde was highlighting in a new way the actual existence and significance of art as a bourgeois institution. A precise social and historical definition of 'art' emerged with the avant-garde which allowed artists themselves to develop an emancipated critical awareness of their own position within the 'nexus of institutionalization', that is, within the sphere, or level, of mediation between (bourgeois) society and its art. 'This level of mediation is not something external to the concept of the work of art', explains Jochen Schulte-Sasse in his foreword to Bürger's text, 'it is essential, as it historicizes and makes relative the concept of the work of art itself.'[2] The actual social function of art in the developed capitalistic society of the nineteenth century engendered the concept of art as something autonomous. That particular social function involved sustaining what were the fundamental attributes of the then modern art as an institution: the balancing of (contradictory) negative and affirmative elements, including the beautiful appearance of a better world, hope for the realization of future social ideals. However, the *fictional* image of a better social order, as well as offering a form of protest against the undesirable prevailing order, 'relieves the existing society of the pressure of those forces that make for change. They are assigned to confinement in an ideal sphere.'[3] But this 'ideal sphere' remains conditioned by social developments. Says Schulte-Sasse,

> Because the concept of the work of art was institutional and that institution stayed in place, the ideological function of art was also preserved. The concept of the work of art was, in fact, the necessary means for art's becoming institutionalized as a medium for ideological reproduction.[4]

Bürger argues that the avant-garde required a quite different con-

cept of the work of art from that operative within the bourgeois institution where the apparent separation of art from social life (a separation organized around the purpose of interpreting social life from a distance and thus from within a detached sphere where 'sensuousness could evolve that was not part of any means–ends relationships')[5] was representative of an hermetically sealed (organic) unity. Intervention in, rather than separation from, practical social life, was the prime avant-garde motivation: thus an art reintegrated into social praxis was the fundamental avant-garde ideal. The basis for the critique was the recognition that the period of bourgeois art, wherein art is seen to lack societal impact and to maintain a tension between art's autonomous status and the content of individual art works, had drawn to its conclusion. The avant-garde, in revealing the nexus between bourgeois art's autonomous status and the absence of any social consequences, turns against 'the distribution apparatus on which the work of art depends, and the status of art in bourgeois society as defined by the concept of autonomy'.[6] Indeed it is the substantive and specific autonomy of art as an institution (the conditions under which art is produced, distributed and received) – its detachment from social praxis and its freedom from pressure to serve social purposes – which allows the distance required for the formulation of truly radical criticism: criticism, that is, which is not merely a function of a social institution, wherein criticism of specific concepts is conditioned by other concepts hostile to the first. In short, it is criticism of an institution itself that is facilitated by distance: what Marx, in the Introduction to *Grundrisse*, terms 'self-criticism', as against 'system immanent criticism'. 'It became apparent that the social effect of a work of art cannot simply be gauged by considering the work itself but that its effect is decisively determined by the institution within which the work "functions".'[7] On this basis also, art development can be periodized. The historical avant-garde movements were progressive, Bürger maintains, but with the subsequent experience of how the culture industry has effected the false elimination of the distance between art and life (that is, with commodity aesthetics designed to prompt purchasers into buying what they do not really need through the use of form as an enticement) art becomes practical. Hence the demands of the historical avant-garde appear to be realized. However, since this commodified art is an art that enthrals, the resultant *disvalue* has been 'a false sublation of art as an institution'.[8] In retrospect, therefore, avant-gardiste thinking appears profoundly contradictory:

> For the (relative) freedom of art *vis-à-vis* the praxis of life is at the same time the condition that must be fulfilled if there is to be a

critical cognition of reality. An art no longer distinct from the praxis of life but wholly absorbed in it will lose the capacity to criticize it, along with its distance.[9]

But a further contradiction exists with the process of the historical emancipation of the aesthetic from religious ritual. Such emancipation facilitates 'a new way of perceiving that is immune to the coercion of means–end rationality'.[10] At the same time, however, the sphere thus opened up is 'ideologized', and this is most apparent from the notion of genius: the genius is viewed as the *individual* who can be free from the praxis of life, and who is alone capable of producing *on his/her own* the autonomous work of art. Under the auspices of Aestheticism, the institution of art, and the actual contents of art works, were made to coincide: art works themselves reflected distance from the praxis of social life, and signified the negation of bourgeois means–end rationality. Crucially, Bürger asserts that avant-gardistes

... assent to the aestheticists' rejection of the world and its means–ends rationality. What distinguishes them from the latter is the attempt to organize a new life praxis from a basis in art. In this respect also, Aestheticism turns out to have been the necessary precondition of the avant-gardiste intent. Only an art the contents of whose individual works is wholly distinct from the (bad) praxis of the existing society can be the centre that can be the starting point for the organization of a new life praxis.[11]

Analytically, therefore, a 'critical science', in attempting to illuminate the present, must examine 'all those problems that idealist aesthetics define as the distinctiveness of the aesthetic'. Bürger explicitly defines the intention of the avant-gardiste as 'the attempt to *direct toward the practical the aesthetic experience (which rebels against the praxis of life) that Aestheticism developed.* What most strongly conflicts with the means–ends rationality of bourgeois society is to become life's organizing principle.'[12]

Bürger's theory is valuable, not least for the way in which it establishes a theoretical frame of reference within which the avant-garde movements of the early twentieth century can be portrayed as involving, not only a new range of forms, but, in addition, a new way of thinking, the consequences of which have yet to be exhaustively examined. But what is the nature of the relevance of such a theory for an analysis of Art Nouveau, which, as a movement, had become virtually extinct by 1914? Bürger himself provides the answer to this question when discussing the issue of 'artistic means' or 'procedures'.

There he stresses that

> certain general categories of the work of art were first made recognizable in their generality by the avant-garde ... *it is consequently from the standpoint of the avant-garde that the preceding phases in the development of art as a phenomenon in bourgeois society can be understood* ... it is an error to proceed inversely, by approaching the avant-garde via the earlier phases of art.[13]

The possibility of making these general categories of art (artistic means) recognizable was facilitated, since the middle of the nineteenth century (that is, subsequent to the consolidation of bourgeois political rule on the continent), by the movement of the form–content dialectic of artistic structures increasingly in the direction of the domination of form over content. This historical process involved a down-grading of stylistic norms (through which social norms were expressed) in favour of the operation of rational choices by artists between various techniques for the specific purpose of achieving artistic effect via the overt demonstration of artistic means *as means*. Although, says Bürger, 'Artistic means is undoubtedly the most general category by which works of art can be described,' it is only since the historical avant-garde movements that 'the various techniques and procedures can be *recognized* as artistic means'.[14] Prior to this, artistic means had been limited by the constraints placed upon them by period style, that is, an established canon of permissible procedures. Thus a clear conception of the literary and artistic avant-garde movements of the 1920s can aid significantly in the elucidation of those artistic movements which preceded them. Such an approach can help to avoid the problem of projecting hidden assumptions of an historicist or determinist nature on to empirical data by working against the possibilities of linking historical periods through a teleological belief in directionality or unilinearity. Consequently, hypotheses about the avant-gardiste content of Art Nouveau can be generated so as to confront these hypotheses with historical data and hence investigate their plausibility for the specific conjunctures under analysis.

By emphasizing the ideological nature of the work of art in bourgeois society that the avant-garde were opposing, Bürger illustrates the recipient as a spectating subject within, and conditioned by, that society and its history. Only this recognition can begin meaningfully to elucidate what lies 'behind' the experience of shock involved in confrontation with the radically new. For this reason, Bürger's theory should not be classified as an 'institutional theory of art' pure and simple: Janet Wolff's assertion that 'an institutional definition of art

would, of course, have nothing to say about the nature of aesthetic experience',[15] can be seen to be inapplicable to Bürger, who is concerned to elucidate both the experience and the social role of the spectating subject.

In its attempts to negate the disjunction of art and the praxis of life, and individual production and individual reception, argues Bürger, the avant-garde creates a new type of art work in which a specific kind of unity is exploded. He makes a distinction between what he terms the 'organic' and the 'nonorganic' work of art: only the latter earns the epithet avant-gardiste. Artists who produce organic works are referred to as 'classicists', but Bürger is swift to point out that this is 'without meaning to introduce a specific concept of what the classical work may be'.[16] Such artists 'treat their material as something living. They respect its significance as something that has grown from concrete life situations.' As the carrier of meaning, the material is treated as a whole, a totality. In the work of classicists 'the unity of the universal and the particular is posited without mediation'.[17]

By contrast, for avant-gardistes, material is nothing more, or other, than material which, in not carrying meaning derived from contexts within the life totality, has significance imparted to it by the artist. Here the unity of universal and particular is a mediated one: 'the element of unity is withdrawn to an infinite distance.'[18] By tearing the material out of the life totality, the avant-gardiste isolates and fragments it:

> Just as the attitude toward the material differs, so does the constitution of the work. The classicist produces work with the intent of giving a living picture of the totality. And the classicist pursues this intention even while limiting the represented reality segment to the rendition of an ephemeral mood. The avant-gardiste, on the other hand, joins fragments with the intent of positing meaning (where the meaning may well be the message that meaning has ceased to exist). The work is no longer created as an organic whole but put together from fragments ... [19]

The (organic) work of art created by the classicist (or realist), therefore, in intending the impression of wholeness, with the individual elements having significance only as they relate to the whole, appears as a work of nature, thus concealing (making unrecognizable) the fact that it has actually been made. The aesthetic limits of this unified totality are, at one and the same time, ideological limits: demarcations that shut off external considerations from the work of art. Conversely, the avant-gardiste work overtly presents itself as an arti-

ficial construct: it proclaims itself an artifact. Moreover,

> the individual elements have a much higher degree of autonomy
> and can therefore also be read and interpreted individually or in
> groups without it being necessary to grasp the work as a whole ...
> it is possible only to a limited extent to speak of the work as a
> whole as the perfect embodiment of the totality of possible
> meaning.[20]

Where the organic work of art, in pretending to be like nature ('the
organic work intends the impression of wholeness'),[21] projects an
image of reconciliation between nature and human beings, the lack
of such a semblance of reconciliation is what characterizes the non-
organic avant-gardiste work. Where the effect of fragmentation
and/or disintegration transforms the break with reality into aesthetic
effect, the parts '"emancipate" themselves from a superordinate
whole; they are no longer its essential elements. This means that the
parts lack necessity.'[22] By this Bürger means expressive or communi-
cative necessity: the addition or subtraction of elements (images,
events), a change in their order – none of this affects the ability of the
avant-gardiste work of art to convey its own kind of coherence be-
cause what is of decisive significance is the 'construction principle'
which underlies the deployment of images and/or events. This has
crucial implications for the reception of avant-gardiste works, since
the mode of reception (appropriating intellectual objectifications)
that has developed through attempting to grasp the total impression
conveyed by organic works of art, is one of experiencing shock. Since
meaning is not now constituted by the relationship of the parts to the
whole (these parts 'are no longer subordinated to a pervasive in-
tent',[23] though their enlarged autonomy will never be total), the
recipient's attention is dislodged from attempting to grasp a work's
meaning, towards greater awareness of the principle of construction
employed. This break, or shock, which accompanies the recipient's
reaction to avant-gardiste works, is a reflection of the formal (rather
than the hermeneutic, that is, the problematic of the understanding
of meaning) methods directed at techniques and procedures that
such works involve. In other words, the hiatus has resulted from the
recognition that the parts have become less important as constituent
elements within a meaningful totality, and more important as signs
with relative autonomy. One result of the break is the disintegration
of the mimetic function of art. However, the avant-gardiste work, in
terms of the act of perception, ultimately *cannot* escape being under-
stood hermeneutically, that is, as a total meaning, because 'even the
withholding of meaning is a positing of it'.[24] As Bürger emphasizes,

the unity has integrated the contradiction within itself. It is no longer the harmony of the individual parts that constitutes the whole; it is the contradictory relationship of the heterogeneous elements ... A critical hermeneutics will replace the theorem of the necessary agreement of parts and whole by investigating the contradiction between the various layers and only then infer the meaning of the whole.[25]

In attempting to provide, to use Bürger's phrase, 'an empiricism that is informed by theory',[26] for the analysis of the phenomenon of Glasgow Art Nouveau, it is necessary to examine to what degree Mackintosh's ideological position corresponds to that of the avant-garde as outlined above. This is only possible through an examination of his expressed ideas and his practical achievements in applied art and architecture. Although Bürger gives the impression that the historical avant-gardes discovered the essential relationship between art and praxis, it remains true to say that the applied arts and architecture already embodied this relationship, because practitioners in these fields viewed themselves as actively taking 'beauty' into society. The aestheticist distinction between art and the praxis of life – elucidated by Bürger as a pre-condition for the avant-gardisme which attempts to transcend this distinction – is, however, of crucial relevance for the analysis of the Glasgow movement, since the latter demonstrated a preoccupation with Aestheticism which was in marked contrast to the Arts and Crafts movement's exclusive emphasis upon the technical and the functional. It has to be demonstrated that awareness of the cultural significance attaching to both of these spheres (the artistic and the technical) in themselves, *and* to their desired interpenetration, characterized the Glasgow movement. Bürger's abstract model of the classical and avant-gardiste works of art, respectively, can provide a valuable frame of reference in considering the kind of elements which appear in the works of the Glasgow movement over the period of their most significant output (1893–1914). The criterion of organicism/non-organicism is particularly helpful here, because, beyond a certain historical point, Scottish Art Nouveau divested itself increasingly of organic symbolism, and what emerged involved a dislodging of attention towards a heightened awareness of the principle of construction. In the indigenous architecture of Scotland Mackintosh discovered elements such as structuration and asymmetry: Herbert Spencer, in the early 1890s, argued that asymmetry was a manifestation of *non-organicism*. The significance of such factors for the avant-gardiste creations of the Glasgow movement require to be emphasized. A full discussion is

provided in Chapter 5 where a comprehensive examination of Mackintosh's extant writings is undertaken.

## Social theorists on the subject of Art Nouveau

In his *Paris: the capital of the nineteenth century* (the draft outline, written in 1935, for his *Arcades* project), Walter Benjamin described iron as having been the first artificial material in the history of architecture. Acknowledging the accelerated development of iron throughout the nineteenth century, Benjamin proceeded to discuss the role of iron in Art Nouveau. 'The new elements of construction in iron – girder forms – obsessed *Art Nouveau*,' Benjamin insisted. 'Through ornament it strove to win back these forms for art.'[27] The 'real significance' of Art Nouveau resided in the fact that it 'represented the last attempt at a sortie on the part of Art imprisoned by technical advance within her ivory tower'.[28] Benjamin's description thus helps to focus attention upon the essential nature of the Art Nouveau endeavour, in that it elucidates the link between the capacities and products of capitalistic industrialization at a precise historical point, on the one hand, and, on the other, the specific concerns and methods employed by Art Nouveau *vis-à-vis* the former. In its aesthetic crusade to confront the realities of mechanization and mass-production – these specifically urban phenomena – and to apply artistic principles to modern practical inventions, Art Nouveau was penetrating the public sphere. In this latter respect it was a movement concerned with everything from artistic commercial posters and shop signs to dwelling houses and civic buildings. Was it then an avant-garde in Benjamin's opinion?

In commenting upon Art Nouveau posters used to advertise commodities, Benjamin noted that these posters manifested a highly ambiguous nature: although they represented 'the ruse by which industry forces itself upon the dream',[29] he asked whether there existed within them 'a likeness for things which in this earthly life none had yet experienced. A likeness for the everyday world of Utopia?'[30] Benjamin thus described the kind of potency which art could bring into a public sphere of production and dissemination. The ambiguous nature of the commercial art poster reflected the dialectic of exteriority–interiority: the public–private social divide which had hitherto ensured that art reveal its autonomy through unique individual productions which eschewed publicly determined considerations. Posters, as examples of an unashamedly commercial art, were positing themselves as commodities, and in artistic terms, this was a new development. In a real sense, artistic posters were, so to speak, the commodity of the commodity. The forces of that 'interiority'

which was the direct result of art's being imprisoned in the private sphere by an advancing technology, were, argued Benjamin in *Paris*, mobilized and given expression by Art Nouveau 'in the mediumistic language of line, in the flower as symbol of the naked, vegetable Nature that confronted the technologically armed environment'.[31]

One important question arises with regard to Benjamin's comments on Art Nouveau's 'obsession' with iron, and that has to do with what he actually had in mind. In other words, what was distinctive about an Art Nouveau utilization of iron? The nineteenth century witnessed a significant increase in the use of iron construction for buildings long before Art Nouveau, but, as Madsen pointed out, by the 1880s and 1890s there was much debate among continental architects about the extent to which iron should be *apparent* in architectural constructions. 'Everyone recognized the qualities and possibilities of iron, but should the construction stand naked and revealed, or should it be a skin of period style?'[32] It was in Belgium in particular that this issue was most debated, and where the manifest desire to create a new style produced, among other things, 'iron architecture' characterized by what Grasset, one of its most vitriolic critics, described as 'the stupid pretence of wanting to show everything'.[33] This overt 'showing' is of central importance in differentiating an Art Nouveau use of iron from what went before. The manner in which Art Nouveau utilized iron from its early period onwards has important implications for the issue of the nature of the avant-gardiste work of art as described by Bürger. What Benjamin describes as Art Nouveau's 'obsession' with iron can be seen to have been focused upon the principle of structure. Indeed avant-garde considerations of the aesthetic value of structure as an expressive mode grew out of the development of iron construction for the kind of social uses in the public sphere which Benjamin draws attention to (arcades, exhibition halls, railway stations, etc.). 'It may be said to be less certain, but more fascinating,' commented Madsen, 'to suggest that the influence of iron construction on Art Nouveau was less important than the *structural expression of Art Nouveau upon the development of modern architecture*.'[34] Such an interpretation certainly orients Art Nouveau in the direction of Bürger's criteria for the avant-gardiste work of art. Alongside the Art Nouveau drive towards integrating art with the social, Art Nouveau begins to look like a progressivist movement by dint of the nature of its productions. Further justification for this view appears at first to be being provided by Benjamin, who, in his *Central Park*, represents German Art Nouveau (*Jugendstil*) as 'the second attempt of art to come to terms with technology'.[35] In this respect it follows on historically, Benjamin claims, from Realism, which was a response on the part of artists to the crisis created for the arts

by 'the new processes of technological reproduction'.[36] 'For *Jugend-stil* the problem as such had already succumbed to repression. *Jugendstil* no longer grasped itself as threatened by the competing technology. But just so much more comprehensive and aggressive was the critique of technology it concealed.'[37] At this point, however, Benjamin asserts that 'For *Jugendstil* it was crucial to arrest techno-logical development.'[38] It thus contained a *regressive* interpretation of technology, and this interpretation is reflected in its 'basic motif', which is 'that of the transfiguration of sterility. The body is depicted predominantly in those forms which precede sexual maturity.'[39] (In the *Arcades* project the relationship between *Jugendstil* and the German Youth Movement (*Jugendbewegung*) is suggested, and this makes apparent Benjamin's desire to pursue the essence of *Jugendstil* into the manifest details of its productions.) Those technically determined forms which are, Benjamin emphasizes, in actuality dependent variables, *Jugendstil* wanted to turn into constants: such a desire renders it reactionary.

It was precisely this evaluation of Art Nouveau on Benjamin's part, which Adorno took issue with when he read and criticized Benjamin's draft outline for the *Arcades* project in August 1935. Adorno wished, at that time, to defend Art Nouveau for what he considered to be its most characteristic aspect, namely, the motivation towards the emancipation of eroticism. This is particularly relevant to the consideration of the Glasgow movement because the erotic content of certain of their works was explicitly commented upon by contemporaries. The Russian art critic M. Mikhaylov, for example, referred to some drawn panels by Margaret Macdonald that were exhibited in Moscow at the end of 1902 as representing 'a page from a sexual psycho-pathology narrated in the language of wood, metal, colours and line'.[40] Adorno was not wholly convinced by the argument that Art Nouveau 'mobilizes all the reserve forces of interiority', being of the opinion that 'it seems to save and actualize them through "external-ization".'[41]

> In place of interiority *Art Nouveau* put sex. It had recourse to sex precisely because only in sex could a private person encounter himself not as inward but as corporeal. This is true of all *Art Nouveau* from Ibsen to Maeterlinck and d'Annunzio. Its origin is Wagner and not the chamber music of Brahms.[42]

Adorno then proceeded to ask:

> is not the dream-interpreting, awakening psychoanalysis which expressly and polemically dissociates itself from hypnotism (docu-

mentation in Freud's lectures) itself part of *Art Nouveau,* with which it coincides in time? This is probably a question of the first order and one that may be very far-reaching.[43]

The question of the relevance of psychoanalysis was not developed on that occasion, but it is valuable, in seeking clarification, to turn to Adorno's *Aesthetic Theory* (the first version of which he began dictating on 4 May, 1961). There he states the view that, for psychoanalytic theory, works of art were essentially projections of the unconscious: such theory emphasized 'the individual producer of art and the interpretation of aesthetic content as psychic content, to the detriment of the categories of form'.[44] This is a highly relevant comment since Art Nouveau (besides being 'obsessed' with iron) was 'obsessed' with form. For Adorno, it is via the law of form that unconscious drives become integrated with the work of art, and are, as a result, externalized. He commends the attempt to conceptualize art in terms of a theory of psychic life since the manner in which the domain of art is constituted 'resembles the constitution of an inner space of ideas in the individual'.[45] But one problem with psychoanalysis was that, although it could illuminate elements in art which were not art-like, it was more in tune with the explanation of purely psychic, as against aesthetic, phenomena. Hence, art was reduced to an 'absolutely subjective system of signs denoting drive states of the subject'.[46] Despite their stress on sex, psychoanalytic studies of artists were 'hopelessly philistine in conception, dismissing as neurotics men of art who in fact merely objectified in their work the negativity of life'.[47] That which is 'objectified' represents the concrete result of the process of 'externalization': what Art Nouveau does with the forces of interiority. Now if Art Nouveau externalizes interiority through the process of aestheticizing the corporeality of sex and the psycho-physical experience of sensuality, what does it do *vis-à-vis* the 'negativity of life'?

Adorno's earlier enthusiasm for Art Nouveau appears to have become dissipated by the time he was working on *Aesthetic Theory,* because in that work he refers to the failure and decomposition of *Jugendstil,* which turned out 'retrospectively to have been no more than a lighthearted journey without substance, as Kafka remarked'.[48] For substance, Adorno implies, *Jugendstil* substituted mere decorative arrangements. Ultimately it betrayed the potential inherent in interiority, itself 'at least in part a forum for protest against a heteronomous order imposed on people'. The dialectic of interiority, however, is to be found in the relationship of this protesting part to 'a tendency to conceive of interiority exclusively in terms of a realm

that is indifferent to order and to leave this order as it is, obeying its laws':[49]

> This accorded well with the emergence of interiority out of the process of labour: inwardness was to help rear a type of person who would do wage-labour on the basis of duty – voluntarily, as it were – just as the new capitalist society wanted and demanded it. As the helplessness of the independent subject grew more pronounced, inwardness became a blatant ideology, a mock image of an inner realm in which the silent majority tries to get compensation for what it misses out on in society.[50]

The consequence of all of this, according to Adorno, is that interiority becomes 'increasingly shadowlike and insubstantial'. Although art is not in complicity with the trends which produce this outcome, it can never be wholly divorced from interiority. But the practice of aesthetic externalization into works of art presupposes a strong and autonomous ego (that is to say, an ego which is not 'outer-directed') 'which alone can see itself in its true light, breaking through its limitations in illusion'.[51]

It is in *expression*, says Adorno, that illusion is most apparent, 'simply because expression pretends to be illusion-free while succumbing to illusion all the same'.[52] Even anti-expressive and mathematized art, which eschews the language of immediacy, does not destroy the legitimacy of expression: immediacy is still articulated through the elements of an alienated and disfigured form: 'This at least is the idea behind a modernism which stops short of absolute construction.'[53] Now where does this locate expression as an Art Nouveau principle? If the avant-gardiste work presents an authentic mode of expression capable of articulating contemporary social conditions, and it does this because it 'stops short of absolute construction', what can be said about expression through 'absolute construction' in late Art Nouveau, that is to say, Art Nouveau *after* the decorative phase which Adorno and Benjamin focus upon? (It has to be stressed also, that even van de Velde had strong misgivings about the nature of German *Jugendstil*, more specifically, the Romantic nature of its ornamentation.) In terms of Adorno's critique, the use of construction by late Art Nouveau practitioners would have to be understood as being representative of an element of decoration, that is, structure being employed as a purely decorative and figurative element. But this raises the question of the relationship of a principle of construction in late Art Nouveau works to the principle of synthesis (in the sense of an organic unity of meaning) in such works. In turn, this has implications for the

question of whether the undermining of organic unity was a specifically modernist process.

Although a principle of construction and the principle of synthesis are manifested with both early and High Art Nouveau productions in ways which sustain overall organic form, this is not the case with the late Art Nouveau of the Scottish School, where the principle of construction (rooted in a cubic, geometric and rectilinear language of forms) is elevated to such a degree as to act against the notion of organic totality. This reinstates the significance of *form*, and, more particularly, structural form as expression. In Glasgow school work, a juxtaposing of symmetric with asymmetric structural elements (which are, in avant-gardiste fashion, drawn attention to), because of the *inner tensions* created through a disruption of form, detracts from a sense of organic totality. Should the Glasgow School of Art design, for example, be understood as avant-gardiste in Bürger's terms because of the employment of structure, where constituent parts, which display an enhanced autonomy, are elements within a homogeneous synthesis which cannot be considered organic as such? Or does this design merely demonstrate a stage in Art Nouveau by which time structure as a decorative principle was being employed in novel ways (à propos Adorno)? The latter proposition is exploded by Mackintosh's dictum that structure (placed in the primary position) should be decorated (in a manner appropriate to it) and not decoration structured. In short, for Mackintosh, the central motivating principle for execution is construction, not decoration. Also, it should be emphasized at this point, that Mackintosh was keenly aware that, as Bürger emphasizes, even the avant-gardiste work cannot escape being *understood* as a totality.

Adorno made it clear to Benjamin that he considered Aestheticism and *l'art pour l'art* not to be identical with the total work of art. 'The total work of art and aestheticism in the precise sense of the word are not identical, but diametrically opposed attempts to escape the commodity character.'[54] In *Aesthetic Theory*, Adorno insisted that the commodity form affects the work of art because the latter cannot escape participation in productive relations. Moreover, material forces of production condition the concept of the new, and consequently works of art become 'absolute commodities'. This means that, although they retain commercial value, works of art 'are social products which have discarded the illusion of being-for-society, an illusion tenaciously retained by all other commodities'.[55] The role of art in a totally functional/instrumental society is afunctionality and lack of instrumentality. The aesthetic substance of works of art facilitates a shift from the ideology inherent in the commodity form towards the potential for truth content. However, art does not auto-

matically become non-ideological through being antithetical to empirical reality, a position well illustrated by Aestheticism: 'The ideological essence of *l'art pour l'art* lies not in the emphatic antithesis it posits between art and empirical life, but in the abstract and facile character of this antithesis.'[56] The Aestheticist idea of beauty led to a filtering out from art works of contents which were not commensurate with what Adorno calls its own dogmatic canon:

> The concept of beauty in *l'art pour l'art* is at once strangely empty and content-laden. It is an artificial *Jugendstil* happening of the sort that inspired Ibsen's formulations about vines that entwine somebody's hair or about 'dying in beauty'. Unable to determine itself, beauty is like an aerial root, becoming entangled in the fate of artificial ornamentation. What makes this idea of beauty so narrow in conception is its direct antithesis to the ugliness of society ....The reason why neo-romantic and symbolistic beauty have become a consumer good so quickly lies in the self-sufficiency of this ideal, that is, its prudish reserve before those social aspects that alone make form possible. Art of this kind brackets the world of commodities, denying its existence. In so doing its products become commodities themselves. They are condemned to being kitsch because latent in them there is the commodity form.... What ultimately won the day was the affirmative side of *l'art pour l'art*, a triumph that spelled the end of this aesthetic ideal.[57]

The affirmative side of aestheticism consisted in its stubborn refusal to submit art to external objectives: the negative side was the clinging to an 'illusion of a purified realm of beauty where the danger of sliding into kitsch is ever-present'.[58]

For Adorno the emancipation of art from means–end rationality necessitated its appropriating the commodity character: but what was adapted to, was also revealed in a new way, in the kind of critical and oppositional manner made possible by artistic form. But later this commodity character was forced out again, not least by *Jugendstil* ('with its ideology of bringing art back to life')[59] which, Adorno argues, prefigured the culture industry and market-oriented cultural production within monopoly capitalism. Growing subjective differentiation, intensified and expanded aesthetic stimuli, the attuning of art to ephemeral individual responses – all of this moved art increasingly away from objectivity and, through ingratiating itself with the public, allied it with the forces of reification. *Jugendstil*, as 'the first collective attempt to inject, by means of art, a new meaning into a world that had lost all meaning',[60] found its abstract negation in functionalism and its counterparts in the afunctional arts, and was

only genuinely exploded by expressionism. But with *Jugendstil*, Adorno concedes, the apparent duality embodied in art – its claim to truth and its affinity to untruth – emerged clearly for the first time.

If this 'claim to truth' inhered to a significant degree in Art Nouveau's utilization of erotic symbols (albeit treated decoratively) – Adorno's earlier reason for supporting it – then it is important to examine, in connection with Adorno, the critique of ornament put forward by Adolf Loos, since Loos was a staunch advocate of the functionalism which Adorno considered was the abstract negation of decorative Art Nouveau. Adorno acknowledged how Loos traced ornament back to erotic symbols, but that Loos's 'rigid rejection of ornamentation' was 'coupled with his disgust with erotic symbolism', and he found 'uncurbed nature both regressive and embarrassing'.[61] Loos appeared to relate ornament to the pleasure principle, and his denunciation of the former as erotic perversion and degeneracy represented puritanical repression on behalf of bourgeois rationality. Loos equated cultural evolution with the removal of ornament from articles in everyday use. Continual revivals of historicist ornament throughout the nineteenth-century had, he insisted, fostered a widescale craving for nostalgia which took the form of fetishism for kitsch commodities: a fetishism at once regressive (anti-rational, sadomasochistic, necrophilous and primitive were the main terms he employed in this connection) and involving distorted perception of both cultural and natural artefacts. The potential greatness of the modern period lay in its 'inability to produce a new form of decoration' and to acknowledge that 'the fusion of art with functional ends is a profanation of the highest degree.'[62] Modernization had destroyed the conditions under which decoration was made possible (traditional craft production): with ornament now having no organic connection to modern life it was rendered superfluous. But if ornament could no longer legitimately be considered 'beautiful' (in Loos's opinion people mistook ornament for 'style'), how was beauty to be perceived within a modern rationalized means–ends society? At this point, Loos reverted to what were actually eighteenth-century views of beauty as residing in (perception of) utility. 'The beauty of an object only exists in relation to its purpose,' he thus proclaimed, 'the highest degree of functionality in harmony with all other parts is what we call pure beauty.'[63] The prime determinant of an object's 'beauty', therefore, is its use value, which, for Loos, predominated over exchange value (involving production and commercial distribution), the latter being responsible for creating the basis for the fetishization of objects through fashion permutations (which necessarily embodied symbolic erotic content). Practical objects were distinguished from artistic objects: artefacts (purposeful) were not

art (which was free of purpose). Hence Loos insisted on the separation of art from (practical/rational) life in a modern society where praxis and functionality alone condition the form taken by utensils. This too involved an eighteenth-century (Kantian) conception of art as the object of disinterested perception. As we shall see, Loos could not have accepted the dictum of Wagner and Mackintosh that the architect of the future needed to become an artist, because, for Loos, architecture is essentially a product of practical/utilitarian, as against artistic, activity. For Wagner and Mackintosh the aesthetic function of the architect resided in the need to *unify* artistic and technical abilities for the transcendence of the historical separation of art from purpose. Loos's description of how purpose is manifested through architecture is, from Mackintosh's point of view, a description of ideological, and not architectural, purpose:

> The court-house must make a threatening impression on the furtive criminal. The bank building must say 'Here your money is securely safeguarded by honest people ...' The architect can only achieve this if he makes use of the same type of buildings, which have always produced these feelings in people, in the past.[64]

Not only does this kind of perception involve historically specific social meanings, but it also requires that discursive knowledge be apprehended in architectural forms: knowledge, that is, which Mackintosh (who wanted to absorb art into architecture specifically for the creation of new architectural forms) portrays as being inappropriate to architecture. The relationship between the perceived purpose of an object, and the complex of inter-subjective social meanings which facilitate the 'placing' of that object within a social context of acknowledged functionality, is not sufficient to elicit the kind of genuinely aesthetic responses which Loos assumed it could. This much is demonstrated by Adorno's critique of functionalism. The objective is, by definition, matter-of-fact, Adorno points out, and matter-of-factness is not in possession of beauty. The law of form embodied in purely functional creations is that of purposefulness, and here the ideal of beauty is abandoned. Anything that is included for the reason of appearing beautiful, in being extraneous to purpose, has the effect of detracting from functionality. But the ultimate in functionality – understood as *being for other* – is absolute objectification (with commensurate meaning) and thus non-artistic factuality.

In the context of Scottish Art Nouveau, the point at which 'pure' functionalism revealed its inadequacies was the point at which an advocacy of the use of decorative elements became crucially significant. Hence Mackintosh recommended 'that construction should be dec-

orated', and that 'the salient and most requisite features should be selected for ornamentation.'[65] The ideal, however, was to be a seamless interweaving of structuration with decoration: as Talwin Morris indicated, Mackintosh 'frequently emphasized the fact that there should be no apparent break between the construction and the decoration of a house'.[66] Mackintosh effectively combined a 'perfect regard' for essentials of structure with a vital sense of the need for 'sparse and reticent enrichment'. Conversely, the functionalist in Mackintosh considered it anathema consciously to construct ornamental forms: 'In his designs for furniture he displays a thorough grasp of the principles of fit and honest construction; *giving us sound, practicable furniture, not patterns in wood.*'[67]

## From Art Nouveau expression to post-Art Nouveau expressionism and the reinstatement of autonomy

Adorno argues that Art Nouveau was finally 'exploded' by expressionism. However, in the context of his own theoretical position, expressionism has very precise connotations. Adorno applauds artistic expression of the negation of social reality which clearly takes place within the sphere of autonomous art. Hence, the role of art, as Adorno conceives it, is not to abandon afunctionality, because, in doing this, art jettisons its critical ability, since this latter inheres in its autonomous status. The concern with expression, however, was crucial to Art Nouveau (which did set out to abandon afunctionality) but clearly Adorno views Art Nouveau expression as a purely decorative phenomenon. Loos, of course, opposed the use of ornament in the 'applied arts' (for him a contradiction in terms); but he supported expressionism with its 'fervent instinctualism' in painting. As Carl Schorske points out, the Viennese expressionists Schiele and Kokoschka looked to Loos as 'their ally, their patron, and their partner, along with Arnold Schoenberg in music and Karl Kraus in cultural criticism'.[68] How then does (non-historicist) ornament, employed as a mode of expression, articulate with Art Nouveau expression of repressed instinctual (especially sexual) drives? And what is the significance of this for the institution of autonomous art?

As Schorske describes, the Secession movement in modern art in Vienna, with Gustav Klimt as the acknowledged leader, was Austria's equivalent to Art Nouveau, and, as such, it 'manifested the confused quest for a new life-orientation in visual form'.[69] Inspiration for young Viennese artists was found within a European avant-gardiste rejection of classical realism. This had already taken different forms: Impressionism in France, Naturalism in Belgium, Pre-Raphaelitism in England, and *Jugendstil* in Germany. According to Wagner in his

*Moderne Architektur* (1895), nineteenth-century eclectic historicist style architecture betrayed the fact that the historical process, according to which, style with its accompanying new ideal of beauty emerged gradually from the one preceding it, had broken down. Social change had been so accelerated that art development was unable to keep abreast. The most fundamental need was for architects to provide lines of development and movement.

> In the quest for a visual language suited to his age, Wagner found allies in a younger generation of Viennese artists and intellectuals who were pioneers in forming twentieth-century higher culture. In 1897 a group of them banded together to form the Secession, an association that would break the manacles of tradition and open Austria to European innovations in the plastic arts and especially to *Art Nouveau*.[70]

The Secession in its early stage certainly provided a new ornamental vocabulary, but the actual Art Nouveau style, Schorske asserts, 'served as much to inhibit as to advance Wagner's principles of utility and structural function in urban architecture'.[71] With the utilization of contemporary Secession style for two apartment houses erected on the Wienzeile (1898-9), Wagner united three constituent principles for the first time: (1) the primacy of function as determinant of form; (2) the candid use of modern materials in terms of their inherent properties; and (3) a Secession-derived general commitment to an ahistorical and quasi-symbolic language of modernity.

Schorske focuses attention upon the significance of the duality of idiom employed by Wagner for these Wienzeile buildings. The ground storey had a commercial business function which Wagner emphasized through his employment of a continuous angular band of glass and iron for the office space. Only with the residential upper storey was Art Nouveau ornamentation used, to symbolize 'the urbane life of luxury that could have its economic basis in the prosaic, rational offices below'.[72] Thus the functional and the ornamental were used to express the two-sided nature of modern urban bourgeois existence which could embrace both business interest and personal taste. Subsequently, however, this duality of idiom was left behind by Wagner, as an expanded, centralized, bureaucratic administration conditioned the predominance of a wholly rationalized, functional style of architecture for the satisfaction of the new requirements for expanded official and commercial space. Hence bureaucratic and commercial expansion welcomed the kind of functionalism shorn of embellishment which Loos believed would purify the visual environment. This was, of course, the Loos who, in the

pages of *Ver Sacrum* in 1898, condemned Ringstrasse Vienna for 'screening its modern commercial truth behind historical façades'.[73] The cosmopolitan spirit of the Secession artists was as consonant with that of the Viennese upper middle class as it was with the bureaucracy. If Wagner's motto to accompany the architectural expansion of Vienna was 'Necessity is art's only mistress', this '"necessity" meant simply the demands of efficiency, economy, and the facilitation of the pursuit of business'.[74]

In heavily Freudian fashion, Schorske defines the original roster of aims of the Secessionists as being those of oedipal revolt (that is, a revolt of the young against the paternalist/conservative/traditionalist culture which they identified with their elders), an identity quest involving artistic experimentation, and, finally, that 'art should provide for modern man asylum from the pressure of modern life'.[75] The question of the function and meaning of art in a modern society motivated the Secessionist drive towards unifying the arts with architecture and thus of regenerating culture in the widest sense. The artists' ideology had been significantly influenced by the radical thought of avant-garde literary and political groups. But around 1906 the same Secession artists who had been dynamically searching for 'new instinctual truth', the freeing of repressed forces, and a truthful practical modern culture opposed to disfiguring historicism, 'turned away from their unsettling findings to the more modest and profitable task of beautifying daily life and the domestic environment of the elite'.[76] Schorske acknowledges a shift in Secession style away from the organic and fluid forms of Art Nouveau to 'Art Deco' 'crystalline and geometric ones'.[77] The greatest triumph of the Art Deco phase was the *Kunstschau* exhibition of 1908 which continued to manifest the principle of the unification of fine and applied arts and the cultural ideal of *homo aestheticus*: 'Functional objects became museum pieces, while even the most serious painting and sculpture was reduced to decorative functions.'[78] For Schorske, the function of the Secessionist art of the 1890s had been to speak psychological truth: this function, however, had been drained in the subsequent process of its adapting its visual language to purely decorative ends within a context of movement from the fine arts to the arts and crafts. But the *Kunstschau*, under the auspices of Klimt, contained within it the means whereby an inversion of this particular prior movement was to be effected, with this time, a new expressionist development showing the way for a separation of the applied arts and painting:

A new countertendency also surfaced within the *Kunstschau* as young artists schooled in decoration showed the first signs of turn-

ing the lessons of their masters in simplified design into a new language for expressing psychological states. It was here that Oskar Kokoschka made his debut.[79]

It was with this 'countertendency', which, importantly, re-emphasized the institutionalized gulf between fine and applied art, that an expressionism involving 'desublimated psychological realism' was to be located exclusively in the former sphere.

The turn which these events took in Vienna had important implications for the continued reception of the Scottish movement there. On the occasion of the *Kunstschau* exhibition a commentator (possibly A. S. Levetus, the Viennese correspondent for *The Studio*) was writing from Vienna to the *Glasgow Herald* pointing out that the absence of the Mackintoshes from the exhibition was attributable to '"those little rifts within the lute" which finally led to the split in the "Secession" and the formation of the "Klimt Group"'.[80] In effect, this was to claim that the events which had led to the Glasgow group being conspicuous by their absence in Vienna in 1908 were intimately connected with the events surrounding the rift within the Secession. The primary cause of the rift illustrates a contemporary perception of the significance attaching to the autonomy status of afunctional art. According to the *Nur-Maler* ('pure painters') group, led by Josef Engelhart, the Klimt group (which included Wagner, Hoffmann, Moser and Carl Moll) were decorative artists who had compromised 'pure' (easel) painting in order to further the cause of design and architecture.

An Art Nouveau form-language was adopted in Vienna by the Secessionists in their search for the means to express 'truth' about human beings (from their sexual impulses and emotional dimensions to their sexual and aesthetic needs): a truth which was seen to have been repressed by the agents of a traditionally ordered Austrian society. But a further dimension was represented by Wagner's 'truthful' architecture: this time the truth at issue was that of the commercial and bureaucratic nature of life in modern urban Vienna, where aristocratic hierarchy was apparently being replaced by bourgeois liberalism. A 'truthful' functionalist mode of architecture, however, motivated by new social requirements, and encouraged by the local state administration, parted company with an architecture displaying the organic decorative motifs of High Art Nouveau. The symbolic and allegorical means employed in the expression of instinctual and primeval forces were, according to Schorske's view, overturned by the new visual language (encountered in the work of artists such as Schiele and Kokoschka) devised for the overt expression of 'irrational' private experience. Thus the irrational was placed squarely in

juxtaposition to the rational (Wagner's functionalist architecture), but in such a manner as to allow both to be welcomed by such puritan rationalists as Loos and Kraus, because both the rationality *and* the irrationality represented truthfulness to (the inner and outer dimensions of) reality. Not only was the opposing position to this one which employed Aestheticism *vis-à-vis* the social reality which it desired to see beautified. It was, in addition, a position which had come to jettison its own original aim of (large-scale) cultural regeneration in favour of (small-scale) cultural cosmetics. With its initial critical thrust gone, the Secession became the Kunstschau, and hence 'the ruling conventional culture of the *haute bourgeoisie*'.[81] As the expression of the 'irrational' became dramatically 'truthful' (that is, explicit), the artistic position which this 'return of the repressed' occupied was squarely in the sphere of 'pure' painting. The symbolic representation and ornamentation employed by Art Nouveau undoubtedly gave way to functionalism and expressionism, as Adorno claimed, and Schorske's description of Kokoschka's 'unification of psyche and corporal reality in portraiture',[82] in reading strikingly like Adorno on Art Nouveau (except, of course, for the reference to the 'realism' of portraiture), clearly demonstrates the Art Nouveau process as giving rise to this form of expressionism. Before Kokoschka, Klimt had combined the corporeal with the decorative: desubstantialized naturalistic elements were combined with mosaic, geometry, gold and silver layers, etc. However, crucially, works such as Klimt's not only contained their own artistic ('objective') content, they also made reference to elements external to the 'fine art' of painting. Thus a solution was posited to the problematical autonomy status of the latter. The Viennese movements of functionalism and expressionism, appearing to occupy mutually exclusive positions within the social/practical and artistic/afunctional spheres respectively, both emerged from the Art Nouveau endeavour which set out to transcend this institutional differentiation by attacking its cultural foundation. In this respect, the Secession demonstrated the ultimate failure of this European movement to integrate the arts in an avant-gardiste manner: through expressionism the social vision of the avant-garde witnessed its demise in images of solitude, anxiety, and isolation.

With Schorske's elucidation of the Secession in Vienna, light is shed upon Adorno's reasons for viewing psychoanalysis as a part of Art Nouveau: many of the classical Freudian preoccupations (neurosis, hysteria, sexual–cultural repression) undoubtedly motivated the *Jugendstil*-influenced Vienna movement in significant ways (Munch already prefigured the 'mixture' of such preoccupations as they would characterize the German and Austrian avant-gardes, for

example, with his *Puberty* [1894] and *Anxiety* [1894]). Both the expressionists' excavation of psychological states (with its dimension of freeing the 'primitive'), and the early Art Nouveau idealist escape to 'the regions of biological prehistory'[83] (with a nostalgia attaching to nature as that which produces the human *species* in pre-social form) were symptomatic of the deepest discontent being felt with Western 'civilization' and its cultural values around the turn of the century. If it remains the case that, as Bürger asserts, Adorno 'insisted exclusively on the new type of work, not on the *intent of the avant-garde movements to reintegrate art into the praxis of life*',[84] and that what ultimately distinguishes Adorno from the most radical aims of the European avant-garde movements is his clinging to the autonomy of art, it is true that the phenomenon of expressionism in Vienna marks the end point of Art Nouveau as a genuinely integrationist avant-garde endeavour. Expressionism, springing as it did from the Secession, represented, within that context, the ultimate afunctional, and thus 'autonomous', art, encapsulating a movement away from the representation of objects to that of feelings. To contemporary critics of the Secession, such as Loos, it appeared that what had been jettisoned was the attempt to transcend the boundaries between subjective art and its environmental context. Where the Art Nouveau concern with the nature and potential of material of the work had gone alongside a (symbolistic and abstract) conception of expression as that which inhered in the formal arrangement of visual elements (including the deployment of space around them), expressionism was essentially characterized by its commitment to the pictorial substance of the image as rendered by the painter for gestural purposes. It is perhaps not surprising that expressionism should have emerged from the Austrian permutation of German *Jugendstil* since, as Dolf Sternberger acknowledged in the 1930s on the issue of *Jugendstil*'s stressing of emotional meaning, 'soulfulness oozes out of every corner'.[85]

In briefly examining the above social theories, we can begin to see what a sociological theory of Art Nouveau might look like. Bürger's strengths for our purposes consist in his aiding the elucidation of the socio-cultural factors which engender an avant-garde movement, and focusing attention upon the fact that avant-gardes have challenged institutionalized notions of what actually constitutes a work of art in the first instance. On the basis of such a model, important hypothetical questions can be formulated, such as 'was Art Nouveau progressive or reactionary?' This helps to give direction to the examination of Art Nouveau as a movement attempting to penetrate society with art: the preoccupation with merely ornamenting the environment would be reactionary, whereas the desire to transform the

environment along aesthetic lines would be progressive. Bürger also helps to focus the significance of Aestheticism for the avant-garde vision, and Aestheticism was undoubtedly a crucial motivator for Art Nouveau. Benjamin describes Art Nouveau's opposition to industrial development within the social sphere. But was Art Nouveau only an extension of the crafts, or was it something radically different? Did it leave technical procedures and traditional organizational relationships unchanged? Both Benjamin and Adorno intend in their critiques towards the decorative phase of Art Nouveau (that is, early and High Art Nouveau: see Chapter 3), and hence do not acknowledge the abstract, geometric (cubic, rectilinear) form-language of late Art Nouveau. The significance attaching to the latter is to be found with its facilitating the mass-produced art object. When viewed thus, late Art Nouveau looks forward in time to the activities of the *Bauhaus* and the *Deutsche Werkbund*: it indicates the direction towards Art Deco (as Schorske acknowledges) but also towards the industrially produced mass commodity. Expressionism, however, should not be understood purely as representing a re-instatement of 'autonomous' art: a preoccupation with new modes of expression fundamentally conditioned Art Nouveau as an avant-garde endeavour, and this preoccupation permeated a range of cultural forms. The *Bauhaus Manifesto* ('vague, ecstatic, and utopian')[86] of 1919 revivifies pre-war expressionism, and not merely through its presentation of a woodcut in 'splintered and dynamic style'.[87] As Frank Whitford points out, 'Expressionism urged social change and even revolution: these were to flow naturally out of a profound change in human consciousness. Art, the expressionists fervently believed, could change the world.'[88]

Schorske describes the compromising of *Sezessionstil* in Vienna that led to the avant-garde, which initially set out to regenerate culture and transform life and the social environment, becoming a group of producers of luxury goods (marketed through the Wiener Werkstätte) for the bourgeois domestic environment. This interpretation, however, ignores the implications of the Wiener Werkstätte being capable of becoming involved at a later date (1920) with certain large industrial companies for the mass production of its designs.[89] It has to be said, though, that on the eve of its demise, in 1931, the WW still appeared incapable of reconciling commercial with artistic concerns, and it perpetuated the antagonisms created by the juxtaposing of a craft-based aesthetic with an aesthetic centred on machine manufacture.

Chapter three

# Art Nouveau as a modern movement

The main intention of this chapter is to provide a clear and succinct account of what the designation 'Art Nouveau' can be taken to mean. Initially, this requires some examination of the attempts made by analysts of the phenomenon to specify the most distinctive attributes of what was ostensibly an innovative artistic form-language or 'style'. The motivations behind the drive to engender a 'new art' need to be carefully elucidated in order to demonstrate at the outset (a) what was actually being opposed in cultural terms; and (b) how Art Nouveau was attempting to engender 'appropriate' new ideas. In respect of the latter, the philosophical assumptions underpinning Art Nouveau are investigated since these are of crucial importance for the understanding of the style itself. The question of the relation between Art Nouveau and cultural movements that were important for the form which it took – symbolism, aestheticism, rationalism, Arts and Crafts – requires to be handled with some rigour because here we are not always dealing with easily specifiable historical sequences, where one cultural 'development' gives way to another. Art Nouveau presents a complex subject-matter for the analyst of culture, not least because of its temporal 'overlap' with other phenomena with which it may well share certain characteristics. The central theme of the chapter is the delineation of an underlying structure common to the diverse manifestations of Art Nouveau which appear within a number of geographically contrasted contexts. I begin by examining the theory of Art Nouveau presented by Robert Schmutzler, since this remains the only attempt by an analyst to include a sketch of the sociological background to the phenomenon.

Art Nouveau, says Schmutzler,

is indeed a style of the upper bourgeoisie, that of the cultured and urbane middle class in the heyday of classical capitalism. It is es-

sentially the first genuinely universal style of a period which was
no longer under the domination of the clergy or aristocracy. Like
Impressionist paintings, its creations were not commissioned by
patrons but were offered directly to the purchaser by the artist.[1]

Having thus begun to outline the sociological background of Art
Nouveau, Schmutzler, in illustrating the socio-economic milieu of
'the leading Art Nouveau artists', presents a succinct catalogue of
selected examples of their work in order to illustrate the social place-
ment of both the artists themselves and the purchasers of their
creations: Gaudi's Palau Güell, claimed to be the most expensive
contemporary private dwelling, was built for the architect's friend
and patron, the industrialist and shipping magnate Don Eusebio
Güell; Whistler's Peacock Room was commissioned by Frederick
Leyland, the Liverpool shipowner, for his elegant and spacious house
in London's Hyde Park Corner; Burne-Jones was by reputation the
highest paid painter of his time; the well-to-do Arthur Mackmurdo,
'whose designs were the first expressions of Art Nouveau', published
the journals *Century Guild* and *The Hobby Horse* for his personal en-
joyment; although the Brussels architect Victor Horta (who later
entered the Belgian nobility) built the Maison du Peuple for the Bel-
gian Socialist Party, most of his work was for upper middle-class and
capitalist patrons (for example, the 'princely proportioned' mansion
for the industrial magnate Solvay); the symbolist painter Fernand
Khnopff, son of patrician parents, inhabited a 'labyrinthine' house in
Brussels. For Schmutzler, nothing characterized the actual life-style
of the majority of practitioners of Art Nouveau so much as aesthetic
comfort and self-indulgence. But although the concept of (econ-
omic) class can be expanded to include cultural factors with the
specifically economic – as Schmutzler does in describing Art Nou-
veau as an upper bourgeois art style – it is important, as T. J. Clark
points out, to 'be clear about the liberties being taken and beware, for
example, of calling things "inherently bourgeois" when what we are
pointing to is relation, not inherence'.[2] For class is a complex matter,
the reality being that, what might, quite legitimately, be collectivized
– various social fractions – under this general heading, will always
comprise 'the many and various'.[3] We may well ask, consequently, if
Art Nouveau is to be portrayed as an inherently bourgeois style, what
is the *relationship* between the (phenomenally expensive) Palau
Güell, intended for the exclusive use of wealthy individuals, and Hec-
tor Guimard's iron railings for the Paris underground stations? Or
between Josef Hoffmann's luxurious and private Palais Stoclet and
Charles Rennie Mackintosh's designs for Miss Catherine Cranston's
public tea-rooms? What legitimates the practice of collectivizing

such apparently diverse cases *apart from* the attempt to make a socio-logical point about the links between social class and cultural production?

In describing Art Nouveau as a 'universal style' – since such was its original intent – Schmutzler seems primarily concerned to illuminate ways in which fundamental notions, concepts, tenets, design philosophies, and ideologies, link a wide diversity of cultural phenomena as expressions of an all-encompassing Art Nouveau sensibility (a sensibility pursuing beauty, so Schmutzler claims, at the same time as manifesting introverted narcissistic self-admiration and exhibitionism through its creations). A widely perspectived cultural awareness such as Schmutzler's, which allows an acknowledgement of what Gresleri calls 'the cultural diversity born out of the complexity of the historical moment',[4] would appear to provide the ideal starting point in the search for criteria of relevance *vis-à-vis* Art Nouveau.

Schmutzler proclaims that certain lines by William Blake – 'energy is eternal delight', and 'no individual can keep these laws, for they are death to every energy of man and forbid the springs of life' – are emblematic of the central element in Art Nouveau which portrays movement as the fundamental source of life: movement, that is, within a 'connected whole and, if possible, a structural homogeneity'.[5] Blake's own 'illuminated' books form a case in point: 'out of originally heterogeneous elements, a calligraphic synthesis of homogeneous forms and signs ... are all subjected to the same rhythm.'[6] Thus in the 'prehistory' of Art Nouveau, Blake's dual talents as painter–poet exemplify the kind of 'reciprocal osmosis through inner affinity'[7] which came to typify what Art Nouveau artists were attempting to achieve with combinations of forms and genres. This is demonstrated, not only in the relationship between poetry and decoration in book design, or between poems and paintings (such as with William Morris, Beardsley, Rossetti, Swinburne), but also between the plastic and graphic arts and music, and between music and literature. Furthermore, as regards the relationship between the theory and practice of Art Nouveau, it is apparent that numerous artists have added clarity to their own work whilst providing information or acting as teachers, through the (back-and-forth) process of adding literary and theoretical expositions to their artistic creation (Dresser, Owen Jones, Morris and his pupil Walter Crane, Obrist, Endell, Gallé, Guimard, Sullivan, Loos). Blake anticipates Art Nouveau, claims Schmutzler, by rigorously developing the *principle of form* in ornament, illustration, lettering, ensembles of books and structures, rhythm, conception, and signification: he was a 'universal artist' 'who was not only poet, painter, book illustrator, and printer of his own works, but who might also have designed furniture and everything else for the home'.[8]

According to Schmutzler, the 'great inclination' of Art Nouveau, exemplified by the reflecting and conscious attitude of its 'artists of higher than average intelligence', is towards *synthesis*, to be achieved through the fusion of form and content, of structural and decorative elements. Baudelaire and Wilde explicitly viewed music as art's 'ideal type' (a term much used by Walter Pater for the same reasons), within which form and its object, and object and technical expression, are synthesized. As specified by Pater, the artistic ideal was to be independent of intelligence, a matter of pure perception, with form and matter unified in creative productions. In his opinion, this ideal was most completely realized by music (this had been Schopenhauer's view):

> In its consummate moments, the end is not distinct from the means, the form from the matter, the subject from the expression; they inhere in and completely saturate each other; and to it, therefore, to the condition of its perfect moments, all the arts may be supposed constantly to tend and aspire. Music, then, and not poetry, as is so often supposed, is the true type or measure of perfected art.[9]

A passage such as this (from 1873) illustrates that a preoccupation with music as representing the 'perfect' artistic form characterized the theoretics of the Aesthetic movement long before Art Nouveau appeared. What then does Schmutzler have to say about the significance of this aspect of Aestheticism for Art Nouveau?

He points out that Whistler, 'the most consistent advocate of *l'art pour l'art*',[10] attempted to exemplify such an ideal with his decorative, ornamental, and musical attitude towards his art. In the 1870s, Whistler combined visual and aural elements, the names of colours with musical terms (*Nocturne in Blue and Green*; *Symphony in White*; *Harmony in Violet and Yellow*), in such a manner as to anticipate the colour harmonies that would later typify the Art Nouveau style (the combination of yellow and violet; blue and green; the use of white). Gaudi's Palau Güell in Barcelona is said to have been constructed around the music room, and Fritz Wärndorfer, who financed the foundation of the Wiener Werkstätte, commissioned a music room from Mackintosh after the latter had exhibited for the first time in Vienna. The significance of music in the drive towards the attainment of synthesis ('the time: 1892. Its spirit: the musical element', noted Hugo von Hofmannsthal) is illustrated by Schmutzler through a cultural 'cross-referencing' which links some of the most significant modern developments in musical technique directly with various innovative cultural notions and trends which exemplify the Art

Nouveau influence to a greater or lesser degree. Music is thus made the aesthetic centre of gravity drawing the cultural consciousness towards a clearer concept of form, more specifically, of form embodying synthesis (object and technical expression *within* form).

According to John Russell Taylor, Art Nouveau sought 'above all to find form inherent in the formless rather than to impose on it a preconceived form from without'.[11] Paul Barker, in distinguishing Art Nouveau from the modern movement, discovers that the 'chief credo of the modern movement was truth to materials. For Art Nouveau, form came first.'[12] Having acknowledged that 'the fewer the formal elements present, the less appropriate is the term Art Nouveau',[13] Madsen distinguished four different main aspects of Art Nouveau form 'which to a certain degree are conditioned by nationality':[14] (1) an abstract and plastic conception (Belgium); (2) a linear and symbolic aspect (Scotland); (3) a floral and markedly plant-inspired style (France); and (4) a constructive and geometrical style (Germany/Austria). Almost everywhere, in all the phases of Art Nouveau, there is apparent an asymmetry of form (for example, with the ornamental characteristic of the asymmetrically undulating line that terminates in an energy-laden movement) which signifies life and activity, movement and equilibrium: 'All the swinging, swirling, throbbing, sprouting, and blossoming is intended to be an unequivocal sign of organic life, of living form.'[15] Themes of water, marine life and lower organic life commonly decorate Art Nouveau textiles, ceramics, wallpapers, silverware, etc. But it is far less organic life in the sense of aspects/elements of 'nature' popularly understood, as of the metaphysically conceived fundamental forces and sources of life. As Schmutzler emphasizes,

> Art Nouveau did not choose to favour forms that are similar to sea anemones and other such lower organisms, half plant, half animal, for their flowery elegance and ornamental form alone, but also because they are close to those forms which first appeared when life was beginning.[16]

The true significance of this is to be found with the acknowledgement that Art Nouveau was attempting a universal regeneration of art and life through a symbolic return to the 'original source' of reality. Only such a radical manoeuvre could free art from the burdensome and stultifying weight of archaism, historicism, eclecticism, and moralism restricting it at the end of the nineteenth century. Even in the abstract forms apparent with High Art Nouveau, that is, in the second half of the 1890s, when practically every European genre manifested the style, movement and life are suggested despite the absence of

themes derived from the natural elements: for example, in the alive and abstract dynamism exemplified by Horta's metal scaffoldings, or van de Velde's merging of illustration and abstract decoration. Schmutzler argues that with the attempt of the Art Nouveau movement to establish some kind of contact with 'original traditions' through an adoration of life, Art Nouveau 'contained a kind of self-frustration within itself, not so much because of its strong element of decadence, of *fin de siècle* and *morbidezza*, as because its romantic nature made it shrink from the harsh reality of modern industrialization'.[17] He appropriates a section from Ernst Robert Curtius's book on the novels of Proust to illustrate the sociological background of Art Nouveau as he understands it:

> the delicate iridescent blooms of this art grow from the creative substance of a great mind. But such a seed could prosper only in the favourable, well-prepared soil offered by the material comfort of cultured and wealthy homes ... the capacity for enjoyment, refined through many generations ... finally, the security of inherited wealth; here is the soil in which this art is rooted.[18]

The key figures of Art Nouveau are the aesthete and his brother the dandy. Dandyism is itself a 'decorative art' (Max Beerbohm), but since the dandy does not produce any work of art himself, he turns both himself and his life into a 'work of art' ('One must either be a work of art or wear a work of art', quipped Wilde), and the dandy, who sometimes united within himself the critical aesthete and the productive artisan, was the representative of the state of culture who, through the nature of his demands for the beautification of life, 'best determined Art Nouveau'.[19] For Schmutzler, therefore, the dandy represents the medium through which a traditionally afunctional and autonomous art achieves functionality through being 'applied' to use objects.

On the Continent, it was with the Belgian Henry van de Velde, the most influential exponent of Art Nouveau, that the ethical concern with social transformation, deriving from Arts and Crafts thinking, became crystallized within a context of conscious concern with the formulation of a 'new art'. Van de Velde coined the term (*un art nouveau*) in his essay *Deblaiement d'art* (The Clearance or Excavation of Art) in 1894. This concern was pointed directly at those aesthetes and decadents, who, for van de Velde, exemplified a moribund, spiritless dependence on *old* works of art, including easel paintings. The latter he viewed as part of the defunct tradition of bourgeois art, a tradition that had, through the commodifying of paintings, attempted to perpetuate the erroneous view of the work of art as a unique expression

of the artist's personality. However, if the aesthetic movement did not harmonize with the Arts and Crafts movement in terms of the ideologies of social reform and utopian socialism, its journal, *The Yellow Book*, with Beardsley as art editor, illustrates agreement on the desirability of a synthesis of all the arts. The graphic and decorative style of the Mackintosh group in the early 1890s, in subsequently being applied to interior design, quite clearly illustrated its debt to the aesthetic movement, in particular, to Whistler and Beardsley. At the 'Architecture and Design of the New Style' exhibition held in Moscow from December 1902 until January 1903, the Scottish contributions elicited comment from Diaghilev on 'Mackintosh with his light, white furniture, with his refined and so-slightly Beardsleyesque panels and the whole airy charm of his interior'.[20]

The first clear point that can be made with regard to the specificity of Art Nouveau, at least in the stages during which the latter was becoming established, is that Art Nouveau initiated an abstract anti-historicist form-language based on the synthesis of ornament and structure. The concept of synthesis, of works of art embodying a unity of form with content, Art Nouveau derived from Aestheticism. But Art Nouveau was concerned also with unity between the fine and the applied arts. The fact that Art Nouveau can be said to have 'naturalized' ornament as an abstract form for the purpose of avoiding historicist imagery is not in itself a distinctive trait. What is distinctive is the manner in which nature was apprehended and depicted. In the following section we will examine this issue in some detail.

### The genesis of Art Nouveau

Examples of what Madsen terms 'proto-Art Nouveau' are first encountered in England with the Arts and Crafts milieu of the 1870s and 1880s (Crane, Dresser, and Mackmurdo being among the leading exponents). English trends in the applied arts, according to Madsen, are suggestive of Continental Art Nouveau in the 1890s: Crane's nursery wallpapers from 1875 manifest a 'wealth of floral ornamentation' and a 'flamelike and whiplike rhythm'.[21] However, in Britain (sic),'Fully fledged Art Nouveau was not really established, the artists instead continued the cultivation of an elegant style developed from the Arts and Crafts movement.'[22]

However, as Howarth pointed out, the latter lacked a clearly defined and conscious attempt by artists and designers to evolve a style totally independent of tradition. The appearance of Art Nouveau on the Continent (applied arts, interior decoration, architecture) is generally described as being a relatively sudden

phenomenon, and the focus of attention, subsequent to research by Nikolaus Pevsner and Siegfried Giedion, was placed upon Brussels, where the first Art Nouveau exponents – Horta, Hankar, Serrurier-Bovy and van de Velde – were active. When Samuel Bing, the Parisian art dealer, opened his new shop in the Rue de Provence in 1896, he commissioned van de Velde to decorate a number of apartments. In 1897 five craftsmen presented an exhibition of the new decorative art at the *Galerie des Artistes Modernes*. Such events undoubtedly furthered the acceptance of the style in France by such as Gallé, Majorelle (Nancy school), and Guimard (Paris). Van de Velde provides a link with Germany (he exhibited in Dresden in 1897) where *Jugendstil* subsequently emerged in Munich, Leipzig, and Darmstadt. A group of young German artists had already been experimenting with new decorative forms: August Endell (1871–1925), Otto Eckmann (1865–1902), and Hermann Obrist (1863–1927). The trend of *Jugendstil* to turn the human figure into an ornament was wryly commented upon by the Viennese cultural critic Karl Kraus: with the *Jugendstilman* 'the very convolutions of his brain became ornaments'.[23] The actual name *Jugendstil* was based upon the periodical *Jugend* which was established in 1896. Art Nouveau was, to a quite unique extent, associated with periodicals. This suggests a significant connection with manifestos promulgated by the avantgarde. As Madsen indicates,

> During the 1890s no less than a hundred art periodicals were founded in Europe. They were all of them the outcome of an intense desire to renew art, and reflected the strong interest which existed particularly in the decorative arts. The spate of periodicals also helps to explain the rapid spread of the style.[24]

But were periodicals the only means by which the style became known? The evidence would appear to indicate that other cultural processes were significant also. An article on 'Scottish Artists' in *Dekorative Kunst* (November 1898) refers to works by Charles Rennie Mackintosh and Herbert MacNair (wine glasses, fabrics, windows) as having a similarity to designs by Koepping, Obrist, and van de Velde. The first link between the Glasgow designers and the Continent had been through the 'City of Liège Arts and Crafts Exhibition' (1895) where numerous exhibits by members of the Glasgow School of Art were shown. This was subsequent to an exhibition at the School which had attracted a significant amount of attention. The Secretary of *L'Oeuvre Artistique, Liège* wrote to Francis Newbery, the Head of the School, to express his admiration of the work that had been seen and to stress that 'what has above all astonished us in your work is the

great liberty left to the Pupils to follow their own individuality.'[25] He commented also upon the apparent advancement of the Glasgow School by comparison with those in Belgium. It is difficult to believe that such continental connections did not foster the kind of cultural reciprocity which would lead to the importation of certain Belgian ideas into Glasgow's artistic circles. But in fact significant Glasgow contacts with the Belgian avant-garde actually pre-dated this.

In the last two decades of the nineteenth century avant-garde art practice could be said to centre on Brussels. The journal *L'Art Moderne* was founded there as early as 1881 by Octave Maus, an art critic and musical impresario, who also created, along with nineteen other founder members, the *Cercle des Vingt* in 1884, which was to organize the first exhibitions combining products of the applied arts (such as decorated books from England) with avant-garde paintings. Van de Velde became a member in 1889. Maus also established the association *La Libre Esthétique* in 1894. Ten annual exhibitions of the *Société des XX* took place between 1884 and 1893 (when the society 'voluntarily' disbanded itself). Those exhibiting included James Ensor, Theo van Rysselberghe, Willy Schlobach, and Fernand Khnopff, all of whom 'had recently seceded from an earlier free society, *L'Essor*, because they thought it "too *bourgeois*"'.[26] At various stages, *Les XX* exhibitions manifested the influences of realist–Impressionism (Courbet, Manet, Fantin-Latour, Whistler, Monet), symbolism (Khnopff, Toorop), Impressionism (Schlobach, Vogels) and neo-Impressionism (Willy Finch, Georges Lemmen, van de Velde). Included among those invited to exhibit in 1893, was the Glasgow artist E. A. Hornel, who sent four paintings, one of which, *The Brook*, had already been purchased by Herbert MacNair.[27] The *Libre Esthétique* exhibitions of 1894–5 presented Morris fabrics and carpets, Beardsley designs, Ashbee silverware, and examples of architecture by Voysey.

In *L'Art Moderne* (1 and 15 March 1891) Georges Lemmen wrote two comprehensive essays on Walter Crane in which he emphasized the importance Crane attached to the capacity of expression contained in forms, lines, and arabesques.[28] Lemmen later demonstrated aspects of Art Nouveau style in some of his own creations (especially *Deux Têtes des Jeunes Filles*, 1895): he was a painter who also designed jewellery, metal-fittings, bookbindings, and tapestries. Crane himself would write, five years after Lemmen's articles, that

> The revival in England of decorative art of all kinds culminating, as it appears to be doing, in book design, has not escaped the eyes of observant and sympathetic artists and writers on the Continent. .... In Belgium particularly .... the work of the newer school of

English designers has awakened the greatest interest.[29]

The forms, lines, and arabesques in Crane's work, to which Lemmen referred, have long since been acknowledged to constitute a distinctive ornamental style, employing 'long sinuous asymmetrical line' (Pevsner), which originated in Britain. Henry Russell Hitchcock[30] argued that it is highly likely that Horta, when he designed the Maison Tassel in 1892, was already acquainted with English decorative work, more particularly, the linear 'Art Nouveau' style of English wallpapers and bookbindings, such as the pre-Raphaelite George Heywood Sumner's tulip pattern wallpapers. If, at this stage, an attempt is made to establish a succinct definition of Art Nouveau, it must inevitably be felt that, in the light of what was said above regarding the deeply rooted metaphysical concern with the sources and forces of life, Pevsner's claim about the leitmotif of Art Nouveau being the long sinuous asymmetrical line, must appear somewhat inadequate. According to Fern, in order to actually define the style adequately, the serpentine curve that is present must be 'a twisting, living thing'.[31] Selz described Art Nouveau's general aims as being a 'desire for symbolic–organic structure'.[32] Clearly, we need to know more: where does this particular 'desire' emanate from?

The link between the symbolic and the organic elements of Art Nouveau structure is provided by the notably vitalistic conception of sources of life: a conception halfway between mysticism and metaphysics. In philosophy, this particular doctrine was to be very much in vogue by the end of the nineteenth century; the seal of approval having been set through high status exponents of quite sophisticated versions of it such as Henri Bergson (1859–1941) and the biologist-philosopher Hans Driesch (1867–1941). Both of these philosophers rejected mechanistic or materialistic views of reality. Bergson's *élan vital*, portrayed by him as being a distinctly creative urge, was claimed, against Darwin's theory of natural selection, to be at the very heart of the evolutionary process – a process which was, for Bergson, non-deterministic. Reality thus comes to appear as some great work of art. As Adorno points out, Bergson's theory derives essentially from artistic experience: it is ideas and images of art that are being projected outwards on to reality. Commenting on the theory of Bergson and Proust that spontaneous recollection brings to life empirical existence when it is harnessed to the imagery of art, Adorno describes them as genuine idealists, in that 'they attributed to reality what they wanted to redeem, whereas actually it is part of art, not reality. Hoping to escape the curse of aesthetic illusion, they simply shifted the illusory quality on to reality.'[33] The depth of influence of the metaphysic of vitalism upon Art Nouveau is difficult to measure

with any kind of real accuracy, but it was obviously significant. It is illustrated by Alejandro Sawa's contributions to the Spanish Art Nouveau journal *L'Avenc*, as it is in van de Velde's comment about line in which the artist is depicted as an abstract source of dynamism and energy. Bergson himself, in 1889, made reference to the aesthetic potential attaching to the impression of movement conveyed by curvilinear forms:

> If curves are more graceful than broken lines, the reason is that, while a curved line changes its direction at every moment, every new direction is indicated in the preceding one. Thus the perception of ease in motion passes over into the pleasure of mastering the flow of time and of holding the future in the present.[34]

The question of the influence of vitalist and idealist thinking upon Scottish Art Nouveau has never really been raised. In fact, in Edinburgh, Patrick Geddes, instigator of the journal *The Evergreen* ('a kind of Scottish Yellow Book')[35] and one of Mackintosh's acquaintances, combined a scientific analysis of the forms of biological organisms with a holistic, non-mechanistic conception of nature that was highly consonant with Bergson's.[36] Geddes's own contributions to *The Evergreen* (1895–6) illustrate a rejection of 'mechanical dualism', 'materialism and spiritualism' in favour of 'idealist monism'. *The Evolution of Sex*, published in 1889 (the same year as Bergson's *Essai sur les données immédiates de la conscience*, his first major work), draws conclusions surprisingly close to those of Bergson in his *L'Évolution Créatrice* (1907), where it is argued that the creative drive, rather than natural selection, lies at the heart of evolution. In the Romantic-sounding concluding section of *The Evolution of Sex*, the 'highest expressions of the central evolutionary process of the natural world'[37] are claimed to be manifested through forms of creativity: love, sociality, cooperation. The attempt to reconcile aesthetic, scientific, and ethical spheres of culture was highly characteristic of Geddes.[38]

Edward Caird, along with his brother John, one of the leading exponents of Hegelian Idealist philosophy in Scotland in the late nineteenth century, explicitly addressed the issue of the original sources of life in his *Hegel* (1883). Like Bergson, Caird was looking towards the self-determining aspects of artistic experience for a solution to the problem of the disintegration of meaning posed by an objectifying positivistic and deterministic science. To Caird, the only hope for the cultural life of human beings against a positivistic science of facts and the disintegration of meaning which had resulted from it, lay with the artist and the poet, who alone could keep alive

the combination of the ideal with the real, the universal with the par-
ticular, and through their impressionistic creations snatched from
'fleeting time', reveal 'blest eternity'. Caird's Romantic language
nevertheless conveyed a contemporaneous message about the prob-
lems of modernity, the experiences engendered within an essentially
fragmented and heterogeneous culture.[39] In 1906 in Vienna, Hugo
von Hofmannsthal, in defining the modern poet's role, echoed the
pronouncements of Caird from over two decades before. The poet's
work was to represent, for Hofmannsthal, the medium through
which unity and cohesion were created. In confronting conflict, con-
tradiction, multiplicity in reality, the poet, as 'the passionate admirer
of things of eternity and the things of the present',[40] was seeking hid-
den connections behind the incoherence of a centrifugal society.

The abstraction of (post-representational) High Art Nouveau, most
notably exemplified by van de Velde and Horta, attempted to em-
body something of the dynamics of those elements of life which
Bergson's eternal vital principle was claimed to encompass. Van de
Velde, most consistently of all, aimed at abstract form where there is
no trace of unassimilated historical examples of style. Dynamism is
expressed symbolically, in the use of ornament, as with the linear
structure of his straight chairs and easy chairs. The theme of the *Tro-
pon* poster (1898), referred to by Schmutzler as Art Nouveau's best
abstraction, is derived, in the latter's opinion, from, on the one hand,
van de Velde's own non-naturalistic synthesis of elements from the
work of Seurat, Millet, and the Post-Impressionists, and, on the
other, technical aspects of the work of Beardsley, who had, six years
previously, innovatively synthesized abstract decoration with illus-
tration (as in his illustrations for Mallory's *Morte d'Arthur*).

According to Pevsner, with the work of the Mackintosh group, the
artistic synthesis achieved was of Beardsley with Voysey and Toorop,
and 'this synthesis of their style was the legacy of Britain to the com-
ing Modern Movement.'[41] (Ludwig Hevesi, in describing one of the
Scottish group's contributions to the 8th Secession Exhibition in
Vienna (1900), noted that 'Whoever enters this room, certainly says
at first: "Toorop". There is definitely a certain affinity present.') [42]
Howarth states that the Mackintosh group found no appeal in the
products of Belgian, and, especially, French Art Nouveau, a claim
founded upon a comment of Mary Sturrock, daughter of Francis
Newbery (who was responsible for bringing together Mackintosh,
Herbert MacNair, and the sisters Margaret and Frances Macdonald
to create 'The Four'). The argument is that Mackintosh 'fought
against' Continental Art Nouveau ('like melted margarine') with his
'straight lines'. Mary Sturrock herself acknowledged Beardsley,

Toorop, and Voysey (with Carlos Schwabe) as influences on Mackintosh. Nevertheless, notwithstanding Howarth's own concern to emphasize the contrast between the Scottish and Continental schools, and his assertion that 'despite the evidence, many people still persist in classifying Mackintosh with the Guimards, Gallés and van de Veldes of *Art Nouveau* persuasion',[43] certain important similarities do appear real enough, and these have to be meaningfully explained and placed within an analytic framework. Nor are the similarities only those which attach to 'linear structure', the 'lines of hesitant elegance' which Ahlers-Hestermann interpreted in Mackintosh's work as conveying 'a faint distant echo of van de Velde'.[44] There are, additionally, the elements of symbolism and abstraction in the Glasgow group's work to be explained. With van de Velde linear structure is employed often for symbolic purposes: Madsen found in the work of the Mackintosh group 'a *linear* and *symbolic* aspect', and in Belgian Art Nouveau 'an *abstract* and plastic conception'.[45] Abstraction is central to Mackintosh's work: he 'intellectualized' about architectural effects by employing abstract concepts such as space ('His supreme skill as an architect was his masterly handling of space'),[46] volume, and shape in his designs, in such a way as to reinforce ideas of place, of self, through confrontation with a non- historicist architecture. With Mackintosh, Talwin Morris pointed out in 1897,

> the controlling scheme is never lost sight of, or smothered in ir-relevant detail. He realizes to the full, the pleasantness and valu-able repose of undecorated space. In conceiving a design, he has felt and realized its effect in the selected material; and not only ac-knowledging the conditions of the space treated, he has frankly met and greeted the difficulties it presented; so that we recognize them no longer as difficulties, but as elements of the composition.[47]

It is significant that, in differentiating Mackintosh's work from that of the other members of 'The Four' – subsequent, that is, to differen-tiating the group's ('homogeneous') work as a whole from the prod-ucts of contemporary commercialism and eclecticism – Howarth should emphasize narrow angular upright forms as being absolutely central to Mackintosh's style. He subsequently asserts that Mackintosh

> appears to have been impelled by an urge to express growth – root, stem, branch and flower – *almost all his subsequent* [that is, after about 1895] *work can be analysed in these terms.* Surging vertical lines invariably predominate, whether in the pattern of a Christ-mas card, or a poster, or in an exaggerated chair back, and they find ultimate expression in the dramatic west wing of the new

Glasgow School of Art.[48]

In referring to an evident 'urge to express growth' Howarth creates difficulties for his own argument about Mackintosh not having been an Art Nouveau practitioner, by relating the latter's style in this way to the style he was supposed to have been rejecting. In other words, to interpret the linear and symbolic element in the Scottish work as expressing 'growth' and 'force' is to directly link it with European Art Nouveau, including the work of the Belgian Victor Horta. In describing the metal mouldings for the façade of Hoffmann's Palais Stoclet, Eduard Sekler differentiates the linear elements in Hoffmann's design from the 'lines of force' characteristic of Horta's architecture: he refers to the former as being 'tectonically neutral', thus implying that Hoffmann in Vienna, with his geometric form language, was not employing structure to the same expressive ends as the earlier Art Nouveau practitioners in Belgium and France.[49] John Russell Taylor, in setting apart 'British' from Continental Art Nouveau, describes the 'geometrical severity and simplicity' of the former, which, he argues, can be understood as a reformation of 'the severe and rectilinear Perpendicular style' of British Gothic at the end of the middle ages.[50] Taylor considers 'British Art Nouveau' to have developed on the fringes of the Arts and Crafts movement. He claims that the former 'followed' the latter but he is nonetheless concerned to elucidate essential differences. The simplicity and lack of clutter apparent with Art Nouveau (illustrated, for example, by Beardsley's decorative book illustrations which contrast with William Morris's constrained and conventional creations) Taylor attributes to a knowledge of architectural principles of construction – principles which could be productively applied in opposing the intricacy of previous styles:

> All through the history of British art nouveau, from the Century Guild to the end of the Glasgow school, architects play a prominent part, directly or indirectly....Hence architectural principles of construction, a certain tendency to build designs on a firm framework, however freely the details might be organized within it, are apparent in British art nouveau right from the start and remain constant.[51]

One of the manifestations of British 'art nouveau's' hostility towards the 'decadence' of the Aesthetic movement, Taylor claims, was the emphasis placed by the former upon geometrical severity and simplicity. But his rather obscure description of British Art Nouveau (was Beardsley – the friend of Whistler and Wilde, and admirer of

Burne-Jones – who acquired no architectural training whatever, really closer to the Arts and Crafts movement than to the Aesthetic movement?) casts little light on the means whereby Scottish Art Nouveau (which he does not distinguish analytically from the alleged English variety) inherited much from the Aesthetic movement, as witness the romanticism and symbolism it employed in the early 1890s. Mackintosh was clearly not averse to the use of the type of high-flown Idealist/Aestheticist modes of expression which would have evinced queasiness in the most sanguine Arts and Crafts ideologue.[52] Early on in their collaboration in Glasgow, a connection was drawn between The Four and the Aesthetic movement.[53] The Newberys' home at Buckingham Street, Hillhead, Glasgow, was acknowledged to have been decorated in an Aesthetic movement manner.[54] *Art et Décoration* (1903) portrayed the Glasgow Style as a manifestation of the ultimate in Aestheticism by relating it to the *outré* taste of the 'decadent' hero of Huysmans' novel *A Rebours*: only a 'crazy *Des Esseintes* would be able to live with it'.[55]

Gillian Naylor presents a similar appraisal to that of Taylor. She, for example, finds Gothic and Art Nouveau elements being combined in Ashbee's silverware.[56] She even claims that Crane, one of the staunchest critics of the Art Nouveau style, 'produced work that can be defined as Art Nouveau'.[57] This is made on the basis of perceived movement in his designs, where these incorporate naturalistic motifs such as leaves, flowers, and plant forms, as well as the asymmetry, complexity, suppleness, and linearity apparent. According to Taylor, Crane was 'not unsympathetic to the elements which were to contribute so importantly to the make-up of art nouveau'.[58]

Leaving aside for the moment the question of the acceptability of these interpretations, if it be asserted that 'tectonic neutrality' was the aim behind Mackintosh's use of straight lines, and that this use was central to his rejection of Art Nouveau, it would still have to be explained why Howarth could find little difficulty in interpreting the employment of these vertical lines as signifying the expression of growth and force. We therefore need to pose the question: what is the relationship between the utilization of straight lines to convey 'geometrical severity and simplicity' ('tectonic neutrality'), and straight lines to express growth and force (organic symbolism)? Such a question cannot be adequately addressed without an elucidation of the relationships that obtained between the Scottish school and the Continent, because the stylistic changes which affected Art Nouveau, including Scottish Art Nouveau, are not apparent in the English context. We need to begin, however, by examining explanations that have been put forward with regard to the possible basis of the new style which appeared in Glasgow in the early 1890s.

According to Schmutzler, the importance of William Blake's work as an influence on the early ornamental drawings of Mackintosh and the (English) Macdonald sisters is apparent in the use of geometric structures, rigid symmetry, arrangements in rows and parallels. Schmutzler goes so far as to assert that 'The Glasgow artists indeed discovered late Art Nouveau through Blake's work.'[59] Typically, what was involved was a synthesizing or blending of representational and abstract elements to the end of achieving decorative work with negligible meaning, but which remained vaguely symbolical. In other words, Blake's themes are emptied of their content, forms are simplified – for example, a patterned shape of circular and oval forms used to create structure (Mackintosh's diploma design derived, so Schmutzler claims, from a specific Blake watercolour) – in order to attain a decorative style, a kind of composite ornament. The emphasis placed on symmetry here, derived from Blake, is as much in contrast to the asymmetry of High Art Nouveau as it is to Japanese art, the latter one of the most significant influences upon Art Nouveau. What this analysis is taken to reveal is that, in the early stages, differences in style between Mackintosh and the two women has much to do with degrees of abstraction in the handling of ornamentation:

> The tangle of powerfully curved bands, lines and stripes which (without their having any recognizable sense as objects or symbols) enclose the very stylized nude figures was later transformed by Mackintosh into entirely abstract ornamentation, while the Macdonalds were more inclined to remain faithful to figurative and representational ornament.[60]

These stylized female nude figures, employed as expressive ornaments, have, according to Schmutzler, a concrete link illustrating the Pre-Raphaelite influence with Ford Madox Brown's unfinished painting entitled *Take Your Son, Sir* (1856–7) which was greatly influenced by Rossetti (although, in this case, the figure is not nude). The image of the baby wrapped in a cloth draped in the form of a rose, Schmutzler claims, provides the Scottish artists with the motif of the abstract rose which often appears in their work 'placed in the middle of an either circularly enlarged or vertically elongated figure'.[61] At the turn of the century, Hermann Muthesius, in tracing the recent history of 'decorative line' back to Blake, acknowledged that 'Rossetti and the Pre-Raphaelites may be regarded as the direct forerunners of J. Toorop as well as of the Glasgow artists.'[62] Certainly the Glasgow artists were highly aware of the Pre-Raphaelites. Mackintosh had reproductions of paintings by Burne-Jones in his

Dennistoun studio. Madsen considered that the earliest Art Nouveau style in Britain evolved with late Pre-Raphaelites: he named Crane, Sumner, H. P. Horne, Selwyn Image, Beardsley, Ricketts, and (more loosely) Mackmurdo. The influence of Beardsley's 'linear contortion and convolution'[63] (illustrations for Wilde's *Salomé*) and Toorop's mystic abstraction (especially his painting *The Three Brides*) upon The Four, has long since been precisely dated to 1893, when the first issue of *The Studio* appeared (September). Jessie Rowat Newbery reflected in the 1940s that this was the first truly significant event in Mackintosh's artistic development. An article by C.F.A. Voysey in this first issue had emphasized the view that authentic new work required a mastery of craft, a complete knowledge of material and a recourse to nature for inspiration and guidance. Mackintosh himself acknowledged his debt to Voysey, whose influence upon him is apparent after 1893. At this time, the Macdonald sisters were day-school students at the Glasgow School of Art; Mackintosh had enrolled there as an evening pupil in 1884, and MacNair had been a fellow student. Newbery, the then Director of the School, an Englishman, appointed, at the age of 31, in 1885, was responsible for bringing together the four young designers after having become aware of a striking similarity in their work. The establishment of The Four 'together with the confirmation and incitement of "The Studio" provided the necessary impetus for the establishment of a fully-fledged style'[64] which was, at the time, held in common by all the members of the group. In 1897, material produced by the group to accompany articles in *The Studio* by Gleeson White (the journal's editor) led to an invitation to 'hold a show'[65] in Vienna.

> The consequent exhibition there not only established [Mackintosh's] place as one of the first modern architects and decorators of the day, but gave new life to a group of brilliant young architects, decorators, sculptors and metal workers who at once acknowledged him as their leader.[66]

The truth behind this assertion by Jessie Rowat Newbery can be validated by referring to an article which appeared in the Glasgow press in 1908 where it was claimed by a Vienna correspondent that

> Both Mr. and Mrs. Mackintosh are held in high esteem in Vienna. It is, however, to him that the young architects and decorative artists turn. In him they see a tower of strength; they admire him, esteem him, and are thankful to him for the lessons he has taught. He is regarded by his contemporary architects and artists here as one of the chief founders of modern decorative art. The influence

that he practises on them is subtle and indefinable.[67]

## The link between Glasgow and Vienna

The participation of the Glasgow group in the 8th Viennese Secession exhibition of 1900 was to have crucial implications for the subsequent development of the Glasgow Style. Indeed the phenomenon of Art Nouveau in Glasgow cannot be adequately understood before some examination is made of the impact upon it of new Austro-German trends (filtered through, and focused on, Vienna). In the following section it will be examined to what extent Howarth's inability to periodize the stages through which Art Nouveau moved led him to deny that Mackintosh's work was capable of being considered Art Nouveau. Mackintosh may well have viewed himself as fighting against the Art Nouveau which emanated from Belgium and France as Howarth claimed. There was certainly no shortage of prejudice against the latter ('Art Nouveau was apparently regarded in [English] artistic circles as another example of French folly and eccentricity, dangerous and probably immoral').[68] But if this was indeed the case, then the most relevant questions to be asked would be, when was this, for what reasons, and in what context? For example, Mackintosh may have been taking issue with the highly ornamental non-functional approach to furniture design apparent with French Art Nouveau. The initial point to be made in this context is that, with Mackintosh's own approach, form followed attention to functional requirements. As we shall see, this had crucial implications for the manner in which he 'handled' Art Nouveau style.

We have already noted that the use of surging vertical lines for symbolic purposes – in the case of Mackintosh, as Howarth presents it, to express (organic) growth and force/energy – is a central distinguishing feature of Art Nouveau style. On what basis then is Mackintosh to be set apart from the 'Guimards, Gallés and van de Velde's of *Art Nouveau* persuasion' as Howarth insists he should be? The use of straight lines ('the sprightly linear style') has been commented upon, notably by Madsen in 1967, as one of the foremost principles of the Glasgow School: he asserted that decoration is never allowed to 'overflow and take possession of the object, as it did in continental Art Nouveau'. This particular characteristic Madsen attributed to the Arts and Crafts movement's struggle to achieve simple, austere decoration. But the Arts and Crafts movement also exerted a significant stylistic and ideological influence upon the Belgian Art Nouveau practitioners Serrurier-Bovy and van de Velde. The latter became absorbed in the writings of Ruskin and Morris, along with those of Nietzsche, around 1889, and it is important to

note the reasons behind van de Velde's tribute to Serrurier-Bovy, written in 1901: he states that the latter was 'unquestionably the first artist on the Continent who realized the importance of the English Arts and Crafts style and had the courage to introduce it to us and to defend it'.[69] Perhaps the significance of the link connecting, on the one hand, Mackintosh, and on the other, these particular Belgian designers, with the Arts and Crafts movement, is underplayed by Howarth because of his prejudice in favour of architecture: Serrurier-Bovy and van de Velde both excelled in furniture design. In the case of the former, Japanese influences figure strongly – as they would in Mackintosh's work after the early period – in his 'nicely balanced asymmetry'. Importantly for the clarification of stylistic influences, the simplified decorative style which appears in Serrurier-Bovy's work after the turn of the century (the stress now being placed on squares, rectangles, abstract geometric shapes) has been attributed to the influence of the Austrian school of Art Nouveau. If this is indeed the case, then the link with the Scottish style is legitimately made. However, what has to be recognized is that, by 1900, the Scottish influence was penetrating the Continent *by way of* Vienna. Howarth's description of Art Nouveau 'radiating fanwise from Brussels' has, consequently, to be corrected: describing an eastwards movement *towards* Vienna takes no account of the spread of influences in the *opposite direction* over a period of time.

Not only was an abstract geometric style very much the new vogue for Art Nouveau in Vienna by 1900 – it had replaced the fashion for a decorative *Jugendstil* – but this style was to owe a great deal to the developments of the Glasgow designers over the next few years. Josef Hoffmann was to be active 'in carefully selecting those elements from the Scottish architect's work compatible with an anti-naturalistic urge of "Abstraktion"'.[70] With the 8th Secession exhibition (1900) a formal abstract–geometric order was already being manifested and this would be the herald of the new direction:

> the contact with Mackintosh's work was undoubtedly one of the factors in renovating Hoffmann's style, at least as far as interior design was concerned ... the favourable reception given to the Scottish architect in Austria and Germany might appear incomprehensible if one were to ignore the link between his design research and the movement towards a *rappel à l'ordre* then emerging in German speaking countries.[71]

Succinctly put, this 'call to order' was directed against naturalism and symbolism, particularly as demonstrated by *Jugendstil*, now considered excessively decorative. Mackintosh's 'design research' was

obviously moving him away from the romantic and organic symbol-ism and the 'naturalism' of the 1890s. Wooden furniture was now (up to about 1902) being lacquered (in black, white, silver), an active negation of the 'nature' of the material: 'straight lines' had now ap-peared to replace curved ones; interiors were designed in black and white. Such design concepts were consistent with those of Hoffmann who expressed his interest as being 'in the square as such and in the use of black and white ... because these clear elements never ap-peared in earlier styles'.[72] Contrast between black and white became a trademark of the *Wiener Werkstätte.*

The actual perceived relevance of such developments on the Austro-German scene was conditioned by a new approach to aes-thetic theory emanating from Theodor Lipps, who, in 1898, interpreted the meaning and significance of Art Nouveau's abstract symbolism of linear form as 'an altogether new art, an art with forms which mean or represent nothing, recall nothing, yet which can stimulate our souls as deeply as the tones of music have been able to do'.[73] If these forms meant, represented, recalled nothing, that is, did not depend upon the assumption of prior knowledge (in the strict sense of objective meaning, knowledge of real objects), and yet they could elicit this degree of stimulation, then this had to result from a pure, aesthetic response to form alone. The combination of a con-cept of the absolute necessity of art's autonomy from social meanings prevalent in the established order, with the recognition of the potency of non-realist expressionism – this underpinned the ideal which attached itself to the potential of pure abstraction. The Mu-nich *Jugendstil* artist and theoretician August Endell attempted to 'operationalize' Lipps's concepts through his artistic work. Endell himself proposed to analyse 'scientifically' the means of symbolic communication with a view to rationally controlling the latter in practical terms. As Ezio Godoli describes, the premise of (conscious) rational control implies *overcoming*

> the need to surrender to the powers of the unconscious found in Jugendstil *naturalism* and *symbolism* in favour of a *Gestaltung* which, by adopting as its own postulates the aesthetic categories formulated by the Viennese school of art history, made geometric abstraction into its own basic morphological law and freed the ex-pression of *necessity* and the response to precise rules of form from the emotive free-will of the poetic ideals of *Erlebnis*.[74]

To interpret the parts the whole must be known: the Lipps/Endell position began from Wilhelm Dilthey's 'hermeneutic circle'. But it subsequently stressed that if the form of the whole derives from geo-

metry (intellectual abstraction) then we are freed from the obscurantism and mystification involved in lived experience (*Erlebnis*), which latter is greatly limited by prior experience, emotionality, and the operations of unknown and unconscious (repressed) forces. Artistic forms consequently become divested of cultural meanings and symbols bound by the past. They are thus free, as 'pure' geometric forms, and closer to true originality. (Walter Benjamin pointed out that the term *Erlebnis* had been misused within the German tradition of *lebensphilosophie* from Dilthey to Bergson. More correctly, the 'lived experience' signified by *Erlebnis* was vivid, intense, and momentary. It has indeed an essential relation to continuity with the past: but if prior experience is taken to refer to everything experienced or learned through experience, then it is more accurately rendered, Benjamin insisted, by the German word *Erfahrung*.)[75]

On the basis of distinguishing High Art Nouveau from late Art Nouveau, Schmutzler emphasizes the point that (a) both spring from the same roots; and (b) late Art Nouveau (geometric, rectilinear, cubic) can, at first, appear to be diametrically opposed to High Art Nouveau (curved, organic). 'In late Art Nouveau, biological life and dynamism give way to rigid calm. The proportions are still directly related to those of High Art Nouveau and the rudimentary forms of the older curve are equally present everywhere.'[76] In the light of this description, it is instructive to compare Schmutzler's interpretation of a photograph, claimed by Herbert MacNair to be of the interior of Mackintosh's studio at No. 2 Firpark Terrace, Dennistoun, Glasgow, taken about 1890, with Howarth's and Mary Sturrock Newbery's attempts to typify Mackintosh's work quoted above. This photograph shows a decorative frieze placed below the ceiling of the room, painted on a long roll of wrapping paper. The frieze has figures 'conceived as concisely limited, homogeneous, two-dimensional forms with broad spaces between them'. Curvilinear, but lacking the type of elements which Schmutzler finds are typical of High Art Nouveau – heavily flowing or convulsive outlines: 'In this instance it is rather a matter of wide and flat curves, like oval segments, almost in the style of late Art Nouveau.'[77] Almost, but not quite, because, stylistically, this frieze appears quite unique to Schmutzler. Which is to say that, even at this allegedly early stage, there is a claimed autonomy from hitherto assumed influences such as Beardsley and Toorop. He then notes the influence of Japanese style upon, not only this frieze, but also the metal candelabra seen before the fireplace in the study and bedroom. We might ask how Schmutzler can square his recognition of the Japanese influence upon Mackintosh in what he takes to be 1890, and the lack of any Japanese influence in 1893–4 (the ornamental drawings), especially since he acknowledges it as being so

important. The major problem with this interpretation is that it is based upon the acceptance of MacNair's testimony, reported by Howarth, that this is the interior of Firpark Terrace in 1890. Subsequent evidence pointed to the likelihood that the photograph was taken as late as 1896, and that the interior is of the Mackintosh family house in 27 Regent Square, Glasgow.[78] An identical 'cat' frieze appears in a photograph of the Davidson family's home, Gladsmuir in Kilmacolm, designed by Mackintosh in 1895. For Macleod, this evidence vindicates the view that Beardsley was indeed a significant influence, and that in Beardsley's work Mackintosh 'saw the basis for decorative exploration which, though using traditional elements, could create a new symbolism'.[79]

In the light of the latter, Schmutzler's description can be reappraised: the 'wide and flat curves almost in the style of late Art Nouveau' now being placed chronologically, and, therefore, meaningfully, within the process of Mackintosh's stylistic development, we are provided with an illustration of him moving towards the late Art Nouveau style (again, geometric, rectilinear, cubic) which so impressed the Viennese Secessionists. The success of the Scottish group in Vienna led to influences *from* Viennese designers which would have an instrumental effect upon the subsequent work of the former. The process of change can be illustrated by reference to the four schemes carried out by Mackintosh for Cranston's tea-rooms in Glasgow. The first (designed, along with the second, in collaboration with George Walton) is in marked contrast to the last, where the influence of abstract geometric style is dramatically apparent. The Cloister Room and Chinese Room in the Ingram Street tea-rooms (1911), and the bedroom of Bassett-Lowke's Northampton house (1916) display a close resemblance to Hoffmann-inspired interiors anticipating Art Deco style carried out earlier by the Wiener Werkstätte.[80] 'The incidence of the square as the principal decorative motive in Hoffmann's work symbolizes his rejection of *Art Nouveau*,'[81] says Howarth, emphasizing the significance of the 'emphatic unity and uncompromising form – the antithesis of the sensuous curve'.[82] Yet Schmutzler consistently places the work of Hoffmann, especially after 1900, firmly in the category of *late* Art Nouveau, along with that of Mackintosh from the same period. For instance: Hoffmann's Brussels Palais Stoclet (1905–11); Mackintosh's Glasgow School of Art west wing (1907–9). This is significant, because Howarth is sceptical of the argument that 'Hoffmann modelled his work on that of Mackintosh'. In focusing upon the period 1900–1 he states that 'the furniture of the two men bears individual characteristics that make nonsense of the suggestion of plagiarism at this stage, despite a strong superficial resemblance.'[83] But since the Glas-

gow school were only invited to participate for the first time at the Secession exhibition in the autumn of 1900, it might appear somewhat strange to be speaking of plagiarism at all. The most significant (well-illustrated) articles on the Scottish group in a periodical by that time had appeared in *The Studio* (July and September, 1897), and *Dekorative Kunst* (1898). Peter Vergo comments that the similarity between the work of the Glasgow school and that of Hoffmann (and Moser) is 'hardly surprising when one remembers the vogue enjoyed by British designers on the Continent at this time (1900), especially in Vienna'.[84] This is much too loose, however, to be helpful for the specification of what precisely the British influences on Continental designers were likely to be. (Sekler has argued that, in certain cases, Hoffmann is stylistically much closer to Ashbee than to Mackintosh.) As noted earlier, the *Dekorative Kunst* article makes the claim that Mackintosh and MacNair designs had a 'remarkable similarity' to designs by Koepping, Obrist, and van de Velde. Plagiarism on either side of the Channel was ruled out, the conclusion being that the Scottish and Continental movements started independently of each other. In this context similarities were ultimately attributed to 'certain things in the air' concerned with 'purely objective logic and technical questions'.

For Howarth, 'Illustrations of Hoffmann's work at the Vienna exhibition demonstrate that if anything, he had made greater strides than his Scottish friend. His furniture betrays fewer idiosyncrasies, and is seldom eccentric.'[85] But as already noted above, the favourable reception in Austria and Germany, which was triggered off by that first Secession exhibition, was rooted in the acknowledgement that the aims, ideology, and psychology of the Glasgow style were greatly in tune with the new movement which was embracing abstract geometry and anti-naturalism. It was surely *subsequently* that elements in the Glasgow Style became increasingly significant for Hoffmann, just as elements in the Secession style subsequently became significant for Mackintosh. Speaking of the effects of the 1900 exhibition, Howarth describes how

> Almost overnight it seemed that the entire Viennese movement, with Hoffmann at its head, blazed into new life, *and the next three or four years* saw the outpouring of a quantity of decorative work and furnishing of a very high order, all in its whiteness and plainness bearing a striking superficial resemblance to that of Mackintosh, but revealing a wealth of original detail and a conception of design which often far transcended that of the Scottish architect himself....And yet there was no suggestion of plagiarism. The linear patterns, the sensuous curves and the mysterious sym-

bolism of the Scottish artists was discarded as surely and as firmly as the wilder affectations of continental *Art Nouveau*, and a distinctly independent Viennese style emerged.[86]

But were the 'linear patterns, the sensuous curves and the mysterious symbolism' not being discarded by Mackintosh also in his movement towards increasing abstraction? And was this not a reflection of the movement from High to late Art Nouveau? Also, why has Howarth now dropped his attempt to differentiate Mackintosh's style from that of the other members of the group? We have already referred to Mackintosh's 'design research' and noted that the process of stylistic change was a gradual one: the 'old' elements were not divested overnight. This was undoubtedly why Hoffmann found himself practising selectivity: only certain, particular elements in the Scottish work at that time being consonant with the new aesthetic and stylistic priorities as he himself understood them. Godoli comments on Hoffmann's interiors 'redeploying' the elements of Mackintosh's language, but 'purged of all symbolist residue',[87] and Sekler claims that

> it is undeniable that the high artistic quality of the Scottish work and the intensity of stylistic expression that came across in it did not fail to make a strong impression on Hoffmann. Even if he did not change his own style fundamentally, some of his pieces bear a marked similarity to Mackintosh's work ... [88]

Within the context of Austrian Art Nouveau, which, as a component part of the European movement, developed later than it had in Belgium, France, or even Germany (with *Jugendstil*), new stylistic ideals were appearing for the regeneration of applied art and architecture. To a significant degree symbolical, organic, floral and stalk-abstracted forms had been bypassed because a decorative style based upon the form-language of geometrical figures had emerged out of a movement that emphasized *construction* and form-material harmonization. Although the actual links with the designs of Horta, Hankar, Serrurier-Bovy, and van de Velde are apparent with the pavilion designs by Hoffmann and Olbrich for the City of Vienna Jubilee Exhibition of 1898 (which employed stylized plant forms),[89] geometry signified the new direction. Indeed, the work of the Secessionists was acknowledged by certain contemporary commentators to represent *authentic* Art Nouveau when viewed alongside the output of the various European movements on show at the Paris Universal Exposition of 1900:

The phrase *Art Nouveau* which is seen and heard throughout the

Exhibition, has no greater justification than in the displays of Austrian furnishing, where the most recent decorative tendencies are applied without exaggeration and do not reach the point of absurdity. As much cannot be said for the other nations making efforts in the same direction.[90]

The room designed by Hoffmann at the Exposition for the Vienna School of Arts and Crafts was described by one contemporary critic as being 'in the manner of the School of Glasgow',[91] and the symbolist Fernand Khnopff made reference to the good reviews Hoffmann had received for his contributions. (One example was that by Arsène Alexandre, who commented that the Secession 'sought to give a lesson in elegance to the whole world ... and in this was completely successful'.)[92] Khnopff insisted that Hoffmann was 'essentially rational and reasonable in all he does, with compositions that are never extravagant, never intentionally loud as are those of some of his more western *confrères*'.[93] Given the common stylistic elements between the Glasgow and Viennese schools at this point in time, it is likely that Khnopff would have had similar comments to make about the former.

The late Art Nouveau of the Vienna Secession is, therefore, intimately connected to the the late Art Nouveau of the Glasgow movement, in the specific sense that both manifest the abstract geometric form-language as a recognizable style. Thus Mackintosh did not abandon Art Nouveau: he came into contact with a centre of the new movement which was already pushing towards a modernist fusing of decoration and function within the 'total' work of art. Also, and importantly, the geometric form-language of late Art Nouveau held significant potential for the possible future mass production of cultural artefacts. The process which followed the initial confrontation between the Scottish and Viennese movements was a highly interactive one. As Sekler summarizes,

> The artistic impact seems to have been entirely mutual between Hoffmann and Mackintosh, since in the wake of Hoffmann's most severely geometric purism, around 1903, the furniture style of the Scottish artist also changed: square or rectangular forms often comprised of straight parallel elements took the place of the earlier characteristic long-drawn curves.[94]

### The significance of symbolism in understanding Art Nouveau

It was in symbolism that early Art Nouveau confronted allegorical devices embodying images founded upon analogy. Lalique, the

French Art Nouveau artist–designer, who worked in jewellery, gold, and silver, was an exponent of a decorative symbolic style which exemplified very precise ideas about the relationship between representation and ornamentation. In what has been termed his 'fanciful naturalism', numerous shades of gold, enamels (opaque and translucent), irregularly shaped pearls, semi-precious coloured stones, are combined in such a way as to create designs with a heightened emotional quality. As Greta Daniel describes, in Lalique's work, 'unconventional freedom of expression is combined with formal arrangement of fantastic images and depends on complete mastery of a technique to make each piece an entity'.[95] These 'fantastic images' were derived from natural forms – plants, insects, birds. This represented an aspect of the style of which Voysey would have approved, despite his expressed loathing of Art Nouveau, a loathing which took the form of a moral, and not an artistic, judgement ('I do not see why the forms of birds, for instance, may not be used, provided they are reduced to mere symbols').[96] By contrast with Lalique, in Hoffmann's work at the turn of the century, there is apparent a concern with pure abstraction which can only be properly understood in relation to contemporary aesthetic theory, concerned, above all, to purge art of the limitations imposed by representation and its derivatives. Given this frame of reference, symbolism remains restricted by its reliance on quasi-representational forms. The movement towards abstraction was attempting to free art from these limitations but this involved a number of 'compromises'. Jean Delville's *Portrait of Mrs Stuart Merrill* (1892) illustrates a symbolic use of geometry with its 'perfect triangle of human knowledge', and Klimt's portraits of women employed geometric and asymmetrical elements. Lalique used the device of having female forms merge into insect, plant, or animal forms, and similar images decorate the pages of *Jugend*. Such obvious products of the imagination could hardly be accepted as representations of the 'real', but neither could they be termed abstract, because they combine contradictory fragments (with their own inherent validity) of a recognizable, objective reality for the purpose of positing images acknowledged as unreal, but also as having overcome the contradictions between the social and the natural.

In the case of the Mackintosh group, figures, especially female figures, were increasingly treated in a *stylized symbolic* manner which did not reflect contemporary female types, and which eschewed naturalistic representation in favour of decorative execution. The stylistic movement, thus apprehended, appears as being in the direction of increasing abstraction through a highly innovative approach to symbolism, which, although founded upon a synthesis of several

contemporary influences, facilitates significant freedom from the kind of substantive meaning concretized through traditions of western realism. The images are moved closer to the sphere of linear, abstract patterns. The interest of The Four in historical examples of monumental metal work has not been much commented upon, and yet the low-relief, embossed, repoussé (beaten metal panelling) works of the Macdonald sisters points to the significance of such an interest for the development of their style. Mackintosh, in his capacity as Architect Governor of the Glasgow School of Art, was to be instrumental in securing a collection of rubbings of medieval English monumental brasses which were subsequently arranged in the Museum in the School in 1911. His own description of these rubbings illustrates that their expressive value was perceived as inhering in the two-dimensional linearity which they presented. He 'referred to the value of the rubbings as showing how *simple drawing conveyed fine sentiment and beautiful emotion*'.[97] If the concern with simple drawing recalls the Beardsley-inspired early period of The Four, the concept of the emotional potential of art harks back to the symbolists. It was 'beautiful emotion' which Art Nouveau wished to impose on reality, and it acknowledged the fact that such could only be achieved through practical means. Not surprisingly, therefore, Mackintosh was concerned with the means for actualizing the potential offered by a whole range of contemporary applied and industrial arts.

The writers and artists who had been influenced by the summarized concepts, distilled from the poetry of Verlaine and Mallarmé and the prose of Huysmans, that were presented by Jean Moréas in his *Symbolist Manifesto* of 1886, were concerned to reject narrative style and the depiction of everyday reality. Symbolism was preoccupied with conveying 'the veiled essence of reality, with the *idea* behind the shape....The aim of art was not to describe observed reality, but rather to *suggest felt reality*.'[98] The aesthetic response to a work of art was to be elicited via a process of 'divining' or 'suggesting' (to use Mallarmé's terms) rather than describing or naming. Thus instead of addressing itself to the intellect, the symbol was to liberate emotion through its being experienced as beautiful. These symbolist notions had a profound effect on Bergson, who described how 'every feeling experienced by us will assume an aesthetic character, provided that it has been *suggested*, and not *caused*.'[99] Bergson employed 'dream', 'sleep', and 'hypnosis' metaphorically in his attempts to describe aesthetic experience as a state of perfect responsiveness to feeling, in which the 'personality' is lulled to sleep. The most potent of the arts, he insisted, was music, precisely because, unlike nature, which *expressed* feelings, music *suggested* them through its ability to employ rhythm and measure in suspending the normal flow of ideas

and sensations. In attempting to provide an analogue of the role of sound in symbolist poetry, or in music, the exponents of Art Nouveau saw themseves as helping to provide the means towards abstraction by emphasizing the symbolic quality of line as an expressive force. Such an approach was anticipated by Crane in England, who, in 1889, insisted that 'line is all-important. Let the designer, therefore, in the adaptation of his art, lean upon the staff of line – line determinative, line emphatic, line delicate, line expressive, line controlling and uniting.'[100] Van de Velde's theory of the expressive forces and emotional values of line is illustrated by his description of line as 'a force which is active like all elemental forces'.[101]

In a *Salon* review written in 1859, Baudelaire, describing art's ability to be autonomous from the world, had insisted that 'art diminishes its self-respect, prostrates itself before exterior reality, and the artist becomes more inclined to paint not what he dreams but what he sees.'[102] For the symbolists, aesthetic experience resulted from the sense of reality being obscured, as in dreams. But having recognized the nature and significance of the dream, the problem for the symbolists was how to maximize art's potential for inducing it. 'Don't copy nature too much,' warned Paul Gauguin in 1888. 'Art is an abstraction; derive this abstraction from nature while dreaming before it, but think more of creating than of actual result.'[103] At this time, that is, subsequent to the 'loss of faith' experienced by the Impressionists in France and the 'beginnings of the attempt to produce what Verhaeren called a "new art"',[104] Gauguin was developing a style of bold, abstract outline, with non-naturalistic colour harmonies, no modelling, no foreshortening, and with depth of composition reduced to a flat plane, with a decorative pattern of rhythmic lines superimposed upon it. These aspects of what were ostensibly an avant-garde attempt to simplify form, relate Gauguin's works of this period to Art Nouveau in spirit. The practice of suspending the definition of objects, so as to express the purely decorative value of two-dimensional shape, became one of the central factors in Art Nouveau decoration. But it is likely that the new decorative style of starkly simplified form was applied to Gauguin's designs for sculptures, decorative plates and vases *before* it was extended into his painting. Emile Bernard, on whose painting *Breton Women in a Meadow* (1888) *Vision after the Sermon* was directly based, had 'borrowed devices from Gothic stained glass windows, medieval textiles, enamel work and Japanese prints'.[105] The relationship of involvement with craft material, demonstrated by these vanguard artists, alongside the formalized stylization of their work, illustrates the closeness to Art Nouveau concerns, as does the (anti-classical) aesthetic theory which underpins the work itself. The latter

explained that the artist's thought had to be given a free reign in order that impressions and emotions could be translated into constructions of simplified forms: structures of colour, eloquent if emphatic outlines, slow movement: for each emotion, each thought, a plastic equivalent, a corresponding beauty, was supposed to exist. If these aesthetic rules (derived from rationalist principles) were followed, then quiet contemplation could be evoked in the perceiver, thus providing access to 'the mysterious centres of thought'.[106]

In his *Théories*, begun in 1890, when at work on the drawings for *Sagesse*, which have been considered to represent some of the earliest Art Nouveau book illustrations, the young French artist Maurice Denis set out the principles of vanguard aesthetic ideology as represented by Gauguin and Seurat. Denis insisted that meaning did not require to be imposed upon the work of art, through the inclusion of objectifications from other spheres of existence. Meaning, beauty, coherence, unity, were qualities intrinsic to the work of art whose ability to arouse feeling in the perceiver did not require, for example, literary allusion or representation (Khnopff occasionally employed direct literary references in his work, such as *La Sphynge* which had a subject derived from a novel by Péladan, or *I Lock my Door upon Myself* from the Christina Rossetti poem).[107] Denis acknowledged the role of a linear language in the expression of a range of typified emotional experiences (upward-moving lines: joy; downward-curving lines: inhibition). It was in the process of elaborating on the ideas of Gauguin and the symbolist writers, and thus refining them – more specifically, in declaring the existence of a corresponding plastic equivalent, a line, colour or shape for each thought and each emotion – that Denis was able to stress the fundamental role of visually meaningful forms in art production. In this respect, he claimed, there was no difference between the fine arts and the applied arts: power of form could just as easily be present in a vase, or a chair, as in a painting. Thus, a new conception of the decorative content and visual meaning of art works was to allow Art Nouveau practitioners a new range of expressiveness, and although the actual expressive content of works would manifest great variety, always the evocative power of the formal qualities would be acknowledged. While originating in graphic design and painting, the new style of embodying meaning in form, by influencing architecture and other spheres of design, had, by the middle of the 1890s, come near to realizing the ideal of a universal style for all things.

In 1897 *The Studio* published a second article by Gleeson White on the new group of Glasgow designers. White drew a comparison between MacNair and the other members of The Four, specifically with regard to the symbolist content in their work. MacNair was con-

sidered to be profoundly in sympathy with the other Glasgow designers, but he had, additionally, found his own individuality of expression: 'in his work there is more conscious symbolism, more of the mysticism which modern critics love to trace to Celtic blood, than is apparent in his neighbour.'[108] White highlighted the significance of this element, not as something peculiar to Scotland, but as part of the modern continental movement in culture:

> The fact remains that in Scotland as in England, in Germany no less than in Belgium, and in many other places, there is a return to mysticism, and to superstition and legendary fancies which at first sight seem out of touch with the 'actuality of modernity' as modern journalese phrases it.[109]

The frame of reference being invoked was the strain within symbolism that was inspired by overt mystico-religious preoccupations. The names of Khnopff, Moreau, and Maeterlinck were cited in order to illustrate the view that the work of the Glasgow movement required complex interpretation because of the depth of idealist and symbolic meaning contained within it. The acknowledged delight in the imagination was explained as being probably inevitable as a reaction to 'realism and naturalistic impressions'. Such an interpretation was validated by Talwin Morris, who, in the same year, was applauding the impressive treatment by the Macdonald sisters of 'the most subtle allegories and mysteries of religion' with their illustrations for the *Christmas Story*. For Morris, the feeling elicited by genuine art was specifically aesthetic feeling, and the media through which art communicated involved symbols, allegories, hieroglyphics.[110]

The (predominantly organic) symbolism specific to Art Nouveau was initially deeply conditioned by the decorative, linear approach to style in the struggle to achieve 'a modernity defined as lean simplicity'.[111] This symbolism was increasingly giving way to abstraction through the striving for a more intensive aesthetic distancing from realism and naturalism. After 1902, and the music salon designed for Fritz Wärndorfer, Mackintosh rejected the literal use of organic decoration and moved increasingly towards geometric abstraction. This involved a less close collaboration with Margaret Macdonald, who has been consistently viewed (Morton Shand, Howarth, Billcliffe) as restricting Mackintosh's experimental abilities. For the Willow tearooms, for example, the extent of Margaret's contribution was the provision of curtains and embroidered and gesso panels. According to Howarth, the reduced collaboration points up the contrast between Mackintosh and the other members of The Four with regard to abstract, romantic, and symbolic elements. For him, Margaret's

work

> shows little sign of development; she seems to have lived in a
> world of roses, love-in-a-mist, cherubs and falling petals – the
> quasi-dream world of Rossetti, Maeterlinck and the MacNairs –
> an amorphous paradise from which Mackintosh might well have
> escaped.[112]

And yet, Pevsner commented upon the 'tendency towards abstrac-
tion and excessive tension'[113] characterizing the interior designs of
the Mackintosh–Macdonald *collaboration* subsequent to 1894. Pevs-
ner was relating these interior designs to the design for the *Glasgow
Herald* building done by Mackintosh in (probably) 1894: what is so
striking about this latter work, is its originality (in particular, the
tower), notwithstanding the fact that it belongs to Mackintosh's early
period as an architect. Howarth concedes that originality was not
limited to Mackintosh, that '*The Four* were exploring many different
avenues in an attempt to evolve an original style of drawing and dec-
oration [and] that the girls were as deeply engrossed in experiment as
the two young architects.'[114] By 1894 their 'peculiar' style was well de-
veloped.

What then allows Howarth to make his stylistic distinction? First
of all, he depicts Mackintosh's art forms as being more 'masculine'
than the others (including MacNair), that is, by definition charac-
teristic of the male sex. It might well be asked, how applicable to
artistic analysis is this sort of stereotyped thinking? The implication
of Howarth's interpretation appears to be that Mackintosh's super-
ior originality was rooted in the factor of his being male. Indeed it is
the criterion of maleness which underpins Howarth's *combining* of
Mackintosh and MacNair on the basis of their more apparent origin-
ality. Hence, despite the coherence and homogeneity of the group's
style, 'individual' traits, Howarth claims, are easily recognizable,
'more especially in the work of the two men'.[115] As a student of archi-
tecture, Howarth portrays his chosen discipline as the 'major' art
form dwarfing all others. Hence, in his opinion, it was architecture
which really allowed Mackintosh to excel: the decorative arts merely
provided a 'testing ground' for the ideas which would crystallize as
distinctive examples of modern architecture. MacNair, already re-
stricted by the 'feminine' style as practised by the two 'girls', and
despite the 'easily recognizable' 'individual' traits in his work, 'be-
came more and more engrossed in the *minor* arts',[116] that is,
specifically design and craftwork. Thus lost to architecture, the ulti-
mate test of artistic 'genius', the inferior MacNair left the route clear
for the better man, who 'never lost sight of the fact that he was an

architect first and foremost'.[117] But *how* Mackintosh himself viewed architecture is extremely significant for the evaluation of Howarth's position, and this requires to be examined briefly.

Art Nouveau moved beyond Symbolism and Aestheticism through its becoming concerned with synthesizing and communalizing the arts, and thereby combining artistic with utilitarian concerns. In a lecture delivered in February 1893, the young Mackintosh demonstrated to what extent he had been impressed by the arguments presented in W. R. Lethaby's recent book *Architecture, Mysticism and Myth* (1892). Lethaby exemplified the link between Gothic revivalism and the Arts and Crafts movement which grew up in the heart of the former (William Morris was a leader of the Society for the Protection of Ancient Buildings). Giuliano Gresleri has recently referred to the influence exerted by this particular book on the Viennese Secessionists.[118] The conception which Mackintosh articulated was of all the arts, crafts and industries being combined in a new artistic form, the chief manifestations of which were to be found in architecture. Mackintosh would certainly not have agreed with Adolf Loos, the Viennese architect, that architecture was not art ('to whom should an architect look for help and encouragement in his war against ignorance and ugliness if not to his fellow artists?').[119] The concept he presented was of an essentially democratic and dialectical process: far from being 'hierarchized', the fine arts were to be synthesized, the crafts communalized, into a new cultural form commensurate with modern requirements. Importantly, it is the inherently *practical* nature of architecture which renders it capable of achieving the necessary motivation in this direction. But the architect, who possesses technical knowledge, and who works for practical ends alongside his fellow workers, must also be an artist who is not isolated from craft work, just as, conversely, the artist should not be estranged from architecture:

> To get true architecture the architect must be one of a body of artists possessing an intimate knowledge of the crafts and no less on the other hand the painter and sculptor and other craftsmen must be in direct touch and sympathy with architecture. There must be a real communion, a common understanding and a working together towards the highest and best aim.[120]

At the heart of this conception there is an essential Aestheticism apparent, but it should be noted that a new role for Aestheticism is to be established through the interpenetration of an afunctional fine art with the supremely functional 'art' of architecture: 'And still you ask what is the connection between architecture and painting. Everything.'[121] Lethaby, a scholar and champion of the past, as well as a

committed socialist and founder-member of the Arts and Crafts movement, had attempted, in the midst of his generalizations about the ancient origins of architectural forms, to establish a modern notion of functionalism. The magic and symbolism of ancient architecture were to find their contemporary analogue so that the modern architectural 'envelope' could be supplied with its necessary content. In extemporizing upon Lethaby's themes, Mackintosh proclaimed that modern designs should express fresh realization of 'sacred fact' and that the true principles of architecture were structure and form. The sacred fact was Nature ('where else indeed should we go for the highest imagination?' asked Mackintosh): but the moral language betrayed the link with Pugin and his followers, for whom the social quality of architecture was concerned essentially with morality. Good architecture could only be produced within a good society, and it consequently expressed moral attributes ('honest structure'). The influence of such ideas upon Otto Wagner can be seen with his proposing, after 1894, when he became Professor at the Vienna Academy of Fine Arts, the necessity for a 'morally' based architecture.

Long after Mackintosh had transcended his flirtation with the early work of Lethaby, the aesthetic and ideological concerns with synthesis, with artistic–architectural unity, remained: a unity, not only of all the arts and industries, or between the arts and society, but a unity within each artistic conception. How this unity was realized changed with the movement away from organicism towards geometric abstraction. Mackintosh employed metaphysical rhetoric in attacking artistic propaganda which exclusively portrayed the abstract, afunctional work of art as the supreme paradigm.

> It may be said that the yearning after abstract beauty unlinked with utility is the higher and most spiritual sentiment; but on the other hand, if we look around throughout the creations of nature we are prompted to reply that in linking beauty with utility, we are more directly imitating 'him' who made man in his own image and in whose works the union of the useful and beautiful is one of the most universal characteristics.[122]

The fetishization of the abstract, afunctional work of art was seen as representing the withdrawal from reality into an almost sacred aesthetic sphere. But the proper aestheticization of life required a practical project for society which began by acknowledging the prior 'aestheticism' which existed within the reality of nature. In cultural terms, 'beauty', hitherto abstracted from the concrete by fine art, was to become intrinsic to it. Are we now in a position to answer

provisionally the question 'What is Art Nouveau?'? In the first section of this chapter it became apparent that early Art Nouveau has long since been characterized as an essentially ornamental style. In respect of this, it demonstrates its indebtedness to Aestheticism, from which it also learned the notion of synthesis, that is, the desirability of form and content to be unified within works of art. In terms of Schmutzler's typology, the form- language of 'early' Art Nouveau, employing curvilinear shape with organic symbolism, gave way at a certain point to a rectilinear abstract geometric style. We saw that the latter, in the form of Viennese *Sezessionstil*, exerted a considerable influence upon the work of Mackintosh, but that the latter also influenced the Viennese. If we consider the duality expressed in Mackintosh's 1893 position, however, a number of analytic problems arise. Here is an argument for beauty *and* utility, that is to say, the *fusion* of the ornamental and the functional (where aestheticism was concerned, art need have no use- value whatever). What are the implications of this view when it is considered that ornamental (aesthetic) and functional (practical) concerns are usually characterized as being ends in themselves? For example, the flower and plant abstracted forms (leaves, stalks, roots, blooms) of French and Belgian Art Nouveau were fundamentally the reason why the latter was, from the earliest years, defined as a specifically ornamental style: decorative form was seen to subvert functionality. The Viennese Secessionists rationalized and operationalized the concept of ornament as an element integral *with* structure, rather than as something applied to it: so far, our examination of what Schmutzler refers to as 'late Art Nouveau' has established this point clearly enough, and thus has begun to acknowledge the Art Nouveau desire for the unification of form and content within objects that clearly have a use-value.

But what was specific about Art Nouveau *vis-à-vis* the cultural movements which influenced it? We can see that Art Nouveau was a pragmatic movement: it attempted to resolve the dichotomy between afunctional art and the functionalism required of social artefacts (from buildings to utensils). But it did not adopt an Arts and Crafts approach. This latter claim is problematic, given that handicraft techniques were often utilized by exponents of Art Nouveau. At a certain point, however, the influences acting upon Art Nouveau gave rise to something specific and different. This can be seen most clearly by considering the 'aesthetics' of Arts and Crafts. The latter tried to establish function as that which was perceived as being beautiful in itself. In sharp contrast to this, Art Nouveau absorbed the Aestheticism which was being opposed to the utilitarian attitudes and values that Arts and Crafts could not avoid. But if Arts and Crafts rejected

the tenets of the Aesthetic movement, it also represented a retreat from the utilitarianism of an industrial order. In seeking a critical paradigm to juxtapose with industrial mass-production, it looked backwards in time to a pre-industrial period, and portrayed handicraft activities as involving production through creativity. By the time Art Nouveau was appearing, both the critique of mass-production (Arts and Crafts movement) and the assertion of art's autonomy (Aesthetic movement) were revealing their limitations. The Art Nouveau reaction to this apparent disintegration of cultural coherence took the form of an incitement to return to fundamentals of cultural production, in order that the problems of the present could confront their 'correct' solution. A metaphysical search for the origins of architecture (Wagner, Mackintosh, Hoffmann) underpinned the Art Nouveau opposition in Austria and Scotland to historicist eclecticism. A new form-language was believed to be capable of providing the vehicle for new artistic meaning. Quality was equated with authenticity and newness, hence a heightened significance was bestowed upon experimentation, inventiveness, and imagination. It was acknowledged that principles of form were capable of engendering a higher meaning than traditional substantive meanings. Abstraction was employed for the 'emptying out' of content in the conventional sense. With the movement from a curvilinear, asymmetric form-language to a geometric, rectilinear, approach, abstraction was retained. In transcending Symbolism, Art Nouveau made synthesis, and an analytic concern with the relation of the part to the whole, the basis of a rationalist conception of the arts integrated with society.

In considering the Mackintosh movement in Scotland in the context of the above description, and in preparing the ground for our subsequent analysis, the following are presented as being its distinctively Art Nouveau attributes:

1. Anti-historicism.
2. A linear form-language in the 1890s which incorporates organicism, asymmetry, and the combination of rectilinear and curved forms.
3. A preoccupation with synthesis: (a) synthesis within the work of art/architecture (form and content unified in the 'total' work of art); (b) the synthesis of arts, crafts, industries, and architecture; and (c) the synthesis of intellect and emotionality.
4. The concept of balance between decoration and structure.
5. Rationality, logicality, coherence of form-language which unites particular with general concerns.
6. The use of abstraction.
7. Concern over the synthesis of functional and aesthetic concerns.

8. The recognition that purpose is not an aesthetic quality.
9. The concept of nature as art, that is, as an analogue of human creativity.
10. A geometric form-language of tectonic neutrality develops out of the earlier form-language which expressed dynamism/energy.

The early Art Nouveau preoccupation with the sources of life did not merely involve a form-language employing nature symbolism. It is crucial, therefore, to acknowledge the significance of abstract dynamism. Art Nouveau broke with earlier concepts of natural beauty and hence, with naturalist techniques for rendering natural beauty in art. Beauty was now being sought, not in nature, but through the kind of *abstractions* that were seen to be unique to the human mind and imagination. Artificiality was welcomed for the uniquely human qualities it could bring to cultural production. The totality of life as apprehended through abstract thought; the abstract principles underlying architecture; the abstract means whereby artistic creations could be imbued with new and enduring qualities – these represented central Art Nouveau preoccupations. 'Nature', as the external world of dynamic, organic processes, mediated through the inner world of the mind of the subject, was, as a consequence, in the early Art Nouveau period represented in the most abstract symbolic terms. But this should not be construed as merely a continuance of *Symbolism* in art. As we shall see, Scottish Art Nouveau was deeply preoccupied with the communicative potential of symbol systems in all spheres of culture. By beginning from an aestheticist theory of the primacy of art and the imaginative dynamism of the artist, rather than from a view which made human society a mere adjunct of nature, Art Nouveau was able to welcome modern technology as the ultimate manifestation of contemporary human creativity. In Scotland, Geddes argued that art, as such, was what guided modern material production, and that industry needed to be organized in terms of a new ideal in order to avoid continued production of the ephemeral and transitory: 'that of producing not more so called necessities of life, but more goods in which the aesthetic element is supreme'.[123] 'If we have a dogma it is to teach a utilitarianism which treats life and culture as a whole and which may sometimes find the Beautiful more useful than the Useful.'[124]

Chapter four

# The European context

In chapter 2 we considered the kind of criteria by which Art Nouveau could be legitimately considered an avant-garde movement. The first section of this chapter attempts to illustrate, through the example of van de Velde, how the avant-gardiste position within Art Nouveau demanded far more than the 'flowering of the decorative arts' which so many commentators take it to have been. Van de Velde helps to clarify the question of the significance attaching to the inclusion of architecture within the programme of the movement. This section sets the key for the chapter, in that it provides a frame of reference for the elucidation of Glasgow Art Nouveau as a movement reflecting Continental avant-gardiste trends. In the final section, some recent attempts to specify the nature of 'Glasgow Style' are examined in order to demonstrate the kind of difficulties which have been encountered (and sometimes created) by commentators in this area.

### Glasgow in relation to Belgian avant-gardisme

The significance of avant-gardiste principles in the attempt to transcend commercial hegemony and historicist/eclectic stylism, is illustrated by van de Velde's presentation of what he considered to be the fundamental tenets of Art Nouveau. Aware that commodity aesthetics could operate in such a way as to convey an image of art having a directly practical role, van de Velde recognized that the commercial agencies fostering this for their own profit-seeking ends, could effectively negate meaningful evaluation of works of artistic production. In retrospect, he described his growing awareness of how such agencies could distort the wider perception of art works:

> It seemed clear ... that the old, relatively frank and straightforward transactions for the sale and purchase of an artist's work might

soon give place to the odious modern machinery by which com-
mercial publicity hoodwinks the public over the quality or value or
whatever it is paid to advertise. Thus in the not far distant future
we could expect to find genuine works of art insidiously branded
with the same sort of mendacious descriptions and fictitious valu-
ations as ordinary mass-produced merchandise for household
use.[1]

For art to impose a regulating and controlling function within the
processes of production and distribution it had to become an instru-
ment of overall planning. Newly invented forms of art could be
employed in confronting the problem of historicist stylism, but there
was the danger that these forms, in being abstracted from the
concrete social needs which gave rise to them, would be manipulated
for purposes of profit and commercial prestige. By becoming an
instrument of overall planning the social arts (art industries and
architecture) could potentially subvert the (often latent) commercial
interests whose motivations were towards organizing the activities of
artists to the ends of merely modifying the designs of objects already
proven to be successfully marketable.

Though greatly inspired by the teachings of Ruskin and Morris,
which allowed him to acknowledge, not merely the need for a com-
plete renewal of the decorative arts, but also that architecture was an
integral part of the much larger task of modifying the entire complex
of contemporary social forms, van de Velde considered the English
movement to exemplify an aristocratic stance, and to be detached
from the real problems of a modern industrialized society. It was in-
adequate to unite art with handicrafts; machinery and mass-
production techniques had to be accepted trustingly for a rebirth of
the arts to be possible. Hence the expressed ideal was to witness 'the
thousandfold multiplication of my creations'.[2] More than Horta,
Hankar or Serrurier-Bovy, his fellow members of the Belgian Art
Nouveau movement, van de Velde was able to penetrate beyond the
pursuit of a developing new style towards a deep realization of the
enduring potency of the debilitating historicist/eclectic stylism that
they, as a group, attacked.

My hopes of what liberation from tutelage to the past and the
dawning of a new era in design might bring about were just as high
as theirs [Horta *et al.*], but such an illusory prospect failed to satis-
fy me. I knew we had to delve far deeper, that the goal to be striven
for was a much more vital one than mere newness, which by its
very nature can be only ephemeral. If we were to attain it we must
begin by clearing away those obstructions which the centuries had

accumulated in our path, stemming the inroads of ugliness and challenging every agency that corrupts natural taste.... I firmly believed that I could achieve my ends ... by virtue of an aesthetic founded on reason and therefore immune to caprice.[3]

In espousing his 'aesthetic founded on reason' within the context of a rather negativizing appraisal of the other members of the group whose one common quality of artistic newness had already led to the coining of the term Art Nouveau, van de Velde was undoubtedly trying to compensate for a lack of concern with theory on the part of the others. His own observation was that technical development was a product of overall socio-cultural development, and hence purely commercial interests were viewed by him as obstructing the latter.

Horta had attended the Academy at Ghent, his birth-place, but prior to completing his studies at the Brussels Academy (1881), he had travelled to Paris after 1878. At this time, Viollet-le-Duc and Vaudremer, along with other members of the *Union Syndicale des Architectes Français*, were experimenting with architectural features. As well as fostering expectations of an imminent change of direction in the arts, the kind of stylistic and technical innovations attempted were to provide seminal elements for Art Nouveau: Vaudremer employed *abstract* chromaticism (for example, his Lycée Buffon) and Viollet-le-Duc tried to popularize *linear decoration* with his iron ornaments (*Compositions et Dessins*, 1884; *Entrètiens Sur L'Architecture*, 1872). This particular French movement reached its climax with the Paris Universal Exhibition of 1889, where French artists' attempts to invent a new type of decoration suited to iron buildings (proving popular for industrial and commercial projects) were in evidence, ones which combined ornamental (cast iron/sheet iron decorations) with utilitarian (riveted surfaces) elements. In important respects it prefigured the role of the 1900 Exposition Universelle which influenced organized attempts to unify art and industry in France (for example, the Ecole de Nancy, Alliance Provinciale des Industries d'Art in February 1901). Horta's experience of the works of the 'Union's' members was important to a degree for his own subsequent development (not particularly notable until the Hotel Tassel in the rue de Turin [now the rue Paul-Emile Janson] in Brussels was built in 1892–3) and was apparent with his juxtaposing of contrasted materials (stones–bricks, iron–glass) in the Maison du Peuple. However, the intellectual content of rationalist theory probably had more of a subliminal than an overt effect upon Horta. In the case of van de Velde, the need to liberate and develop the rationalist potentialities for a more rigorous aesthetics is clearly apparent. Such could only be achieved through a process of absorbing the numerous

anti-traditionalist stimuli which were motivating the various contemporary avant-garde movements.

In the early 1890s, the actual social context within which Belgian Art Nouveau was emerging saw the founding of the 'National Belgian Society for the Encouragement of Art in its Application to Street Decorations and to All Objects of Public Usefulness'. Established in 1894 on broad populist lines, the Society (which, by the turn of the century, had upwards of 3,000 members) had two main objectives: firstly, to ornament the façades of dwelling houses and public buildings in accordance with artistic principles (apparently the model was derived from Flanders and Italy during the Renaissance); and secondly, to encourage the application of art to modern practical appliances and inventions. This 'liberal and democratic artistic campaign',[4] promoted by artists, architects, and leading public officials, was claimed to have enjoyed general approval, no doubt because the emphasis was consistently placed upon the proposition that art had to appeal to the mass of the people if it was to recover its lost educational force. The initial medium for the diffusion of a wide knowledge of art among the masses was to be the application of artistic designs to everything which the members of the population were brought in contact with in their daily lives. In Britain, *The Art Journal* reported on the movement:

> Nothing is considered too unimportant to come within the scope of the new movement, from a door-knob to the façade of a cathedral. In this manner, the artistic education of the people will be brought about by permanent examples which meet the eye everywhere, and gradually make a lasting impression. Thus, it is argued, artistic traits in the people will become hereditary.[5]

From his vantage point of the Art School in Glasgow, Francis Newbery clearly followed with intense interest developments such as these. The role that artistic education could allegedly have upon heredity was being debated within the Glasgow School of Art also at this time.[6] But there were more concrete reasons for an interest in Belgium: Glasgow's art school had been deemed more 'advanced' than art schools in Belgium after its contributions to the Liége Exhibition of 1895 were seen. For his part Newbery considered the School of Art, not merely as a symbol of Glasgow's cultural development in the fostering of an art-educational establishment for the talented sons and daughters of the local middle class, but as a unique organ for the active integration of art with modern urban living. As he expressed it, 'He thought the school would get by-and-by to the position that, instead of instructing the students, it would be in the

position of educating the community.'[7] In other words, art education would transcend its traditional institutional context and effectively penetrate society for the betterment of all of its citizens. In 'art education' Newbery included the kind of practical training which, he hoped, would involve the wider elevation of the status of the crafts to that traditionally enjoyed by the fine arts. His declaration that 'The artist was nothing if he was not a workman'[8] illustrated his commitment to what Walter Gropius, in 1924, referred to as 'the reunification of the world of work with the creative artists'.[9]

It is significant that Jean Delville, the Belgian symbolist artist and disseminator of Péladan's teachings, should be invited to Glasgow by Newbery; he took up the position of Professor of Drawing and Painting in the Life Classes at the Glasgow School of Art in 1901 (he left in 1906 to settle in Brussels).[10] Notwithstanding his hostility towards materialism and his 'mystical Decadence' (Philippe Jullian), Delville's expressed view was that aesthetic ideas were always capable of being applied to social ideas: writers on socialism, he insisted, 'ought at the same time to be cognisant of art if they wish to become perfect organizers of human life'.[11] The beautiful was inseparable from social life; art was virtually the only *social* force with the power to assist in uplifting the population. Delville juxtaposed the avant-garde ideal of art's integration with social life to the 'theory' of 'art for art's sake', in such a way as to emphasize the criticism that an exclusive devotion to painting as a profession could only precipitate artistic backwardness. At the time of Delville's departure for Glasgow, the young intellectuals in the Belgian Workers' Party had been anxiously debating the relation of art to socialism, and the party had supported Art Nouveau as the most desirable style for modern architecture. Van de Velde was placed in charge of the party's graphics.

Newbery's personal scrap-book contains a press cutting reporting a lecture given by William Morris in Glasgow (circa 1889) where the educative purpose of the city's Art School is specified as being for the 'public at large, and not for the special advantage of the manufacturer or of special localities'. Morris proceeded to say on this occasion that

> the very existence of a school of art in a great commercial city like Glasgow hinted, and not obscurely, that it was the business of artists to do their very best to bring it about that artists should no longer be a small class, but that either in the work they carried on, or in complete sympathy with it, the whole population should be in one form or another artists. (Applause.)[12]

This was placing a heavy burden of social responsibility on artists,

and as a moral imperative it was completely characteristic of Morris the ideologue. Shortly after this, Continental Art Nouveau, itself taking theoretical inspiration from Morris's movement, would become a favourite target for attack by his followers. But in real terms, in what sense could Glasgow's own most significant artist's match up to Morris's requirements of them? In examining this question the first thing to be noted for our purposes is the importance of the relationship between Glasgow's artists and cultural developments in England (the Aesthetic movement), and on the Continent (Symbolism) which were to facilitate Art Nouveau. The most illuminating way of beginning to examine the European context for the Glasgow School of Painting is from the vantage point of Newbery's ideologically-informed perspective.

## The importation of a Continental school of painting

The group of painters who called themselves the 'Glasgow Boys' (led by James Guthrie, John Lavery, Arthur Melville, George Henry, E. A. Walton, E. A. Hornel) established in Glasgow the first significant link with developments in art on the Continent. At about the time when Morris was delivering his polemic in Glasgow, their works were being exhibited at both the Grosvenor Gallery in London and the Glaspalaste in Munich (1890). The twenty-three principal Boys were not all born in Glasgow: Lavery was born in Ireland; Crawhall in Northumberland. One of the main factors uniting the painters initially, was a loathing of the Royal Scottish Academy in Edinburgh. Sir William Fettes Douglas, President of the RSA, was reported in 1889 as finding the 'Glasgow fellows' 'very troublesome', and asking, 'What do they want *here* at all? If they are badly hung in Edinburgh I am sorry for it but we must look after ourselves.'[13] By this stage, ironically, Guthrie (who expressed his admiration for the 'vitality and activity of the Glasgow School of Art')[14] had been elected an Associate of the RSA (14 November 1888), rising to full Academician in 1890. Walton became an Associate in 1889, and in 1890 Henry, Lavery and MacGillvray were elected Associates. Clearly, their success was too profound to go unacknowledged by the art establishment indefinitely. Works by Scottish artists in the last twenty years of the nineteenth century were purchased by galleries in Paris, Berlin, Vienna, Prague, Budapest, and Munich, as well as by the municipal collections in Ghent, Barcelona, Venice, Stuttgart, Karlsruhe, and Weimar. The Boys formed themselves into a society with a form of constitution in 1887, with Glasgow-born William Kennedy (1859–1918) elected President. The more adventurous members of the Glasgow school had adopted the style of Bastien-Lepage from the

1880s. As Roger Billcliffe has pointed out, this style was actually closer to that of the Academicians than the Impressionists (led by Monet, Renoir, and Pissarro): it was novel and yet traditional. 'Bastien-Lepage's painting challenged current academic thinking in both Scotland and England but it was not such an affront to it that it might forever bar his followers from public acceptance.'[15] However, connections with France had been significant for Glasgow painters even prior to the earliest period of the Boys. The European centre of culture in the late nineteenth century was Paris. McTaggart visited there in 1859, 1876, and 1882; Melville travelled to France in 1878 and painted in Paris and Grès near Barbizon (David Gauld, a close friend of Mackintosh, visited Grès in 1896). Thirteen of the Boys were made corresponding members of the Munich Secession in 1893 when its first exhibition took place. Guthrie (whose style changed dramatically after he visited Paris in 1882) became an Honorary Member in 1896.

The achievements of the Glasgow painters were placed squarely within an 'Art for Art's sake' category by Newbery in 1897 when he wrote the introduction to the first book to be published on the artists' work. The author was David Martin. Here Newbery establishes a contemporary context from which to understand the relevance of the Glasgow school: this context being the European avant-garde movements. The Glasgow Boys have, he asserts,

> a firm belief in *one* thing – which is, that it is quite sufficient for *Art to be Art,* and to be the most beautiful thing that the hand of man is capable of making her....None the less are they the force behind a movement whose influence is both evident and extending.[16]

Newbery referred to this movement as a 'renascence' whose birth was in many places, although he was swift to point out that the Glasgow school did not have to suffer academicism, a Royal Academy, or 'a power that held possession and which either ruled the market or dictated the taste'.[17] Instances of opposition, he stressed, could be found in London (the New English Art Club assaulting the 'citadel of academicism'), Paris (the fight against the State School tradition and the atelier), and Munich. He then drew attention to the significance of specifically urban forces for the creation of an art movement.[18]

There was nothing accidental about Newbery referring to this modern artistic movement – of which the Scottish phenomenon was seen to be a manifestation – as a 'renascence': van de Velde employed the same term and Otto Wagner talked of 'Naissance'. In Newbery's case a strong influence clearly emanated from Patrick Geddes in

Edinburgh. Geddes was greatly preoccupied with what Bürger terms 'The nexus between art and the sciences that the Renaissance created',[19] and he saw as the most pressing need the *re-creation* in a higher cultural form of 'Leonardo's, Dürer's dream of uniting Art and Science'.[20] Geddes was sufficient of an optimist to claim, as early as 1884, that 'the long-delayed renaissance of art has begun, and the prolonged discord ... is changing into harmony.'[21] Taking his cue from this prognostication, Newbery articulated the conviction that the essence of the Renaissance, far from having diminished with history, was existent as an immanent potentiality embodying an unlimited field for knowledge. It was while discussing the Renaissance that he pointed to pre-Raphaelitism as carrying the power to activate new artistic movements on the Continent.[22] This was Newbery's not very clear way of acknowledging the influence which pre-Raphaelitism was having on European Symbolism (it was also to be significant for modernists such as Picasso and Kandinsky), and via Symbolism, on Art Nouveau (expression, synthesis, decoration were all central Symbolist preoccupations). Objective cultural conditions were seen by him as working themselves out, often independently of the conscious intentions of artists themselves. For this reason, he insisted that any orientation which understood art as consisting of the lives, works and influences of particular artists, or with selected schools, was engaging in 'archaeology'. What was traditionally termed 'art', Newbery portrayed as an emergent phenomenon which transcends the activities of those referred to as 'artists': 'the Art that artists do, lives after them; the rest may be interred with their bones.'[23] He thus hypostatized art as an independent, suprahistorical structure of spiritual values: at the same time, he was acknowledging the apparent autonomy of art, its ability to emancipate itself from its material origins and develop in accordance with specifically artistic inner laws of form. The European movement of artistic radicalism which he polemicized about provided the ground for innovations whose very autonomy were a vital condition of their intrinsic value. Hence, the Glasgow Boys were depicted as representing a cohesive group of artists working within this contemporary European movement, which was comprised of interacting combinations of avant-garde agents, all of whom were asserting their originality, independence and freedom in opposition to established traditions. Within the artistic group itself, the adoption of a particular style was certainly viewed as being the object of a voluntary choice, the latter being validated by the artist's individual talent. This was fundamental as the medium through which real art expressed itself. In 1909, Newbery, by then associated with the Glasgow School of Art for twenty-five years, continued to demonstrate his conviction that art was inseparable

from individuality, by announcing that 'full scope was allowed the individuality of the students. In that school, so long as he was connected with it, individuality would be regarded as a precious thing.'[24] As Giuliano Gresleri has emphasized, the 'concept of individual action became, in the programme of the avant-garde, a formative, polemical, and social obligation.'[25] The principles involved for vanguard artists emphasized individual creative freedom and the primacy of the imagination. With Art Nouveau this was directed towards the creation of a new universal style which would oppose traditional styles and be autonomous from historical models. In the context of Newbery's portrayal of the Glasgow painters, style could be developed innovatively by an individual or by a small group; what was most significant was that it presented an alternative to what the concerted contributions of recent past generations had bequeathed through tradition.

The nature of the dialectical relationship between the individual and tradition takes on a different form, however, in the sphere of architecture and the applied arts, as can be seen from the manner in which external elements (that is, to originality, independence, free creativity), in the form of practical requirements, affected avant-garde projects within the public sphere. In adapting the new Glasgow Style form-language to the requirements of particular construction requirements, difficulties arose. Out of this tension-filled relationship between the architect and a given project, there emerged a rift in the balance between particular (individual) and general aims, not least because avant-garde architects were attempting to eliminate the hegemonic influence exerted by 'external' eclectic references and were attempting to transform conventions inherited from the past: conventions become concretions of power and influence through institutional agencies. The problem is highlighted by Mackintosh's Gothic design for the Liverpool Anglican Cathedral Competition of 1903 which was undoubtedly determined by the knowledge that the assessors would inevitably choose a design conforming to the traditional mode/form of English ecclesiastical architecture. Such instances betray the intractably institutionalized imperatives underlying eclecticism: they also help to focus the attention on the practical experiential difficulties confronted by proponents of avant-garde ideas in architecture. Unlike artists such as the Glasgow Boys with their easel paintings, avant-garde architects and designers were not 'alone' before their work, and faithfulness to a new form-language ultimately had to confront the requirements of specific objective circumstances. In other words, the actual function of a project, and/or the nature of a commissioning client or body, were to prove crucially important in relation to final design outcomes. We shall return to

this issue later in the chapter, and examine it through certain concrete examples in Glasgow. In the meantime, however, it must be said that the view just expressed about the Glasgow Boys is not an adequate one, because, under the respective influences of Aestheticism and Symbolism, the traditional concept of 'the painting' with its allegedly 'realist' content was itself undergoing considerable change in the hands of certain Glasgow artists. The immediate environment, hitherto considered extrinsic to the artist's content-laden creation, was to influence the process of formal execution itself.

Alongside the series of pictures (sketches and finished paintings, about fifty in number) which Lavery executed during the summer of 1888 in the grounds of the International Exhibition, and a group of paintings by James Nairn recording urban surroundings, the only Glasgow school painting to concern itself with the life of the industrial city is W. Y. MacGregor's *A Joiner's Shop* from 1881.[26] Lavery's work presents a highly decorative and aesthetic effect which disturbs the relationship between the artist and the 'reality' being portrayed, and links his compositions to the contemporary works of Hornel and Henry which strongly influenced the two-dimensionality of Glasgow Style Art Nouveau.[27] The real, as a fragment of optical factuality, is made the starting-point for artefacts of the artist's apartness from social reality. In Lavery's case, with the Exhibition pictures, constructions purveying harmony, order, enjoyment, contentment, perfectly in concord with the priorities of the commercial interests which have conveniently supplied the subject-matter, venue, and events. On the subject of the French realist paintings exhibited in Glasgow in 1888, Billcliffe makes the point that

> most, if not all ... were concerned with rural life. There was a dignity attached to these representations of rustic labour which no doubt made them acceptable to the Scottish collector, but few artists seem to have tried to attract his attention by recording the conditions in which many of his own workforce would have spent their daily lives.[28]

The most obvious question that this raises is, given the predominantly decorative and harmonious nature of the styles of painting employed by the Glasgow artists, would such 'depictions', even if attempted, have amounted to anything more than idealized representations of workers at one with their virtuous, if back-breaking, labour? Or as manifestations of the daunting 'natural' force of socially necessary labour which had constituted them as a mass: a force with which they would appear in mystical harmony? French rural life and peasant labour had been reified through the sentimen-

tal and nostalgic misrepresentations forming the content of the paintings produced by Millet and the Barbizon school to grace French petit-bourgeois households. In importing this cultural form, the Glasgow Boys imported the basis for an appealing aestheticization of social 'reality'. The change which took place subsequently within Glasgow painting was essentially stylistic. The works of Lavery, with their representations of recreation within carefully selected segments of urban landscape, executed under the influence of Whistler's teachings, illustrate the consistent removal from view of social conflicts and deprivations through the medium of an artistic style which was made at least as important as 'realist' content.

The same economic prosperity which produced commercial and residential Glasgow in the years of expansion in the nineteenth century also engendered poverty, appalling working conditions, and inadequate and overcrowded housing within insanitary environments. But for the middle classes, trapped within Glasgow's commercial sector, if not its impoverished areas of poor housing, the new forms of cultural production were increasingly being focused upon as having an autonomy and a quality which they were reluctant to reduce, invariably, to commercial processes as such. Rather, the arts which had emerged, and which were now apparently flourishing, were portrayed as holding the promise of a new quality of living, a quality that could be considered the more desirable result of industrial activities so negatively appraised in the past.[29] The success of these 'flourishing arts' in the public imagination could be easily attributed to the influence of the Glasgow Boys. This was not to say that their influence was perceived as having affected fine art alone. In fact, Glasgow's 'arts' were to a considerable degree apprehended in terms of a pragmatic attitude which was being disseminated through the language of the press.[30] Even in 1888, it was being acknowledged that the work of the Glasgow painters held the promise of a beautified social environment. For the Exhibition of that year, held at West End Park, ten central galleries devoted to the visual arts (including architecture and photography) were incorporated by the architect James Sellars. In describing the Sculpture Gallery, the *Glasgow Herald* had this to say about Roche and Hornel's quality contributions to the decorative scheme:

> The presence of these works in the Sculpture Gallery, and others of a similar nature which have been embraced by the architect in his designs, will do much to open up a field of art of the highest order at present closed against artists in this country, and may suggest the decorative scheme which should be applied to the rooms and salons of our public buildings.[31]

Writing in 1897 of Hornel's style, David Martin attempted to pin-point the artist's distinctive characteristics of decoration and colour:

> His pictures are panels, wherein the artist seeks to give expression to a motif which is entirely concerned with the beauty of colour in conjunction with a decorative quality of line or of spacing....He is concerned more with the building up of spaces of colour, rich and full in quality, which, with a fine sense of composition, results in a scheme that is highly decorative.[32]

This is a strikingly 'Art Nouveau' interpretation: beauty of colour and a decorative linearism/spatialism are acknowledged as being employed for purposes of *expression*. A telling illustration of the thoroughgoing attempt to exploit fully the decorative potential of the whole, is the gold leaf Hornel and Henry used on parts of the canvas in *The Druids* (1890) and in *The Star in the East* from the following year (1891). By deliberately associating painting and the applied arts, symbolistic image with ornamentation, works such as this challenged the traditional academic categories of art forms. This was acknowledged by the critic of the American journal *Harper's Weekly*, who invoked analogies with other media – stained glass, tapestry – in describing Hornel's *May Day*. It may be likened, he reflected, 'to a gorgeous tapestry in which joyous children disport themselves in brilliant sunlight'; while Hornel's 'wonderful Japanese studies in their colouring suggest the brilliancy and translucence of stained glass'.[33] There can be little doubt that Newbery's and Martin's interpretations of the Glasgow painters' work were influenced by press coverage in Glasgow of critics' appraisals of their work shown at the St Louis Exposition of 1895. Commentators writing for American journals and newspapers were unanimous in hailing the Scottish work as 'advanced' and thus representative of a strong and original influence upon modern European art. The apparent incongruity of using oil paints to create the effects of stained glass or embroidery, and the new emphasis being placed upon imaginative/inspirational content, were acknowledged as being central characteristics of avant-garde art. The art critic of the *Evening Times* in Glasgow, subsequent to having received a number of press cuttings from the United States, commented that it was 'one of the most gratifying features of the American appreciation that it is based on sound judgement and a clearer understanding of what the artists are driving at than seems to be possessed by the average British critic'.[34] This 'clearer understanding' can be seen to have extended to an acknowledgement of several features apparent with the work on show that relate directly to early Art Nouveau by way of Symbolism.

The use of *expression* to emphasize the sensual and intensify emotion, was much commented upon, as was *inspiration*. The significance of 'Nature Rapport' (French Art Nouveau artists were, at this time, committing themselves to Nature as the primary source of inspiration) was seen as having nothing whatever to do with imitation of nature by the art critic of the St Louis *Post-Democrat*, who, in analysing the works, and differentiating them from the products of realism, pointed in the direction of distinctive elements of Symbolism and Celtic mysticism.[35]

An equally relevant example of recognition of what was to be a central Art Nouveau concern is to be found with the references demonstrating that the Scottish work resulted from the kind of psychology capable of suffusing thoughts with emotions. (Five years later Hermann Obrist, in *Dekorative Kunst*, would insist that 'If we trustingly followed our feelings and thoughts ... we would see that we can find everywhere this essence of all that is art.'[36]) 'The men of the Glasgow School think and feel, and thought and feeling are involved in all their work,' proclaimed the critic of *Harper's Weekly*, and the Chicago journal *The Arts*, in its response, illustrated the conviction that inspiration required the merging of thought and feeling before genuine creative originality, and individuality, were possible.

Beyond the Barbizon and Whistlerian 'realist' modes employed,[37] and beyond the established norm for easel painting, the most significant Glasgow school appropriation was that of Symbolism: it was in respect of this that the 'cross-over' point between the Glasgow painters and the exponents of applied art was most noticeable. The adaptation of works such as those of Hornel and Gauld (which anyway already employed a formal repertory appropriated from design as against representation) to other media, illustrated the interrelationship between a style of painting utilizing forms defined by colour and flattened perspective, and the decorative arts (an applied art like glass-staining provided a link with architecture). However, in concrete terms the new 'Glasgow Style' of the Mackintosh group in applied art manifested greater stylistic unity than had been the case with the Glasgow school of painters. This made the former comparable with the newest developments in Europe. But the aesthetic tastes which the Glasgow painters had appealed to in their most 'modernist' works, were 'universalized', so to speak, through the integrationist tendencies of the decorative arts (including interior design and architecture). The intimate relationship between a decorative style of painting which involved the use of symbolism and abstraction, and interior decoration, and the implications of this for the English realist tradition, were referred to by Audley Mackworth in *The Art Journal*. A 'decorative picture', Mackworth explained, was

'arranged not so much for its own sake as to fill a space, and to pro-
duce a harmony of colour with its surroundings'.[38] In stark contrast
with this, only an easel picture, whose 'vocation' was to depict 'men
and women as they lived' and thus be 'truthfully historic', could be 'a
precious thing in itself'. Mackworth insisted on the 'complete diver-
gence' of realist easel pictures from decorative ones in order that the
'essential nature' of each was not destroyed. Any assumption of equal
value was dispelled by the attribution of a moral role which, for
Mackworth, following Ruskin's line, was the proof of the superior
artistic status of the realist easel painting. This carefully understated
attack upon the Symbolist/Aestheticist approach to art made its
point very lucidly: decoration meant Decadence, and it simulated dis-
turbing Continental tastes at odds with English moral gentility.

## The decorative arts, architecture and 'Glasgow Style'

As the nineteenth century drew to a close, the shops in central
Glasgow's bustling Buchanan Street testified to the spending power
existing in the city. There was a considerable demand for modern fur-
nishings, as a glance at Wylie and Lochead's turn of the century
catalogues reveals. Appointed cabinet makers to Queen Victoria, the
firm had furnished the royal suite of reception rooms for the 1888
Exhibition: as well as repeating this for the 1901 Exhibition (at which
displays imported from the Paris Exposition of the previous summer
appeared), they built a pavilion with separate rooms designed in
'Glasgow Style' Art Nouveau by the team of E. A. Taylor (a drawing
room, referred to by Lewis Day as 'designed and furnished on lines so
rigorously vertical as to be in a sense almost elementary'),[39] John
Ednie (dining room as well as a tea-room interior), and George
Logan (bedroom and library). All three had attended the Glasgow
School of Art before being recruited to the firm's furniture depart-
ment. At this time, both Taylor (who joined Wylie and Lochead in
1893) and Logan (who joined in 1882) were instructors in furniture
design at the Glasgow and West of Scotland Technical College.
These room settings were shown the following year in Hungary when
the whole pavilion was transported to Budapest for the British Arts
and Crafts Exhibition. Furniture designed by the trio appeared at the
Turin Decorative Art Exhibition, also in 1902. At the Glasgow Ex-
hibition of 1901 Fedor Shekhtel (the architect whose 'Russian Street'
was on show) saw work by Mackintosh for the first time.[40] Shekhtel
was subsequently to be one of the organizers of an exhibition entitled
*Architecture and Design of the New Style* held in Moscow the following
year at which a small 'white room' by Mackintosh with chairs, a table
and drawn panels in wood and metal (by Margaret Macdonald) was

displayed. In an article published in *The Studio* in 1933, E. A. Taylor (who married Glasgow Stylist Jessie M. King) referred to a volume (*Our Homes and How to Beautify Them*) which appeared in England shortly after 1902. He provided some quotations from this publication (taken from a chapter with the title 'Hooliganism in Art') which illustrated clearly that the acknowledged interactions taking place between the Scottish movement and the Continent were being viewed in the most negative terms in England at the time: the 'dreadful designs' of 'The Scotto-Continental New Art' (a pejorative designation), with their 'washed out contrasts [which] "clang" on the optic nerve', were 'like sweet bells, jangled, harsh, and out of tune ...'[41]

In *Dekorative Kunst*, Hermann Muthesius (whom Taylor called 'Germany's keen-sighted admirer of everything that was original and progressive in architecture'), in observing that a 'whole school' had emerged that was moving in the paths trodden by the Mackintosh group, referred to the 1901 Glasgow Exhibition as the first British exhibition at which completely furnished rooms were presented as examples of the designer's art. It was Muthesius' contention that, although England had been at the centre of art development, since 1896 and the death of Morris, nothing in that country had changed artistically; a total standstill was now visible there, with the same artists producing exactly the same things. What was conspicuous by its absence 'in any kind of London exhibition of applied art',[42] was the final logical consequence of the tectonic developments engendered by the new movement which began where Morris had left off: namely, a complete room, designed as a totality.[43] With regard to this particular achievement, Muthesius placed the new Scottish movement unambiguously alongside the continental avant-garde:

> It is quite remarkable how almost exactly with the year of Morris's death the new movement commenced around England: in Belgium, France, Germany and Scotland. And everywhere there was immediately present the dear goal: to view the room as a whole, to develop it as an artistic unity. In this context, the Scottish movement must be viewed as being totally distinct from the English one, running parallel with the continental movements.[44]

Within Great Britain itself, claimed Muthesius, the 'gravitating point' of the whole country's artistic movement had now shifted from London to Glasgow, even though, artistically, the latter was a totally new city. It was, however, unburdened by artistic tradition. Muthesius viewed both the Glasgow school of painters and the Mackintosh movement as having benefited from the lack of 'any established academy and its unavoidable artistic following'.[45] Where Edinburgh

had been the centre of Scottish artistic developments in painting and architecture throughout the nineteenth century, the new Scottish school of painting brought Glasgow to the fore: the Glasgow school was distinct from both the contemporary English and Edinburgh schools. Within the Glasgow context, however, the movement of painters and the movement of decorative artists represented, Muthesius insisted, two generations of artists who confronted one another 'as estranged if not as enemies'.[46] It appeared that what distinguished the Glasgow Style of the Mackintosh group was its manifest character of a specifically local idiom: a certain relationship was present between the art of this new movement and the 'local spirit of Scotland'. Here Muthesius stressed the form which the tectonic attributes of the Glasgow Style manifested as reflecting indigenous cultural traits (such as were apparent with, for example, Scottish castles no doubt: the south façade and east end of the Glasgow School of Art have been likened to certain medieval and later examples) in which puritanism and romanticism, abstinence and mysticism were combined. Moreover, the Glasgow Style apparent in 1902, with its strictness of line and its 'broad undecorated surfaces', emphasized tectonic rather than ornamental qualities: 'The Glasgow group first became known through the latter and found, at that time, the most opposition.'[47] Muthesius thus felt that he was drawing attention to a transformation that had been effected within the Glasgow Style, the latter having been an essentially decorative style when it originally appeared in the early 1890s.

Just prior to this particular article, Muthesius was writing, also in *Dekorative Kunst*, about the distinctive 'ornamental playing with line'[48] apparent with the Mackintosh group. On this occasion, the attributes of the group's work, as he emphasized them, opposed both traditional concepts of realism in representational art, and traditional ideas of ornament in the applied arts. In posing the question of whether it was appropriate to stylize the human figure 'in order to force it into an ornamental linear scheme as we do with plants', Muthesius reflected that

> We find no parallels for this in the history of ornament; hitherto all ornamental applications have remained true to the basic proportions of the human body....But in art there are no laws, here, what is decisive is the artistic deed ... [49]

Despite his claim, then, about a change of emphasis from the ornamental to the tectonic having taken place within the Glasgow movement, Muthesius was still finding a concern with ornamental attributes to be significant. What are the implications of this? Just how

did the tectonic articulate with the ornamental if it be safely assumed that a concern with functional objectivity did not eschew completely what had been learned within the movement about an experimental (and clearly, from Muthesius' description, highly Art Nouveau) procedure with regard to the whole issue of ornament?

It is clear that turn of the century Glasgow, with its affluent, fashion-conscious middle class, was capable of engendering an artistic market oriented towards European models. By 1909 it had been noted in the Glasgow press that 'The Mackintoshes' had exhibited their work in Vienna, Munich, Turin, Venice, Moscow, 'Buda Pesth', Dresden and Berlin.[50] Indeed, the new concepts of interior design and architecture (which included a concept of the designer as a professional who had transcended craft-based activities) which Muthesius commended in the Scottish movement, can only be fully understood in direct connection with European activities. If a medium is sought for the dissemination of continental ideas in the decorative arts in Scotland, then the most obvious must be *The Studio*. The initial issue (1893) introduced Beardsley to Europe. But the journal's awareness of continental developments ran high. As Philippe Jullian points out,

> ... the magazine was much more conversant than the French reviews with what was happening abroad, so that it obtained considerable international success, and its influence on the decorative arts was enormous. The magazine even gave its name to a new rectilinear style reminiscent of Mackintosh's buildings.[51]

In other words, it revealed the significance of architectural influences in the decorative arts emanating from Scotland.

Within the architectural sphere in Glasgow the contemporary of Mackintosh closest to him in every respect (personally, ideologically, stylistically) was his friend James Salmon (son of the architect William Forrest Salmon who was on the Board of Governors of the Glasgow School of Architecture). The Continental connection is illustrated in Salmon's best works, and not always in predictable ways, in particular the design for the St Vincent Chambers in 142 St Vincent Street, Glasgow's tallest building at the time (commonly nicknamed 'The Hatrack' because of its unorthodox shape). With the variety of form apparent, and the undulating façade, this building (constructed from 1899 to 1902) comes as close as any in Britain to French Art Nouveau, partly because of Salmon's ornamental details and partly because the device of providing the maximum area of glazing becomes a pretext for decorative interpretation. According to Andor Gomme and David Walker in their idiosyncratic book on

Glasgow architecture, contact with the Continent was closer for Salmon than for Mackintosh, and the 'Hatrack' 'gives Salmon if anyone the best right to be called Glasgow's architect of the *Art Nouveau*'. He appears to have set out as a 'self-conscious stylist', conceiving of architecture in highly decorative terms. Yet the exterior of the 'Hatrack' eschews sinuous curves and imitations of natural forms. In asymmetric fashion, no two storeys are quite identical, variety being created by sharply demarcating separate storeys, which, in turn, gives an oscillating, or rippling, effect. Inside, the lift hall has ironwork demonstrating the direct influence of Mackintosh's iron and paint designs: bulb and leaf motifs here, the curved, abstract design of the semi-cylindrical lantern over the front door, and the bulging, almost Horta-like, balconies towards the top, are all classic High Art Nouveau features which derive more from France and Belgium than anywhere else on the Continent. (Gallé, for example, in Nancy, employed plant themes for décor – including carvings, iron work, brackets, cornices – which was intended to cohere with the façade of a building in terms of an overall decorative unity. Because the local council in Nancy demonstrated considerable ineptitude in town planning, for the most part leaving the provision of buildings and roads to private agents, Art Nouveau architecture began to attract attention in the form of *individual* apartment blocks, villas, and houses. In Glasgow, despite municipal policy claimed by the Corporation to benefit 'the whole body of the citizens'[52] rather than individuals, the lack of availability of sizeable portions of land at reasonable prices for redevelopment created the imperative for the highest buildings possible to be accommodated on available individual plots of ground.)

Salmon's design (with John Gaff Gillespie) for the Anderston Savings Bank of 1899–1900 exhibits considerable Art Nouveau decoration and detailing, especially surrounding the doorway, which has sculpture by Albert Hodge (1875–1918), and the whole design is to a considerable extent asymmetrical.[53] Interior alterations carried out in 1900 by Salmon and Gillespie to Nos. 14 and 15 Woodlands Terrace (wooden doors, entrance porches, internal woodwork with inlaid glass), and to Nos. 12–14 University Gardens, provide a telling illustration of work of a highly restricted nature being made available to Art Nouveau architects in Glasgow (Salmon and Gillespie received a commission for the church hall, but not the church, of St Andrews in 681 Alexandra Parade; the latter being given to the conservative James Miller). Often the actual Art Nouveau elements themselves were greatly curtailed: the 23-year-old Salmon's Mercantile Chambers, 39–69 Bothwell Street (1897–8) one of the largest commercial office blocks in Glasgow at the time (seven storeys),

combined sinuous, curvilinear Art Nouveau elements with Victorian pseudo-Renaissance styling.[54] The Salmon and Gillespie British Linen Bank, 816–818 Govan Road (1899), is a rather conventional design (though described at the time as being in 'Modern Movement' manner),[55] but for some Art Nouveau sculpture around the main doorway and an openwork crown on the top of the corner of the roof. Gomme and Walker appear to view such instances as less than wholly successful preludes to the adoption, around 1900, of a fully integrated style, as manifested in Salmon's 'Hatrack'. Certainly, the fact that Salmon and Gillespie were allowed to be responsible for Glasgow's first tall building to utilize a reinforced concrete frame (Lion Chambers, 170–172 Hope Street: designed circa 1905) is significant; but it has to be noted that such instances of complete buildings using modern materials and manifesting a non-historicist style were rare in Glasgow. The turn of the century may well have brought a dramatic change in Salmon's 'attitude' to architecture, as Gomme and Walker claim, but notable opportunities for full-scale creative projects were not always forthcoming. Work carried out by Salmon and Gillespie, such as the remodelling of a Renaissance-style façade at 79 West Regent Street (1903–4), involving little more than the installation of metal-faced bay windows with Art Nouveau motifs in repoussé,[56] illustrates all too well the factor of avant-garde architects requiring significantly more than an 'attitude' to have their most ambitious ideas actualized.

As an avant-gardiste, Mackintosh was concerned, above all, to transcend the fickleness of mere fashion and establish a new Scottish movement. On the architecture front, as Howarth pointed out, the Board of Governors of the Glasgow School of Architecture (housed in the School of Art) were conservative almost to a man: the one exception, William Forrest Salmon, the father of James, being influenced to an extent by Mackintosh's style. The office of Honeyman and Keppie, where Mackintosh was employed (he became a partner in 1901), and where he worked alongside MacNair during the latter's period there (1889 until 1905), had, according to Howarth, its work divided into two quite independent parts: a concrete reflection of the differences of opinion and approach between Mackintosh and his fellow worker Keppie ('in no sense an original mind'). Howarth informs us that, though admired, usually by younger men, as 'a brilliant draughtsman, a prodigious worker, a prolific and talented designer',[57] the deeper implications of Mackintosh's work were not recognized. Indeed, he was considered a bit of a crank, a dreamer, far removed from the world of everyday practice:

> In this manner, whatever influence Mackintosh was able to exert was quickly dissipated. Under such unstable conditions the forma-

tion of a nucleus of enthusiastic, progressive designers similar to, say, the Wagner school in Vienna, was out of the question. From 1906 onwards, Mackintosh himself began to lose faith and to realize that it was impossible, alone, to bring about any fundamental change in the attitude of mind of his contemporaries.[58]

In contrast with this portrayal of the central significance of Mackintosh as a prime motivator, Gerald and Celia Larner, having described Glasgow at the turn of the century as 'ripe for a flowering of the decorative arts',[59] proceed to declare that, even without Mackintosh, Glasgow would have developed into a centre for the decorative arts. This was because 'the talent, the commercial motivation, the visual awareness, the teachers, and the craftsmen were all there'.[60] The Larners say nothing whatever about contemporary architecture in their (albeit short) book on *The Glasgow Style* (the first to be devoted exclusively to the subject), and this creates problems for a proper understanding of the relationship obtaining between the spheres of architecture and the applied arts (and Mackintosh did profess their crucial inter-relationship). More seriously perhaps, this kind of approach, as articulated by the Larners, can say little of relevance in explaining the emergence of an avant-garde in Glasgow which took a particular form: the cultural context is so hypostatized as to dissolve into obscurity any specificity attaching to the avant-garde, and hence to the form-language and ideology which it alone presented. The Larners write of Scotland at the end of the nineteenth century as having created, through artists and designers who would have produced nothing worth preserving had they lived in another place or another period, 'a decorative style distinguished by an emotional fervour associated normally only with painting and sculpture'.[61] Those who were actively involved in this burgeoning of decorative creativity were sustained, not only by Mackintosh's influence, which they undoubtedly absorbed, but additionally, by the actual experience of having been produced by the Glasgow milieu. What analytic meaning can be attached to the term 'Glasgow Style', given this kind of contextual 'stretching', it may well be asked? By 1909 a change of taste had occurred in the city, the Larners claim, and even Mackintosh was rendered powerless in the face of a cultural environment now grown inimical to his work. The proposition of Howarth, namely, that Mackintosh was, by this stage, 'in decline', is rejected. The Larners portray Mackintosh as apparently suddenly adopting the Viennese Secession Style, because he was unable to find a new style of his own with which to satisfy the jaded, fashion-obsessed local middle class. Given that the really significant contact with Vienna took place in 1900, the statement that 'even at this stage [1908] he seemed to be

moving towards the continental secessionist style'[62] cannot avoid seeming ludicrously anachronistic. The whole phenomenon of reciprocal interaction between the Glasgow and Viennese schools (with the results of this interaction correctly periodized) is rendered obscure. When this book first appeared (in 1979) an anonymous reviewer in *The Scotsman* took issue with its depiction of the Glasgow Style as something 'confined to the Kelvinside boudoir'. It was stressed that Glasgow Style was essentially a public art, that 'It literally blossomed at street corners, as Salmon's sinuous interpretation of the city arms still heralds in the otherwise dour reaches of West Regent Street.'[63]

Another short publication on *The Glasgow Style*, this time emanating from the Department of Decorative Art in the Glasgow Art Galleries and Museum, focuses almost exclusively upon craftwork and design. Here the Glasgow Style ('that idiosyncratic variation of Art Nouveau peculiar to Glasgow designers and craft-workers of the late nineteenth and early twentieth century')[64] is defined extremely narrowly and in such a static manner as to eliminate any explanation of modification of the style. The latter issue has crucial implications for the recognition of Glasgow Style as the potential source of a mass-producible style. To elaborate: what this publication correctly acknowledges to be the style as established in the 'formative years of the early 1890s', is subsequently presented as covering the whole period up to the 1920s. In describing the designs produced by Mackintosh, MacNair, the Macdonald sisters, Salmon, Talwin Morris, Jessie Newbery and George Walton, the writers assert that

> the results were invariably striking, if sometimes rather bizarre and clumsy. They shared a vocabulary of stylized, organically inspired motifs – particularly roses, foliage, butterflies and willowy human forms – and employed sinuous curves played off against taut lines.[65]

While adequate as a generalized description of the kind of work produced in the 1890s by an apparently cohesive group of practitioners, this attempt at a definition (which, it should be noted, includes Walton, whose work Gleeson White, in 1897, insisted was devoid of the new and individual qualities which made that of the Mackintosh group so striking) proves embarrassingly deficient where Mackintosh's mature work has to be explained:

> The mature style he developed was quite distinct from that of his contemporaries, but in many ways the Chinese and Cloister Rooms designed in 1911 for Miss Cranston's Tea Rooms can be

regarded as a refined and final statement of the Glasgow Style.[66]

Here stylistic continuity is apprehended, but stylistic 'development', though also acknowledged, is in no sense explained. Consequently, what is concealed is that the later projects actually manifest an enhanced rationalism and stylistic simplification, with unornamented geometric shapes coming to characterize a 'developed' Glasgow Style which points towards the feasibility of its reproduction and standardization via modern manufacturing techniques.

We noted above (pp. 100–2) that Muthesius considered tectonic to have subsumed ornamental attributes within post-1900 Glasgow Style: that is to say that, formally, functional/rational components had become more significant than decorative/expressive ones (an anonymous contributor, possibly Muthesius, commented in *Dekorative Kunst* in 1899 that with the Scottish movement the 'lines do not originate in playful whims but rather in the *purpose of things as it represents itself to artistic personalities*').[67] But how does Glasgow Style architecture articulate with Glasgow Style decorative art in respect of such descriptions? Gomme and Walker attempt to contrast Mackintosh's stylistic approach to architecture, with that to the decorative arts respectively:

> The sinuous curves, the tendrils and cabbagey things that, in Horta's buildings and in some of the interiors of Sullivan's, make decoration seem more important than their basic form – these are virtually unknown in Mackintosh's architecture, though familiar in his interior decoration of existing buildings not his own.[68]

Where Muthesius' ornamental-functional distinction is applied to Glasgow Style in such a way as to permit a periodization grounded in the claim that a preoccupation with the functional followed sequentially from a preoccupation with the ornamental, Gomme and Walker's distinction tries neatly to place functional concerns exclusively within Mackintosh's architectural sphere of activity.

It seems relevant at this point to consider the kind of distinction presented by Kathryn Bloom Hiesinger in her discussion of the *Jugendstil* movement in Munich. Hiesinger argues that this movement was, in actuality, not one, but at least two movements, which were simultaneous, and not, as has often been suggested, sequential. 'One movement was concerned largely with decoration and individual expression, the other with functionalism and rational standards.'[69] The latter was certainly not an exclusively architectural movement: it was led by Richard Riemerschmid, who, according to Joseph Lux, was the first within the movement to 'show a concern for

simplicity and constructional logic'.[70] Constructional logic, it will be remembered, was what Muthesius commended in the later work of the Scottish movement. Significantly, the same Muthesius, shortly afterwards, expressed his admiration for the simplicity and clarity of Riemerschmid:[71] and if Muthesius found local/national Scottish character/spirit to be significant in the context of explaining the Mackintosh work, he found it to be equally as important for the German Riemerschmid ('... here is folk art. It is worthy of this name because it is modest and German').[72]

In point of fact, the epithet 'local' was also used by the critic Ludwig Hevesi in 1905 when describing the geometric purism of the Viennese idiom as practised by Hoffmann and Moser. Hevesi remarked that 'Great autonomous artists like the Mackintosh group in Glasgow ... already occasionally work in this local (that is, Viennese) manner.'[73] Whether the location was Austria, Germany or Scotland, therefore, a simplified, rectilinear, tectonic approach appeared to signify, to commentators such as Muthesius and Hevesi, evidence of a return to indigenous cultural qualities. Muthesius' reference to 'folk art' immediately invokes the image of collective, as against individual, cultural activities. But more than this, the kind of *fin-de-siècle* anxieties in the face of cultural fragmentation which fuelled the Symbolist movement (influenced in this respect by pre-Raphaelitism and the Morris movement), gave rise to a preoccupation with ancient legends and folkloristic traditions as providing access to deeper cultural truths. Nor was this preoccupation, even within Symbolism itself, invariably incompatible with a scientific outlook involving a seeking for logical principles of execution: 'Truth is to be found in a purely cerebral art, in primitive art,' asserted Gauguin. 'Our only salvation lies in a return to principle.'[74] The combining of symbolism and scientificity, mysticism and rationality, instinct and logicality, is precisely what Muthesius found distinctive about the Scottish work. In *Das Englische Haus* he demonstrated that 'a strictly tectonic underlying factor'[75] was common to both the work of the Scottish architects round Mackintosh and the London architects round Voysey (acknowledged by Mackintosh as an influence on his own work), but that

> the essence of the art of the Glasgow group in fact rests in an underlying emotional and poetical quality. It seeks a highly charged artistic atmosphere or more specifically an atmosphere of a mystical, symbolic kind.[76]

On one level this was Muthesius reaching backwards in time beyond the Symbolist movement, and appropriating Ruskin's conception of Scotland's authentic cultural creations as having been, historically,

symbolically representative of the collective experience of the country's people.

As we saw in chapter 3, there can be little doubt that the contact which the Glasgow avant-garde had with Vienna in 1900 had a fundamental impact upon the subsequent nature of Glasgow Style. In respect of this particular contact, there appears a sequential change which affected the form-language: a change that, in turn, enhanced functionality, and not only the functionality of avant-garde architecture. In the period when Hill House was built (1902) for the publisher Walter Blackie at Helensburgh, Mackintosh was employing a simplified rectilinear, geometric/cubic approach to furniture design which facilitated increased sturdiness and utility. Aside from Mackintosh's own work, a reflection of his desired communalizing of the arts with architecture can be found with James Salmon's 'Hatrack' design, where decorative/expressive and rational/functional elements interweave. After a certain point, however, functional lines clearly predominate with Salmon also, as is apparent with Lion Chambers, which, stylistically, is not so far removed from Mackintosh's Art School project.

Even before a recognizably Art Nouveau form-language had been fully adopted in Glasgow, a central concern with tectonic elements is implicit in Mackintosh's recommendation that architecture be the paradigm for all of the arts, expressly because the latter needed to embrace greater practicality (functionality). The extent to which this was achieved in reality was greatly conditioned by the actual nature of the work in question, that is, the extent to which work was oriented towards decorative, or technical, requirements. Certainly, as the 'core' style became increasingly geometric and cubic it moved closer towards the technical sphere and thus enhanced its potential for mass-producibility. The issue of an approach to style which eschews obvious ornamentation is crucially significant in this respect. Muthesius' admiration for the 'ornamental playing with line' apparent with the Glasgow group can be understood as being grounded in the recognition that shape and the 'spaces' which it creates without *added* ornament (what he termed 'superficial elements')[77] can itself embody ornamental qualities. In other words, the ornament is never merely ornament: rather, the 'ornament is always symbolic'.[78] Such a positive commendation for the Mackintosh group for these particular reasons, can best be understood in direct relation to Muthesius' own energetic views, expressed in this same period, on the need for modern mass-produced art of quality.

Juliet Kinchin, in underlining what she takes to be the contrast between the 'folksy quality of much English Arts and Crafts and the

urban flashiness of the Glasgow Style', comments upon the designers Logan, Ednie, and Taylor's 'healthy respect for the mechanical and engineering skills which were inescapable in their city'.[79] Kinchin detects something of this respect in the actual work produced by the Wylie and Lochead team. That is to say, awareness of mechanical techniques can be seen to permeate what is ostensibly decorative art. But this is really to beg the question of what the connection actually is, in more explicit terms, between the elements apparent with Glasgow Style and the potential for a productive application by the latter of 'mechanical and engineering skills'. It is in respect of this that the situation of *Jugendstil* in Munich is relevant to a clearer understanding of the Glasgow movement. In the hands of Riemerschmid and Behrens, a plainer, simplified style emerged which contrasted with the richly decorative approach adopted by such designers as Pankok, Obrist, Endell, and Eckmann. The former style was equally as central to the *Jugendstil* phenomenon as was the latter (Howarth writes of Riemerschmid and others as having 'formulated their own interpretations' of *Jugendstil*).[80] The same could be said of Glasgow Style, where the simplified shapes and tectonically-conceived functionalism apparent after around 1900, developed out of the ornamental/symbolic linear form-language of the early 1890s. Bruno Rauecker, writing in 1911 of the spare functionalism of the Munich movement, noted that 'without doubt, this newly developing style, which has its origins in *Jugendstil* forms, will be of great influence in the creation of an artistic machine production.'[81]

Rauecker's optimism was raised by the apparent movement away from ornamentation towards a genuine recognition by the designer of the need to produce practical artistic goods. (At this particular time, the Wiener Werkstätte, under the influence of the designer Dagobert Peche, was actually decisively shifting its emphasis from functionalism to a renewed preoccupation with ornamentalism.)

Muthesius had argued that mechanization needed to be brought into some kind of relationship with art, insisting that 'in the realm of modern art, the correct inclusion of machine work is the most difficult but at the same time the most far-reaching and most significant.'[82] The spirit of the times, according to Muthesius, was scientificity, and this expressed itself in the 'general development towards the lack of ornamentation, the objective, the simple'.[83] The drift of Muthesius' argumentation leads to the portrayal of Glasgow Style, understood as modern representational practice, as having come to symbolize the ethos of scientific rationality. It had achieved this through a unique combination of indigenous and continental elements. The themes highlighted by Muthesius in his descriptions of the Scottish work set the agenda for the following chapter. His em-

phasizing of the tectonic basis for the form-language of this work focuses attention upon the question of the relationship of (a) a theory regarding the application of architectural principles to *all* objects of design for the scientific addressing of contemporary functional requirements, to (b) an innovative approach to the realization of artistic values. This issue will now be examined within the context of an examination of the ideological orientation of the Mackintosh movement.

Chapter five

# The Scottish ideology

This chapter takes as its starting point an acknowledgement of the need to address the issue of the relationship of what has been inadequately termed 'Glasgow Style' to contemporary eclectic/historicist stylism. It will be demonstrated, in particular with the aid of Mackintosh's extant writings, that the new form-language of Scottish Art Nouveau, as manifested in individual works, was representative of a collective visual ideology. Also, that this visual ideology was *critically opposed* to the conformist eclectic/historicist stylism which already existed. In the earlier section of the chapter we will see that, for Glasgow Art Nouveau, the concept of visual ideology was, in the first instance, fundamentally rooted in an all-embracing theory of architecture and its history. This leads to a discussion of how the attempt was being made to elucidate the nature of the relationship between visual ideology and critical knowledge. It is argued that the new form-language, *as visual ideology*, was perceived by its exponents as providing access to knowledge which was of a scientific nature, but which was yet capable of being experienced through emotionality.

### A Scottish ideology?

In retrospect, Mackintosh must appear as the leading ideologue of the Scottish Art Nouveau movement. What remains of his arguments in written form is incomplete and sometimes less than ideally coherent, but his presentations were considered sufficiently strong to interest a German institution (whether a university is not known) in inviting him to teach in that country.[1] Although there are a number of manifesto-like passages scattered here and there throughout the extant set of notes originally written to be delivered as lectures, a proper appraisal of the thought contained therein is only possible on the basis of a careful process of analysis which can aid in the elucida-

tion of specific themes that are not always exhaustively handled within the confines of a given lecture. Secondly, there is the factor of various theoretical influences being productively applied at different times: social evolutionism in 1893; the avant-gardiste conception of the integration of artistic production with social living in 1902; a modernist (as distinct from a Gothic revivalist) functionalism in 1905. The significance of these influences needs to be highlighted through their being carefully differentiated and examined. This procedure not only aids clarification of what are old, and what new, ideas; more importantly, it illuminates the *purposes* for which Mackintosh appropriates earlier thought, and thus enhances our understanding of the ways in which he employed the ideas of others for his own attempts at problem-solving. I am also concerned to elucidate the similarities between the Scottish and Continental Art Nouveau movements by highlighting specific instances of comparable positions.

Although Howarth found Mackintosh's lecture notes 'rambling, inconclusive and full of familiar clichés'[2] – with the exception of the untitled paper read to a Glasgow literary society – specific elements of a coherent ideological position can be distinguished through a more analytical examination. In fact, the criticisms which Howarth made do not constitute a problem for a 'deconstructive' method which acknowledges that no one individual is ever capable of dominating the language which s/he employs, or, conversely, the meanings which that language elicits in the minds of others. The actual depth of influence which Mackintosh's ideology exerted upon the other members of the Glasgow movement cannot be gauged with real accuracy due to the paucity of written material by the others. However, it is worth bearing in mind Hoffmann's remark about a 'beginning movement *around* Mackintosh',[3] which would indicate the strong likelihood that the others would not have escaped his ideological influence to any significant degree. A Glasgow newspaper from circa 1893 refers to the Macdonald sisters as 'art apart ... remarkably clever girls, who not only hold, but can explain their *theories* ...'[4] James Salmon Jnr, 'Mackintosh's closest friend professionally',[5] was described as having strong views which he expressed fearlessly: 'In fact, he might be ready to call himself a social and municipal Bolshevik and smile all the more if some chuckle-headed people were shocked at the announcement.'[6] And E. A. Taylor, in a lecture delivered around 1904, complained that 'Nothing apparently is further from the thought of modern decorators than that their efforts should, however indirectly, *lead anyone to think*.'[7] Such comments lead directly to a consideration of the meaning of 'ideology' as employed in the following chapter. This is derived from Bürger and can be stated succinctly:

ideology here refers to a coherent body of ideas which are a critical expression of the perceived division between an institutionalized art and architecture and the remainder of society.

An article by Baillie Scott on Voysey's architecture in *The Studio* illustrates to what extent the most 'progressive' elements of English architectural thinking were in accord with the continental critique of eclecticism by 1907. (Significantly, with regard to an article written for *The Studio* by Scott in 1895, Billcliffe comments that 'if Mackintosh had enjoyed the same access to the press as Baillie Scott, he would doubtless have published similar statements'. [8]) Scott considered the modern house (that is, the average villa) to be both practically and rationally 'a tissue of absurdities'. The attempted 'ideal mansion' on a contracted scale, adorned with pseudo-artistic furnishings, was insanitary and comfortless.

> To those who have become inured to such houses it is not strange that a rationally designed dwelling should appear bizarre, affected and eccentric; and though in other arts – in that of literature for example – the merits of direct and simple statement are understood, in architecture we do not recognize the existence of art at all, unless all the obsolete and meaningless features of the past are added, as an outward screen, to a building in which they bear no structural significance ... the inevitable and logical course for the modern architect is to get back to essential facts of structure, and leave the forms to develop naturally from that.[9]

A call to return to 'essential facts of structure'; the importance of functional as well as aesthetic criteria; the appeal to rationality; the subordination of ornament and decoration: these priorities spelled out by Baillie Scott were equally important for Mackintosh.

In the untitled and undated paper on architecture which Mackintosh delivered to a literary society (circa 1905–6 according to Howarth's surmise), structure is dealt with under the heading of 'strength of stability': this is one of the three attributes or 'principles' of architecture that he outlines as being fundamental. The other two are Usefulness (or Utility), and Beauty. Mackintosh's initial starting point in this paper is a definition, derived from Sir George Gilbert Scott, of architecture as uniting abstract beauty with utility. Unlike painting and sculpture, the 'sister arts', which arise directly from purely artistic inspirations alone, architecture arises, first and foremost, from practical necessity and utility, and only secondarily 'from the desire to clothe the result with beauty'.[10] When Goethe called architecture a 'petrified religion', and Madame de Staël 'frozen music', says Mackintosh, they were merely, 'in common with poets

and orators of all times', considering it to be a Fine Art. However, in architecture, art and science are brought together, and this is nowhere more apparent than with the application of sheer physical power. But architecture, Mackintosh is swift to add, is not building, and building, which is a highly diverse practice (churchbuilding, housebuilding, shipbuilding, and coachbuilding are given as examples), 'does not become architecture merely by the stability of what it erects'; it is immaterial whether an edifice stands, floats, or is suspended on iron springs. Ruskin's definition of architecture is cited: not only must the body be served but the mind must be pleased.

Within the context of the Glasgow School of Art, the main argument here can be seen to derive from Alexander McGibbon. In the 1890s, McGibbon, then Director of Architecture at the School, when criticizing Viollet-le-Duc's definition of Gothic, insisted that, if the view that architectural effect resulted from the structure and the practical necessities of the work in question, was accepted as the whole truth, then this would mean that utilitarianism had been the root-principle of Gothic, and hence 'the style would require to be transferred from the province of architecture into that of engineering.'[11] McGibbon's view was that the building, pure and simple, which ministered to physical nature alone, was not architecture, since the latter only resulted when the service of purpose in design coincided with the aim of eliciting 'mental pleasure'. In emphasizing this point, McGibbon cited Ruskin: architecture proposed 'not merely a service to the human frame, but also an effect on the mind'. However, McGibbon ('a rational admirer of Gothic') conceived of Gothic architectural practice as involving a creative process within which both structuration and artistic designing were entwined with each other. On the issue of the ecclesiologists' claim that symbolism was fundamental to Gothic style, McGibbon warned that it was a mistake to see moral maxim and religious dogma in forms which the designer had only intended should please the eye. The intelligent interest in Gothic architecture that Ruskin's writings had evoked in the cultured public was more apparent than real, in McGibbon's opinion, since attention had been directed to what architecture was supposed to teach that Ruskin considered to be of moral value. With regard to Ruskin's argument that Gothic architecture was directly connected with nature, 'as manifested in the human form and in plant life', McGibbon replied that 'architecture proper finds no prototype in physical nature, but is among the most artificial of the arts.'[12] As we shall see, this particular insight, which parts company with Ruskin on Idealist grounds, had crucial implications for the new aesthetics of the Mackintosh movement. On a theoretical level McGibbon could conceive of a modern version of a universal style – the Art Nouveau

ideal – but he did not have an image of such a style. It is revealing that he should have believed that a new style could result from historical/evolutionist 'tendency' alone. In negativizing 'individual caprice' he effectively devalued the role of originality and experimentation in the search for a new universal style, and dissolved away the significance of what was crucial for Mackintosh, namely, the role of the creative imagination. It is, consequently, the factor of a new form-language which establishes the contemporary importance of links between the Glasgow movement and the Continent.

In illustrating the argument against pure utilitarianism, namely that in all ages, with every race and nation, the need for men to create beauty has been fundamental, and, moreover, that this need has, on occasion, preceded even that for the satisfaction of bodily needs, Mackintosh demonstrates the closeness of his theorizing to that of Otto Wagner whom he met on his trip to Vienna in 1900.[13] Indeed, it is as if he has just come from a reading of Wagner's *Moderne Architektur*[14] where the attempt to return architecture to its primary sources is highly apparent. Gottfried Semper, in his *Kleine Schriften*,[15] had employed the theme of architecture as having originated in the simple hut: by 1895 Wagner was claiming that

> The need and necessity for protection against inclement weather and against men and animals was certainly the first cause and the original purpose of building. In building itself lies the germ of every method of construction, whose development advances with purpose. The creation of such work corresponds to the idea of pure utility. But it could not suffice; the sense of beauty dwelling within man called on art and made her the constant companion of building. Thus arose architecture![16]

The first motivation towards construction – the 'primitive cell of architecture' – is rooted in utilitarian needs (usefulness), but what is apparent historically, Wagner asserts, is that the 'independent creation of the beautiful', manifested in the drive towards decorating buildings, is a constant dimension of human experience. Mackintosh thinks this also:

> no race or nation has ever accepted these [exclusive] utilitarian maxims, and hence we may assume, none ever will; the rudest savage ornaments his war club and decorates himself and his hut ... history as we have seen, proves man to be possessed of this sense of beauty.[17]

Mackintosh is a critic of exclusive utilitarianism, since, in his opi-

nion, this orientation has emphasized usefulness to the detriment of attractiveness.[18] Mackintosh provides a concrete, contemporary example – Glasgow's railway companies – and in so doing, emphasizes the role of economic power in effecting large-scale environmental ugliness. It is precisely because these economically motivated agencies possess such power and influence that they are allowed to perpetrate constructions guided by 'principles' which are determined by strict utility alone. The bridges spanning the river Clyde manifest the strident ugliness that is a consequence of this overriding economic utility, an ugliness 'which a poorer shopkeeper would not be allowed to practise'.[19] This, however, should not be understood as a straightforward argument in favour of the ornamentation of such structures, which, Mackintosh stresses, would be better left unadorned. He is aware that 'beauty' in the form of ornamentation can also be 'urged by those who are financially concerned in its production'.[20] Stark ugliness *and* ornamental 'beautification' are thus acknowledged as having common roots in the profit motive.

Mackintosh's critique is aimed directly at the absence of what he calls 'politeness', together with the overt expression of 'selfishness', both of which are integral to the financial priorities of those wealthy individuals and corporate bodies involved in fostering the worst kinds of modern civil engineering. The outcomes of these financial priorities, since the latter eschew considerations of beauty and appearance, go uncorrected by modern architecture. Hence, the problem is not with the manner in which practical requirements of building involve a jettisoning of aesthetic considerations; rather, the problem emanates from those financially motivated agencies who, for economic reasons alone, are sacrificing architecture. In terms of Mackintosh's Ruskin-derived criteria, these are agencies which are directed at making profit through addressing practical requirements alone, while ignoring psychological, emotional, and aesthetic needs. At the close of this particular paper Mackintosh emphasizes the point that the very principles which govern architecture are themselves influenced by 'public' forces that are, to all intents and purposes, external to architecture as such. The mention of literary and art critics, poets, and novelists, illustrates Mackintosh's awareness of the influence such agents can exert in the conditioning and moulding of cultural meanings and responses. The most significant influence over design, however, is exerted by the 'all-potent employer', before whom the architect with his architectural principles is rendered powerless: 'for living to please,' says Mackintosh, speaking for all architects, 'we must also please to live.' This illustrates his awareness of the structural position of architects as cultural workmen within what Bürger terms the 'nexus of institutionalization', or

the sphere of mediation between capitalist society and its art production. For Mackintosh, recognition of the detachment of *authentic architecture* from contemporary social praxis facilitates the distance necessary for radical criticism to be formulated.

In his 1905 paper, then, Mackintosh argues that there are fundamental principles which underlie architecture in all historical periods and that these principles are strength, utility, and beauty: but the actual *practising* of these principles 'must vary with circumstances'. Instrumental in the modern period are institutionally located 'public' forces, the most powerful of which is the financially/economically motivated employer who demands utility alone. When utility is made the exclusive criterion of building, the standard of architecture necessarily suffers as a consequence. By emphasizing the role of active agencies in determining the form that their particular building requirements should take, Mackintosh avoids a hypostatization of architecture. This is apparent with his description of how practicality, growing opulence, and the desire for convenience were the significant factors conditioning the forms of medieval architecture, a description which allows him to develop the argument that conformity to practical requirements need not necessarily lead to ugliness and a compromised architecture. He subsequently turns his attention to the theme of inspiration from nature which he had already addressed in his 1893 paper on architecture. There he had emphasized that 'the servile imitation of nature is the work of small minded men'. Nature could provide inspiration, but the acknowledgement that all architecture was 'the direct expression of the needs and beliefs of man at the time of its creation' was fundamental. Beauty was nothing if not the actualization in marble, colour, or sound, of the *idea* of beauty in the artist's own mind: this idea, though innate, 'has to be developed by intense study'. Not the study of nature, which involves attempts at emulation by imitation – 'nature is not to be copied' – but rather study of 'the *ideal* that can be raised from the positive and the actual into grandeur and beauty'.[21]

By 1905 Mackintosh was claiming that the 'general purpose' required of a building is, effectively, the prime determinant of the form that building will take, that is, function *precedes* form. The imperatives underlying architecture are thus seen to be human-centred in the specific sense of springing from social praxis combining with human ingenuity, and involving (to borrow Simmel's terms) calculation and spatial structuration:[22]

from the Basilica all our cathedrals sprung and the form of the cross was always kept for the plan, but beyond that arbitrary rule it was growing opulence alone which influenced the medieval

architecture, not nature, as has been absurdly believed. The pointed arch grew out of the semi-circular, nearly invariably to suit convenience, rarely aesthetic wants, and *never* to imitate a forest avenue; nor was the idea of painted windows ever taken from the sun gleams among the branches. Yet this, with a vast amount of other absurd rigmarole, is believed by many indiscriminating admirers of nature, who, unable to deduce a principle, would attempt a childish mimicry.[23]

Nature, then, like Beauty, is, first and foremost, rooted in ideas which people have inside their heads, and which are facilitated by economic and cultural 'developments'. Given that Mackintosh acknowledged this, there appears little reason to emphasize, as does Frank Walker, a 'fundamental semantic conflict in Mackintosh's art and design [that] is vested in the counter claims of Nature and Geometry',[24] since this is to make the mistake which Mackintosh lampoons: to view nature as a purely external influence, and, further, to juxtapose this to geometry as a fundamentally and exclusively human creation in the sense of being 'inner'. Actually, both nature *and* geometry are 'inner' for Mackintosh (hence the central significance for him of the idealist notion of *inspiration* within an aestheticist ambience): nature has to be given articulation via the *ideal* realm of human imagination, which latter emerges out of socio-cultural experience, including the experience of specifically human needs.

Mackintosh's use of the expression 'to deduce a principle' illustrates clearly that his real concern is with grounding theoretically the logical and cognitive basis of architecture; and with the premise that this basis can only be apprehended intellectually, imaginatively, and actively (hence the emphasis upon practical purpose). What distinguishes 'good architecture' from 'mere building' is the ability of the former to facilitate decoration: but decoration which grows *out of* a rational understanding of a building's practical necessity. As he asserted in his Ruskin paper,

> the [chief] virtues of Architecture [according to Ruskin] are defined to be strength or good construction and beauty or good decoration. That is not altogether the way to put it for *there may be architectural beauty with little or nothing of what is usually called decoration.*[25]

That Mackintosh could practise what he preached was made clear by Sir John Stirling Maxwell, who, at the opening of the completed Glasgow School of Art – the best example of Mackintosh's attempts to actualize his ideological principles – in December 1909, emphasized

that Mackintosh

> had shown that it was possible to have a good building without
> plastering it over with the traditional, expensive and often ugly or-
> nament ... Mr. Mackintosh had the real faculty of being able to
> adapt a building for the purpose for which it was really intended.
> The Glasgow School of Art was a conspicuous success of that
> kind.[26]

It is not surprising that elements of Scottish vernacular architecture
(albeit heavily modernized and thoroughly integrated) should be ap-
parent in the Art School design. Even in 1891 Mackintosh had
acknowledged the 'extraordinary facility of our style in decorating,
constructing and in converting structural and useful features into ele-
ments of beauty'.[27] The indigenous architecture of Scotland, because
of the manner in which it overtly manifested purpose, appeared to be
pointing the way to a functionalism capable of avoiding ugliness. But
although structure and utility are taken to represent the fundamen-
tals of this paradigm of good architecture, it should be noted that
Mackintosh did not jettison the role of decoration. In 1905 he was
still arguing that, historically, buildings which derived from recogniz-
able practical purposes gave rise to the best architecture:

> These cathedrals again were coincident with powerful fortresses
> and castles with whose appearance everyone is familiar, and also
> with commercial warehouses, colleges and many other forms of
> buildings such as the manors and barns of the low counties of Eng-
> land, among the most picturesque buildings extant; all these
> buildings were erected for particular purposes, and which particu-
> lar purpose was in every case served, and yet redeemed from the
> selfishness of mere building by good architecture ... in all these dif-
> ferent cases the architecture, while always preserving a certain
> continuity and similarity, was the decoration of the different prac-
> tical requirements – that is to say, no beholder would mistake the
> general purpose of a building.[28]

This emphasis upon general purpose was a trait which Berta Zucker-
kandl found was essential to Hoffmann's architectural principles in
the same period. In a substantial article in *Dekorative Kunst* publish-
ed in 1904, she wrote:

> His artistry grows from his ethical and social views ... after a
> struggle he has reached the conviction that a style can be shaped
> only by the recognition of the psychic and physical needs of a time,

by translating this recognition into forms that are logically shaped and that *stress the purpose as clearly and strongly as possible*.[29]

A letter written by Olbrich to Hoffmann in 1894, from Benevento in Italy, further illustrates the affinities between the concerns of Mackintosh and the Viennese architects, more particularly as regards seeking the essential role of the functional in vernacular architecture. 'The old ruins teach us mainly three things,' wrote Olbrich, 'that the architects built them out of a sense of beauty, fantasy, and taste; and to this they added a decisive sense of the practical and functional.'[30]

Mackintosh is critical of attempts to 'beautify' buildings: if truthfulness to the necessities of a building is what conditions the form taken by ornamentation, which is to say in effect that a symbiotic relationship should exist between practical purpose and architectural decoration, then any attempt to 'shuffle around' decorative styles which have become abstracted from the architecture which originally gave rise to them, and to apply these in an arbitrary manner, is to be deplored:

> I do not say that these [historical architectural] varieties could be equally beautiful, by no means, but the incumbent duty of making the best of each case and still preserving truthfulness to the necessities of the building was admitted and surely with happier results, than that of these modern antiquarian sentimentalists, who, getting the half truth firmly embedded in their unpractical minds, that the Greek Temple and Medieval Cathedral are worthy of all admiration and imitation, further it by erecting marvellous villas which only by an unfortunate chimney can be decided not to be a place of pagan worship, or, as in some cases I know of, monastic cloisters.[31]

Mackintosh's intense interest in medieval architecture is apparent with the large number of drawings in his 1891 sketchbook from the 'grand tour' of Italy and northern Europe, where several renderings of Italian medieval architecture are presented. This may well contrast with Hoffmann's lack of interest in such architecture, a factor which, as Eduard Sekler has commented, illustrates Hoffmann's characteristically Central European training. However, it is significant that for Hoffmann, as with Mackintosh, his trip to Italy in 1896 'provided him with the possibility for a general rethinking of the very significance of "architecture"'.[32] Hoffmann became interested between 1890 and 1900 in Oriental and late Roman models, but as Sekler points out, 'for Hoffmann the monumental architecture of the Renaissance

and the Baroque played a very small role as a potential model for eclectic reuse, and ... the Middle Ages were strongly neglected.'[33] However, Mackintosh's interest in historical architecture had little to do with its potential for 'eclectic reuse'. Rather the concern was with elucidating the principle that design should be *appropriate* to construction. Historical examples could be used to substantiate this. In his lecture on *Elizabethan Architecture* he claimed to discover such appropriateness in buildings of that period: 'there was in Elizabethan buildings a care for architectural effect, the construction was generally sound and truthful, and there was an appropriateness in design which rarely fails to please.'[34] The concept of 'truth' in architecture, in being applied to the evaluation of Siena Cathedral, allowed Mackintosh to speak of the lack of coherence between exterior and interior as a 'fraud'. The exterior represents a fraud because the actual purpose of the building is not being made plain: this in turn undermines the design, which, as a result, lacks recognizable coherence. Architectural adornment was always out of place 'where its application prevented the reasonable purpose of the building being manifested'.[35] To a significant degree 'purpose' is conceptualized by Mackintosh in terms of space and how it is organized. How space is actually deployed conditions the relationship between interior and exterior of a structure, and the harmony or discord in this relationship significantly engenders evaluation of 'truth': but 'truth' as a criterion of whether the qualities inherent in specific materials are correctly utilized is a central element here also.

The issue of materials occupies an important position in the literary society paper, where Mackintosh reveals that his interest in historical varieties of architecture is indeed deeply connected to his conviction about the central role of utility in conditioning the nature of construction and adornment comprising compositional form. The materials of construction, the nationality of the builders, different climates, the nature of the buildings produced, all of these, Mackintosh acknowledges, manifest great diversity. Even where the practice of Roman Catholic Christianity required similarity of ritual in different countries, such as Italy, France, and England, it was the factors of climate and available building materials in these countries which determined how the standardized requirements would be worked out. This provides illustration, not only of the primary role of utility in architecture, but also of the dignity, beauty, and variety which result from the application of correct utilitarian principles:

> you will see that utility which must in common sense be studied (and will be no matter what the artistic fraternity says) is not inimical to architecture but on the contrary gives variety and

character....We have thus examples to show how dignified and beautiful a building may be when exactly fulfilling a utilitarian purpose as the ancient temples of the Greeks did, with side walls unbroken by a single window ... surely no one will say that the cathedrals of Northern Europe are anything less than perfection in their own degree. Yet the principles which governed both were identical – the practising of which principles must vary with circumstances – but may always be resolved into the three we are considering namely: strength – utility – beauty ... [36]

The fact that these principles, notwithstanding the diversity of forms that they give rise to within various sets of circumstances (geographical, national, social, climatic, etc.), always remain the same, is something, claims Mackintosh, that is demonstrated by human history. The history of architecture is almost as old as mankind itself, and, consequently, 'there is hardly any form that is applicable for construction that has not been tried.' A house, basically, is composed of walls and a roof: the latter necessitates either the dome, the pitched roof, or the flat roof. Walls necessitate windows and doors, openings that can only be spanned by the lintel or the arch: if the latter, 'there is no form which has not been used – semi-circular, pointed, horseshoe and ogee'. Given the universal limitations, physical and psychological, of human beings, only a finite number of characteristics of architecture are possible. But at the same time, architecture, as one of the oldest cultural forms, is actively modified through various transformations that are always rooted in specific social configurations. Thus Mackintosh addresses the dialectical relationship between the universal and the singular, the general and the particular, by way of a theory which attempts to unite the abstract with the empirical.

In 1905 John Belcher ARA, President of the Council of the Royal Institute of British Architects, proclaimed that, like both music and poetry, architecture 'was subjective in its appeal; for the same arrangement of lines and colours would suggest 50 different things to 50 different persons'.[37] This kind of view represented a problem for Scottish Art Nouveau. A new architecture, emerging within a conservative, traditionalist, and often hostile socio-cultural environment, could not but suffer as a consequence of such subjectivist evaluative diversity. A new architecture needed support if it was not to be destroyed by such a context, and, for Mackintosh, such support required appraisals that were rooted in an intelligent understanding of what was being proffered. Since architecture was as much science as art, a scientific knowledge of its underlying principles offered the

potential for enhanced objectivity. Thus architecture needed to be differentiated from its 'sister arts' and its own unique characteristics specified. Analogies such as that employed by Belcher had to be shown to be spurious. But the relationship between new work and the spectator raised the very issue of questioning what was involved in such a relationship in the first instance. This led Mackintosh to consider debates in the eighteenth century surrounding the attempt to develop a theory of aesthetic experience which had centred on the nature of the cultural and psychological processes involved in perceiving and understanding external objects.

Mackintosh's proffered definition of 'Taste', far from portraying the judgement of taste in terms of such polarities as disinterested delight or aversion, delivers a description which attributes taste to cognitive factors and to the perceiver's active recognition of essential features in the object, which latter, moreover, is to be *evaluated* on the basis of knowledge. Mackintosh's concern with underlying principles allows him, within the confines of his theory, to have a clear notion of what architecture, the 'commune of the arts', is actually doing, so that this, in turn, facilitates the addressing of the question of whether it is doing it well or badly. Hence architecture is assessed in terms of its portrayal or actualization of correct concepts designated as principles. But if criteria of validity are being established for the evaluation of architecture, Mackintosh is also aware of the relative nature of evaluations of beauty, and 'beauty' is one of the three fundamental principles of architecture. A distinction between architecture and other art forms is made by Mackintosh on the basis of specific criteria:

> [Beauty is] by far the most difficult [architectural principle] to deal with as there are erroneous ideas regarding it to be removed and true and reasonable ones to be substituted. Yet there is no final standard of taste to which all may appeal, no code of laws to which every little detail may be submitted – no authoritative committee of taste to decide on the disputed points, for even the most learned in these matters diverge widely in their ideas of the beautiful. Many, because of the disagreement among professors – *which, however, is more upon matters of practice rather than principle*.[38]

Thus the strong implication is made that focusing on 'principle' can provide the way out of the *impasse* resulting from a conglomeration of divergent opinions. Mackintosh then introduces a distinction between 'taste' which involves relative and arbitrary subjective evaluations that eschew consideration of objectively established

criteria, and 'Taste' that evaluates through the application of criteria of validity which, through cognition, assess the successful/unsuccessful application of correct principles:

> Many foolish persons discredit the existence of any other way of deciding than their own personal taste; you say a design is bad, they say it is good; well, there is no more to be said, simply, they like it. They mischievously take the proverb 'There is no disputing about taste', which only applies to the palate or other senses, quite different from Taste which is another word for *sound and cultivated sense, judgement and perception of fitness ...* [39]

The latter definition here is related to, and dependent upon, a theory of the nature of art and the aesthetic which acknowledges that art objects embody some kind of truth-content. Or, stated differently, they contain, or should contain, actualizations of correct cognitive ideas (visual knowledge in the form of symbols and insignia) that can be perceived and judged. On one level, this theory, as Mackintosh employs it, and, in particular, applies it to architecture, is attempting to establish the precise functions of architecture in order to facilitate the assessment of whether different architectural constructions actually reproduce the requirements so conceptualized. It is important to emphasize this at this point because Mackintosh will later introduce the term 'expression', and what he means by that term cannot be adequately understood without a consideration of the manner in which he stresses the act of perception, and how, in that act, prior knowledge is brought to bear on the object. In making the distinction between 'taste' and 'Taste', Mackintosh is clearly invoking Humean categories, that is, there is a differentiating between the senses ('the palate and other senses') and ideas (the notion of 'association of ideas' as Hume presented it is employed). Hume's attempt to employ reason in the endeavour to go beyond beauty as something 'felt' (emotion) and to fix an objective standard,[40] is mirrored in Mackintosh's movement from emotion to reason, whereby the two become synthesized. Thus the ideal that should guide all artists is 'Reason *informed by* emotion, expressed in beauty, elevated by earnestness, lightened by humour'.[41] By uniting reason with emotion he can address the phenomenon of modern architecture – an authentic modern architecture where art and science in combination engender a new style – and at the same time outline an aesthetics commensurate with it.

The endeavour to analyse why certain antique forms of architecture can be 'universally approved', as Chambers had argued in his *Treatise on Civil Architecture* (first edition 1759), led Mackintosh to

attempt an elucidation of the 'principles' held to underlie these forms. But the import of the recognition of the relative nature of individuals' aesthetic responses, and the attempt to transcend this situation, lie at the heart of Mackintosh's pursuit of a subject–object epistemology to administer to a conception of architecture as art as well as science, and, for this reason, capable of embracing both the creative imagination and the understanding. What motivates this strategy is the concern, not only that architecture be correctly understood, but that the employment of reason should not lead to the destruction of spontaneity and experimentation. Conversely, knowledge can inhibit an excess of imagination, the latter manifested, for example, with the desire for novelty: 'variety and novelty if not carried too far, are qualities both allowable and desirable, but by ignorance often clamoured for most unreasonably.'[42] Ignorance, that is, lack of knowledge, therefore, presents a real problem:

> I can but bring you, as wise men, some FACTS regarding the PRIN-CIPLES which are considered essential to architecture, and submit them for your criticism, in all modesty admitting that in matters of taste when I say a thing is so and so, I only mean that I THINK it is so and so.[43]

Bearing in mind that these are lecture notes, taste here should really be emphasized in order that the import of the statement is not lost: knowledge of facts and principles would facilitate 'judgement and perception of fitness'. It is noteworthy that what is *not* being said is 'I *believe* it is so and so', or 'I *feel* it is so and so'. The index of FACTS–PRINCIPLES–THOUGHT is *knowledge*, and, for Mackintosh, only knowledge of architecture and its inherent principles can provide liberation from arbitrary subjective taste.

In his lecture on *Seemliness* (1902) Mackintosh strongly emphasized the need for future architects and craftsmen to adopt an intellectual approach to their *specifically artistically conditioned* work: 'the craftsman of the future must be an artist, not what they too often are just now, artistic failures, men and women not *intellectually fit* to be architects, painters or sculptors.'[44] In 1893 he had stressed that 'architecture ... interpenetrates building not for the satisfaction of the simpler needs of the body but the *complex ones of the intellect*.'[45] By 1905, his position is that knowledge of architecture is not to be limited to specialists: knowledge of the 'elementary rules' governing 'true' architecture is deemed necessary in order that people can become critical in relation to the architecture constituting the social environment which surrounds them.[46] Architecture and the applied

arts in modern society, then, are to be understood as involving a fundamentally intellectual endeavour: but, to repeat, this is an intellectuality which has, 'ideally', to unite reason with emotion, so as to equip itself for the transformation of a realm split between forces engendered by a ruthless utilitarianism on the one hand, and a complacent and defensive Aestheticism on the other. A meaningful utilitarianism must be united with a concern for beauty in order that the foundations of a new approach to aesthetics can be laid. Rigorous science and free creative imagination have to be brought together in confronting modern problems and needs. Thus 'the Architect must become an art worker' who has to *synthesize* and *integrate* with his conscious knowledge 'myriads of details and circumstances of which he cannot be directly conscious'.[47] With this invoking of what are ostensibly contents of the unconscious, Mackintosh attempts to provide an offensive to the position that would emphasize exclusively knowledge as that which is derived from social learning and social institutions, and which would have no way of addressing products of insight and imagination that it could not reduce to this formulation. As he had underlined in *Seemliness*, the appreciation of what is required of a modern art worker has to be personal and individual 'and expressed without resorting to the remote accessories which mark the feeble mind that thinks it follows, but as a fact only abuses, all precedent, all tradition, all custom'. The critical motivations of the architect–art worker are ideologically grounded and they generate the kind of convictions and ideals which lead him/her to forgo the 'questionable distinction' of being respected as the founder, or head, of a large and successful business (these remarks would appear to substantiate Muthesius' claim that Mackintosh wanted nothing to do with a 'school' of followers). A kind of imposed asceticism is demanded along with a workmanlike assiduity: but the comments about eschewing the questionable distinction of being successful in business give the impression of an attempt to preempt criticism of the artistic way of life viewed as part-and-parcel of the new architect's role, an aspect of that role which many contemporaries would have viewed as undermining the discipline and strictness deemed necessary for a career in a 'respectable' profession. (See p. 185.)

The necessity of an intellectual approach to art is consistently stressed by Mackintosh: 'It is by advocating this and insisting upon it that all the applied arts will once again take their proper and dignified place in the world of artistic production.'[48] Above all, an intellectual approach is required for the realization of the potentialities offered by adherence to the principles uniting utility with beauty. The views on the issue of beautiful utensils for everyday use, expressed in a letter to Hoffmann, (see p. 25) are echoed in

*Seemliness* which dates from the same year:

> it is only then [that is, when future craftsmen are intellectually fit
> and have become artists] that the possible utility and beauty of
> every article of everyday use and personal adornment will be real-
> ized, will be designed thoughtfully to suit its every purpose, will be
> designed beautifully to please artist and owner alike.[49]

But the pleasure being derived by both artist and owner is grounded
in an enlightened acknowledgement of the degrees of success at-
tained in uniting utility with beauty. Mackintosh wants to extend
such enlightenment to all: 'I only want each individual to know or
seek to know when the requirements of a thing are fulfilled, and
when presented in beautiful form, without violating the elements of
usefulness on the one hand and appropriate beauty on the other.'[50]
He calls into question the 'clichés' about the 'bad taste' of the public,
their lack of appreciation and want of thought, and focuses his criti-
cism upon 'the majority of presumably highly educated artists and
designers'. These are considered the main offenders, whose products
are lacking in style, character, and substance, and whose artistic work
is thin, light, artificial, and revealing of no 'personality'. As we shall
see, the significance of this for Mackintosh lies with such work lack-
ing *expressive* qualities.

It is the *individuality* of the modern art worker that is to be the
emancipatory medium whereby the stultifying accretions of the past
are thrown off. But, additionally, it is individuality that is to lead to
*true art* and *true architecture*. This staunch individualism is easily
apparent as an outcome of the non-conformist stance adopted in re-
lation to orthodox social–institutional and academic attitudes.
Significantly, what is being acknowledged also, is that the emancipa-
tion of the individual art worker signifies, at one and the same time,
the emancipation of all art workers:

> The focus of the true art of our country of the world is being grad-
> ually but surely accepted, and that focus will eventually prove to
> be the work of the individual worker, will prove to be the emanci-
> pation of all artists from the stupid forms of education which
> stifles the *intellect*, paralyzes the *ambition*, and kills *emotion*.[51]

These three categories: intellect, emotion, ambition (or conviction),
have a seminal significance for the new aesthetics, and their effective
synthesis is fundamental to that end. The use of the phrase 'our
country of the world' immediately places Scotland within an interna-
tional context: the relationship between the 'individual worker' and

this context is all-important. It is the creative originality of the individual worker which legitimizes the employment of sources of inspiration from further afield. Only creative originality can synthesize these sources into something embodying 'individuality and revolutionary motive'; and such a synthesis does not represent mere imitation. This is the essence of the consistent emphasis upon individuality. Individuality and free creative imagination do not require to imitate: invention, not imitation, is the spring of true art. As Georges Baltus, who joined the staff of the Glasgow School of Art from the Academy of Fine Arts in Brussels, expressed this notion in a lecture on *Art and Social Aesthetics* in the School in 1906, 'if imitation were the highest summit of art, then the arts might be called sciences.'[52] It is precisely because Mackintosh acknowledges the dialectical interplay between the science *and* the art of architecture that imitation is rejected.

The ambitious, intellectual modern art worker, illuminated by principles, whose intellect is informed by emotion, and whose actions are commensurate with the social developments surrounding him, is a recurrent image with Mackintosh. Emotion and 'intelligent understanding' are brought together by way of 'scientific knowledge of the possibilities and beauties of material'.[53] Not only does this formulation encapsulate the essential modern movement credo of truth to materials, it is, in addition, pointing firmly in the direction of the modernist position which recognizes that work springs from the intellect rather than from the emotions. As Henry Lenning pointed out, 'the intellectual as opposed to the emotional approach to the problems of production' is what distinguishes the early Art Nouveau of practitioners such as van de Velde from the preceding Arts and Crafts movement.[54] Mackintosh returns to the issue of materials when insisting that it is only when attitudes are changed

> that artists will thoroughly understand and appreciate the possible application and beauty of each material he is called upon to handle; that all the varied problems and materials the world has to offer will be understood and thoroughly valued because of the artistic possibilities that is in them.[55]

It is knowledge of modern requirements (buildings, objects, within 'new forms and conditions of life') which operates to unite emotion with intellect and both with ambition/aspiration/conviction. Time and again Mackintosh invokes this most fundamental synthesis:

> The only modern individual art ... is produced by an *emotion*, produced by a frank and *intelligent understanding* ...

129

It is delightful to see *thought and feeling and aspiration* dressed in the bright raiment of present day art ...

I am sure that no one of any gifts of *reasoning* will question the value of a high ideal – a strong *ambitious conviction* ...

All good work is thoughtful and suggestive – carefully *reasoned* – and characterized no less by wide *knowledge* than by closeness of observation and *instinctive* appropriateness ...

A fearless application of *emotion* and *knowledge*, a cultured *intelligence* and a mind artistic yet not too indolent to attempt the solution of these problems that have not before arisen.[56]

Clearly, the desire is to transcend accumulated knowledge that is the result of (institutionalized) forms of education and which is always limited by its relationship to the past and thus not adequate to the issues of modern requirements and the analysis of contemporary complexity (of which the plethora of eclectic architectural 'styles' is a manifestation). Moreover, this accumulated knowledge, by its very nature, engenders conventional modes of expression (the latter a key concept for Mackintosh). Mackintosh can just as easily refer to the 'indefinable side of art' and the intangible qualities that are 'excited by ambition and instinct' as to the 'wide knowledge' so necessary for good and 'true' work. His concern is equally as much with what he called the 'etherial' (sic) as with the technical. Regardless of whether the emphasis at any given time is upon the intellect, or upon metaphysical insights, the underlying thrust is the preoccupation with escaping (a) sensual aestheticism (the Aesthetic movement contained a violently anti-utilitarian strain with the ideal of works of art totally without purpose), and (b) moribund academicism. Hence the debunking asides about the 'artistic fraternity' who are portrayed as opposing the necessary study of utility. The motivation behind such study (as with Otto Wagner) was quite clearly the need to understand better how perception of purpose could, in itself, elicit aesthetic responses. The significance of the appeal to 'instinctual' and 'inborn' propensities lies with the conviction that these cannot be reduced to the outcomes of institutionalized social learning. If, therefore, Mackintosh's work is 'intended to embody *aesthetic* values',[57] then our understanding of his intentions must acknowledge that these values are decidedly not those of the Aesthetic movement which bespoke luxurious sophistication. It is a new kind of aesthetic response that Mackintosh wants to engender. Nor does the rationalism, functionalism and utilitarianism of his arguments relate unproblematically to neo-Gothicism and Arts and Crafts ideologies respectively. Because architecture is an art the scientific knowledge necessary for its actualization must also embrace the faculty of a free creative imagination.

Only this synthesis is capable of creating new technically realizable forms free from tradition and intractable authority. To 'look upon all the arts going hand in hand as one'[58] is to envisage architecture as art in that functional and practical requirements need not necessitate the eschewal of inventive imagination and a sense of beauty. Nor need the latter attributes be either anti-modern or anti-democratic. There is more to Mackintosh's ideology than a Gothic revivalist functionalism (apropos Macleod), but the picture of Mackintosh as a modernist (apropos Howarth) has to be made conditional on the basis of recognizing that the concerns with (a) beauty, imagination, and inventiveness; and (b) the creation of new *forms*, are turn of the century Art Nouveau preoccupations. The decline of three-dimensional realism fostered the search for new *forms* such as two-dimensional decorativism with pattern predominating over perspective and the exploration of the potentialities of abstraction and a 'linear language'. Vanguard art practice after the 1880s demonstrated a scientifically informed awareness of the potential in experimental techniques for new forms of representation. In Art Nouveau architecture there is apparent the decoration of prior fundamental structures (explicitly recommended by Mackintosh), detail merging into mass (the 'hot breath of Art Nouveau' effect described by Gomme and Walker when examining Mackintosh's *Glasgow Herald* building tower of 1893), the manipulation of structure to create tension, for example, with asymmetry. In the Glasgow School of Art design the main entrance is asymmetrically positioned: also, the south elevation has seven 'sections' within each of which symmetry is imposed: but when viewed as a whole, these sections can be seen to comprise a totality manifesting the asymmetry of an Art Nouveau conception. As an instance of Bürger's description of the avant-gardiste work presenting its constituent elements as having relative autonomy within a whole which is effectively constituted through the contradictory relationship of heterogeneous elements, the Art School design is especially noteworthy. But Mackintosh employed an asymmetrical manner of composition for Windyhill (1899) and Hill House (1902) also.[59]

It is apparent that Scottish Art Nouveau was exploring the 'new kind of mentality' (Schorske) – with thought and feeling permeating each other – which was the preoccupation of the Viennese Secessionists also. 'The questions of an artist's knowledge, his learning,' Mackintosh declares, 'must inevitably *merge into* that of his perceptions, his visions, his divinations.'[60] But it is clear from this particular assertion that emotion is not to impair the sharpness of vision required by the modern architect. Carl Schorske's description of the driving force behind this new psychological and philosophical

outlook as being the avant-garde ideal of an integrated life of art and living, could scarcely apply more to Mackintosh. It is a vision underpinned by a new philosophy of design and its social– psychological role, of an integrated life that is most concretely detailed with the description of beautiful design for every object of everyday use:

> I want to speak on the possible improvement in the design of *everything*, on the possible improvement in the education and work of architects and craftsmen as artists. To insist on some artistic intention being evident in the making or adornment of each article for everyday use or requirement, an appeal for a discriminating thoughtfulness in the selection of appropriate shape – *design for everything no matter how trivial*.[61]

Here is the conviction that even apparently trivial everyday objects, if produced in a beautiful *form*, can attain the significance they deserve as elements within a coherent twentieth-century environment. Such thinking is extremely consonant with the *Deutsche Werkbund* and its 'cult of the everyday object', particularly as it was analysed in journals such as *L'Esprit Nouveau* and the annual yearbooks of the *Werkbund* published between 1912 and 1915. Significantly, Hermann Muthesius was a regular contributor to these, along with Gropius, Behrens, and Riemerschmid. As Gillian Naylor has pointed out, the 'recognition of a need to establish a rational order and clearly defined standards in architecture and design was ... inherent in *Werkbund* thinking prior to World War 1.'[62] The more radical members of the *Werkbund*, with their admiration for Greek architecture and its stressed values of clarity, order, logic, and discipline, operated with a theory of architecture commensurate in its essentials with that outlined by Mackintosh. Concepts of structure, space, harmony, were portrayed as being eternal and capable of being expressed through the application of predetermined orders. In the employment of these orders ornament *emerged*, and this ornament was, in itself, logical, and, consequently, justifiable.

The fact that such a theory of architecture joins hands with a view of design being applied to the objects produced by, and for, modern living, may well owe a great deal to Muthesius' intense admiration for Mackintosh as an exponent of what Muthesius took to be modern movement principles. At any rate, what is distinctive about Mackintosh's ideology is the way in which it fuses a new philosophy of design with an analysis of the actual social and psychological purposes of design and architecture: this particular fusion preparing the way for the ideals and doctrines of the modern movement. It is likely that Muthesius would himself have influenced Mackintosh, in particular, in the

respect of thinking through the implications of standardization for design. Muthesius was in no doubt about standardization of goods being necessary, and, moreover, that this would in no way endanger the quality of potential design. The notion of a beautified living environment, with beauty signifying meaning, clearly went beyond an individual such as Mackintosh in Glasgow at the end of the nineteenth century. An item in a Glasgow newspaper of 1897 illustrates that such thinking was unambiguously attributed to the Art School and its sphere of influence:

> If a thing of beauty be a joy for ever, why not make our houses, our furniture, and everything about us as beautiful as considerations of propriety and utility will admit? There is no valid reason why we should not, and that to an extent that a people ignorant of the grandly simple elements of art have no idea of. Beauty of form in an article of daily use is surely preferable to unmeaning ugliness, and it need not cost a bit more ... the education afforded at the School of Art is largely calculated to stimulate towards better things and educate the eye of the artizan class amongst us ... [63]

## The concept of truth and the specificity of architecture

Architecture, Mackintosh avers in 1905, exists coextensively with civilized people. Architecture comprises the social environment. Sculpture and painting, by contrast, do not occupy such a cultural space and 'must generally be sought for' in art galleries, museums, homes, etc. But pictorial and decorative art serve quite contrasted functions, and for this reason primarily any description of truthfulness that is to be applied to them respectively must be fundamentally conditioned by this criterion of function. Importantly, this has decisive implications for the consideration of historicism and eclecticism in architecture, both of which negate truth as a primary quality. In modern architecture, the use of historical styles as a mode of adornment is, for Mackintosh, the worst kind of 'conservatism' and some of his most vitriolic language is reserved for the depiction of the practice: ' this conservatism is often made a cloak and excuse for mediocrity in design and the senseless and unceasing repetition of features which have only their age to recommend them.'[64] Historicism *as adornment* is now being opposed on the grounds that it can conveniently serve to conceal poor design, that is, it perpetrates a fraud. However, this is merely one aspect of Mackintosh's critique of historicism. More specifically, the arbitrary use of historical styles in a modern period is itself taken as an illustration of the moribund nature of most modern architecture: work which demonstrably lacks

'the sustained note of informing purpose'.[65]

Hoffmann also demanded a consideration of 'purpose' in conjunction with material and 'absolutely honest thinking' in his 'manifestolike, programmatic' (Sekler) text which he wrote to accompany the publication of a number of 'ideal' furniture designs in *Das Interieur* in 1901. In that text the prevailing tendency of reverting to historicizing, eclectic imitation of form is denounced in the context of an argumentation which deploys similar elements to those of Mackintosh in the lectures. Hoffmann declares that 'Purpose alone is the source of the motifs. Main support [is] absolute honesty and simplicity in conception and execution.'[66] To some extent these similarities between the ideas of the two men can be attributed to the mutual influence upon them of Ruskin. *The Seven Lamps of Architecture* appeared in a German edition (translated by W. Schoelermann) in 1900. Says Sekler, 'Volumes of the German edition of Ruskin's works still remain in Josef Hoffmann's library and many of his programmatic pronouncements have a strongly Ruskinian flavour.'[67]

To Mackintosh, historicized architecture, an architecture that is not authentic to its own period, is at the same time a debased architecture which is attempting to conceal the fact that the real problem of a lack of a modern style is being created by agencies external to architecture which are actively involved in promulgating what is in effect a travesty of architecture. This travesty, hopelessly lacking in the essential faculty of invention, is capable, given the absence of historical awareness of the authentic architecture of past epochs, of being accepted as 'contemporary architecture'. The authors of this work without distinctive style, from the years recently passed, are thoroughly implicated in this deplorable situation: they neither recognized the limitations of art, nor apprehended its distinctions: lacking in inventiveness and unable to compose new images, they have produced work of a wearisome artificiality. In the literary society lecture, Mackintosh renders more explicit some of the most fundamental of these distinctions and limitations of art: more specifically those of painting and sculpture. This is mainly in order to demonstrate clearly what are the problems peculiar to the architect. A young, struggling painter, he states, can embody his conception if he is but capable of acquiring paint and canvas, 'and when the work is finished he submits it to the public patronage and if looked at impartially it stands or falls on its own self-evident merits'. Basically, the situation for a sculptor is much the same. For the architect, however, the position is a radically different one. The drawings which the architect submits necessarily convey an extremely poor idea of what the finished reality will actually be. Indeed they provide 'far less shadow of resemblance to the reality, than that possessed by the scribbles in

an academy catalogue'. That finished reality will involve, for the perceiver, experience of a physical and spatial entity that alters with every step taken. Thus what the architect is required to provide initially, is 'a prophetic view of a non-existing structure', and, for this, practical artistic skill as such is required to a very limited degree. The precise nature of the concept of space being utilized in this context of avant-gardiste utopianism is noteworthy: it is of space as something fluid which fuses in ever-changing ways. This is in marked contrast to the kind of thinking which joins, in a static manner, finite, simply defined spatial units. Mackintosh's admiration for the Gothic revival and for Gothic architecture of the High Middle Ages again reveals its significance for his avant-garde theory of architecture. Gothic had achieved a great deal in terms of the utilization of space and light within its unique structuring, that is, buttresses, pillars, arches and suchlike, which facilitated an 'opening out' of spatial areas. Students connected with the architectural classes of the Glasgow School of Art regularly visited Melrose Abbey during the 1890s[68] where elements that were significant for Scottish Art Nouveau could be analysed, such as ornament based upon natural forms, geometric tracery, perpendicular lines, an enhanced sense of space (facilitated by the amount of wall area given over to windows: possible only because of the style of 'flying-buttress' construction). Melrose also provided the opportunity to wallow in the sense of romance which Scott's historical fiction had cast around this abbey which he himself cherished.

Towards the close of his literary society lecture, Mackintosh returns to the themes which had occupied him in 1891 (*Scottish Baronial Architecture*), and 1893 (*Untitled paper on Architecture*), respectively: namely the concept of a 'national' architecture, and the theme of the historical evolution of architecture. It is important to recognize at the outset that Mackintosh is looking to a 'national' architecture for a solution to the problem of eclectic historicism. In essence the view is that this latter phenomenon has succeeded in falsifying Scotland's cultural heritage insofar as this heritage is capable potentially of being conveyed by architecture: 'The history of nations is written in stone, but it certainly would be a difficult task to read a history from the architecture of this nation at the present time.'[69] The progressive evolution of architecture has been severely curtailed due to the obsession with historical styles and this has been a function of modern cosmopolitanism. The breaking down of national barriers has engendered greater awareness of the architecture of other nations, but this fragmentary awareness has impeded the necessary understanding for Scots of the historical development of their own architecture:

We do not build as the ancients did who in each succeeding build-
ing tried to carry to further perfection the national type. No, we
are a world-acquainted people who cast aside all prejudices and
build now in Greek if we love the classic, now in Norman if we
dote on the romantic, or if we have travelled show them [our] ill-
reputed admiration for foreign beauties by reproducing Swiss
chateaux etc., etc., in the most inappropriate positions.[70]

Architecture, reasons Mackintosh, is like language, where new words
and phrases are gradually introduced over a period of time. Eclecti-
cism as cosmopolitanism will therefore involve the introduction of
elements that are culturally inauthentic in the specific sense that they
cannot initially be meaningfully accommodated to the manifesta-
tions of the indigenous culture, since the latter have only attained the
form they have over a greatly extended period of time. Hence the
conviction that 'we should be a little less cosmopolitan and rather
more national in our architecture.'[71] It is not too difficult to perceive
in this Mackintosh's experience of the significance for the arts and
architecture of Glasgow's dependence upon world markets: a de-
pendence facilitating world culture in its widest sense as a resource
for growing eclecticism. Additionally, there would be the factor of
the apparent 'throw away' character of capitalism's products, includ-
ing its architecture, nowhere more apparent than with the buildings
erected for the International Exhibitions of 1888 and 1901 (Geddes
made an unsuccessful plea for the retention of James Miller's build-
ings subsequent to the closing of the 1901 event). The lack of
permanence engendered by buildings intended to last for a limited
period, and with limited function. The functional imperatives of
Scottish capitalism were acknowledged by Mackintosh as being
threatening to real architecture, and Newbery bitterly referred to the
'chimney stalks, hideous structures, and railway girder bridges
[which] were all concomitants of our choked civilisation' and which
'had as much to do with art as they had to do with the Stock
Exchange'.[72]

**An Art Nouveau semiotics**

Although Mackintosh draws the analogy with language on a number
of occasions, this does not mean that architecture is understood as
conveying knowledge that is in some sense linguistic. He is acknow-
ledging the uniqueness of visual thinking which conceptual thought
rooted in language and discourse would be inadequate to address or
elucidate. Moreover, he seems to be implying that modern architec-
ture should break with the ideological forms which architecture has,

in the past, been implicated in. To argue that 'a temple should aim at sublimity, a villa at domesticity, a Palace of Justice at dignity and so forth' (what he terms the 'phonetic' argument) is, he insists, not to recognize that 'it is generally only association of ideas which has given these attributes any standing.'[73] Chambers had used 'dignity' as one of his examples of the type of concept which results from reasoning and hence the association of ideas. But if such ideas do not emanate from the architecture itself, which is to say that they are effectively being imposed on it, what is the nature of the knowledge which architecture should, ideally, convey? For Mackintosh architecture can only really be signative and symbolic: as such it 'expresses' certain principles, and, of these, the most important, arguably, will be that of structure: 'the want of appearance of stability is fatal':[74] 'perceiving differences of style in buildings both in their ornament and general construction they acknowledge the existence of some ruling principles although ignorant of their nature':[75] ignorant of their nature because, although the principles are being expressed, the full apprehension of their real nature requires the spectator to bring the relevant knowledge to bear. Here Mackintosh appropriates Reynolds' argument that it is signs incorporated into works of art which, in being understood, elicit responses towards the objects, which are subsequently apprehended as 'beautiful' on the basis of the social meanings encapsulated within the insignia. As with paintings of Apollo with his lyre, Bacchus with his Thirsus and vine leaves, or Meleager with the Boar's Head (so runs Reynolds' argument) we need to have an *idea* of who Bacchus, Apollo and Meleager are before we can properly understand the content of the pictures. No response is possible without this prior understanding. Thus the lyre, thirsus, vine leaves and boar's head act as signs which, to use modern language, combine cognitive with expressive ideas. Interpreting these ideas requires prior knowledge, but in Reynolds' example this knowledge is commensurate with the actual cognitive/expressive content of the pictorial images. Here Mackintosh attempts to go beyond Reynolds' position. By contrast with the situation where knowledge in the spectator's mind is in accord with the knowledge embodied as form–content, sublimity, domesticity, or dignity, being ideological constructs applied in an ahistorical manner, are extra-artistic. In this sense, Mackintosh views them as being superfluous to true architecture, alien to both the scientific and artistic aspects of it. The understanding and evaluation of architecture requires knowledge that markedly contrasts with this: knowledge of what is contained within, or which underpins, the architecture *as architecture* in question. Thus Mackintosh opposes 'purpose' as a revolutionary approach to architecture, illuminated by the logical principles of the latter, to

'purpose' as the expression of inherently non-artistic/architectural ideology:

> The expression which is plainly observable in the different styles has led to the establishment by some critics of a distinct element in Beauty, namely that a building should be *phonetic*, that is, explain its *purpose* or illustrate history....I think that a building cannot really be phonetic, merely expressive.[76]

In the context of this particular argument, 'purpose' is specifically not meant as 'useful function'. It is 'Purpose' defined in terms of language, discourse, and social ideology that is being rejected as superfluous to architecture. For the latter to 'express' it must be understood as having a form and content; and for that form–content to be apprehended knowledge is required. But it is a very specific knowledge that is needed: it is, to put it succinctly, knowledge of the principles that are being given direct expression through architectural creation.

It is instructive to consider on this point, some illuminating comments made by Hoffmann in a lecture from 1911 on the subject of expression in architecture as Art Nouveau practitioners had attempted to realize it. Speaking of the period in which the Vienna Secession was launched, Hoffmann reflected that

> It is characteristic of this era that almost all artists from Wagner to Van de Velde saw the exact fulfilment of construction as the only right thing but that the *expression*, that is, *the formal fulfilment of this idea* was tried in incredibly varied ways.[77]

In this context, we may be justified in interpreting Mackintosh's invoking of 'expression' as an example of his concern with the 'formal fulfilment' of the concept of construction. In point of fact, P. Morton Shand pointed out in 1933 that, in terms of post-war architectural criticism, it was Mackintosh's 'architectural–constructional work' that was considered most significant. Furthermore, if there appears to be a significant affinity between Mackintosh and the Continental avant-garde with respect to 'expression' at the turn of the century, then the same can be claimed also for the significance of the *sign*, which, as we have seen, led Mackintosh backwards in time to the eighteenth century when there emerged 'a systematic aesthetics as a philosophical discipline and a new concept of autonomous art'.[78] Giuliano Gresleri describes Hoffmann's contribution to the development of modern architecture as

a body of work that belongs to a climate of general precariousness, one in which the values of the *sign*, of materials, and of surfaces are investigated with a scientific and irreverent curiosity altogether unknown to the Modern Movement.[79]

This climate of general precariousness was, as we shall see, a potent motivating force behind the attempts to elucidate the significance of 'national' architecture, and here too Mackintosh was in line with continental events. More specifically, both he and Hoffmann manifested a similar type of preoccupation with this particular issue.

Mackintosh, with the aid of the same Reynolds argument, had already investigated the values of the sign and the significance of expression in his 1893 lecture. There he had attempted to make a distinction between the contrasted modes of thought that were involved historically in the creation of architectural forms. Some of these modes, he had claimed, were unconscious and instinctive – 'desires' oriented towards the realization of aesthetic qualities such as symmetry, smoothness, sublimity, and suchlike. Symmetry was explicitly referred to by Chambers as owing its power to the ideas that are connected with it. For Mackintosh, symmetry and sublimity are specifically aesthetic qualities, hence his rejection of a religious-based meaning for the latter (temple: sublimity). But what is most noteworthy is the attempt to transcend Chambers' position by introducing a quasi-Freudian formulation (actually purloined from Lethaby) which posits symmetry, sublimity, etc., as realizations of unconscious desire. Importantly, this view allows for forms of thought which are in some sense autonomous, in that they are not unproblematically the result of social traditions

Other modes of thought, Mackintosh explains, were 'direct and didactic, speaking by a more or less perfect realisation, or through a code of symbols accompanied by traditions which explained them'.[80] In terms of these conscious modes, Mackintosh wishes to establish a distinction at this point between linguistic and non-linguistic thought. However, the 'perfect realization' of which the former is potentially capable, is not to be equated with superior powers of intelligibility in all spheres of cultural meaning. This is illustrated by Mackintosh's assertion that it is symbols (in the sense of non-linguistic ideas) which need to be understood and appreciated before the true meaning of art and architecture in a given period can be interpreted and evaluated.[81] In a passage which synthesizes the arguments of Reynolds and Ruskin, he demonstrates that he was deeply concerned with the issue of cultural production as a purveyor of meanings, and with the nature of the involvement between the spectator's subjectivity and the cognitive content of the architecture

which s/he confronts. Significantly, it is being argued that art forms such as sculpture and painting can potentially convey greater intelligibility with regard to cultural meanings than can written or spoken language. A building may be denounced or eulogized on the basis of the spectator's own prejudiced loves or hates. The *space* between buildings and spectators can therefore comprise endlessly proliferating meanings: meanings without any final closure and which are not grounded in a stable point of origin. Mackintosh's conviction that this state-of-affairs can be transcended lies with a subject–object epistemology: only by seeking out and reconstructing meanings that are/were contemporaneous with specific cultural productions can we place ourselves in a suitable position from which we can apply the knowledge that will move us beyond confusing emotionality and arbitrary proliferating meanings. The attempt is to be as rigorous and as comprehensive as possible in taking into account the sites of meaning production most significant for architects at a given moment in history. Nietzsche's comment about the necessity of symbolism in the future conquering the 'entire compass of the inner life' for an *immediate* language of feeling to be possible is brought to mind (see p. 11). Thus 'until we are certain that we understand *every symbol* and are capable of being touched by *every association*' we cannot legitimately, or productively, employ the criterion of expression in evaluating architecture. It becomes apparent therefore, that, for Mackintosh, the evaluation of expression is understood as involving a highly cognitive and culturally informed relationship between architecture (as object) and spectator/subject: but this must *encompass* feeling in order for the necessary aesthetic responses to be possible; expression, after all, involves far more than indication. Where the architectural object is concerned the relationship *between* the general and the particular is of cardinal importance. The concern to maximize the correct apprehension of symbols and associations is undoubtedly rooted in the acknowledgement that the more properties which are presented by objects, the more those objects transcend the limitations imposed upon them by the values and distinctions conveyed through the symbol systems themselves. That is to say, objects take on more 'real' properties through the process of their becoming apprehended as empirical instances of the general cultural type described by the symbol system.[82]

With both Ruskin and Muthesius we find meaning being inextricably linked to 'objective reality', more specifically, the objective reality of social living which is believed to find meaningful expression through authentic forms of vernacular architecture. The problem arising out of the misunderstanding of meanings apprehended as embodied in architecture was referred to by Muthesius in a brief

discussion of house-building in Scotland. The 'outer dress' of buildings in outlying areas around Edinburgh, Muthesius asserted, remained 'strongly reminiscent of the superficiality of the stylistic historicism of the nineteenth century'.

> Men saw the 'picturesque' but did not grasp the *meaning* of the features which they felt to be picturesque. They mistook them for *objective reality* and the result was the characteristic quality of all stylistic imitation: meaninglessness, superfluity and falsity.[83]

Ruskin, when eulogizing 'those misty and massive piles which rise above the domestic roofs of our ancient cities', proclaimed that 'there was – there may be again – a meaning more profound and true than any that fancy so commonly has attached to them.'[84]

In an article in the *Magazine of Art* in 1885, G. F. Watts, the Symbolist painter, described how 'Perceptions and emotions are shut up within the human soul, sleeping and unconscious, till the poet or the artist awakens them.'[85] Mackintosh appropriates the Symbolists' notion of the unconscious as the domain of emotionality: Scottish Art Nouveau, as with the Continental Secessionists, was indeed searching for what Schorske calls 'new instinctual truth'.[86] However, an important distinction needs to be made with regard to this point. When Hoffmann wrote to Kokoscha, 'you know that intelligence and excessive knowledge kill the cultural impulse ... only the right sensitivity and the inborn feeling count,'[87] he presented as exclusive polarities the very phenomena which Mackintosh, following Geddes, wanted to reconcile. For Scottish Art Nouveau, the subject–object epistemology is trying to *encompass* 'sensitivity and inborn feeling'. Fundamentally, Mackintosh's architectural theory shows him following the Scottish Hegelian line that 'in the intelligence, as the subject–object, there lies an adequate principle for the interpretation of nature and history.'[88] The theoretical model of the spectator/subject is extended by Mackintosh to encompass intelligence, emotionality, desire, and imagination. The scientific aim of knowledge is to be combined with the aesthetic aim of pleasure or satisfaction. The traditional, entrenched, dichotomy between knowing and feeling, the cognitive and the emotive, gives way to the acknowledgement that scientific and aesthetic experience alike are fundamentally cognitive.

If this is an accurate description of the relationship between object and spectator which Mackintosh requires with regard to his own architecture, then how are we to regard Frank Walker's assertion that 'Tension, conflict, the ever-present possibility of alternative interpretation: these are the hallmarks of Mackintosh's architecture,

and it may be that his frustrated and broken creative life testifies to this same achievement in a sadly parallel disintegrative way'?[89] The grammar and the meaning, the syntax and the semantics, for Walker afford their alternative interpretations. Now it is true to say that in the act of perceiving an object, the 'boundaries' of meaning enclosing the object can be dissolved: the object can then elicit other meanings which often interact with those within the boundaries in quite tenuous ways. Which is to say that 'the ever-present possibility of alternative interpretation' is, in effect, a function of the 'space' between object and spectator. But as we have seen, this arbitrary 'association of ideas' is precisely what Mackintosh was addressing himself to so as to ground a more 'objective' alternative. The capacity of a work of art or architecture to express meaning was, for Mackintosh the theoretician at any rate, dependent upon underlying principles and logical formal structures that were common to all such works. Thus the syntax and the semantics were to be mutually complementary. Walker also argues that the Scottish movement manifests a dialectical tension between the practical and the mystical, the functional and the symbolic. The mystical and symbolic are here related to characteristics of the Symbolist and Aesthetic movements, such as were manifested, for example, in Wilde's fairy tales or Rossetti's mystical romances:

> While the English had become increasingly rational and utilitarian, arguing the case for a kind of crafted Functionalism, the Scots – every bit as receptive to the writings of Ruskin, Morris and Lethaby – were, nonetheless, still in thrall to the 'fairy-tale world' of Romanticism.[90]

It is necessary, however, to make a distinction between (expressive) symbols and 'symbolism': we have seen that Mackintosh meant something quite specific by his employment of the former category: symbol, or sign, systems, and the characters within those systems, were the means whereby works were interpreted. Such interpretation required that subtle relationships be discerned within and between works and their environmental context. 'Symbolism' does not necessarily follow from this usage, and not only because 'symbolism' was often used in Mackintosh's period to refer, explicitly or not, to the ideas propounded by the Symbolist movement in literature and art. A further complication arises with Mackintosh's appropriation of sections from Lethaby's *Architecture, Mysticism and Myth* for his 1893 lecture, because Lethaby propounded in that work a theory of symbolism in which ancient architecture was described as embodying and expressing ideas about the magical properties believed to be inherent

in the world structure. In 1902, when Mackintosh refers to 'symbolism' it is to argue that the will towards symbolism must give way to the superiority of the 'creative imagination'. He insists that, despite possessing an extremely rich psychic organization, an easy grasp and a clear eye for essentials, an extensive variety of aptitudes, an artist's 'vocation' is determined most of all by 'the exceptional development of the imaginative faculties', a development, it should be stressed, which embodies all of these prior attributes and abilities: 'The power which the artist possesses of representing objects to himself explains the hallucinating character of his work – the poetry which pervades them – and their tendency towards symbolism – But the creative imagination is far more important.'[91] This distinction between symbolism and creative imagination is crucial: the new aesthetics is grounded in the transcendence of the former by the latter for the purpose of a higher synthesis. Moreover, because the aesthetic attitude and the aesthetic experience which surrounds it are dynamic, restless and searching ('shake off the props ... tradition and authority offer you – go alone – crawl – stumble – stagger – but go alone')[92] they involve not so much attitude as action: the motto of Geddes' Summer School, *Vivendo Discimus*, 'By Living We Learn', and Geddes' recommendation that the artist alternate creation/study with participation in life, here reveal their relevance for Mackintosh. For him this is action directed beyond symbolism, and thus beyond emotionality and a concern with reality as something always transcending the actual, towards the creation of the new: 'must you not after long study of the beautiful that is and has been, seize upon new and airy combinations of a beauty that is to be'.[93] Hence 'study', which necessarily involves cognition, given the correct attitudes and activities, can engender art forms capable of eliciting aesthetic experience in which the emotions function cognitively. But for this to be at all possible, expressive symbols still have to be properly 'understood': beyond symbolism can never mean beyond symbols. Symbol systems are essential to the creative imagination and to the understanding of its new productions. But these latter are to be judged by how well they serve the cognitive purpose: functionality, utility, pleasure, are all dependent upon this. The aim of architecture is enlightenment (Mackintosh substituted the word 'true' for Lethaby's 'esoteric' in 1893 when discussing structure and form in world architecture). The employment of the creative imagination beyond immediate need is for the sake of understanding: the formulation and apprehension of what is to be communicated. Judgement of the products of creative imagination rests upon how well these serve the cognitive purpose (for example, through the consideration of stability, simplicity, coherence, subtlety, precision; the aptness of allusions), how they participate in the constitution,

manipulation and transformation of knowledge. Here lies the real significance of newness: to impart true knowledge in creations which reveal that their moribund forerunners purveyed falsehood. To link modern architecture with the true architecture of the past by reaching beyond the pseudo-architectural travesties of the present and recent past.

### Architecture, social evolutionism and the renovation of 'Scottish peculiarities'[94]

Macleod has argued that Mackintosh appears to appropriate Lethaby's notion of 'purpose' in ancient (sacred) architecture (that is, that belief in magical properties deeply influenced the development of ancient building customs); but that because, in contrast to Lethaby, he 'did not accept that the gulf between ancient arts and the present was impassable', the modern *'purpose* to which he referred was still one of symbolism and magic – albeit a magic of light rather than darkness'.[95] Now because Mackintosh did not accept the gulf between the ancient and modern as Lethaby described that gulf, why should it be assumed that Mackintosh believed the *modern* 'purpose' of architecture to be essentially the same as the ancient one? Lethaby acknowledged that 'At the inner heart of ancient building were wonder, worship, magic and symbolism; the motive of ours must be human service, intelligible structure, and verifiable science.'[96] The modern motive, as described here by Lethaby in the 1920s in notably rationalist terms, well summarizes Mackintosh's own position! In point of fact, it is the concept of social evolution, nowhere referred to by Macleod in his analysis of the 1893 lecture, which leads Mackintosh to argue that 'purpose', as something expressed through the architecture of ancient societies, was equally as necessary for modern societies, but that 'purpose' had to be now quite different because social needs and beliefs have of necessity changed. If recognition of the central importance of *meaning* in architecture leads Mackintosh to bestow upon the importance of meaning for human beings an historical continuity, it *cannot follow* that meaning itself remains the same through evolutionary history. Mackintosh accepted Lethaby's view of modern motives in architecture, but he employed Geddesian social evolutionism in his attempt to breach Lethaby's gap between ancient and modern. Social evolutionism and a philosophy of history which teaches that time is both homogeneous and void are employed by Mackintosh in opposing the neutralization of standards wreaked by a historicism which fossilizes history and portrays it as an inert continuum. The modern images of Scottish Art Nouveau are made possible through a 'fashioning' creativity which detects 'correspond-

ences' (to employ Benjamin's term) between the authenticity achieved with the genuinely new, and those images from socio-cultural pasts that are capable of being appropriated for new functions in the present. In this sense it is the creator of the new who is the enemy of *both* the imitator of classical models *and* the paralysing understanding of history which results from this imitation.

In 1905, Hugo von Hofmannsthal, in attempting to characterize his epoch in its entirety, averred that 'the essence of our epoch is ambiguity and uncertainty. It can only rest on that which is gliding and it is aware of the fact that gliding is what other generations believed firm.'[97] In citing this statement in the context of a discussion of Hoffmann and the Palais Stoclet, Sekler makes the point that 'In the face of such uncertainty one of the few points of departure that supposedly remained firm beyond dispute was a return to the roots of a nationally oriented tradition.'[98] Given that aspects of this are apparent in Mackintosh's arguments in favour of a more 'national' cast to Scotland's architecture, we need to ask how this related in his ideology to the acknowledged needs and problems of a modern massified, industrialized society.

Running through the 1893 Glasgow Institute lecture on architecture is the theme of the evolution of architecture, and this is clearly illuminated by a reading of Herbert Spencer, a central theorist for Geddes. In 1891 Mackintosh's discussion of Scotland's 'national' architectural heritage had been limited to an analysis, with concrete exemplification, of the elements comprising what he argued was a coherent style indigenous to Scotland. There was no explicit view of evolution as such. By 1893 the argument is considerably more abstract and theoretical. He now acknowledges that the subject of architecture can only be 'rightly handled' by one having the 'equipment of a wide scholarship'. But having stated this, he subsequently makes it clear that his own credentials should not be in doubt: regular apprenticeship and long practice in any art or craft being capable of engendering 'a certain instinct of insight not possessed by mere outsiders though never so learned'. It is not too difficult to see that the desire is to *combine* 'scholarship' with 'insight'. Mackintosh cites Spencer in order to establish the premise that languages and usages are not devised, but that they evolve. This provides the basis for an evolutionary theory of architecture:

> Behind every style of architecture there is an earlier style in which the germ of every form is to be found, except such alterations as may be traced to new conditions or directly innovatory thought in religion, all is slow change of growth and it is almost impossible to

point to the time of the invention of any custom or feature.[99]

Almost, but not quite impossible, apparently: by recognizing and distinguishing what is contemporaneous, and what points to a precedent in an architectural form, the evolutionary process can, it appears, be pinned down. Early examples of stone construction, so it has been pointed out, continue to repeat the forms of the manner of buildings constructed in wood which preceded them – 'and so it is always'. Thus a picture of a chain of precedents which can be constructed with the aid of abstraction is invoked so that the primary precedent can be elucidated. In doing this in the way that he does, Mackintosh employs a distinction which was fundamental to Art Nouveau in the 1890s: 'If we trace the artistic forms of things made by man to their origin we find a direct inspiration from (if not a direct imitation of) nature.' The juxtaposing of 'imitation' with 'inspiration', extolling the latter and negativizing the former, was a central tenet of avant-gardiste ideology. As Sekler makes clear,

> it obviously is important to understand the vast difference in meaning that for architects of this period [the eighteen-nineties] separated 'imitating' from 'being inspired by' something. While with the avant-garde imitation was entirely despised because of the lack of creative originality it implied, seeking inspiration from various sources seemed permissible.[100]

Here Mackintosh presents the phenomenon of taking inspiration from nature as a vital element in the human make-up which has been seen to exist since the origins of the artistic forms which objectified it. Since social evolutionism is being applied to the elucidation of the history of architecture, it follows that architecture is a function of social evolution, that is, social and ideological developments condition architectural change:

> architecture changed or rather evolved because the religious and social needs and beliefs changed ... the changes of architecture were only the expression and embodiment of the natural unconscious evolution of man's thoughts caused by the changes of civilization and things around him.... All great and living architecture has been the direct expression of the needs and beliefs of man at the time of its creation, and how if we would have great architecture created this should still be so.[101]

The message is clear: a modern architecture of quality must be the expression of modern needs and beliefs.

Greek temples, says Mackintosh in his own words in 1893, had
dignity *as temples* when they were built, but they must surely lose all
of their dignity when they are imported into Britain thousands of
years later and set up for a variety of contemporary purposes. Some
people, however, dispute the loss of dignity even in modern applica-
tions. So what does dignity consist in? 'Dignity in architecture is the
same as natural dignity – the very frankness of some natures is the es-
sence of all that's dignified – which frankness if copied by one not
naturally frank immediately becomes impudence not dignity.'[102] Dig-
nity in architecture, then, is essentially a quality of frankness, that is,
of *honesty.* But one historical period's honesty is another's dishon-
esty because 'all great and living architecture has been the direct
expression of the needs and beliefs of man *at the time of its cre-
ation.*'[103] So if architecture ideally is fundamentally expressing
contemporary needs and beliefs before it is doing anything else, then
what we call architectural 'style' must be a result of this. That is to
say, the architecture is made purposely, the style is not. To focus ex-
clusively on contrasting styles *qua* styles is to misunderstand the
substantive processes of socio-historical evolution which give rise to
them: 'What are called architectural styles were not made purposely
as many people imagine – some say I like gothic – some I like classic
– but you cannot surely believe that architecture changed from classic
to gothic because the old architects were sick of classic.'[104] The eclec-
ticism of style which Mackintosh deplores in the architecture he sees
around him, signifies for him the lack of a *genuine* architectural style
that is recognizably of its time. The apparent variety – the result of
the absurd idea that it is the duty of the modern architect to make be-
lieve he is living hundreds, or even thousands, of years ago – is viewed
as existing without a single original architectural idea. The closeness
of the thinking within this element of the Scottish ideology to that of
Gropius when he founded the Bauhaus, and Richard Riemerschmid
who 'made an important contribution to *Werkbund* theory' is note-
worthy.[105] Riemerschmid asserted that 'Life, not art, creates style',
that 'it is not made, it grows', and that 'every epoch creates its own
style':[106] an argument, in short, which duplicates that which Mackin-
tosh was presenting in 1893. Such assertions as are made within this
particular theme have to be founded upon historical assumptions
which, in turn, invoke a primary theoretical overview of architectural
history.

In his lecture on *Elizabethan Architecture* from the early 1890s,
Mackintosh attempted to illustrate how a too sudden development
from one architectural form to another – an apparent development,
that is, which signified the negation of the processes of social evol-
ution which are themselves instrumental in the conditioning of form

– could result in the production of a defective architecture. 'The Elizabethan was a fusion between the new and the old in architecture,' Mackintosh argued, referring to the admixture which distinguishes it, of classical details with general forms of a gothic character,

> and in this [fused] character has not been sufficiently considered, a neglect due to a great extent to the rude execution of much of the detail, and more particularly to the badness of the representations of the human figure. These defects were the effect of a development too sudden for the available number of competent workmen to execute. Hence the grand ideas and the bad workmanship.[107]

What this brief exposition illustrates, is that, within the evolution of societies, the actual division and deployment of labour forces represents a crucial element in generating qualitative cultural changes. Indeed it is the efforts made by the work forces – and here Mackintosh refers to masons, plasterers, and carpenters working together in comradeship 'with much striving in the dark and half realization of good intentions' – which generate development at the concrete level of socially organized activity. This can be seen with the apparently contradictory instances of diverse quality, even within a recognizable, given style. Consequently it is problematic to attempt to deal with form in an analytically static manner:

> it is not easy to define with precision, the forms of so-called Elizabethan Architecture. For we may find in one example, a roughness and vulgarity of execution, almost deserving the title of barbarous, while in other buildings of the same style, we can detect evidences of a purity of taste together with a beauty of detail, almost equal to many examples of good Italian work.[108]

Here was not only evidence of skill and aptitude, but also of the desire for creative experimentation.

Two basic orientations become apparent within Mackintosh's ideological schema: as regards the first of these, the central concern appears to be with quality in architecture. To this end, architectural creations are identified as truly such, as the embodiments or depositories of a quality believed to be objectively discernible. Authenticity follows from this, in the sense that authenticity is a matter of quality being traceable to its source in particular architectural examples in history ('We mean to stand to architecture in its widest sense – we plant our feet in traditional tracts, we will not relinquish one item of the time honoured programme of our art as practised in days of

old').[109] This demonstrates that the priority placed upon authentication is methodologically inseparable from the value accorded to creativity. Hence the need to transmit a set of 'principles' of authentication alongside a corpus of authenticated work, which latter is, moreover, intended to illustrate those principles. The analysis and celebration of authentic architecture is viewed as being potentially civilizing in itself, and as a means to safeguard and to perpetuate those value systems which are the yardsticks of civilization. Alongside this view of transcendental 'quality' Mackintosh presents a second orientation: the significance of historical changes which affect the values and meanings of architecture relative to other social practices. It is here that the acknowledgement of architectural *function* is productively applied to social evolutionism in such a way as to provide a theory of how architecture functions within specific sociohistorical formations – formations which are constantly in a state of flux, of continuous change. Given this analytic context of sociohistorical formations, it becomes apparent that 'authentic' architecture is only so, relative to a given period, since it cannot be extruded without loss of real identity and significance. Social needs within historical epoch and individual country condition actual architectural 'styles', that is, recognizable distinctive forms of execution and expression. Thus, notwithstanding the claim that the actual principles always remain the same with architecture of quality, 'each style has an expression peculiar to itself – an expression which would only be weakened by the introduction of any other.'[110] This meant that a modern style could not attempt to unite elements of other styles within itself: if each style has an 'expression peculiar to itself' then a modern style must have this also. If, for example, with the Glasgow School of Art, Mackintosh did not view himself as uniting other styles in an example of modern style, then the expression involved here would have to be considered by him to be an expression of architectural principles addressing modern social requirements and manifesting the technical knowledge and creative flair of a contemporary architect in tune with modern artistic developments *and for this reason* producing a modern style with an expression peculiar to itself. Thus, contemporary work, when honestly addressing the realities of its time, is capable of subsuming the values of the past: what Newbery called 'the good traditions', which, he insisted, could not be revived either by an individual or a generation once they were lost.

For the Scottish Art Nouveau movement the enlightenment purveyed by a genuinely modern architecture is enlightenment through coherence: the lack of coherence perpetrated by eclecticism/historicism can only be transcended by the union of the new with the enduring principles which such debased work has compromised. As

Owen Jones had stated, 'The principles discoverable in the works of the past belong to us; not so the results.'[111] When Mackintosh posed the question of what the art and architecture of the future would be like, his answer demonstrated that the central preoccupation of the Scottish movement was with meaning and the quality of living which a revolutionized art and architecture could potentially engender within an ordered, industrially developed society. On the question of the future, his language could be that of the visionary, and in this respect it reflected nothing so much as the optimistic idealism of Geddes and the 'Scots Renascence':

> The message will still be of nature and man, of order and beauty, but all will be sweetness, simplicity, freedom, confidence, and light: the other is past and well is it, for its aim was to crush life; the new, the future, is to aid life and train it, 'so that beauty may flow into the soul like a breeze'.[112]

In Mackintosh's ideological schema, architecture is initially apprehended as being an international phenomenon capable of being specified and defined in its totality. Architecture, it is claimed, is fundamentally an expression of human needs and ideas. Because it is international it has created, historically, a variety of (national) 'styles' (or elements of styles) which have often been used interchangeably by different nations. In an individual country an 'imported' style might be modified to suit specific national requirements. Over time this modified style, often with the incorporation of further 'imported' elements, can become accepted as the 'national' style. The national style really results from evolutionary adaptation to the socio-cultural environment and its available materials. It can coexist with more obviously 'imported' (historical and other) styles, but the latter have not resulted from evolutionary adaptation over time to the country's socio-cultural requirements. The 'national' style has become indigenous with historical developments, the imported styles, by contrast, have merely artificial applications.

Modern cosmopolitanism allows a plethora of styles to coexist, but this makes it difficult to apply awareness of what constitutes 'true' architecture. In the midst of this complexity and confusion it becomes necessary to search via abstraction for the actual principles underlying architecture, so as to distinguish 'true' from fraudulent forms within the diversity of contemporary situations. The absence of a truly modern style faithful to both the principles, and contemporary needs, becomes apparent. Because of the theory of evolutionary architectural development, and the accompanying attempt to elucidate the principles underlying the architecture of the past, existing

elements of a 'national' style are discovered to represent examples of 'true' architecture. For this reason, these examples are considered to offer the potential for further development in strict accordance with modern requirements. In addressing these requirements, the 'national' style of the past can be transformed into the international style of the future because of the national-barrier-breaking nature of modern international technologies which facilitate new modes of inspiration and production for architects and art workers.

The correct addressing of modern requirements and needs, illuminated by knowledge of both architectural principles and modern materials and techniques, can produce an authentically modern architecture with international applicability. But this is only possible when the fetishization of inappropriate abstracted 'styles' is transcended. The new visual ideology would be manifested through creations which took architecture beyond the limits of a national territory. Each individual creation would be a unique concretization of this ideology, apprehended as modern style. Thus in the Scottish ideology, evolution ultimately gives way to revolution, as direct intervention to effect radical change is recommended. The attention is focused upon 'living strenuous work' as promising 'the beginning, the morning of our lives – not the grave of our aspirations'.[113] The architectural theory of the 1890s is subsequently merged with an avant-gardiste concern to unite art with modern social living via the beautification of everyday objects and with living environments conceived as composite wholes which consequently facilitate an emergent aesthetic coherence.

The endeavour to ground architecture epistemologically leads Mackintosh to attempt to bridge the gap between eighteenth-century rationalism with its paradigm of a reasoning spectator susceptible to aesthetic responses which are the result of cognitive understanding of the meaningful content of objects, and a turn of the century avant-gardiste conception of the individual embodying consciousness and unconscious as psychological polarities, seeking social meaning through, and within, a coherent architectural environment. In this model, perception, conception, intellect, and emotion interact and intermingle. The importance of intellectuality is made explicit, but in counteracting a detached over-intellectualization and a cognitive aesthetic experience deprived of emotions, Mackintosh endows the understanding with emotions, that is, emotions are held to participate in cognition. The cognitive use of emotions involves discriminating and relating them in such a way as to grasp and rationally evaluate architectural works, and thereby integrate them with the remainder of experience and with the social world. Hence emotions are modified through aesthetic experience.

What constitutes good, correct, truthful, or satisfactory architecture is, in general, held by Mackintosh to be relative to function and practical purpose: this leads him to stress the affinities between art and science, both of which are seen to come together in architecture. The terms 'true' and 'false', commonly applied to hypotheses in science, are thus applied to architecture where truth and its aesthetic counterpart become 'appropriateness' under different terms. This is only possible on the basis of the realization that the difference between art and science is not between synthesis and analysis, beauty and truth, feeling and fact, or passion and action, but rather rests upon specific characteristics of symbols and signs and their relative dominance. All of this underpins and gives substance to the argument about architectural principles; and consequently to the assertion about architecture being fundamentally addressed to human needs, including the need for beauty. The best architecture was to be revealed as being not merely what the 'best traditions' had ordained it should be, but everything that experiment demonstrated it could become.

Chapter six

# The institutional context

This chapter illuminates the institutional context within which
Glasgow Art Nouveau emerged, and examines the extent to which
the Scottish ideology was realized within the Glasgow School of Art.
In considering the basis for the peculiar combination of rational and
Romantic elements which was characteristic of the Scottish Art Nou-
veau mentality, some analysis of the School is made necessary. The
following discussion provides an account of the Glasgow School's
position within the national system of such schools funded by the
government. This was originally established from London for the re-
form of public art education towards utilitarian ends in Britain as a
whole.[1] We will see that the quasi-scientific notions of art as invol-
ving disciplined technical training, which were disseminated by
the Central School at South Kensington, were, within the Glasgow
School, linked in a very specific way to Romantic–Aesthetic ideals
about artistic self-expression and inspiration. For a time, a project to
integrate charisma with technical knowledge was under way in the
Glasgow School, and this undoubtedly determined the form taken by
the avant-garde. We will also see how the conviction that art could
not be taught led to an enhancement of the means towards creative
experimentation within the School.

Writing in 1904 on the subject of the South Kensington art schools'
characteristic use of line, Hermann Muthesius argued that the latter
had developed 'quite distinctly under the spell of aestheticism, more
precisely, under the influence of Rossetti's art'.[2] He proceeded to
describe the 'linear construction' to be discerned in Rossetti's paint-
ings: 'The rigidity of the straight lines in his figures combines with the
flow of the curves to create a line that is full of emotive atmosphere
and distinctive elegance.'[3] For Muthesius this technique of combin-
ing straight with curved lines was transposed, via the study of plants,

into the 'plant ornament' characterizing English flat pattern. The apparently opposed concerns of Aestheticism and disciplined accuracy were thus acknowledged as having, in important respects, come together in the work fostered under the South Kensington system. But this pre-Raphaelite concern with aesthetic values needs to be carefully distinguished from *fin-de-siècle* Aestheticism with its continental affiliations, its stylistic liberty, and its (in terms of the South Kensington view) suspect morality. With pre-Raphaelitism there was certainly no contradiction between purely aesthetic values and values which attached to fine workmanship, flawless technique, and precise execution. It seems hardly surprising, therefore, that something of this particular 'aestheticism' should have been absorbed into the British national system of art/design education. But to recognize this is to prepare the ground for the beginning, and not the ending, of an analysis of the Glasgow School of Art as the institutional locus for the emergence of 'Glasgow Style'. The latter, at its inception, was hardly an instance of 'English flat pattern'; it was nothing if not experimental, and hence necessarily overtly, rather than latently, aestheticist: but aestheticist in a way which was pointing towards the Continent and Symbolism. We need to know how this kind of experimentation was made possible within an institution sponsored by the British state. Glasgow Art Nouveau brought into focus the inherent contradiction between Aestheticism and moralism, and it did so within a social context, and in a period, where Aestheticism became a code-word for moral disintegration.

## The dialectics of art educational ideology in Glasgow in the 1880s

Newbery took up his position as Headmaster of the Glasgow School of Art in 1885. He was accompanied in his move from South Kensington by Aston Nicholas, who was to be Jessie Rowat's (Newbery's future wife's) tutor for her course in textiles and stained glass design. In the year before Newbery's arrival in the city, his predecessor, Thomas C. Simmonds, was commenting upon the decrease in numbers of students in some of the School's classes, in particular, the Mechanical and Building Classes. The reason for the decrease was, according to Simmonds, to be found in the contemporary 'great depression in trade', and he drew attention to the fact that 'the majority of the students left in consequence of want of employment in the shipbuilding yards of the Clyde.'[4] Twenty years later, Professor Baldwin Brown would refer to Glasgow's architectural sphere facing a time of depression and a period of 'lean kine'.[5] Despite the circumstances being described by Simmonds, the work of the students was held to illustrate a material advance on the results of the previous year, 'and this,

too, in the highest branches of Art study'. 4,136 works had been forwarded to London, 51 of which were publicly exhibited during July
and August 1884 in the South Kensington Museum. Speaking of
these (temporarily discontinued) exhibitions, Simmonds emphasized
the point that a number of the highest awards in Britain had been obtained each year by the Glasgow School and that, in the 1884
exhibition, nothing to compare with the Glasgow contribution was
apparent from the other students provided with access to the Museum at South Kensington. The explanation for the apparent
superiority of the Glasgow students' work was to be found, in Simmonds' opinion, in the role of Glasgow Corporation in actively
fostering art education in the city.

Simmonds subsequently drew attention to the fact that some of
the results of the architectural class within the School had been acknowledged by certain national journals.[6] After mentioning that the
Life Classes had been increased in number and were now 'the most
complete out of London', he expressed his regret that this 'great advance' in the School's work had met with little recognition on the
part of Glasgow's citizens. Because of the latter's indifference, it appeared likely that the students would 'have to continue their studies
under unfavourable conditions, as regards premises, that one Government Inspector after another has condemned in no measured
terms'.[7] In their Annual Report of the following year (1885) the
Committee expressed their acknowledgement to Simmonds

> for his past services in bringing up the School to the requirements
> of the present day and for being the means of raising it to a posi
> tion of eminence, especially in 'Design', which has been fully
> attested by the high and numerous Awards gained in this subject.[8]

Such had indeed been the case. Before Simmonds' appointment in
June 1881, enrolments, along with income, had been continually declining, and the number of prizes awarded to Glasgow students in the
National Competition was greatly reduced over previous years.
Under Simmonds, the School once again attained a high status
through prize-winning, and there was an increase in student enrolment; although, with the exception of the Life Classes, this had
dropped in numbers once again by 1884, the year in which Mackintosh enrolled for evening classes.

Many of the comments made by Sir James Watson, the Chairman
of the School at this time, are especially interesting for the way in
which they demonstrate that, prior to Newbery's arrival in Glasgow,
two fundamentally antagonistic ideological orientations were being
juxtaposed within the School. Watson began his Annual Speech in

1884 by commending the British legislature for having acknowledged the vast advantages arising to the country through the establishment of Schools of Art offering admission to 'all classes of the community' in a variety of towns. He then put forward a succinct version of the central South Kensington dogma about the need for rigorous training in drawing techniques before any kind of designing was possible. However, he did not exclude 'the higher art of painting' from the catalogue of artistic and technical activities considered capable of being adequately embraced within an avowedly utilitarian schema, the index for which was to be 'drawing'. It was indispensable, Watson insisted, that within such a schema, 'Art' be taught on the most scientific of principles, and that this should involve linear geometric drawing, beginning with the most simple examples, and leading, ultimately, to the more complex, 'as is done in this Academy'. Now this exposition of the activities and objectives of an Art Educational institution would have been perfectly adequate for the greater majority of practitioners of the South Kensington system at that time. Importantly, however, Watson clearly wanted to argue the case for acknowledging the relevance of what the aesthetically aware fine art oriented opponents of South Kensington had been stressing:

> But even after mastering what may be called the mechanical part, something more is required to make an accomplished Designer. There must be a portion of the inventive faculty, and a power to embody the ideal, and if the Student is wholly devoid of this, he would be better to turn his attention to some other profession. No doubt it is of value to be able to copy a machine or a pattern, but it requires genius to embody a new conception or to form a new construction. To some this faculty is given in a high and to others in a lower degree, but to all who in any measure possess it, the more it is used the greater it becomes. A few specimens will show the progress, in this respect, made by the Students of this Institution.[9]

This talk of the 'inventive faculty', which Mackintosh later replicated, on one level could be ascertained as deriving from Ruskin. But it would be quite inadequate to claim that these two antagonistic orientations which Watson juxtaposes represent South Kensington and Ruskin respectively: for one thing, Ruskin can actually be accommodated to the first orientation. Certainly, the problem from the vantage point of South Kensington, which Ruskin had denounced, resided in the fact that Ruskin had bestowed a special status upon art production: a status which was rooted in a fundamental mystification of the process of art making. The difficulty here had to do with

Ruskin's invoking of the role of the imagination (and 'inspiration') as being of central significance. The rigorous 'scientific' approach of the School of Design to teaching allowed no place for something as intangible as imagination. At the same time, the ideological potency of an apparently autonomous 'Art' (as distinct from 'Design') to a significant degree emanated from this very mystification. The problem was not merely abstract. One of the major difficulties encountered within the Schools had been the numbers of individuals wishing to learn fine art rather than 'Design' for industry. However, Ruskin's pronouncements on art education were sufficiently ambiguous to enable many of them to be utilized by the advocates of regressive art courses in justifying their ideological views and institutional activities. For example, Ruskin made the assertion that 'To give him [the student] habits of mathematical accuracy in transference of the outline of complex form, is therefore among the first, and even the most important, means of educating his taste.'[10] In 1873, he insisted that 'superior diligence and more obedient attention' were the qualities which merited prizes, and not 'indications of superior genius'.[11] Such statements give the impression of him flagrantly contradicting his affirmations about good design being impossible without inspiration and heaven-sent genius. Moreover, his description of the fragility of the faculty of imagination hardly makes the latter appear commensurate with the rigorous requirements of 'superior diligence and more obedient attention'. The imagination, he was wont to plead,

> is eminently a *wearable* faculty, eminently delicate, and incapable of bearing fatigue; so that if we give it too many objects at a time to employ itself upon, or very grand ones for a long time together, it fails under the effort, becomes jaded, exactly as the limbs do by bodily fatigue, and incapable of answering any farther appeal till it has had rest.[12]

If teaching 'habits of mathematical accuracy' constitutes the 'most important means' of educating students towards that most rarefied quality 'taste' (although 'sensibility' would be more apt, since Ruskin was somewhat ambivalent to the notion of taste: he considered taste worthless as a criterion for judging beauty), what has happened to those God-given (that is, innate) abilities which *cannot*, so Ruskin also claimed, be taught?

At this point, it becomes relevant to consider arguments being propounded by Herbert Spencer (whom Mackintosh would cite to substantiate his claims on the evolution of architecture in 1893). In Spencer's view, anything that operated to repress inherited charac-

teristics – and here he was overtly expressing opinions on the issue of art education – was actively hindering human evolution.[13] He explicitly condemned the geometrical method of outline drawing fostered by the Science and Art Department (and to a lesser degree by the Society of Arts founded in 1754 to further public art education) on the grounds that it inverted the normal order of human psychology, which, he insisted, demonstrated that *abstract* modes of learning were preliminary to 'the concrete'. Described thus, Spencer's notion of preliminary abstract modes appears related to Walter Benjamin's conception of the *mimetic faculty*, that is, the imitative, representational abilities, which involve the employment of fantasy, to establish 'correspondences' with the social world. Benjamin viewed the individual child's gesture as a creative impulse which corresponded exactly to the receptive impulse: the outward expression of children's fantasy could be viewed in their gestures while they were absorbed in such activities as painting, dancing, acting, etc. Benjamin considered this language of gestures to be more fundamental, in terms of cognition, than linguistic and conceptual abilities, since children's cognition was rooted in their actions and tactile experiences. When children play or perform, he asserted, 'new forces and new impulses appear': children *act upon* the world around them, and it is this very activity which socialization under capitalism suppresses.[14]

Spencer condemned elementary, disciplined drawing from copies, involving straight, curved, and compound lines, as being akin to 'prefacing the art of walking by a course of lessons on the bones, muscles, and nerves of the legs'.[15] But if the starting point for good art education was to be a necessary acknowledgement of innate predispositions, Spencer still believed that the evolutionary process was geared for the development of human faculties towards increasing *accuracy*.[16] It is illuminating to note how Mackintosh appropriated and developed this kind of thinking wherein *instinct* and *accuracy* are brought together. The artist of the future, Mackintosh stressed, 'must possess *technical invention* in order to create for himself suitable processes of expression – and above all he requires the aid of invention in order to *transform the elements with which nature supplies him – and compose new images from them*'.[17] What is innate, is therefore viewed as constituting the primary potentiality, which, in order to achieve fruition, that is, to be expressed, requires refined technical invention. The close affinity between this latter facility as described by Mackintosh, and what Spencer refers to as 'accuracy and completeness of observation', is clear, particularly since, in both instances, it is the instincts that are given the fundamental role. However, Mackintosh has integrated the component of 'invention' in such a way as to bestow upon the role of imaginative creativity a

central significance, and one which takes technical invention far beyond what a traditional art–technical education had hitherto been considered capable of providing. Paradoxically, perhaps, Ruskin bestowed a similar status upon the instincts as Spencer, and he too acknowledged the significance of evolutionary processes. For Ruskin, elementary manual discipline oriented towards the development of precision and dexterity (what Spencer called 'accuracy') was absolutely necessary for the production of quality ornamental work. Moreover, it was this same precision and dexterity which, he believed, far from inhibiting or repressing the imagination (or 'fancy'), effectively acted as a stimulus to the latter. Ruskin's habit of self-contradiction can appear to be operating where he is in agreement with Spencer over the claimed existence of innate abilities; abilities which are, moreover, deemed to be grounded in human activities aimed at the intensification of precision/accuracy. It is these activities which engender innate/instinctive abilities through the evolutionary process, and which, according to Ruskin (who, incidentally, described the science of the nineteenth century as being 'either of mere mechanism or evolutionary nonsense'),[18] give rise to 'a new species of animal'.

When Ruskin asserted that 'drawing may be taught by tutors, but Design only by Heaven', he was attempting to demarcate the sphere of influence of taught techniques from the inner realm of 'instinctive gifts'. He was emphasizing that too much was beyond the control of the agents of the Schools, and that good designers could not be 'manufactured'. But here the central paradox in Ruskin's theory of art education emerges. He could hardly continue to oppose a system which attempted to practise what he himself was advocating, namely, to impose 'a perpetual discipline of the hand as well as of the fancy'.[19] But this was to reduce body, intellect, and imagination to 'discipline'. The contradictions, however, remained unresolved, which meant that the polarities of discipline and imagination became 'institutionalized' as they were absorbed into Art School ideology. Whatever the abstract dialectics were in the 1880s, in practical terms, it was 'discipline' which predominated. It was this same discipline which Simmonds, on his departure from the Glasgow School of Art, was commending as the central benefit which the School had bestowed on all of its students.[20] But for Art Nouveau the stress was to be placed squarely on the role of 'fancy', originality, and individual expression. P. Leslie Waterhouse, in retrospectively scanning, in 1902, the work of contemporary Austrian and German architects, pointed out that these architects, being wearied with the resuscitation of classical forms 'which, they felt, left them no scope for individuality, became suddenly attracted to the new style of architecture known as

l'Art Nouveau'. Waterhouse went on to say that this strategy had 'allowed them to give free play to their fancy, and it was seized upon and travestied by architects of Dusseldorf, Cologne, etc., with enthusiasm'.[21] The affinities with Scottish Art Nouveau in respect of the centrality of 'fancy' or imagination should, by now, be clearly apparent. In the next section the significant art–institutional factors surrounding and facilitating the emergence and development of the Glasgow Art Nouveau movement will be examined.

### From imagination to experimentation: the struggle for aesthetic significance

We have seen that, before Newbery's arrival in the city, the Glasgow School of Art's ideology juxtaposed what had become two recognizable orientations: on the one hand, the rigorous teachings of the Science and Art Department at South Kensington, aimed, above all, at developing accuracy of observation and skill of technical execution; and on the other, that frankly 'artistic' orientation which had asserted the crucial need for a true art education to facilitate and enhance Aesthetic feeling and to stimulate the creative imagination. This latter orientation, while clearly reflecting certain Ruskinian notions, moves beyond these by way of an Idealism towards which Ruskin was decidedly ambivalent, in the distinct direction of the Aesthetic movement.[22] We saw also that both Ruskin and Spencer, ostensibly critics of the South Kensington system, put forward theories that were in essential respects in concord with that system's fundamental tenets. It will be argued below that the Glasgow School of Art, because of the dialectical nature of its ideology, helped foster Art Nouveau and the 'Scottish Ideology'; and that, within a time span during which the Art Nouveau movement came to fruition, the School was providing the locus within which the search for new aesthetic significance took the form of the *experience of experimentation*. However, what will be consistently emphasized is that the phenomenon of Glasgow Art Nouveau cannot be reduced to Newbery's influence and activities (an interpretation either predicated or implied by much of the literature on this subject), although these were undoubtedly of great significance for it: the role of cultural dimensions specific to the Glasgow context (acknowledged as significant by Newbery himself) require to be elucidated.

In his first public speech in the Glasgow School of Art, which he gave on the occasion of his appointment as Headmaster, Newbery addressed himself, in conclusion, and to the students in particular, on the issue of 'method' in the production of art work.[23] There was nothing dialectical about this exposition: here was pure, unadulterated,

South Kensington dogma. Moreover, there was a real irony in the fact that, since Newbery was at this stage advocating a method of study and practice aimed ultimately at nothing so much as 'rapid mechanical dexterity', that he should also be admitting virtually that none of this guarantees the actual production of 'art'. What then was the point in striving to obtain 'every atom of good from every study'? And how could the 'store of knowledge' accumulated through the process of such study 'last you through all needs' if one of those needs is the need to produce 'art'? On this showing, the rigorous study of a variety of art works, and engagement in a range of 'artistic' activities with the ultimate aim of attaining precise mechanical/manual dexterity, is a necessary, but not a sufficient, condition for the practical production of 'art' as such. But this much was already being acknowledged by such as Watson within the Glasgow School. What is clearly apparent from Newbery's initial address in Glasgow, is that, in 1885, he was unashamedly utilitarian in his views. The most obvious evidence of this is to be found in his typically South Kensington emphasis on copying and disciplined drawing. Significantly, twenty years later, 'An Old Student' wrote to the *Glasgow Herald* to complain about these being continued at the Glasgow School as integral elements within the curriculum:

> Students of 20 years ago remember the painfully careful drawings of classic and renaissance ornament which used to occupy or waste their time, but it was thought that a new regime had altered all that. Today, however, we find that the school has to all intents and purposes reverted to a style of work which was found to be antiquated a generation back. What possible purpose can be served by the laborious slaving which passes for high-class work today? No student can possibly do more than two or three such 'studies' in a session, and when he has done them he will be as much at a loss what to do with them as he would be with a white elephant.[24]

The use of the word 'reverted' here indicates that, for a time at least, and the time in question coincides with Glasgow Art Nouveau, the situation within the Art School had radically changed.

Ruskin and Spencer viewed the individual as inheriting instinctual abilities through processes of evolution. It appears that Newbery accepted this view, and, moreover, that he believed himself to have developed an effective method for testing the quality of innate propensities within an individual. He considered that this method now put him at odds with South Kensington, and the reason for this would appear to reside with the factor of the latter consistently refusing to acknowledge the significance of imagination in the production

161

of art. In following Ruskin, Newbery would have viewed imagination as springing from the instincts. In an interview given to the *Glasgow Evening News* in 1895, he was claiming that, in the Glasgow School of Art, 'until the student can draw well and paint well no copying from pictures is done':

> A young man or young woman comes to me and says he or she wants to be an artist. Well, I don't listen to that. I put them on to make an outline drawing of a cast selected by themselves in The Antique Room, and from that drawing I see what the student can do, and apportion for him work in accordance. He then goes through the course, learns to draw, and after that it lies with himself what special branch he will devote himself to.[25]

It could be hypothesized that the outline drawing signifies for Newbery the means whereby innate or instinctual abilities can be gauged; with the inner world of the individual being penetrated and abilities made concrete through a mode of externalization. This has little to do with acquired skills (although, realistically, these could hardly be discounted), since Newbery is quite explicit on the point that it is the course itself which teaches the rudiments of drawing. The precise nature of the work to be apportioned to the student is presumed to be commensurate with the actual quality of the innate abilities themselves. However, there is a point to be stressed here: if Newbery was attempting to evaluate a kind of 'primitive' art making with his strategy, then his interest would have been focused upon the results of what could be termed an 'expressive symbolism' (such being associated with, for example, children's artistic productions). However, he employs one of the least innovative techniques for the period – line drawing from a cast: a technique which had been for long associated with some of the worst aspects of the South Kensington system, and a technique apparently ill-suited to the attempt to penetrate an unconscious repository of involuntary spontaneous responses. However, Newbery's initial starting point in his evaluative procedure was *the real*, hence his utilization of existing objects. The artistic production of the non-existent would come later, subsequent to the medium of the existent having been traversed. Attempting to imagine, with the aid of fantasy and invention, a strictly non-existent object, he would have considered gratuitous.

Significantly, for Newbery's anonymous interviewer in 1895, his evaluative strategy was acknowledged as being 'scarcely according to Kensington'; meaning that it was in marked contradiction to the requirements of the Central School. 'Kensington! I recognize no such thing as Kensington,' blustered Newbery. 'Yes, but Kensington exists

and Kensington has methods,' pointed out his interviewer, somewhat disingenuously. This seemed to bring Newbery down to the level of acknowledging concrete institutional realities, and of reminding him of his organizational role within the national art educational nexus, since his subsequent description of the South Kensington system was notably moderated. Having asserted that Kensington had no methods, he continued in a rather idiosyncratic manner to present this alleged lack of methods in a positive, rather than a negative, light:

> To the schools under it – or, rather, the schools examined by it – Kensington issues no set of rules and regulations, saying, 'You'll copy casts in this or that particular way', or, 'You'll do your landscapes in the style of this man and not the style of that'. The Schools where South Kensington is regarded as a bugbear are the schools where weakness at the top has necessitated refuge being taken behind what some people are pleased to call the South Kensington system.[26]

This was tantamount to claiming that, where a given school demonstrates a strong organizational capacity in the managerial running of its affairs, that school is likely to have rejected in some measure 'The South Kensington system'. But Newbery clearly needed to believe that, although 'the system' was inherently bureaucratic, this bureaucratic nature was sufficiently flexible so as not to impede innovation, and, indeed, deviation: 'we find that Kensington is very reasonable. It may be slightly red tapeish, of course, now and then, but it is ever ready to recognize conscientious, if unconventional, effort.'[27] Two years previously, in 1893, Newbery gave voice to his recognition that Glasgow and London had contrasted views on what constituted 'good art':

> Glasgow was handicapped by the fact that what was called art in London did not pass muster as good art in Glasgow, and *vice versa*. He desired a distinctive school of art for Glasgow ... if in order to gain gold medals they required to please the London school [that is, South Kensington], he did not care if he did not win gold medals; he would rather win the golden opinions of Glasgow.[28]

This had the virtue of pointing up Glasgow's own cultural specificity. Speaking of poster design at the Glasgow School of Art in 1895, Newbery expressed satisfaction about the results 'progressing famously', but he was under no illusions as to the attitudes at the Central School:

South Kensington, of course, has nothing to do with them. The possibilities of the poster are great. Our early efforts (with which the public must be fairly familiar by this time) met with a shower of adverse criticism. We expected that, and were not cast down.[29]

But in 1896 he would be insisting that 'Had it not been for the much despised and often maligned and entirely misunderstood South Kensington, the Glasgow School of Art would have had to close its doors before now.'[30] If South Kensington had been 'entirely misunderstood', then Newbery himself could have claimed to be making his own contribution to the misunderstanding.

Perhaps, however, Newbery's was not a wholly unrealistic appraisal of South Kensington volatility in this period. The Technical Instruction Act of 1889 had provided local councils with the authority to form a Technical Instruction Committee which facilitated the provision of classes for artisans *vis-à-vis* local industries. Two important consequences of this act were the abandoning of the National Course of Instruction for Government Art Schools (which had enforced working from the flat); and the enhanced position it gave to the Arts and Crafts movement. Thomas Armstrong (appointed Director of the National Art Training Schools in 1881, and Director of the Art Division and South Kensington Museum from 1881 until 1897) on a visit to the Glasgow School of Art in 1899 emphasized the system's ability to absorb criticism and to change.[31] If anyone was in a position to value South Kensington volatility, it was Armstrong. As a staunch advocate of Arts and Crafts and decorative design, he had invited Walter Crane to lecture in the National Art Training Schools in the late 1880s, with an ultimate view towards integrating the Arts and Crafts movement within public art institutions. Armstrong was also responsible for initiating the first classes in enamelling at the Central School (under Dalpérrat); the enamels being fired in the Science Division's metallurgical laboratory. It is noteworthy that Armstrong should have expressed the wish that Crane succeed him as Director of Art at the Science and Art Department.

'Weakness at the top' was hardly an issue for Newbery where the Glasgow School was concerned. From the secure vantage point of Glasgow, South Kensington was a long way off in a number of respects. The sense of autonomy he was expressing was no doubt derived from the radical transformation which had taken place in the School's system of government in 1892. According to the new constitution set out in that year, various 'principal public bodies' within the city of Glasgow were to nominate triennially a board of Governors to represent them. Previously known as 'The Glasgow School of Art and Haldane Academy', the institution was now incorporated

under the Companies' Act as 'The Glasgow School of Art'. The motivations behind this reorganization were directed towards the strengthening of links between the School of Art and other local agencies. As the School's Annual Report for 1892 put it, 'This change of government has not only widened the interest of the citizens in the School's welfare, but has given an assurance of responsible management to civic and other established authorities.'[32] The nature of the context within which the School existed as an institution is made explicit here: a local context that encompasses considerable public and business interest; and, since this is a specifically Scottish interest, the sphere of influence of the Scotch Education Department *vis-à-vis* South Kensington has an enhanced significance.

The year 1892 was notable in the history of the Art School for other reasons. 1,736 works were sent for examination at South Kensington (192 up on the previous year). Mackintosh was awarded a gold medal for a design of a chapter house.[33] In that year, too, a deputation from the School's governing body had visited the Art Schools in Birmingham and Manchester, and after consultation with the South Kensington authorities, the decision was made to provide instruction from artist–craftsmen in a number of applied arts, which, without exception, reflect the influence of the Arts and Crafts movement – glass staining, pottery, repoussé and metal work, wood carving, and bookbinding. The intention was to establish 'a complete cycle of technical artistic education applicable to the Industrial Arts of the City of Glasgow'.[34] To what extent this development would actually prove to be applicable to Glasgow's industrial arts, however, remained to be seen. Stuart Macdonald makes the point that 'it is a fact that those art institutions which have achieved the highest reputation at various times ... have done so at that time when they deviated from national art education policies.'[35] This was certainly true of the Glasgow School throughout the 1890s, and there is not a little irony in the fact that it was the consistent success upon which this reputation was being built, that helped to assuage the wrath of many a South Kensington official. This much was revealed by Armstrong in 1899, when he addressed the prickly topic of the 'Glasgow Secession' and the immediate patronage of the Scotch Education Department.[36]

Newbery clearly equated the 'inventive faculty' with artistic instincts. Significantly, this conception explicitly points to the limits inherent in any system of art education that it cares to name: art education, by its criteria, cannot teach creative imagination since this is predicated as being grounded in inherited abilities. In terms of the Ruskinian argument, a disciplined art education could facilitate or enhance the workings of the imagination, but this was only acceptable when

imagination was oriented towards utilitarian ends. There is a central ambivalence towards the imagination with Ruskin which relates to a mode of thinking within which imagination, specifically because it is a function of the instinctual, is apprehended as encapsulating selfish, amoral, and socially disruptive elements. The affinity between such an evaluation and the consistently emphasized need for 'discipline' (manual, intellectual, moral, etc.) need not be laboured. However, where Ruskin had wished to inhibit and subsequently 'mould' the instinctual artistic propensities through discipline focused, from the initial stages of art–technical instruction, upon the body (manual functions), Newbery emphasized the crucial significance of primary potentiality as something that had to be freed rather than inhibited. Thus, the recognition of the innate potential for artistic creativity in all children had to be given first place by any system of art education: but this meant placing (the potential for) 'art' before the art education itself:

> the most colossal discovery of modern education was that every boy was a potential artist. But art came first and hand work afterwards. The difficulty was to bring the two terms down to a stage at which they would be understood by the ordinary commonplace comprehension.[37]

In Newbery's view, therefore, everyone inherits artistic instincts, but since art production manifests a great diversity of media ('Pictures were simply one revelation of art and nothing more')[38] different individuals will demonstrate specific abilities, which can, however, be considered to be artistic in generic terms. As *The Studio* commented on the procedure employed within the Glasgow School of Art, 'if the artist be discovered in the student, the deductive process must vary with every individuality presenting itself'.[39] Herein lay the significance of Newbery's (albeit crude) testing procedures for *individual* potential students. James Fleming, the School's Chairman, stated in 1894 that 'From his private knowledge of Mr. Newbery, he knew that he was eminently fitted to draw out the *individual* capabilities of students.'[40] *The Studio* referred to the significance of the studies of the whole School being directed by 'one who is himself an artist':

> The originality and strength of his personality, and the freshness and vigour in his manner of regarding artistic questions, become strongly conducive to originality in the students who pass through the school. His unwillingness to tolerate anything merely conventional or commonplace, and his encouragement of original effort, are most important factors in forming the taste and setting the convictions of the pupils.[41]

The essence of Newbery's teaching in the period when The Four were establishing their own strikingly original style was expressed by a student in 1894 who claimed that the Glasgow School had 'thrown overboard the old convention and is bravely struggling to uphold a new standard in Art – originality even at the expense of excellence.... It is in pursuit of *ideals*, however mystic or erratic they may seem, that the future of Art is assured.'[42] 'So far as the work of the student is *experimental*,' exclaimed another student in a letter to the *Glasgow Herald* in the same year, 'it matters little what style is followed, provided it be subservient to the end in view.'[43] The real significance of this emphasis upon idealism, originality, and experimentation being realized through the medium of an emphatically artistic inventiveness, is to be found with the conviction that what is being liberated in this way, is the *personality*, or psyche, of the individual artist. When Mackintosh was bewailing the absence of the 'essential faculty' of inventiveness in contemporary artistic/architectural work, it was on the grounds that such work was 'revealing no *personality*'.[44] 'This expression of a *personality*, psychological as it may appear in its language, is a candid record of the effect of a real education, and it is a matter of little moment by what exact efforts this feeling has made itself manifest:'[45] so ran *The Studio*'s analysis (1900) of an account given by a Glasgow School of Art student of his, or her, experience under Newbery's teaching.

In a lecture delivered to the Govan Art Club in 1896, Newbery noted that many in the Govan area of Glasgow were 'working at art connected with commercial pursuits, and they were desiring a freer field and a greater expression of personality than the workshop or their office work would allow'.[46] He proceeded to argue for the significance of evidence of overt manifestations of personality in the fields of craft and industrial art:

> That expression of personality really made the artist. Art might be, and probably was, a quality possessed by every human being, but it was only he who expressed that personality, whether he worked in clay, wood, iron, or anything he liked, that became the artist.[47]

Personality was therefore the medium through which the individual freed his or her innate artistic propensities.

In terms of South Kensington rationality, such ideals as were being striven for in Glasgow were indeed mystic or erratic, but, more dangerously, they were ultimately destructive if founded upon the belief that originality could be achieved through the diminishing of excellence or accuracy: at South Kensington the latter were invariably associated with hard, rigorous, work and strict discipline. 'There

is now a great deal of talk of originality being stifled by over much drudgery,' complained Armstrong in his visit to Glasgow in 1899; 'I have never known originality which was good for much stifled by hard work ... without accuracy, boldness and freedom are no better than rashness and licence.'[48] But for the new movement afoot in 1890s Glasgow, this was to miss the point: accuracy did not produce art. Pugin had acknowledged this in the 1840s when he criticized the teaching models being applied in the Design Schools: 'models which must fail in generating *original artists*, and which can only form bad copyists and adapters'.[49] Despite the continued adherence by such as Armstrong to the original principles, the actual historical experience of the South Kensington system had fostered a hostility within which the very concept of 'art education' was now being called into question: such was the significance now bestowed upon *innate* artistic abilities that the Glasgow School of Art's Chairman, James Fleming, stated, quite unambiguously, in 1894, that 'wholesale teaching of art, except in the most elementary form, was an absolute impossibility'.[50] Significantly, this was to bestow a quite extraordinary status on the Glasgow School, since no less was being claimed than that, in Glasgow, as nowhere else in Britain, the instinctive 'artistic impulse' towards originality was being allowed to manifest itself. Thus, Fleming drew attention to the fact that 'There was an amount of artistic impulse in the school, which he was bound to say he was not familiar with in any other school of art in the country.'[51]

The views of Maurice Greiffenhagen, appointed in 1906 as Jean Delville's successor in the Glasgow School's Life Classes, were very much in concord with this radical questioning of the value of art education. An ex-student of the Royal Academy School, Greiffenhagen expressed intense contempt for the Burlington House system of art education, which he himself had experienced for seven years, from the age of sixteen. J. Stanley Little remarked that Greiffenhagen 'feels that he could have done just as well, or better, without it. A student learns a few things which are either of no use to him, or which it is best to forget.'[52] Little emphasized that few contemporary artists had such a full sense of the requirements of decorative art as did Greiffenhagen, and that this had resulted from the artist's experience of 'Naturalism, carried to a point which endangered the sanity of its devotees, while it killed in them the real art faculty.'[53]

If Newbery's stress upon creative, experimental originality in the 1890s was producing results in the Glasgow School that were quite unique in Britain, his cry of *ars longa vita brevitas*, delivered when he was demonstrating his commitment to South Kensington principles on the occasion of his Glasgow appointment in 1885, was to have a rebounding effect in the form of a letter to a Glasgow newspaper in

1892, where that same Latin axiom was borne as an appellation:

> As a student of contemporary art, who for some years past has attended your local exhibitions, I have been able to watch the gradual development of some of your very clever young artists, and to deplore that their 'pretty conceit' of *originality* has blossomed into gross eccentricity. The besetting fault of the *fin-de-siècle* author, musician, and painter is *vagueness*. The *impressionist* of the past has become the *'notorietist'* of the present. If the ambitious young men who constitute the Glasgow School of Painting wish to avoid the suspicion that whisky might have been used for the mixing of their colours, let them in the future remember that true 'art', like 'charity', 'vaunteth itself not'.[54]

But Glasgow School 'originality' was not always so negatively received. Indeed, it was not overlooked that products for the market manifesting evidence of free imaginative creativity could have strong commercial potential alongside the power to educate public taste. 'The students should have the most free scope for the exercise of their artistic instincts,' proclaimed a newspaper article in 1891 on the 'Glasgow East-End Industrial Exhibition',

> in order that these may be, in the first place, developed to their fullest extent, the limitations of the possible or the payable in workmanship coming as a restriction in connection only with the actual production of designs for the market. Under such a method of working only can an art school be expected to lead, as it ought to do, and not to follow public taste.[55]

What was being acknowledged here, was that new designs for consumer goods (which are always the same) were essential, since these goods had continually to appear to be new and original in order to stimulate interest.

With the emergence of Art Nouveau style, the linking of instinct with imagination took on a new significance. The apparently free and spontaneous fluency manifested by the style in the 1890s was associated with a liberated imagination: and since the Ruskinian paradigm maintained its apparent relevance for the elucidation of artistic expression, these liberated powers of imagination were, as a consequence, viewed in terms of potent instinctual discharges. Ruskin's notion of 'Vital Beauty' of form (that is, a form which is revealed in organisms that have developed in accordance with their laws of evolutionary growth), together with the corresponding conviction that organic form was virtuous (with geometric form considered as evil),

had considerable relevance for a contemporary 'theory' of early and High Art Nouveau. Moreover, the relationship of Ruskin's 'Vital Beauty' to the central tenets of *vitalism* is apparent. However, for the ideology of Scottish Art Nouveau, with its inherent rationalism, its subject–object epistemology, and its all-important synthesis of knowledge and intellect with aesthetic sensibility, Ruskin's claim that 'art is always instinctive' represented an illicit half-truth.

The ideas of Walter Crane were undoubtedly of significance for Glasgow, not least because, where his views on art education were concerned, he consistently expressed his lack of sympathy with the South Kensington system with its requirement of 'flatness of treatment' for utilitarian purposes. His own ideas on art education emphasized the central importance of free-drawn designs and he loathed the practice of copying which the National Course of Instruction insisted upon. A new course of teaching under Crane's guidance was introduced into the Manchester School of Art in 1894. This was probably the most notable instance in this period of the penetration into public art education by the Art Workers' Guild (which had been founded in 1884). Crane's new course was initially run concurrently with the National Course of Instruction for which the school received finance from the Government department. However, subsequent to the number of successful student passes being seen to have declined, it was decided that, by running both courses separately, students' chances of gaining their South Kensington certificates would not be hampered by their need to cope with two contrasted teaching programmes. This signified failure for Crane, in that the state system's official course had demonstrated its resistance to the incorporation of his ideas. He resigned from his Manchester post in 1897.

Crane was invited to Glasgow in 1891 by the Glasgow Socialists' Society. William Morris presided at Crane's lecture on 'The Educational Value of Art' in the Waterloo Rooms.[56] Crane asserted on this occasion that the mistake that had been made in modern times was that art had come to be regarded as something outside of both life and education. Many causes had worked together to engender this habit of thought, and one of the central causes was the entire transformation of the system of industrial production which had resulted in the situation whereby 'it was about as difficult for a workman to be an artist as for an artist to be a workman'. He made it clear that he was far less concerned with the process of conveying ideas to the student about the meaning or value of art, or about the 'power of accomplishment' made possible by a system of teaching, than he was with the actual influence of art as 'the most expressive of languages',

with a power to carry in the most definite form, all kinds of ideas in all departments of knowledge. He then went on to talk about 'inventive delight in combination of life and form, and the refining influence of its beauty'. He argued for a conception of the object and scope of education that was grounded in a view of life itself which had acknowledged both the aims and objects of life, and the claims and relations of humanity. The question of what constituted an ideal education was secondary to that of what was our ideal in life: 'He thought we might very plainly see the absence of an ideal of life in our system of education.'

Isobel Spencer has drawn attention to Crane's promotion of design in art education as representing 'a valuable contribution to the modern movement'. He encouraged experiment and spontaneity through his teaching, and thus 'gave students a real sense of the resilience and adaptability which would be more and more required of designers if they were to respond to the needs of a developing society'.[57] But the state of affairs in the Manchester School of Art, where this 'experiment and spontaneity' were alienated from the main course, was not paralleled in Glasgow where Newbery was attempting to integrate these new ideas into the main curriculum. Newbery was later to reflect (in 1902) on Crane's own 'methods and mediums', and to comment that *'the hand obeys the thought* in that wonderfully *unconscious* way that is the gift of the few.'[58] It was not for nothing that Newbery viewed Crane as having been, in the 1880s, a 'pioneer'. But if Crane had started out as a pioneer, he had not, in Newbery's opinion, managed to establish a widely spread movement. Writing in a period of international success for the Glasgow movement (Vienna, 1900; Turin, 1902; Moscow, 1902) Newbery contrasted Crane's limitations with the strengths of the Scottish Art Nouveau approach to design: 'there is in Crane's work a certain want of conviction and a lack of relation to Nature, which appear to have arrested all progress above a certain plane.'[59] But this was not all, and here Newbery spelled out what, to him, signified the most fundamental limitation underlying Crane's work:

> The history of book decoration finds in him an historian; and to all this may be added other labours, which speak of his unselfishness and disinterested devotion to the social welfare of his fellow man. But there is a danger in all this – the danger that a man working in art may have no time to study that art itself![60]

The background to these comments is all-important: this was Newbery expressing opinions which were heavily influenced by Art Nouveau ideas at the same time as he was experiencing first-hand the

success of Glasgow Style designers abroad. In other words, this was the Newbery who had, in crucial respects, gone beyond the ideas of Ruskin, Morris, and Crane. The significance of a theory of art for the new movement is made explicit with this latter comment above about the need to 'study that art itself'. Says Lenning on the significance of *theory* in this context, 'without the theoretical aspect of the *Art Nouveau*, there could be no bridge from nineteenth-century eclecticism to what we have come to know in the twentieth century as a modern art-form.'[61]

The views expressed by Sir James Watson in the Glasgow School of Art prior to Newbery's arrival in the city, illustrate that the ideology of art education at that time embodied a central dialectical tension. A discourse centred upon a Romantic–Aesthetic conception of art appears, in respect of this tension, to be significant for the Glasgow School's ideology. It is at this point that links between the School and the University begin to betray more than a local institutional relevance, since the University's Principal in the 1880s placed himself squarely within a tradition of Scottish Hegelianism. Not only were Idealism and Romanticism–Aestheticism potent forces for Scottish Art Nouveau, but in addition, dialectical thinking has itself a central role to play in Mackintosh's theory of architecture. In England, with Walter Pater, and in the context of the Aesthetic movement, a concept of history – derived from a reading of Hegel (and Darwin, among others) – was presented, within which a perpetual dialectic ensued between two fundamentally conflicting tendencies of wholeness and fragmentation. The former of these was to be identified with the classical tendency (centripetal) – an attitude towards discipline, order, and restraint; and the second with a tendency of romanticism (centrifugal) – abandonment in undirected imagination, delight in colour and vividness, in beautiful material, and in everchanging diversity of form. Pater prefigured Art Nouveau's concern with music as the paradigm for an art that had transcended the form–content dichotomy and attained a new synthesis. He saw music as most completely realizing the artistic ideal of saturating form with matter (or content), subject with expression, end with means, thought with feeling: 'form and matter, in their union or identity, present one single effect to the "imaginative reason", that complex faculty for which every thought and feeling is twin-born with its sensible analogue or symbol.'[62] Pater considered that the function of 'speculative culture' (philosophy) was to stimulate 'constant and eager observation', thus facilitating insight and intellectual excitement. But experience itself, and not its outcome, was the end to be attained. In this manner, Pater *combined* abstract thought with aesthetic experience: 'Philosophical theories or ideas,

as points of view, instruments of criticism, may help us to gather up what might otherwise pass unregarded by us.'[63] But abstract theories and systems of ideas always foundered when confronting the fundamental potency of psychological immediacy. The limits to the coherence supplied by thought systems lay in the fragmented nature of human experience. 'All melts under our feet', impressions, sensations, are of the moment alone, and our experience betrays an 'awful brevity'.

Pater's Hegel-derived centrifugal and centripetal tendencies can be seen as having relevance to the Glasgow School of Art in Newbery's early period there: discipline, order, and restraint were highly characteristic of South Kensington teachings and methods (the centripetal); with the Romantic–Aesthetic orientation which emphasized inspiration, the 'ideal', and creative imagination representing the antithesis of the former within a tension-filled dialectical relationship. In the 1890s, the Art School – an institution of public art education with a predominantly utilitarian role – provided the locus for a synthesis of the Romantic–Aesthetic orientation with the 'scientific' methods and teachings embodied within the national courses of instruction, and thus allowed, by encouraging artistic experimentation in the School as a whole, both the traditional dualism that had separated the intellect from the passions to be bypassed, and the Glasgow Art Nouveau movement to appear.

Edward Caird's book on Hegel (1883) had emphasized the relevance of the dialectical method in philosophy for demonstrating that antagonistic tendencies are always resolved in a higher unity. In that particular work he attempted to demonstrate that the antagonism between conventional religion and materialistic science could be transcended through a doctrine of scientific law as something spiritual or *Ideal*. In finding the Ideal *everywhere*, the Ideal could be found *anywhere*. Man, God, and Nature – traditionally distinguished in theology – were perceived, Caird argued, by a genuinely philosophical theology (and Caird, in a manner characteristic of the Scottish Hegelians, viewed Hegel as being essentially a theological philosopher) as being combined in one single spiritual principle. This attempt at combining the everywhere with the anywhere through the medium of the Ideal, can be seen to have its analogue in Mackintosh's theory of architecture, in which context the specificity of the particular (the architecture of a given period, for which Mackintosh provides significant empirical exemplification) does not stand in opposition to architecture as historical universal. Nor does originality (as specificity of a particular creative work) conflict with logicality (the coherence purveyed through recognizable universal principles) for Mackintosh. A further characteristic of Idealism in Mackintosh is to

be found with his insistence that the art worker/architect have 'convictions' (that is, quasi-religious ideals). The early Art Nouveau preoccupation with the sources and motivations of organic life, and with the 'power of life to transform itself eternally',[64] would, in the Scottish context, have found with Caird a convenient source of Romantic biological historicism: the 'higher unity' within which antagonisms become reconciled, Caird described as 'unity as manifesting itself in an organic process of development'.[65]

What Pater had specified as the problem of the fragmented nature of human experience seemed in many ways to present one of the central challenges which Scottish Art Nouveau addressed. Nothing so much as the striving towards coherence and unity typifies the thinking of Glasgow's new movement as it differentiated itself from the Arts and Crafts mentality. Newbery's discussion of the role of Art Galleries and Museums as specifically educative institutions (in 1895) illustrates in its essentials a transition point between the old and the new mentalities: Henry Cole, the director of public art administration in Britain over the period 1852–73 (who was of the opinion that 'unless museums and galleries are made subservient to purposes of education, they dwindle into very sleepy affairs')[66] and Ruskin were brought together as representatives of the argument about the social role of art; but these were connected with the contemporary Art Nouveau preoccupation with the creation of the whole (unity, coherence) through a process of meaningfully relating the particular to the general (the anywhere to the everywhere, in Caird's terms) which asserts the powers of the mind. This latter mode of thinking displaces Ruskinian ideas. Ruskin's thinking was not essentially concerned with emphasizing the *relationship* of the fragment to the whole.

Newbery's conception of the potential offered by art galleries for creating a quasi-religious 'wholeness' was a highly positive one, and to a considerable extent this was due to his appraisal of characteristics which were specific to Glasgow.

> Here in Glasgow the picture galleries are open week in and week out, day and night, from the first till the last day of the year. And the boon is inestimable – priceless. It is a privilege that is not possessed by Londoners, nor enjoyed in Paris, Brussels, Amsterdam, Berlin, Vienna, Florence, Rome or Madrid.[67]

One means of appropriating this willingness to learn and of leading the attention towards art works was, for Newbery, a comprehensive and systematic lecture scheme: 'Any series may be complete in itself, but it must be part of a whole.' Included in this whole, there were to be lectures on the 'treatment of painting' which would include ana-

lysis of methods and mediums, 'the painter's material and its uses; colour and its attached science; the history of processes with their applications and limitations'. But, in addition, there were to be lectures on architecture, sculpture, and the decorative arts. The field for knowledge, clear and popular, Newbery insisted, was unlimited: but the ultimate aim of such schemes was to increase 'study [of] humanity as expressed by Art':

> the hearers of such a lecture or series of lectures, would go away with some idea that a picture may be more than paint and canvas, colour and panel, and may contain as many lessons as a book; as many moralities as are possible to be preached from a pulpit in a year; as much religious appeal as a church service, and yet may fulfil the first and last necessary reason for its existence, and that is, that it be beautiful, because it is a work of art. And similar treatments could be made of the Social and Philosophical and Political sides of life by other selections of pictures, and by other demonstrations.[68]

What is most striking about these sections is the manner in which they focus upon an autonomous 'Art' and aestheticization in the attempt to create wholeness (intelligible structures) out of fragmentation and lack of unification. The description moves from the recognition of moral relativism ('as many moralities') to that of cultural complexity ('the Social and Philosophical and Political'). The drive towards coherence acknowledges fragmentation and heterogeneity but desires a cognitive synthesis that is to be achieved through (what Pater called) imaginative reason. The art gallery/museum provides a site for coherence by bringing together a diverse range of artistic/cultural objects and artefacts which are experienced as belonging to a totality. Even a multiple series of lectures, Newbery insists, must constitute a 'whole'; and on one occasion he said he detested the ugly telephone wires in Glasgow because 'there was no *unity* and no *harmony* in them'.[69] Art (and the worship of beauty) is to perform the function no longer addressed by religion (in respect of this latter, a similar strain of thinking was already to be found with Ruskin and Geddes who were concerned to liberate the aesthetic potential of imagination from the forces fostering mysticism and theology, which had exploited an uncritical imagination for their own ends). For this to be possible, the emancipation of the aesthetic from sacral functions has to be acknowledged, and this, Newbery does. The contemporary work of art, he claims, can present religious imagery, but its significance is now recognized as being aesthetic, not theological. Conversely, contemporary agencies of religion acknowledged the

potency of aesthetic attributes and appropriated these for religious ends: 'Religion building the house of God', wrote Newbery in 1902, 'claims the same artistic hand to enrich the light streaming through its painted windows.'[70] Historically, as the power of the church diminished, that of art increased:

> perhaps the reason why grand ladies posed as Virgins before Titian and Veronese, before Rubens and Vandyck, was because the power of the Church was no longer Canonical in the days of these artists, even as the religious sentiment is non-ecclesiastical, however deeply emotional, in Burne Jones.[71]

If the issue of the 'whole' was to have a thoroughgoing significance for Newbery under the influence of the new Glasgow movement, then this can be understood as being grounded in the acknowledgement that personality–mind–psyche always involved the creation of psychological *Gestalten* which were subsequently externalized through forms of cultural creativity. *The Studio*, for example, reflected the relevance of such thinking for a true understanding and appreciation of the work of Glasgow Art Nouveau designers, when it discussed the MacNairs' contributions to the Turin Exhibition of 1902. Such examples of artistic creativity were found to be capable of 'showing in what manner the necessities and beauties of life can be brought together in one harmonious whole'.[72] In Newbery's article for *The Studio* on the English Section at the International Exposition of Modern Decorative Art at Turin, his criticisms of the Arts and Crafts exhibits on show centred upon the failure of the latter to achieve the 'wholeness' manifested by the contributions of the Glasgow School in the Scottish section[73] and the forty rooms in the German section decorated by twenty architects (Mackintosh did not exhibit a complete interior: he was represented by a furniture grouping occupying a position in a passageway).[74] Newbery was appointed delegate for Scotland to collect and select work for the Exhibition. 'The winter has been spent in obtaining from Scottish art workers the best that was obtainable by their efforts',[75] stated the *Glasgow Herald*, which acknowledged the essential nature of the Scottish approach in describing that 'the decoration of the whole section is to be in itself of the nature of an exhibit, the aim being that the spectator shall on his entrance be at once struck with the treatment'.[76]

In describing the German section, Newbery had this to say:

> Olbrich, of Darmstadt, makes three rooms upon a given space. Each is a related and relateable structure, each has its proper plenishings and decoration in perfect *ensemble*, and it is only by

such work and through such means that decorative art can ever hope to have a place or make a progress. And it is because these things are neglected that the English section is the exhibition of a collection of work, arranged without idea and without scheme, instead of being a selection of art work, related by beauty and through utility to its purpose.[77]

'Beauty', 'utility', 'purpose' were categories which stretched backwards in time, through Ruskin and Pugin in the nineteenth century to Reynolds and Chambers in the eighteenth. But they now take on a new mode of application as they are integrated into Art Nouveau aesthetic theory employing innovative concepts of structure and space. A mere 'collection of work' without unity, says Newbery, brings to mind the contents of most museums where the layout of items is limited by 'the exigencies of space'. Such may satisfy the archaeologist, but not the artist. Space is thus acknowledged as being of central relevance to aesthetic responses, and, as with Mackintosh, Newbery considers architecture to represent the fundamental art form: 'To cultivate the artist in the architect is the one aim of [the Glasgow School of Art's] curriculum,' stated the *Glasgow Property Circular*[78] in 1895. It was 'architecture' that was singularly absent from the English section at Turin:

Drawings, paintings, designs, sketches, modelled panels, executed work, elbow each other on the walls, without either sequence or meaning....Where is the art in all this? What of the architecture which is the root and basis of all things artistic? What of the house for which all these objects were made, or of the room that, decorated by them, was further to be enriched of them.[79]

Notwithstanding Newbery's criticisms of an English Arts and Crafts approach to design, it is questionable to what degree he himself was able to fully and consistently transcend Arts and Crafts thinking with regard to art production, and embrace the modern design aesthetics of J.D. Sedding (which were obviously shared by Mackintosh). The latter, it should be stressed, was attempting to face squarely the issue of the decline in patronage for the arts in urbanized, massified societies. Furthermore, Newbery's emphasis upon architecture betrays more of Mackintosh's influence, in this, his most successful period, than being related to any wide-scale movement of building in Glasgow. For Mackintosh, it was *because* architecture was 'the root and basis of all things artistic', 'the 'commune of the arts' which embodied the synthesis of art and science, that he desired contracts from public agencies and authorities with a view to potentially transforming the

177

entire public realm. The conflict between Scottish idealism and English empiricism (which was considered by the former to be a means for fragmenting the world, and thereby rupturing the individual's relationship to it) is made apparent with Newbery's review of the Turin event. Undoubtedly, the experience of the German Section at Turin brought home to him, with considerable force, the relevance of the close relationship between *Gestalt* thinking in Scotland and Germany respectively, and the fruitfulness of this thinking for creative purposes in design and architecture.

There can be little doubt that Newbery desired an intellectual and cultural credibility for Glasgow's School of Art. In respect of intellectual and cultural status, the University held a monopoly, and, furthermore, in the eyes of not a few Glaswegians, the latter's representatives had for too long displayed an unjustly supercilious attitude towards the Art School. A high measure of indignation at this situation between the two local institutions was expressed through the press, and the opportunity was seldom missed to underline the intellectual and cultural significance of certain activities within the Art School. Thus the *Glasgow Herald*, even by 1910, was reporting on a lecture scheme for the public in such a way as to praise the School's progressiveness in supplying this service, while implying snobbish disinterest on the part of the University.[80] On occasion, sufficient reason was found to consider the Art School a University in its own right: 'The Glasgow School of Art might also claim to be a University of art, for they taught there those who were to be the teachers of others ... during the past three years 2,500 teachers of Glasgow and the West of Scotland had passed through it.'[81] These comments date from six years after the Scotch Office declared the Art School a Central Institution exclusively for Higher Education. This meant that the School was now authorized to award its own Professional Diplomas. Subsequent claims about its 'University status' were founded upon this development. But the University itself was often viewed in the most negative terms for being deprived of all that art was believed capable of bestowing. 'Let us make our University a thing of beauty', wrote a 'Decorative Artist' bewailing the starkness of the building and its environs, 'which shall be a lasting memorial to the skill of our artists and the public spirit of our citizens.'[82] A similar sentiment was expressed by a *Membre de la Société Des Artistes Français*: 'Our University as such does nothing to inculcate the appreciation of appropriate beauty or the understanding of the fine arts that glorify and dignify our lives. Our University is almost destitute of Art.'[83] But in this instance, Art was not to be confused with the arts, and the specifically aesthetic sensibility which an education in the former could potentially enhance, was not the preserve of the Art School. How-

ever, the *membre*'s aesthetic mystification of Art seems to have been quite blind to its own contradictions. If 'all that Art can supply' extends to design, decoration, and architecture, as he claimed, then universities were hardly likely to have supplied them. And if 'the decorative artists of Glasgow at present stand as high in general estimation as any in Europe',[84] given the embarrassing reality of 'The Artless University', it made little sense to disparage the Art School which had made them possible. On the other hand, this kind of perception of the attributes of the University where art was concerned was clearly of great relevance, and not least for such as Newbery.

The influence of Aesthetic–Romantic idealism within the Art School is well illustrated by an account which a student gave of his experience there prior to 1900 (just how prior is not known):

> Eventually there came to me the new birth, a wonderful factor in the art life of every student, when everything is transmuted, and the transmuting power is in his own eyes – eyes that before were blind and saw not. It is as if the heavens open.[85]

These are the theological metaphors of Scottish Hegelianism 'transmuted' into a language of intense idealist aestheticism owing much to Pater ('to burn always with this hard, gemlike flame, to maintain this ecstasy, is success in life').[86] The essence of this kind of thinking was presented by John Caird in a lecture delivered in Glasgow in 1886 on the subject of 'that which is somewhat vaguely designated by the word "Art"'. It is not known whether Newbery actually attended this, but his personal scrapbook includes a cutting from a local newspaper which reported fully on the lecture's content. Caird's description of the 'artistic observer' is highly commensurate with Pater's centrifugal attitude of Romanticism. Importantly, it is in this context that the significance of the distinction between imitation and imagination (crucial for Art Nouveau) was made explicit:

> For the artistic or poetic observer, for the mind that is in sympathy with the soul of things, sensuous forms, colours, motions, are alive with the spirit of beauty, transfigured with the hidden glow and splendour of a light that other eyes see not – a light that never was on land and sea. And it is his high vocation, not merely to copy, to tickle our imitative susceptiblities by a matter-of-fact imitation of what we saw before, but through the language of imagination to interpret nature, and make us look upon her face with larger, other eyes than ours. But we may go further than this, and boldly say that there is a sense in which art does 'improve on nature'. All art that is worthy of the name is creative, calls into existence some-

thing more than the bare facts which the outward world offers to the senses. These are the materials on which it works, but it does not leave them unchanged.[87]

The insights of Scottish Hegelianism which stressed the implications of specifically *creative* imagination in art were to be seized upon by Mackintosh. What characterizes the artist above all else, and what determines his vocation, Mackintosh declared, was 'the exceptional development of the imaginative faculties – especially the imagination that creates – not only the imagination that represents'.[88] John Caird had posed the question of whether art improved upon nature, or upon human life:

> can the loftiest genius invent a fairer world, can the most soaring imagination conceive, or the resources of art depict, forms more lovely, lights more dazzling, harmonies of tone and colour more subtle and various than those we have but to open our eyes to behold?[89]

And Mackintosh, in taking up the challenge in favour of utopianism, had answered,

> what is art but the fixing into substance of the 'invisible'? Are you discontented with this world? This world was never meant for genius to exist[;] it must create another (the invisible). What magician can do more? What science can do as much?[90]

As with the Cairds, science is here down-graded in a very specific sense: science alone is viewed as not being capable of producing charismatic individuals. Edward Caird insisted (in 1889) that 'he who has received from nature the gift for pure art is distinguished in *kind* from those who merely imitate him', and that what ultimately distinguished an artist (notwithstanding the 'mechanical elements' of his work, which had to be learned) was 'a faculty of free construction which cannot be fully explained'.[91] The Mackintosh of 1893, in following this conception of art's autonomy from the praxis of life, was also perpetuating the cult of genius. From the vantage point of the Arts and Crafts movement, this was quite unacceptable. Writing on the subject of William Morris, van de Velde made it clear that 'pride in artistic genius and some form of special inspiration' was abhorrent to him. '"The talk of inspiration is sheer nonsense", he said; "there is no such thing: it is a mere matter of craftsmanship".'[92] Morris's notion of art thus involved portraying art as the practical alone, whereas Mackintosh began by separating art and the aesthetic from

the practical in order to stress the specificity of the former. It was acknowledged that art idealizes life through the medium of the creative imagination. The autonomy which idealism bestows upon the imagination was to have crucial implications for the formulation of the new aesthetics of Scottish Art Nouveau, specifically where art and science, idealism and materialism are unified, because such was only possible on the basis of the recognition that imagination with its cultural symbols represents the crucial medium through which the inner confronts the outer, the subjective the objective, in all spheres of human culture. John Caird described how 'Nature reflects herself in the mirror of man's mind, but the mirror in most cases is opaque or dim, sometimes distorted and fractured, *and the reflection takes its character from the medium by which it is produced.*'[93] Such a view signalled the impoverishment of both naturalism in art and the assertion of the sovereignty of nature over culture. It firmly established that perception of 'reality' was an inherently phenomenological process: but in speaking of nature's 'reflections' within the human psyche, it pointed towards the potential in art for the freeing of 'primitive' or 'primary' sources of inspiration. Edward Caird desired a modern synthesis of science and spirituality. With Scottish Art Nouveau the synthesis, to be achieved through praxis, was to be of science and art, but the latter was acknowledged by such as Newbery as having replaced theology through its emancipation from ecclesiastical ritual. Thus, what was traditionally an artefact of theology, namely convictions, was expressed by Mackintosh as a dimension of artistic 'ideals' ('The man with no convictions – no ideals in art – no desire to do something personal[,] something his own, no longing to do something that will leave the world richer his fellows happier is no artist').[94] Scottish Hegelian idealism provided the substance for a concept of the relationship of the individual to the totality which emphasized the substantiveness of the inner world of the individual. It was thus in greater concord with Symbolism than with Ruskin, for whom 'facts' of nature were paramount, and who was convinced that art, when followed for its own sake, destroyed what was 'best' and 'noblest' in humanity. In Glasgow, the Cairds taught the potency of an autonomous imagination as the dimension of unification of subject and object; they fostered the concept of the dialectic; and they juxtaposed art with science in such a way as to demonstrate that both were founded upon 'ideal' modes of thought. In Edinburgh, in the mid-1890s, Geddes proclaimed that the age of the 'dualism' of materialism and spiritualism was ended, and 'that of an organic and idealist Monism is begun'.[95] Even the juxtaposing of two antagonistic orientations within the ideology of the Glasgow School of Art in 1884 can be seen as a manifestation of Scottish

Hegelian thinking, since John Caird presented what was virtually an analogue of this ideology in his 1886 lecture.

Although such Romantic–Aesthetic ideals as were expounded by the Cairds were far from alien to Glasgow's cultured intellectual élite, it seems that, even in 1891, Newbery had yet to discover the true significance of imagination over imitation: in that year he was asserting that 'true art is to *copy* nature'. This was undoubtedly an artefact of his South Kensington background (Stage 8 of the National Course of Instruction's Drawing Course involved copying 'Human or animal figures from the round or from nature'). But his dictum (which was reported in the *Glasgow Herald*'s 'Notes and Comment' column) did not go unchecked, and his personal scrapbook contains a cutting of a letter from one Adam Drysdal of Glasgow, which had been sent to the *Herald*, and in which it was implied that Newbery's conception of the artist was of the latter as being an 'art mechanic'. This would have had the effect of criticizing Newbery in direct relation to his South Kensington-derived position and function. 'Mr. Newbery's dictum to "copy" Nature is but rarely a true canon of art', proclaimed Drysdal:

> The truth he has been trying to express is evidently not such 'copying', but as I would say, adherence to the order observed in Nature, but always remembering that the artist is not a mere art mechanic or photographer, but is a sentient being with perceptions and feelings and conceptions and possibilities of projecting, glorifying *idealities*, even in the region of Nature. Let us consider the fitness of things in art and design, and not copy, but evolve from Nature.[96]

Drysdal had argued that imitating flowers for close viewing was absurd, since with imitations nature must always 'beat' the artist. A painter of flowers should therefore aim for a symbolic representation which would allow only the more prominent features of 'form and foliage and efflorescence' to be recognized and identified. Many pictures considered 'classical' were composed of highly imaginative elements 'to say nothing of incongruities and anti-naturalism', factors which meant that they should be 'classed with the unrealities of dreamland and valued accordingly'. (*The Architectural Review*, in writing about the Glasgow International Exhibition of 1901, would make the claim that a great exhibition scheme 'facilitates to an unusual extent the realisation of dreams which are not possible in the confines of everyday practice'.)[97] Drysdal incorporates here a number of elements that were to be central to Scottish Art Nouveau: namely symbolism, idealism, creative imagination, the notion of fitness, and, importantly, synthesis. Indeed, his description of synthesis could have been lifted from Maurice Denis who, when writing on

Cézanne, described how the first symbolists (Gauguin, Bernard, Anquetin) were most struck by the effects that could be achieved through employing unity of plane (apparent with the 'enveloping chiaroscuro' of Venetian painting in the sixteenth century), and by sacrificing aerial perspective to a synthetic system of softened flat tints, followed by hard contours, and leading to a balanced decorative effect. Synthesis, Denis insisted, 'does not necessarily mean simplification in the sense of suppression of certain parts of the object; it is simplifying in the sense of *rendering intelligible*'.[98] But Denis claimed that painting oscillated perpetually between invention and imitation, sometimes copying and sometimes imagining.

The fact that Drysdal's letter occupies a place in Newbery's own collection of press cuttings perhaps suggests something of its significance for him in terms of his attempts to come to terms with what he acknowledged to be Glasgow's own particular cultural ideas and artistic interests. At any rate, one of his first 'manifestos' was laid down at the beginning of 1892 when arrangements were being made for the forthcoming Annual Public Meeting of the Art School. According to a Committee Minute, 'It was deemed expedient on this occasion to have the Artistic element more prominently represented than hitherto on the platform and that invitations should be issued accordingly.'[99] The prelude to this had been the appointment of 'Visitors' in painting, in 1891, such as James Guthrie and Joseph Henderson, to be followed by E. A. Walton and John Lavery. Newbery, with the Governors' approval, was thus 'opening up' the School to significant external influences. Before his arrival there had been no lecturer in Architecture. By 1891, two, together with a Visiting Master (not a 'Visitor'), had been appointed. At the Public Meeting in 1892, the President of the Royal Scottish Academy, Sir William Fettes Douglas, appeared with six other eminent painters and one architect.

From at least Pugin's period in Britain, aesthetics had been viewed as part of the preserve of philosophy, and, more specifically, of German idealist philosophy. Hence, the institutional locus for theoretical elucidation with regard to the essential nature of art was widely perceived to be the University. In Britain generally, however, this philosophy was treated with some suspicion as being a 'foreign' importation. But, by contrast, in Glasgow, by 1880, there existed an established school of Scottish Hegelianism, and this would operate to bring a philosophy of aesthetics into closer proximity with the local institutions of art education than was usual in English cities. By the time Bernard Bosanquet published his *History of Aesthetic* (1892), he had been made an Honorary Doctor of Laws by Glasgow University. One of the few English Hegelian idealists, Bosanquet was also one of the few British philosophers to take aesthetics seriously

enough to write an extensive work on the subject. He was offered a post at St Andrews University, where he taught from 1903 until 1908.

For Newbery, it was not only that the work of the University 'may be for the democracy, as the modern tendency is', or that it was 'willing to recognize in her most fitting manner both the work of and the worker in art'. Most importantly, the University owned what the Art School was yet to acquire:

> What is wanted is that cultured, *aesthetic side*, which is acknowledged to be lacking at the present time, and which the University with its organization and tradition can supply. Thus drawing and painting, although taught outside the University, may satisfy all demands upon technical excellence and stand to an academical recognition, exactly as all good extra-mural teaching does or should do. But supplementing this direct study of drawing and painting from the antique and life are subjects like anatomy, social aesthetics, philosophy, classic history, mythology, and other aids to knowledge and imagination.[100]

Two years after these comments were made, the issue of links between University and Art School was again given an airing: this time, on the occasion of the opening of the second part of the new Mackintosh Art School building in 1909. Said the *Glasgow Herald*:

> while it is true that opulence has brought leisure to enjoy and utility to procure the pleasures of literature, music and art so that these flourish among us, it is equally true that real appreciation of aesthetic delights is diffused among the many by a slow educational process and hence the enormous value to the community of every institution that aims at cultivating taste.[101]

As with Newbery, the cultivation of 'taste' was now related to what an academic curriculum had traditionally placed on offer. But the actualization of a long-struggled-for new Art School building – 'a great addition to an already handsome school'[102] – gave cause for increased optimism as regards a closer union between the University and the School of Art, and this was expressed by Professor Phillimore (Professor of Greek at the University) who

> hinted at the possibility of a closer union ... and one would be glad to see something of the kind. Already students of the School of Art are attached to other institutions to receive instruction in the theory and practice of communicating knowledge. It is not less important that they should dip into those humanities that have a natural affinity with the aesthetic arts.[103]

The rift between University and Art School in Glasgow had for long been a thorn in Newbery's side: five chairs of the fine arts existed in England and only one in Scotland, with no degree in fine art being granted by any Scottish university. He declared that a distinct and organized faculty of the fine arts was wanted which would have a Head occupying a seat in the senate, and with a staff of art teachers or professors 'whose powers both as craftsmen and as teachers should meet all demands made by university requirements'.[104] It was a matter for consideration as to whether the School of Art would it-self be within University precincts, or be an extra-mural school. The central requirement in Newbery's opinion, however, was that the professor of fine art be a working artist: this was a *sine qua non* – he should be either a painter, an architect, or a sculptor, and, ideally, a combination of all three. Moreover, he should be a man of distinction in his art, and of culture in his outlook and work. But herein lay an enormous problem for the integration of artistic with academic education: a deep and established belief held sway among 'respectable folk' which portrayed the artist as an irresponsible being, of some questionable character, who was in possession of his *own* moral code and decalogue.[105] The history and development of art, and the history of social aesthetics, Newbery insisted, were parts of the larger subject of history: at any point in time the movements of a body of artists were simply those of a section of expressive humanity, and the influence and works constituting an artistic movement were historically relatable. With regard to the decorative arts under existing circumstances, the University should provide both patronage and protection 'because within its walls the students may work free from the control of the market and feel no need to respond to the call of commerce'.[106] This may have been a utopian attitude, but it was undoubtedly a function of his concern over the devaluation of the artistic sphere by a commodity-based economy; one forever establishing its dictates *vis-à-vis* the Schools of Art.

How far removed this negative sentiment of Newbery's about commerce was from those of the Art School's Directors when Newbery was appointed can be gauged by considering some of Watson's comments on the occasion of Newbery's appointment in 1885:

> The numerous manufactures of Glasgow afford a very wide field of action, and it is to Glasgow manufacturers that the Directors look for encouragement and sympathy to further the future efforts and develop to the utmost the resources of the School in the subject of design. To further this work we have engaged a special teacher, whose best endeavours and energies will be directed to the making of the instruction given by him consonant with the

requirements of Glasgow manufacturers.[107]

From Newbery's point of view, he had ultimately been forced to acknowledge the problems created for a wide acceptance of quality design by commercial agencies themselves: 'it is not altogether a secret that Commerce and the Arts and Crafts are not considered bosom friends';[108] 'commerce should not be allowed to preach where she should pray'.[109] However, the problem was that this predominantly Arts and Crafts mentality (and these latter remarks date from the peak of Glasgow's Art Nouveau success), and with it the practical work in the lighter handicrafts carried out within the Glasgow School of Art, was not establishing significant connections with contemporary technological developments in industry. The concepts of large-scale environmental design; of the mass production of well-designed items which could enhance the quality of life in a massified society; of intensified cooperation between art and industry; and of an architectural milieu reflective of the social needs of the time, to a significant degree were absent from Newbery's perception. He had started out by protesting against Ruskin's pessimistic outlook for the future of art by expressing a desire 'to take the present state of mechanical aids to manufacture as the new order of things'.[110] But in 1893 he made it clear that the machine was rendered impotent in the face of Arts and Crafts concerns: 'The machine cannot build a cathedral nor carve its wood and stones. It cannot fill its windows with stained glass, nor cover its floors with inlay, nor gild its roofs and mosaics.'[111]

The Glasgow School of Art in the 1890s undoubtedly witnessed a significant movement away from the established practices of copying, or imitating, natural objects, as required by the Science and Art Department at South Kensington, and this development helped to prepare the ground for the emergence of the Glasgow Style. Significantly, the School's Chairman, James Fleming, in 1894, was expressing relief that 'within the last few years especially the tendency to merely imitate natural objects – "objects of natural history" was the phrase in most catalogues – was gradually diminishing. At all events, the people who imitated them did so with more *artistic perception*.'[112] But by 1910, the period of stressing experimentation and originality appeared to be over. Reporting on the annual competition by children in Glasgow and district schools of drawing specimens done in the Glasgow Museum, Newbery (with fellow judges James Grigor and Joseph Vaughan) directed the attention of teachers and competitors to suggestions for further improving the quality and character of work submitted. One of the criticisms made was that

in the representation of vases, whether plain or ornamental, the light and shade due to the cylindrical form of the object must be expressed. In many instances the contours of vases were drawn and the ornament copied just as though the surface were flat, like a wall paper.[113]

If this resulted from a reaction to the old South Kensington approach, where drawing from the flat produced these kinds of result, the irony was that the free, decorative, two-dimensional, linear style of Art Nouveau practitioners – considered a significant advance in its time, not least in the form of innovative wallpaper designs – seemed now to have been quite negated as a desirable approach to drawing. Not only was naturalism being insisted upon, but experimentation, which had been greeted with little short of ecstasy in the 1890s, now seemed to be strictly tabooed, as the old South Kensington requirement of 'accuracy' was emphasized: 'all "tricky" or mannered technique should be discouraged. The essentials of good work are accurate and searching observation of form, light, and shade, or colour, to be expressed by careful, and intelligent workmanship in whatever medium may be selected.'[114] Ironically, this was the very 'method' of art education for children which Crane had abhorred. For Crane, the ideal to be attained in primary art education was complete freedom of expression. By contrast, Newbery's position in 1910 placed him alongside Crane's opponent Lewis F. Day, who took up an intractable position with regard to the movement towards imaginative work. 'Don't ask or expect originality from children', declared Day at a London County Council Conference on the Teaching of Drawing in 1908. 'Let them begin by copying ... the present reaction against it has gone far enough, if not too far.'[115]

In fairness to Newbery, it should be pointed out that the strength of the approach to art education which he exemplified most consistently, and which he practised as much in 1891 as he would in 1910, lay in its awareness of labour and imagination as being intertwined (this had indeed been acknowledged by Ruskin). This much he certainly contributed to Scottish Art Nouveau. His concern to integrate the Art School and the University illustrates well his fundamental conviction that artistic perception and intellectual understanding were intimately connected, and that, for this reason, their epistemological and institutional separation represented the most pressing of problems. But in struggling to establish a sphere of freedom for artistic production for an art no longer restricted by traditional reifying distinctions (high art, applied art, industrial art, etc.) the Art School–University dichotomy was viewed as representing a crucial field of determination desperately requiring to be transformed. If the route

to an aesthetically significant art and design of the highest quality had, of necessity, to be through the medium of the existent reality, then the elements of cultural relevance for a new art within that reality needed to be fundamentally different from those that had preceded them. This was the imperative constantly fuelling the vision of the arts united with academic culture in Scotland, which, for Newbery, represented nothing so much as the summation of a clearly apparent onward going process.

Although a workshop system was being operated in the School, production for social requirements on anything like a significant scale was external to it. In this respect the avant-garde were deprived of a consistently focused propagandizing role, since those who had been trained in the School did not subsequently have an institutional base other than their own limited locus of production. Meanwhile, the School turned out cohorts of students, but it did not directly solve the crucial problem of the inadequate relationship between art/ design/architecture and industrial production. Nor did the experimentation that was encouraged point in the direction of new ideas capable of effectively tackling this situation. In arranging for the incorporation of a Decorative Arts Department within the School, where artist–craftsmen were to give instruction in such subjects as glass-staining, pottery, wood carving, and artistic needlework, Newbery was not so much developing the teaching capacities of the School in the direction of actually supplying the needs of local manufacturing industries for new designs, as helping to provide what he himself believed these local industries should have been interested in acquiring. Indeed, the actual establishment of this department appears, above all else, as the realization of the desires of an Arts and Crafts ideologue forced by professional circumstances to argue that such activities were commensurate with Glasgow's requirements in the sector of industrial arts. The Programme for Session 1905–6 of the Advanced Course in Design and Decorative Art, subsequent to Adolphe Giraldon's appointment as Professor of that department, illustrates to what extent a social situation in which the artist/designer worked for wealthy patrons was assumed. The hedonistic imagination fostering such luxurious craft production was unquestionably far-removed from industrial art and the concept of general environmental design for a modern urbanized society favoured by Mackintosh. Under Giraldon, Design in the School was being conceived in terms of ultra-chic Arts and Crafts, and in doing so it was unavoidably invoking the paradigm of the life-style of the cultivated wealthy. Such could hardly be said to be commensurate with the most modern European trends after 1900, which were concerned to propagate closer co-operation between architect, designer, worker, and manu-

facturer. It is revealing that Mackintosh, on completing the new Art School building in 1909, should have chosen to indicate the progress of the School during the period that Newbery had been Director by mentioning expansion of staff alone; that 'when he took up that position 25 years ago the staff numbered 9; today it numbered 60'. No other achievement was referred to.[116]

Chapter seven

# Dissemination and reception

## The aesthete in Glasgow

Throughout the 1890s in Glasgow one of the most striking images created by the popular leisure journals was that of the 'decadent' aesthete.[1] It was in no sense accidental that this rarefied personage should have been portrayed by *Quiz* as one of the fashionable consumers of the *outré* modernity purveyed by Cranston's Tea-rooms.[2] An ethos of 'populist' sentiment was central to these petit-bourgeois journals – the *Bailie* had a weekly column entitled 'What the Folks are Saying' – and two dimensions of this pseudo-populism were to be found in anti-intellectualism and anti-aestheticism. Sneering at the pretensions of the intellectual 'coteries' was a regular theme. A common ploy was to make the aesthete appear to be a fake, a *poseur*, someone as equally ordinary and 'innocuous' as everyone else who appeared to be refusing to conform; but more importantly, a person who was, in actuality, the very opposite of what he was so pretentiously pretending to be, with his talk of 'the Yellow Book, and the decadents' moods and tenses, the last "daunce" and the Glasgow School' and who was ultimately more respectable than the respectable.[3] But with the first of the Wilde trials barely over, and with Aestheticism unambiguously linked with the unsavoury topic of homosexual 'perversion', an emphatic tone of outrage demonstrated that the time for humour was now over. It was thus proclaimed that

> a crisis in literature has been reached. The Decadents, the Neuroticists, the Yellow-Bookists, the Ibsenites, the Passionists, the Egotists, the Keynotists, the Yellow Asterites, the Ships-That-Pass-in-The-Nightists, and all the rest of the morbid and effeminate crew have been voted impossible.[4]

The repetitive and circular representations of 'Artistic Glasgow' continued, however: the array of stereotyped 'descriptions' still being

190

presented as the outcome of the reporter/observer's confrontation with real-life situations. Both 'fiction' and 'parody' are recognizable elements within much turn-of-the-century popular 'leisure' writing in Glasgow. In the whimsical book *Erchie* by Neil Munro (actually Hugh Foulis) a chapter describes a visit to the Willow Tea-rooms. Amusement centres on the effects, recounted by working-class Erchie, of the new decorative art upon the lives of him and his wife. Thus the aims behind the art itself, and the products of it, are made to appear ridiculous through the device of playing upon the sense of the incongruity of 'artistic' objects being used to decorate a tenement interior. But the sense of incongruity extended also to middle-class interiors where, for example, the effects of modish stained glass windows could provide amusement.[5]

The commonest means whereby Glasgow's petit-bourgeois journals set limits to discourse on and around artistic developments was by ignoring to a striking degree the Art School and most of the events relating to it. In 1901 *The Studio* remarked upon 'the influence of that "local patriotism", of pride of local citizenship, which in the old days was a source of such potent encouragement to every kind of art work in European towns and cities'.[6] This same influence, it continued, still operated here and there, 'as in Glasgow; but it is quite unknown in many Scottish and English towns'. This particular kind of encouragement was not, however, characteristic of Glasgow, despite the civic enterprise and civic pride manifested within the city throughout the nineteenth century. A significant gap existed between the Art School and local trades and manufacturers: an emphasis was placed in the former upon working in precious metals and jewellery, hand-made ceramics, carved wood, stained glass, mosaic, book-decoration, needlework and embroidery, which was not connected to modern technological potentialities. It is as if, in acknowledging this gap, the popular press – greatly in tune as it was with commercialism – set out to demonstrate its contempt for such antiquated endeavours. But this was not all: the fact that a new and distinctive local style had been created, passed apparently unheeded, and there appears to have been a deeply rooted hostility towards the overtly 'artistic' and the very aspects of 'advancement' that were being applauded abroad. When the Art School forwarded 110 exhibits to the Liége Exhibition of 1895, *L'Oeuvre Artistique* commented that

> Our Schools of Art are far, very far indeed, from being so advanced as yours and what has above all astonished us in your work is the great liberty left to the Pupils to follow their own individuality. Such is so different from the ideas current in our Schools of

Art that it is difficult for us to comprehend this freedom although we admire it very much.[7]

It seems that the press in Glasgow, together with a significant section of the local artistic establishment, had difficulty in comprehending it also. The Belgian Art Nouveau architect Paul Hankar was sufficiently impressed by the Glasgow School's work shown in Liége to comment that 'It would be highly desirable if this exhibition could be studied by all the heads of the "drawing factories" which in Belgium are known as Academies of Fine Arts.'[8]

An Inspector from the Science and Art Department at South Kensington, in his visit to the Glasgow Art School in 1897, had referred to the latter as being 'one of the most enterprising and vigorous schools in the Kingdom.....The variety of the work and the practical nature of the instruction reflect great credit on Mr. Newbery.'[9] Later in the same year, *Saint Mungo* (which, in contrast to the other journals, chose not to consistently ignore the School, and which took delight in ridiculing the work and activities of the School as well as of its Director Newbery) printed a 'Burlesque Operetta' ('Potentate and Painter') in which Newbery, as 'Diavolo Oldberry', was derided for being a theorist, an aesthete, and a follower of Whistler.[10] This made explicit how the Art School and its ethos were perceived by many. The fact that Newbery's own flat was decorated in the manner of the Aesthetic movement, with eastern rugs, tapestries, and washed-out walls, would have provided substance for the mythology of 'decadence' being promulgated. The *Evening Times* commented on the Macdonald sisters looking 'most aesthetic' in their 'sacque gowns and muslin fichus'.[11] Significantly, however, a contrast emerges between the popular journals and the local newspapers in the manner of portrayal of the Art School. With the latter, effete decadence and aesthetic bohemianism gave way to disciplined utilitarianism as the claimed central characteristic of the institution. On one noteworthy occasion the utilitarian aspects were so heavily emphasized by the *Glasgow Evening News*, and in such an idiosyncratic manner, as to portray even that bastion of rigorous discipline, South Kensington, as being 'decadent':

The school is under South Kensington – the South Kensington that is understood to make for all that is feeble, meaningless, and effeminate in art – yet the school prospers, and produces work which may be eccentric, daring, and, occasionally, crude; but is seldom weak or deficient in originality, suggestion, and resource. Round the school there has sprung up a distinct Art Student coterie, the members of which live and move much as did Clive

Newcome in his day, and as do his up-to-date prototypes of the big
Continental schools. Their talk on and off duty is of Art – schools,
movements, methods, values, motives, and the rest – and their
jargon is the jargon of the studio. In one respect, however, they
differ – fortunately or unfortunately, as you please – from their fel-
lows in France, Germany, and Holland – there is not much of the
Bohemian element about them; they seldom hear the midnight
chimes; they never give wine parties; and the police don't know
one of them by sight even. The Glasgow Art student is a conscien-
tious mortal, he looks ahead, and his school days are for him no
time of play.[12]

Whether the School was being denounced or commended, therefore,
the criteria of judgement employed were almost invariably rooted in
prejudice in favour of utilitarian values.

A couple of months after this description appeared, Geddes ad-
dressed the issue of the relationship of aestheticism to utilitarianism
within the pages of the *Evergreen*. Characteristically, his discussion of
these 'polarities' focused upon the elucidation of what he believed
was their involvement in an evolutionary dialectical movement. As
with Mackintosh, the scientific and the artistic were viewed as having
a common grounding in the dynamic imagination which mediates be-
tween subject and object. When he came to consider the doctrine of
Art for Art's sake ('and we all know how superior Art is to any
restraints of morality') Geddes employed an image of the aesthete as
a self-sufficient individual, sheltered amid the wealth and comfort of
the modern metropolis. In the cultivation of an aesthetic appreci-
ation of the world, this individual has ignored the call to action and
has calmed his 'questioning intellect': dispassionately absorbed, he
impartially observes the rich variety and contrast of modern life.
Hence, the aesthete develops as never before,

> his impressionist mirror growing more and more perfect in its pol-
> ished calm. So develop new subtleties of sense; and given this
> wealth of impressions, this perfection of sensibility, new combina-
> tions must weave themselves in the fantasies of reverie. Our new
> Merlins thus brighten our winter with their gardens of dream.[13]

Eventually, the morbid strain which lies latent in every individual life
is roused as an effect of this inaction. As though in an aside to
Beardsley and his consumptive condition, Geddes described how 'the
degeneration of the artist may set in from the physical side'.[14] Be-
cause this degeneration must find outlet, the temptations of the
urban aesthete begin to arise and increase. His training in ascetic

moral and intellectual resistance having been steadily relaxed, the aesthete is unable to resist these temptations. Does this mean then that all aestheticism is ultimately evil, and only (work-directed) activity good, asked Geddes. Has the last word to reside with the jeering, coarse, utilitarian, the joyless ascetic?:

> Not so: the road of life ever lies forward, through the present phase of evolution, not back from it, be its dangers what they may. This so-called Decadence of literature and art which, as we have seen, science fully shares, is no hopeless decline, but only an autumn sickness, and one of rapid growth and adolescence.... Thanks then, and even honour, to the art and science of the Decadence, since from it we have learned to see the thing as it is; it has even helped us likewise to imagine it as it might be: it remains only to ask if in some measure we can make it as it should be, and here lies intact such originality as is left open to us – that of Renascence.[15]

Thus in Geddes' view, aestheticism, in opting out of utilitarian functioning, has facilitated the distance required for a new kind of 'seeing', a qualitatively new perception of society at the height of modernity, and this has, in turn, engendered the hypersensitivity and imaginative potential required for the necessary vision of a new social order. A vision which replaces confusion, instability, and fragmentation with unity, creativity, and coherence: 'To see the world, to see life truly, one must see these as a whole; and only those who see this in movement do see it in whole.'[16] It is not so much the perception of being, therefore, which engenders wholeness, as the perception–apperception of *becoming*. Hence Geddes spoke of survival *and* initiative; conservation *and* innovation; decline *and* renascence. Fundamentally, the attention is drawn to the phenomenon of decadence in *fin-de-siècle* society as having facilitated, through a retreat to the inner sphere, the social distance necessary for an aestheticization of reality which is effected through an aestheticization of thought. David Frisby has pointed out that the 'retreat into inwardness (*Innerlichkeit*) and the *intérieur* is often taken to be a consistent feature of *Jugendstil*',[17] and in discussing Simmel's *The Problem of Style* (1908), he draws attention to the argument that the attempt by the individual to escape from the exaggerated subjectivism fostered through confrontation with a reifying objective culture in modern capitalistic society elicits a 'thirst for stylization' which is focused upon the (spatially confined) living environment. This stylization of the domestic sphere is central to *Jugendstil* and its attempt to realize the 'total work of art'.

Similar concerns are to be found in Glasgow in the same period. 'The room gradually became regarded as a work of art in itself,' wrote Hermann Muthesius in describing the 'element of novelty' characterizing Scottish Art Nouveau, 'not merely an accidental outcome of various artistic details collected together'.[18] The actual aesthetic effect achievable by stylizing the interior of the dwelling house and treating it as a harmonious work of art could be considerable. Desmond Chapman-Houston, an Anglo-Irish actor, writer and biographer, and a close acquaintance of the Mackintoshes, reflected that 'To enter the studio of Margaret Macdonald Mackintosh is to realize very vividly that only dreams are true.'[19] And Chapman-Houston would have been less than perceptive had he not realized that these were the dreams of an aestheticism energized by the drive towards maximizing the 'space' between (stylized) interior and (urbanized/commercialized) exterior. Thus the Mackintosh studio was

> far away in that mist-encircled, grim city of the north which is filled with echoes of the terrible screech of the utilitarian, and haunted by the hideous eyes of thousands who make their God of gold. Vulgar ideals, and the triumph of the obvious, are characteristic of the lives of the greater portion of its population; and yet, in the midst of so much that is incongruous and debasing, we find a little white home, full of quaint and beautiful things, with a big white studio empty of everything but the Artist's Jesso panels, all prepared and made beautiful for her by her artist-husband, in order that her genius may have a fitting home, and her exquisite, quiet art congenial and fitting surroundings.[20]

## Local reaction to the appearance of the new style and the significance of Beardsley

There is, perhaps, a deep irony in the fact that Margaret Macdonald's 'quiet art' should, along with that of her sister, in the beginning, have elicited the kind of outrage which has often accompanied the reaction of a complacent 'public' to the kind of 'artistic' experiences which it would rather not have. The description 'quiet art' is, in this context, a ridiculous one. In 1894 Glasgow was presented with images so strikingly modernist that the ensuing hostility of the local artistic establishment must, in retrospect, appear to have been inevitable. The fact that this hostility was far from being an overnight affair, that it was rather to have a lasting effect upon local perception of Glasgow's avant-garde, must be viewed as a fundamental indicator of the depth of resentment felt for this new development on the eve of its inception.

At the Students' Exhibition of Holiday Work housed in the old

Fine Art Institute in the spring of 1895 '"The Four" isolated their contribution and in their section, was seen the first blooming of a new style in Architecture, internal decoration, and in various crafts.'[21] Thus ran Mrs Jessie Rowat Newbery's description of the event which appeared to signal the origins of the Glasgow Art Nouveau movement. But even before this particular exhibition, work by the Macdonald sisters had elicited in many quarters a hostility strongly characterized by the desire to equate the style and imagery manifested in the work with decadence, morbidity, and wayward affectation. Underpinning the reactions there were hints at associations with sexual licence, disease, and degeneration. The initial expression of revulsion came from Alexander Roche, one of the 'Glasgow Boys', who referred to the water-colours by the Macdonald sisters which were shown at the Exhibition in November 1894 on the occasion of the Distribution of Diplomas to the Glasgow School of Art Club:

> As regards some of the extraordinary things which were exhibited, he personally felt that they were dreadfully clever, but the question he asked was – Where is this thing leading? It seemed to him to be leading to the graveyard. (Laughter.) He thought the designs he referred to exhibited a very unhappy spirit, which should not go very much further. He would like to say nice things, but after examining some of these productions he had had a dreadful nightmare and one of his fellows was now ill. (Laughter.) If he had an opportunity, he would press upon future judges the desirability of putting down this ghoul-like sort of thing ... [22]

The tenor of Roche's comments – not so much his emphasis upon death as being the meaning underlying the artistic liberty manifested in the work, as his demand for increased control – mirrored that of the *Westminster Gazette*, which had remarked of Beardsley's work in the first edition of the *Yellow Book* (April 1894), 'we do not know that anything would meet the case except a short Act of Parliament to make this kind of thing illegal.'[23] The day after Roche's outburst was reported, a letter appeared in the *Glasgow Herald* making explicit the relationship between the style of the posters on show (by unnamed students) and the style of Beardsley.[24] But not everyone considered the work worthy enough to be considered alongside that of Beardsley (recently dubbed Weirdsley by a contemporary art critic) or his true followers. When in January 1895 a poster executed by Mackintosh (though not credited to him at the time: it was even suggested that the work was, in fact, by Beardsley) for the annual exhibition of the Fine Arts Institute appeared, a lover of Beardsley, signing himself 'No Flim-Flammery', complained that the poster had

none of Beardsley's qualities of 'genuine artistic elegance and correct perspective ... except that the colour printing is good'.[25] The real sense of outrage, however, had been directed at the works by the Macdonald sisters seen in November 1894. A letter from 'A Mere Outsider', printed in the *Glasgow Evening News*, contained the germ of what was to blossom into the 'official' interpretation of the new style: this was the work of inept amateurs, who, in setting out to employ the device of shocking the public, attempted to conceal their lack of genuine ability and mastery of technique:

> Painting figures with no clothes on has always excited opposition from a large portion of the public, but these ambitious enthusiasts in their search after truth paint their figures without even their flesh on. The only consolation I can see is they can't go much further. What I want the 'Life Class Student' and 'Amateur Artist' to tell me is – (1) Will this new art do anything to elevate the masses to a higher degree of culture? and (2) What new beauty has been created by it for the solace of mankind?[26]

The one thing that both the admirers and the detractors were agreed upon, was that the work on show represented a style that was, unquestionably, new, and in respect of this, the significance of the gender of the artists involved did not go unmarked: 'Many of the pictures exhibited by ladies at the Exhibition of School of Art Work in the Fine Art Institute are fearfully, wonderfully, and weirdly "new". Their impressions of the female form, particularly, are startling.'[27] A view such as this of the 'New Woman' (independent, creative, career-oriented) in art was undoubtedly illuminated by an awareness of the political significance of a transformed perception of women's artistic abilities, and may well have come from someone active in the women's suffrage movement. At the time of The Four's controversial debut Jessie Newbery began teaching her embroidery class at the Art School. Along with a number of other women artists and designers in Glasgow (Ann Macbeth, Helen Frazer), Jessie Newbery was active within the women's suffrage movement, and attention has recently been drawn to the practice, by Glasgow School of Art students, of stitching suffrage banners between embroidery classes.[28] The fact that certain practitioners of the 'new style' were also 'new women' would, in itself, have been sufficient to engender local hostility, even without the presentation of shocking images. Thus, along with the dangers of Aestheticism went the threats posed to the traditional middle-class requirement that women acknowledge their social duty and become settled, respectable, wives and mothers. Given that the Macdonald sisters did actually marry, their position as wives and ac-

tive artists could not help but be a contradictory one in the context of conventional gender stereotyping and role requirements. 'If Eve is to be allowed to come in and interfere in civic affairs,' proclaimed the *Bailie* on the topic of the 'mad' suffragette 'ladies of Glasgow', 'then Heaven only knows what will occur. Why won't she stay at home and see to the cooking of the broth and the darning of the stockings?'[29] The 'new woman' was clearly perceived as being disruptive and dangerous: such a woman (as against 'lady') would be expected to cultivate bizarre tastes and interests, and *Quiz* made it clear to its readers that one such interest, namely in aesthetics, could even help provide for the new woman access to the detested 'Gilmorehill coteries' (albeit through a man): 'She spoke. "James", she said, "promise – (sob) – you'll – (sob) – wear pale blue – (sob) – ties no more, and – (sob) – that you'll attend – (sob) – University Extension courses on Aesthetics – (sob) – Geology – (sob) – and Physics – (sob)".'[30]

When *Quiz* referred to the 1894 Exhibition it was to commend landscapes, flower studies, and etchings: 'As for the "ghoul-like" designs of the misses Macdonald,' it complained, echoing Roche, 'they were simply hideous, and the less said about them the better. Distinctly the authorities should not halt till such offences are brought within the scope of the Further Powers.'[31] More abuse was to come, and in February 1895 it emanated from the direction of the by now well-established Glasgow Boys. James Guthrie, in delivering a half-hour-long address to Glasgow School of Art students, seized his opportunity to damn the efforts which were proving so controversial, and, significantly, to present them as evidence of brash inexperience and lack of disciplined abilities:

In his criticism of the endeavours of the Glasgow School of Art – some of them exceedingly wild endeavours, be it parenthetically remarked – Mr. Guthrie, whilst commending in warm terms the originality displayed by the students in all their work did not spare their ludicrous striving after that supreme simplicity which comes only after long years of weary, hard, and laborious study. He seemed to insinuate that these students, or at least many of them, at the outside of their careers, fancied that simplicity of *technique* was an easy thing to acquire, and that they had only to go imitating some master or other with a simple style and, – hey presto, – they would all be painters. On this score he disillusioned them effectively, at the same time emphasizing the value of a simple style in the hands of one who knows how to use it. The splendid simplicity of Phil May is in reality elaborate complexity, and the myriad of

mediocre pen-men who have endeavoured to follow in his foot-steps and tumbled into the ditches of oblivion, is surely a warning to the young men and women who study Art and Posters, under Mr. F. H. Newbery.[32]

But what of Beardsley? The most exciting 'new designer' of the peri-od, the man widely acknowledged as providing the model for so much of the work eliciting reaction in Glasgow, merited not a mention by Guthrie (whose work, ironically, appeared, along with that of Roche, in Volume XI of *The Yellow Book*). This was hardly accidental, far less an example of Guthrie's ignorance of new developments: here was another instance of setting limits to discourse. The contrived silence, the refusal to raise the controversial issue of 'decadence', and the expressions of contempt for the deserving victims of oblivion, would undoubtedly have had the effect of engendering the view that Glasgow's most experimental artist–designers were producing work which was original, but which was technically deplorable. Thus ques-tions of content or meaning, questions which could not have avoided confronting the implications of this apparent language of dissolution (that is, of artistic form *and* cultural coherence), were conveniently circumscribed by focusing exclusively upon technique and by deliver-ing 'an instance of the backward complaint that avant-gardistes never learn to draw'.[33] This point cannot be overstated because such an 'in-terpretation' was subsequently to be applied with unbending con-sistency to avant-garde developments in Glasgow. Even in 1901 the *Glasgow Advertiser* referred to the 'abortive efforts' which resulted from Art School 'amateur workers' 'with just enough knowledge of art to copy its eccentricities'.[34] No specific names were named – such an action may have had the dreaded effect of encouraging interest – but since 'straining after effect' was the specified crime, then Glas-gow's press-informed citizens would have had knowledge of who some of the worst culprits were. Seven years may have elapsed since the initial controversy, but the ensuing silence had been pervasive enough to virtually eliminate any confusion as to who were being (not) referred to.

Howarth commented upon the similarity of form, technique, and emotional content between the early drawings of the Macdonalds and those of Mackintosh and MacNair. The earliest dated example of a water-colour by the group was Frances Macdonald's *Ill Omen*, or *Girl in the East Wind and Ravens Passing the Moon*, executed in 1893, and which appeared (along with works by Margaret Macdonald and Herbert MacNair)[35] in *The Yellow Book*, Vol. X, July 1896. Howarth found this work 'surprisingly mature, and hardly suggests an initial essay in a borrowed style....The style is well developed and technically

the painting is more accomplished than, for example, Mackintosh's Conversazione Programme of 1894.'[36]

It was indisputable, on the basis of a close examination of their early work, asserted Howarth, that the Macdonalds played an important part in the evolution of the Glasgow Style. But which particular works were shown at the controversial 1894 Exhibition? It would appear that *A Pond*, *The Fifth of November*, and *Summer* (a stained-glass design) were seen, for two reasons: firstly, these were reproduced in the Spring and November numbers of *The Magazine* (now in the Glasgow School of Art) in 1894; and secondly, they correspond to contemporary descriptions which appeared in the press. One contributor to the correspondence columns of the *Glasgow Evening News* complained:

> Imagine human-beings drawn on the gas-pipe system – arms, legs and bodies of the same skinny pattern with large lips and immense hands. The background of one of these masterpieces consisted of various parts of anatomy subjects, floating about in an objectless manner in a sea of green mud.[37]

This was clearly *A Pond* by Frances Macdonald, a pencil and wash drawing symbolizing November. In Howarth's description this work is

> a composition of two repulsive, emaciated human figures representing dragon-fly nymphs framed by aquatic plants, and crowned by a writhing group of tadpole-like masks. The subject is *A Pond* and admirably captures the atmosphere of a most unpleasant submarine world of stagnation, slowly undulating slimy vegetation and decay, the principal colours being mauve and green, now greatly faded – a most peculiar choice of subject for a young lady of the 1890s![38]

Howarth compared this work with the 'somewhat bizarre' subterranean–symbolistic design by Mackintosh which appeared on the cover of *The Magazine* in the Spring 1894 number: he concluded that the two works were 'of particular interest because of the contrast between Frances Macdonald's hideous, angular, and greatly distorted females and the plump, well-proportioned nudes by Mackintosh'. He expressed the rather psychologistic view that 'Sadness and tears always seem to dominate the minds of the sisters',[39] and that the 'gently flowing curves' apparent with their experimental early work were 'the curves of *art nouveau*'.[40]

Adorno, in rejecting a subjectivist interpretation of new work

which elicits a shock effect, insists that the category of the new in art has nothing to do with base sensationalism: rather, newness 'emerges irresistibly with the development of art itself'.[41] The concept of modernism, says Adorno, was necessarily abstract, and it indicated firmly that 'something ought to be negated, and what it is that ought to be negated'.[42] Abstraction challenged the illusory notion that, in a society of economic power and bureaucratic control, meaningful life still subsists, and it provided a means to achieve aesthetic distancing from tradition and social conditions. In a non-traditional society that is constantly engendering change, the dynamic quality inherent in that society's concept of historical tradition makes the notion of aesthetic tradition highly dubious. Thus where styles and artistic practices were negated by new styles and practices before modernism, the latter negates tradition itself: 'In so doing, it extends the sway of the bourgeois principle of progress to the field of art. The abstractness of that principle is tied up with the commodity character of art ... the new is intimately related to death.'[43] It is in its mimetic relation to a petrified and alienated reality that the modernity of art is to be found, and it is this which makes it 'speak'. The new is thus a necessary outgrowth of what is objective rather than subjective:

> As soon as capital does not expand, or, in the language of circulation, as soon as capital stops offering something new, it is going to lose ground in the competitive struggle. Art has appropriated this economic category. The new in art is the aesthetic counterpart to the expanding reproduction of capital in society....The only way in which art can henceforth transcend the heteronomy of capitalist society is by suffusing its own autonomy with the imagery of that society.[44]

When viewed in this way it becomes apparent that there was nothing accidental about the juxtaposing of 'decadent' modernist subjects with examples of poster art in these 1890s exhibitions (such as the Macdonald sisters' poster advertising Joseph Wright's *Umbrella Factory* in 1895). The motivations towards the symbolism of decay, despair, morbidity, and death in early Glasgow Art Nouveau are inextricably linked with the motivations towards an art which, most relevantly with Beardsley and the poster, was making overt its attempts to aestheticize commercial imagery. 'Advertisement is an absolute necessity of modern life,' Beardsley declared in *New Review* in July 1894, 'and if it can be made beautiful as well as obvious, so much the better for the makers of soap and the public who are likely to wash.'[45] The existence of the poster was justified, Beardsley continued, on the grounds of utility, 'and should it further aspire to beauty

of line and colour, may not our hoardings claim kinship with the galleries'.[46] The attempt to combine beauty with utility represented the starting point for Glasgow Art Nouveau and it is extremely significant that this strategy should have been recommended by Beardsley, long since acknowledged to have exerted a considerable *stylistic* influence upon The Four. The best poster art from the 1890s illustrates well the striving for intensified abstraction with its elements of linearism and stylized two-dimensionality, and with Beardsley the very aestheticization of images for advertising purposes heightens the sense of distance between the image and the product that it is advertising.

In Adorno's view then there is a point at which modern art surrenders itself to that which it opposes, and identifies with the negativity of social conditions. In this context he could easily be taken to be describing the reaction to early Art Nouveau in Glasgow when he asserts that 'The noisy witch hunts and the charges of decadence that have been an abiding feature of the reception of modern art take off from here.'[47] This identification with social negativity on the part of artists and intellectuals, while acknowledged by Geddes, represented for the latter something to be transcended. Such transcendence could only be achieved subsequent to the realization that the negativity was, in fact, objective, and not merely subjective, as he believed Freud was claiming: 'these horrors which Freud and others treat as simply psychological and biological, are also deeply social in nature and origin.'[48] Here Geddes points in the same direction as does Adorno (and of course Simmel, Benjamin, and Nietzsche), and orients the discussion of modernism towards a recognition of its crucial relationship to a 'decadent' modern social reality. Where artists indulged themselves in the creation of images of horror through the 'art play of imagination', their 'Modern Art', said Geddes, resulted in 'too much pathological phantomology with a touch of technical invention'.[49] At this point Geddes virtually replicates the criticisms that were directed at the paintings of the Macdonalds: in particular, he casts aspersions upon adequate technical ability. For art to survive meaningfully in a future, qualitatively transformed, social state-of-affairs, imagination needed to be more fully related to emotion and intellectualism. Too many artists were 'Thought-Derelicts', 'or else at best worshippers of phantoms, when not of fossils'.[50] They lacked ideals, and a philosophy of reality. Modern art and poetry were 'too often morbid, despairing, even delirious, with confused design, even vague vision, since lack of purpose'.[51] The tragedy of modernism was that it proffered images of a dead social reality and 'in modern days we see our poor, empty, circumstances, our sad physical facts, in pictures, too, more often dead than alive!'[52] Geddes' creed was that the

next stage of 'civilization' would require a synthesis of art and science, to be achieved through active labour – a working Philosophy of Life. Mere sense-data alone could not constitute art: 'Art ... demands PRACTICAL CO-ORDINATION, plus CONCEPTION (Imagination, Design), plus WORKMANSHIP (Technique); then PASSION will give creative execution: a combination of Intuition with Emotion, yet with Intellectualism, too.'[53]

As the sensuous and symbolic Glasgow Style of the 1890s gave way to an increasingly austere, abstract, and functional form-language around the turn of the century, it is perfectly possible to conceive of Glasgow's avant-garde, already fully in tune with the combination of art and utility, nodding with some approval at Geddes' recommendation that art merge with science, free creativity with discipline, whilst being actively involved in the process of developing their modern style. But having already acknowledged the importance of architecture as a 'real art', a problem remained: given the prevailing lower middle-class ambivalence to modern art in Glasgow, an approach to architecture betraying the influence of the new art was not going to be easily countenanced. Glasgow's 'public' would not quickly forget the links between newness, either in art or in women, and 'decadence'.

## An avant-garde approach to uniting art with utility

The potential for decorative art to begin to colonize the public sphere in Glasgow was being acknowledged in the city prior to 1890. In the context of the International Exhibition of 1888, the year of the first Arts and Crafts Exhibition, the *Glasgow Herald*, when referring to the design by the architect James Sellars for the galleries which were to contain the art works (paintings and sculptures, but also photographs) to be exhibited, commented upon the decorative treatment to which the walls of the galleries were being subjected. What was desired as much as anything, it was stressed, was to make the gallery itself 'in the first place' attractive. The initial focus of attention was viewed as settling on the design of the room itself: 'to get a room which by its own beauty shall restrain people from hurrying through it is one of the first steps towards getting them to examine its contents.'[54] The actual significance of the relationship between the room, salon, or gallery, and the objects deployed within it, was thus already becoming an issue for comment, and the work of the architect was being placed in the primary position. Where new concepts of artistic design were concerned, the importance of theories emanating from architects in this period cannot be overstated.

T. L. Watson, in introducing the first of a series of lectures on the

*Principles of Medieval Architecture* sponsored by the Art School, and delivered (illustrated by 'lime-light views') in the Corporation Galleries in 1894, stressed that the significance of a knowledge of architecture went far beyond the architectural field itself:

> To students of architecture it went without saying that the history of architecture was an absolutely necessary part of their study, but it should also be considered that for all engaging in any class of art work, the study was almost equally important in order to perfect familiarity with the forms of architectural styles. That, he thought, was being recognized more and more every day. They would find that the best designers in different classes of work were those who had studied architecture, which was not only the foundation but also the union of the different arts in one harmonious whole. The period to be treated in the lectures was a highly important one – there was none would better illustrate the harmony and the unity of the various arts employed.[55]

Here was not only reference to the Art Nouveau concern with the unity of all of the arts, but also a specification of the central relevance for contemporary arts of what the Gothic Revival had drawn attention to as the principles underlying all of the best architecture.

There had long been a tension in Glasgow between the elements of the artistic and the technical as these affected the perception and practice of architecture, particularly where the city's architects themselves were concerned. As early as 1861, Alexander Thomson, in his capacity as Chairman of the first meeting of the session of the Glasgow Architectural Society, proclaimed that the object of the society was *not technical.* 'We do not wish to wrap our art in mystery in order to gain an ascendancy over a superstitious public.'[56] In terms of the view from South Kensington, as presented by Thomas Armstrong in an address delivered in Glasgow in 1889, however, it was not the technical side that was wrapped in mystery so much as the artistic:

> If you can get the artisans to your school [that is the Art School] the general well-being of your town will be promoted, for every mechanic, and especially those connected with the building trade, can be taught that something which will make his labour more valuable. For these, generally, I attach more importance to mechanical drawing with instruments – geometry, drawing to scale, and the elements of architecture. Such work is apart from and beyond its immediate commercial value to the workman, an intellectual exercise of the highest value, inducing accurate habits of thought as well as dexterity of hand.[57]

But for Scottish Art Nouveau, technical concerns merely represented the basic starting point for architecture. As Mackintosh made clear, it excluded what was fundamental to the development of a new architecture. For quality and originality to be at all possible, the true aim had to be an artistically informed one, and this required a clear distinction to be made in the first instance between the grammatical (syntactical) and meaningful elements of architecture:

> Architecture must no longer begin and end with the mechanical possibilities of the tee square[,] the set square[,] the pencil[,] bows, the deviders [sic] the undoubtedly meritorious work of those necessary instruments may be likened to the alphabet, the grammar, of language[;] the artistic and beautiful phrasing of literature [likened] to the more precise adornments of a building, and that is just where the real work of an architect as an artist should and must begin if the architect is to be appreciated as an artist, if his work is to be given to the world and understood by its people as the great mother art, the all embracive[,] the comprehensive embodiment of all the arts. But to do this requires conviction.[58]

This illustrates that, even in 1902, by which time Mackintosh's work had become more overtly 'functionalist', the basic Art Nouveau 'conviction' had not been sacrificed. To assert that the real work of an architect should be likened to 'the artistic and beautiful phrasing of literature' involved perpetuating the language and imagery of aestheticism (in the sense of the motivation towards beautifying both life and art) and there can be little doubt that Mackintosh was fully aware of the connotations which this orientation conveyed in his contemporary Glasgow. Aestheticism was by now widely associated with decadence, amorality (or at least the rejection of moral purpose), hedonism, contemptuous mocking of the traditions and conventions so beloved of the middle classes, and, ultimately, with the transvaluation of bourgeois values. If Wilde's dictum that 'industry without art is barbarism'[59] seemed harmless enough and not too disruptive of the status quo, the dangerous intensity so characteristic of aestheticism had produced the 'perverse' opinion that true beauty resided in 'that which the middle-classes call ugly'[60] (and that what they called beauty did not exist). In 1897 *Saint Mungo* had already invoked populism as a weapon against Glasgow's Art Nouveau practitioners (whom it dubbed 'Jim-jammers'). They were mocked in characteristically 'ironical' fashion, and portrayed as having an elitist contempt for 'the public'.[61]

In taking account of 'Muir's' description of the architectural scene in Glasgow in 1901 it appears that considerable optimism was attaching itself, at least in some quarters, to the ability of architectural

'style' to develop in accordance with functionalist and constructivist principles. But in terms of the commendation of such principles alone, apparent 'artistic' elements, such as organic symbolism, were negatively differentiated on the basis of their exhibiting an allegedly effete or 'weedy' influence:

> within a radius of half a mile from the Exchange there is much that is balanced and well relieved, and the newest comers are breaking up the skyline with an almost startling variety of profile, while the sparing use of the emphasis of detail upon wide, tranquil spaces lends it the sudden brilliance of a good 'attack' in music.[62]

So far, this commendation of a 'sparing use of the emphasis of detail' to the end of aesthetic effect is commensurate with Mackintosh's recommendation that attention to the 'more precise adornments of a building' should represent the starting point for the architect who desires artistic credibility. In both cases the analogy is with art forms dear to the aesthetic movement, namely, music and literature. But when the Aesthetic effect of apparent construction is acknowledged, the significance of adornment is downgraded. Consequently, this has crucial implications for the Art Nouveau influence, since the latter had been associated with the practice of adding 'artistic' adornments and decorative motifs to the basic structure of a building:

> There is to be noted, also, a growing tendency to accentuate the constructional lines. The style has become not only simpler, but more varied, and almost everywhere the belief that honesty lies at the root of good art is refreshingly evident. Some few things here and there show a weedy, 'arty' influence, and in certain places the strange idea seems to obtain that the vegetable is the architect's pattern. But it must be said, on the whole, that architecture is distinctly promising in the West of Scotland.[63]

From the vantage point of Mackintosh's architectural philosophy a description such as this presented an unreal distinction; a distinction founded upon the assumption that between the 'arty' and the functional/constructional a universe obtained; and that if the latter came into any sort of contact with the former, then it was hopelessly enfeebled as a consequence.

In 1960 Pevsner pointed out that, shortly after 1900, a wave of influence affected the Continent from Britain which appeared to be anti-Art Nouveau in its apparent pointing towards a twentieth-century style, but which, in fact, involved a synthesis, emanating from Mackintosh ('a Scotsman and a Celt') 'of Art Nouveau and anti-Art

Nouveau which was the most inspiring of British exports'.[64] A similar view was expressed in *Time* in 1953, where it was argued that

> In architecture Mackintosh subordinated the vegetable writhings of *Art Nouveau* to massive stonework reminiscent of 17th-century Scottish castles. His famed Glasgow School of Art so well integrated the two that critics today vehemently disagree as to whether the building was a flowering of *Art Nouveau* or a foreshadowing of Gropius' bald glass and concrete Bauhaus building at Dessau.[65]

Such views represent a not very successful attempt to pin down just what was distinctive about Glasgow Art Nouveau. Why should functionalism–utilitarianism be 'anti-Art Nouveau' if Art Nouveau was avant-gardism which was motivated towards the *integration* of art into a fundamentally utilitarian society? But even 'Muir' could not consistently maintain the distinction between the 'arty' and the 'honest', even within the confines of a single book, and this is nowhere more apparent than with 'his' appreciation of the specifically artistic qualities apparent with the Mackintosh tea-room designs. In this context, all connotations of 'weediness' were conveniently subverted as the 'world of art' and the world of the 'Glasgow man' were seen to be capable of harmonious unification within specific social locations.

On the concrete level, a process of attempting to unite (a utilitarian) architecture with art can be delineated in Glasgow at the turn of the century, and the prime agency of motivation in this was undoubtedly the Art School. *The Builders' Journal*, in discussing the classes at the Art School which were considered to be of especial use to architectural students, mentioned those on geometry and perspective, life and antique drawing, modelling, design, and decorative art.

> We strongly recommend all students of either architecture or of design and decorative art to take both courses, for no thoroughly good work will ever be done in the arts that relate to architecture unless the worker has some considerable knowledge of the sister arts.[66]

Newbery urged the importance of public control over city architecture, suggesting, at the same time, the possibility of such a body as a committee of public taste. His attention focused upon Paris, where the Art Nouveau style had recently been presented to the world at the International Exposition of 1900: 'In Paris an architect was an artist. Here we treated our architects as builders.'[67] This succinctly specified the direction in which the avant-garde wanted architecture to move. The best architecture, he continued, was a crystallization of

thought, architectural instinct, and artistic insight. Even Lord
Provost Chisholm (forever being lampooned in the popular jour-
nals), in bewailing the 'dull monotony' of the city's skyline, polemi-
cized about bringing an artistic approach to bear on the public
sphere. He acknowledged that the bestowing of an artistic quality on
the environment wherever possible, redeemed much of the sordid-
ness of city life, and he expressed the desire to see 'even our
lamp-posts and other adjuncts of the city, not only useful but giving
expression to some aspect of beauty of form and design'.[68]

The area contained within a thirty-mile radius of Glasgow's city
centre was considerably more heavily populated and densely built
than any other Scottish area of similar dimensions, and thus spare or
open ground was at a high premium, a harsh factor of the city's reality
which could, on occasion, be conveniently obscured by those with a
vested interest in supplying exclusively the needs of the middle
classes. If modern domestic architecture was being claimed by the
traditionalists to be significantly free from constraints of style, it
could hardly have been said to be free from constraints of land-value.
A. N. Paterson's Liberal Club design (1909) demonstrates the effects
of such constraints in the way in which it incorporates a style of
balcony derived from that in J. J. Burnet and J. A. Campbell's
Royal Scottish Academy of Music (Athenaeum). This latter design
of 1891–3 had 'pioneered' the narrow frontage vertical composition
that subsequently became common in Glasgow with the increasing
redevelopment of highly priced Georgian house plots.

The problems of land values, restricted space, and the kind of
bland utilitarianism which Mackintosh denounced, produced, in the
form of the design for the new Royal Infirmary, a focus for criticism
from those elements in the architectural profession who welcomed
the interpenetration of the utilitarian with the artistic. Subsequent to
having viewed the front elevation of the design chosen by Glasgow
Corporation for the new Infirmary building in 1904, Horatio K.
Bromhead, President of the Glasgow Institute of Architects,
complained that

> the proposed sky-scraper could only be considered a calamity to
> the most venerable specimen of architecture in Scotland, the Ca-
> thedral. If it were for the public good, feelings might be stifled, but
> when it was known that the most modern and perfect ideas were
> dead against it, when one saw that the most remarkable modern
> hospital [Belfast] was only one storey high, and the intended new
> building at Birmingham was to be only two storeys high, one could
> not help seeing the ill-advisedness of spending a large sum of
> money after the manner of a bygone generation.[69]

Bromhead proceeded to underline his argument that the problem lay with the 'unfortunate tendency' to divide the architectural profession into two parties: firstly there were those 'who seemed to want to make out that art was everything, and who struggled to get elected into some art atmosphere, which they possibly imagined was superior to architecture, where they could ignore business capacity and practical knowledge by employing skilled specialists to do the real work for them'.[70] On the other hand there were those who were content with making their work purely practical and businesslike, and whose skill enabled them to employ materials sensibly and in an economical manner, 'but with little thought of suppressing what was ugly'.[71] It was a disaster, said Bromhead, referring to the recent agreement between the Glasgow School of Art and the Glasgow and West of Scotland Technical College, to confine the 'art teaching of architecture' to the former, and the constructive and scientific branches of architecture to the latter. The antidote, however, was 'in the air', as exemplified by what had become a pressing contemporary question, namely, the statutory registration of architects, and this, Bromhead concluded, was the 'happy medium' represented by a combination of both ideas.

But one issue that the statutory registration of architects was not going to affect was the relationship of women to architecture, and this has crucial implications for the consideration of Glasgow Art Nouveau, because the latter was a movement in which women were prominent. When Ethel and Bessie Charles became members of the Royal Institute of British Architects in 1898 and 1900 respectively, there was fierce reaction. In Glasgow, even where women's 'enterprise' and 'unconventionality' in art production were acknowledged, the traditionalists still considered that unconventionality was not a desirable attribute for cultivation in women:

> If there be any doubt about the prevalence of the [female] sex in the artistic world, one has only to go to the Art Institute tonight and see the appalling prominence of the girl pupil in Mr. Newbery's school. Nowhere, indeed, is the girl more bounding than in the Glasgow School of Art, where, by her enterprise and her excesses in unconventionality, she has far outstripped her brethren of the brush.[72]

With the exclusion of women from the architectural profession, apparently fundamental attributes of architecture itself were equated with 'masculine' properties, and values rooted in gender stereotyping were projected onto architectural creations. The most obvious of these was 'structure', which was connected semantically with positive

qualities such as stability, strength, honesty. When the quality of Mackintosh's work was being debated in the 1930s, it was the constructivist elements in his architectural practice which were singled out for commendation. Conversely, the 'artistic' or 'decorative' aspects were negativized, and in such a manner as to present the latter as having been unfortunate manifestations of the ('feminine') influence of Margaret Macdonald. Thus P. Morton Shand, in the 1930s, writing in a letter upon the issue of a proposed exhibition of work by the Mackintoshes, stated that

> Roughly speaking, what will interest the Continent is purely Mackintosh's architectural-structural work; not the dead and forgotten 'artistic' or 'decorative' frills which so often marred it.... These are not my views ... but those of the whole body of international post-war architectural criticism. They do not make any 'distinction' between husband and wife; they simply do not consider there was a 'wife' in that sense ... I cannot say anything to imply that I attach the slightest importance to Mackintosh's 'Decorative' work, or to any of his wife's whatsoever.[73]

The previous month, Shand had written that Mackintosh's mentality 'anticipated the future with amazing provision, hers was statically contemporary, and contemporary to a still-born, purely decorative phase of art'.[74] These criticisms occupy a midpoint, so to speak, between 'Muir' at the turn of the century, and Howarth in the 1950s, within a modern 'tradition' that has consistently devalued the significance of the 'artistic' or 'decorative' side of Glasgow Art Nouveau. In this respect it has perpetuated the kind of prejudices that were originally directed at the Aesthetic movement: namely, that a conscious desire to 'beautify' or 'decorate' manifests inherent elements of weakness (associated with 'femininity', or, worse, if the culprit is male, effeminacy and gender-inversion). Underpinning such prejudices lay associations with weirdness, effeteness, selfishness, and morbidity. Julius Meier-Graefe, ten years after the exhibition which had first presented the Macdonald sisters' work to the Glasgow 'public', illustrated something of what Glasgow Art Nouveau inherited when he commented that 'In Glasgow English art was no longer hermaphrodite but passed into the hands of women.'[75]

### Arts and Crafts and Art Nouveau at the 1901 Exhibition

On the surface of things, Glasgow's largest International Exhibition, that of 1901, might easily be assumed to have provided a significant opportunity for the city's avant-garde artistic movement to demon-

strate not only its style, but also something of the ideology behind that style. Such, however, would have required a quite different type of exhibition from what was actually mounted; and what was mounted was hardly a serious follow up to the Paris Exposition of 1900. The nature of the problem was highlighted by Alexander McGibbon, who had started out by comparing the Glasgow event with the achievements of Chicago and Paris, both of which had been 'truly expositions of the world's progress in art, science and commerce'.[76] He then proceeded to reveal the kernel of the issue: the Glasgow Exhibition was a highly generalized affair, initiated by those whose main motive had been to give delight to the city's citizens and to accumulate an economic surplus. 'Doubtless a more directly educative result would have been attained, had the promoters attempted some specialized display of Scottish – not to say British – arts and industries on a somewhat more extensive scale than that of the London series, the "Fisheries", "Naval", and others.'[77] The Exhibition did not, therefore, provide the opportunity for Scottish work to be either coherently or comprehensively displayed. But overall, the lack of any display theory or technique was painfully apparent. 'The first impression of a Great Exhibition is bewildering,' declared Lewis F. Day in *The Art Journal*, 'simple as the plan of it may be, and in this case it is.'[78] From the vantage point of the spectator confronting a multiplicity of commodities the initial psychological effect was one of mind-numbing confusion and incoherence. McGibbon had a similar response: he complained that 'much of the Exhibition, as an object lesson in the progress of humanity, and an illustration of the development and correlation of mind and matter, is lost in the very multiplicity of the display.'[79] This was a highly Geddesian view. Geddes, in the *Evergreen*, had welcomed what he called the larger view of Nature and Life, and he expressed the conviction that such a view resulted from 'a rebuilding of analyses into Synthesis, an integration of many solitary experiences into a larger Experience ...'[80] McGibbon's invoking of an image of a correlated mind and matter which has developed through history, relates directly to Geddes' notion that, towards the close of the nineteenth century, in the 'science of life', mind and body were coming together again through dialectical processes on the level of thought. This had its analogue in the interpenetration of the 'science of energy' with the science of society: 'physics and aesthetics, economics and ethics are alike steadily recovering their long-forgotten unity.'[81] But many solutions remained lacking. 'Many of us are no longer satisfied with analysis and observation, with criticism and pessimism; many begin to ask for Synthesis, for Action, for Life, for Joy.'[82]

In the first of the five 'Notices' which he wrote for *The Art Journal*,

Lewis F. Day, one of the founders, with the architect Norman Shaw, of the Art Workers' Guild, complained about the inadequate representation of English art and craftsmanship 'as it is at the beginning of the new century',[83] on show at the 1901 Exhibition. If the North seemed perhaps to have outdistanced the South on the basis of what was on show, that would prove merely that it was better represented, and of this, said Day, there was no doubt. The exhibition provided an opportunity, never so fully enjoyed before, of appreciating the quality and value of Scottish decorative art, in comparison with the best contemporary English and foreign works. The 'Northern art' was here upon its native heath, but whether this particular context was as sympathetic to it as Day implied is another question. Hostility towards the examples of Art Nouveau style apparent at the Exhibition was certainly expressed by English journals, such as the *Architectural Review*, but in terms of the Glasgow press, it was as if Art Nouveau as a developed style was as yet to be invented, let alone represented at the Exhibition. On the other hand, the euphemism 'artistic' was so overused, and so arbitrarily employed, as to render it useless for any purposes of reasonably accurate description. The *Glasgow Advertiser*, for example, referred to the Doulton pottery company's salt-glazed products as 'art examples', and to its 'artistically-coloured' slab mosaic panel in Parian ware (a material with a dull egg-shell texture) 'depicting Progress seated on a throne, with on her left the latest types of battleships afloat, and on her right numerous factories'.[84] Many of the innumerable examples of Doulton pottery wares were claimed to be 'extremely handsome and artistic'.[85] Ironically, Day should have been well pleased with the manner in which the *Glasgow Advertiser* chose to commend the English Arts and Crafts movement while at the same time belittling the achievements of the Glasgow School of Art. This deserves to be examined in some detail, not only because of the significance of a local publication negativizing (albeit in an unspecific way) the 'authentic' Glasgow Art Nouveau style that had been winning accolades abroad; but because a distinction was made *vis-à-vis* Arts and Crafts products between an 'artistic' and a commercial approach to design, and on the basis of this distinction the work of the Art School was portrayed as representing inferior quality Arts and Crafts products.

The context within which English Arts and Crafts were considered began with a description of the pavilion designed (that is, plans and decoration) by William Benson of New Bond Street, London. The exhibit was described as being a combination of 'artistic work' by London firms, illustrating some novel constructional features, and consisting of a long central-vaulted room, with small offices leading off it, in which were exhibited Benson's electric fittings and art metal

work. A number of cases displayed tableware, tea and coffee suites, kettles, trays, dishes, lamps, vases, and drawing-room ornaments in brass, copper, and electroplate. Three large gilt electric pendants, characteristic of Benson work, hung from a vaulted ceiling and various other electric fittings were shown on the walls or in the inner offices: 'These are few in number, and are placed effectively for lighting the pavilion, so as not to destroy in any way the effect of what is intended to be *an artistic rather than a commercial exhibit*.'[86] The firm of James Powell and Sons of Whitefriars was responsible for the glass used extensively with the Benson fittings and mounted vases, some 'new types of decorative glass' for above-positioned small windows, and for mosaic panels in the corners on either side. Wallpapers by Jeffrey and Co. of Essex Road, Islington (including the famous tulip frieze by Heywood Sumner), lined the ceilings, offices, and the central room. A grate designed by Ernest Newton was made by the Falkirk Iron Company in Scotland, and enclosing tiles were the work of the Pilkington Tile and Pottery Company of Burslem. The chief point of the exhibit, it was claimed, was to illustrate on a small scale the work of various firms associated with the 'best traditions of the English Art Movement'[87] (Voysey, Crane, and Mucha worked for Pilkington's, at which Lewis F. Day was chief Artistic Adviser):

> This movement, which started with William Morris and his pre-Raphaelite collaborators in the sixties, has effected a great and memorable revolution in popular taste. Closely allied in its origin with the English architectural revival, it has established an influence which is even more widely recognized on the Continent than in its native country. Indeed, it is not too much to say that the English movement is the original source of nearly all that is best in Continental applied art and decorative work, seeing that this indebtedness is freely admitted by foreign writers of authority.[88]

The primary purpose of this movement had been somewhat lost sight of in the profusion of 'extraneous growths' that had sprung up around it. These were none other than the Art Schools, which, although

> founded with the worthiest motives and doing excellent work, have nevertheless fostered a host of amateur workers with just enough knowledge of art to copy its eccentricities, and just enough technical skill to endow them with slovenly workmanship. These abortive efforts do not in any sense represent English 'arts and crafts'. They are a thing altogether apart from the ideal which actuated William Morris and his successors, of an artist's brain

213

directing and controlling the craftsman's hand. The characteristic of all the work exhibited in the Benson Pavilion, whether metal work, glass ware, wall papers, or pottery, is THOROUGHNESS. Good design goes hand in hand with the most perfect workmanship obtainable, and not a trace will be found of that straining after effect which is responsible for so many odd creations masquerading in the name of art.[89]

This was a calculated insult directed at Newbery (who arranged the exhibits of sculpture and architecture at the Exhibition), at Mackintosh, who designed the Glasgow School of Art Stall, at all of those in and around the School who could be accused of 'eccentricity', and ultimately at what was clearly acknowledged to be the assimilation of (English) Arts and Crafts into the Glasgow School of Art. But it was more than this. It effectively raised once again the old prejudice about the School's experimental work signifying inexperience and technical deficiency combining with a motivation towards outrage: in fact the very criteria employed by contemporary Arts and Crafts representatives in England to denounce the avant-garde work of the Glasgow School were here being reinvoked within Glasgow itself (Madsen noted that Benson 'who had been in contact with Morris, regarded the simple unornamented form as so essential that he hardly made contact with the [Art Nouveau] style').[90] But this was a double-edged sword: because the *Advertiser* was wholly in concord with the commercial exploitation of 'artistic' elements, it was, in effect, in a rather ambiguous position with regard to the Arts and Crafts movement, particularly where the latter were still emphasizing the artistic *as against* the commercial. But viewed from the angle of its pro-commercialism the *Advertiser* could be claimed to have favoured the kind of approach to industrial design and mass production represented by such Arts and Crafts-derived ideologues of a modern design aesthetic as J. D. Sedding. However, if it were to be suggested that the advocacy of commercially mass-produced 'artistic' goods was what lay at the root of the hostility expressed towards the Art School (which, as we saw, was not making significant connections with local manufacturing industries) it would have to be stressed that the *Advertiser*, in its coverage of the Exhibition, was commending both the commercial *and* the 'artistic' endeavours on show, but that where the latter were concerned these were allegedly at their 'purest' when demonstrating their allegiance to the standards of the English Arts and Crafts movement. Thus having established the latter as the paradigm of quality artistic design achievements, the Glasgow School, assumed to be following in its footsteps, by being evaluated in terms of the same criteria would have its manifestations of

experimentation interpreted as lack of firm knowledge and proper understanding of the true canons of Arts and Crafts technique and teaching.

Strong dissent from such a view of Arts and Crafts, as expressed by the *Advertiser*, was provided by Alexander McGibbon, who referred to the Canadian Pavilion as being 'of the style sometimes described as arts and crafts'.[91] He refrained from making any further comment at this point. However, when he later came to discuss the eight corner pavilions in the Industrial Hall, he complained that it could not

> be argued that the elements elsewhere employed – dado, column, entablature and attic – were in their adaptations exhausted; why then need they have been discarded for a form not in itself particularly beautiful. *It is a gratuitous surrender to the trivialities of the latter-day arts and crafts cult in architecture.*[92]

The most obvious question which follows from this is: how did McGibbon view Glasgow Style Art Nouveau? And how did the latter differ in his eyes from English Arts and Crafts?

The slavish following of English developments was by no means something new in Glasgow and it was certainly not unique to the *Glasgow Advertiser*. Considerable controversy surrounded the choice of an English architect of dubious merit for the permanent Art Galleries. 'Even now Glasgow has architects not unworthy of her,' proclaimed Dugald S. MacColl in the *Architectural Review*:

> Messrs. Burnet and Campbell, to name no more, have done good and congruous work. Why, then, did the Corporation, when they had a museum to build, go out of their way to introduce into the town the style of Mr. Waterhouse? That style has pervaded England because Mr. Waterhouse is a favourite with local committees who wish to have an academical assessor to aid them in their judgement. Candidates thereupon design in the manner most likely to meet with Mr. Waterhouse's honest admiration. But why, in the name of Scottish independence, did Glasgow follow this English custom like a sheep? The result is a fidgetty building, out of character with the surroundings in form and colour.[93]

*The Bailie* described the Galleries as belonging to the 'bride cake' order of architecture, and pronounced them a failure 'as far as their outside aspect is concerned'.[94] As regards the interior, Joseph Pennell, the celebrated black-and-white poster artist and friend of Whistler and Gleeson White, asserted that he had never seen space so wasted, and complained that the lighting was so atrocious that it

215

was impossible to see the pictures: 'You would say that the last thing thought of was the very object for which the building is supposed to have been designed.'[95]

McGibbon had referred to the Canadian Pavilion as 'arts and crafts', but when subsequently noting that it had been designed by local architects (Walker and Ramsay) he commented that some of its details illustrated the 'Glasgow School': 'that section of it at least whose energies are employed not in the fostering of a renaissance of national tradition in architectural style, but in timidly adapting the riotous unconventionalities that in Germany have already been freely exploited'.[96] If McGibbon had the Art Nouveau style in mind, then the most recent and accessible evidence of this style's 'riotous unconventionalities' on the Continent had obviously been found at the Paris Exposition of the previous year, where the house of the *Art Nouveau Bing*, with its six rooms designed by Georges de Feure, Eugène Colonna, and Eugène Gaillard, had assured the success of the new style. It had elicited the response from the critic Charles Gennys (in the *Revue des Arts Décoratifs*) that 'It is claimed that the *Art* called *Nouveau* consists of new forms substituted for other outmoded forms, yet it is forgotten that (the *Art Nouveau*), like its predecessors, must remain logical, well constructed, and observe the limitations imposed by the materials employed.'[97] Among the sections on show, Germany had occupied the most space. The German gallery of decorative arts had *Jugendstil* décor that was already veering towards the kind of heavily linear and geometric simplicity which would come into its own in 1925 with the Exhibition of Decorative Arts in Paris. The German national pavilion manifested an 'official' classical style of straight, 'modernist', lines, emanating from Berlin; but the decorative section was dominated by Munich. The latter had presented a *Salle Riemerschmid* with work by Hermann Obrist (embroidered draperies with rectilinear as well as curved motifs), Bernhard Pankok (chair and dresser with curved sections), and Richard Riemerschmid. Madsen found in Riemerschmid's furniture contributions evidence of an Arts and Crafts (*and*, confusingly, 'Modern Movement') austerity and constructive simplicity; by contrast, his ceiling frieze was described as being unmistakably in the *Jugend* style ('we find the scroll motif in *entrelac* in the form of a frieze').[98] Was it, then, the *Jugend* style which McGibbon saw being assimilated by a 'section' of the Glasgow School?

McGibbon does not make a distinction between architecture and applied arts when talking about the 'Glasgow School'. This leaves us to consider the distinction he does make – that is, between the renaissance of national tradition and the assimilation of modern continental trends which were breaking with convention – in the

light of his acceptance of the 'Glasgow School' as representing the kind of artistic unity which he himself clearly welcomed. Consequently, both parts of his distinction can be seen to apply to Glasgow Art Nouveau. However, the distinction itself is wide of the mark and raises doubts about McGibbon's ability to understand fully the aims of the movement as articulated by Mackintosh. The fundamental aim was something McGibbon himself was obviously in favour of, namely, universality. Under Mackintosh this was to be achieved through, on one level, the creative synthesis of old and new elements (the combination of the kind of principles which McGibbon considered underpinned Gothic architecture and which Mackintosh found manifested in indigenous 'national' architecture with a modern inventiveness); and on another the integration of contemporary international stylistic elements towards a 'modernist' universal style. The German contributions to the Paris Exposition had already elicited from the critic André Hallays the assertion that 'The Germans streak the draperies of their most Gothic interiors with weird designs and produce an extraordinary mixture of the medieval and the new.'[99] Hallays found that everything on show manifested the 'decorative parody' of the new fashion that had emanated from Belgium and which had now spread across the world. English art was to be found at the origin of the Belgian movement, 'But today, in everything called Modern Style, in France, in Germany, or elsewhere, one finds only a slavish imitation of Belgian art.'[100] This meant, of course, that Austria and Scotland were 'imitating' it also. But it is certainly not the case that the Germans were at that time content to view themselves as slavishly imitating what the Paris Exposition was presenting as the genuine Art Nouveau with its *Art Nouveau Bing*. Max Osborne, writing for *Deutsche Kunst und Dekoration*, commented that 'For us Germans (the *Art Nouveau*) is a bit too feminine, too whimsical, too *cocotte*. For the French, perhaps, exactly what they desire'[101] (the French journal *L'Art Décoratif* printed an article on the Scottish style in 1898 in which it was stated that the style was unsuitable for Paris). The Preface to the official catalogue for the German section at the Dresden exposition of 1906, however, illustrates that the reference to the influence of Belgian Art Nouveau upon the Germans had not been rashly made. In singing the praises of van de Velde, it was stated that

> Above all, it is this Belgian who has made us Germans aware of Brussels; this man who, for the last ten years, has made Germany the centre of his activity, through whom our arts have found an encouraging direction, and around whom we have fought for recognition; a man whose work has endowed the evolution of

German applied arts with an undeniable energy. Belgium gave
him birth and educated him. She has endowed him with the deter-
mination of a revolutionary as well as a sense of tradition....
Germany has assigned him a place among his peers.[102]

Georges Lemmen (1865–1916), the Belgian painter and admirer of
Crane who joined the new applied art movement, and who worked
with van de Velde on the Dresden Exposition Lounge in 1897, had
already demonstrated that, before this date, a linear as well as a
stylized floral technique (such as was characteristic of Serrurier-
Bovy's early work) was to be found in Brussels as early as 1894. In
1897, the exhibition at the Congo Colonial Rooms, at Tervuren out-
side Brussels (van de Velde, Hankar, Serrurier-Bovy), showed a
result manifesting 'a surprisingly rectilinear architectural layout'.[103]

It is likely that McGibbon was presenting yet another negative ap-
praisal of the Glasgow Style of Art Nouveau, and, moreover, that he
was thinking at least as much of Austria as of Germany when refer-
ring to 'unconventionalities': after all, the Glasgow School had
participated in the Viennese Secession Exhibition, with significant
success, just the year previously. The form-language of Austrian
(late) Art Nouveau is linked to that of the Darmstadt group in Ger-
many through the involvement in the latter of the Austrian Joseph
Olbrich (1867–1908). With the Darmstadt group *Jugendstil* elements,
such as the decorative thickening of curved lines and the use of floral
details, are greatly reduced in favour of stylized, abstract patterning,
and are moderated by being combined with a system of horizontal,
vertical, and parallel lines. Olbrich executed a room interior for the
Paris Exposition as did also the *Wiener Kunstgewerbeschule* (with
Hoffmann-designed walls).

McGibbon's opinions illustrate that, even within the Art School
itself, the most progressive artist/designer/architects could not rely
upon consistent support for the style they were developing. Elements
in McGibbon's own theory of architecture were sufficiently close to
Art Nouveau ideology to indicate where his sympathies lay with
regard to the results of the intertwining of utilitarian and aesthetic
motivations. His response to the *actual* Glasgow Style was, however,
another issue, and appears, at best, to have been ambiguous. At any
rate, the main lines of the Canadian Pavilion he described as being
'fairly orthodox'. His remarks on the Glasgow School seem all the
more enigmatic when his positive response to the Russian contribu-
tion to the Exhibition is considered (see below, pp. 219–20).

There was obviously confusion over how to categorize those styles
of architecture on show at the Exhibition which deviated from appar-
ently straightforward historical models. The Benson pavilion, so

eloquently commended by the *Glasgow Advertiser* for its English Arts and Crafts integrity and its 'novel constructional features which are intended for the information of architects and builders',[104] was found by D. S. McColl to manifest 'a little too much of "L'Art nouveau"'.[105] McColl, painter and critic (for *The Spectator*), had been an ardent supporter of Degas and of French and British Impressionism; but with the work of the Post-Impressionists (Van Gogh, Cézanne, Gauguin) he betrayed a hatred of change, considering the new work to demonstrate a lack of skill and culture. Speaking of the group of critics who had supported Impressionism, of which McColl had been a member, William Gaunt noted that 'A native conservatism appeared in their desire to preserve a revolt as an institution....To welcome a second revolt was unprincipled.'[106] When it is borne in mind that Post-Impressionism emphasized form over content, and the primacy of the mode over the object of representation, then a relationship becomes apparent between McColl's hostility towards Post-Impressionism and his dislike of Art Nouveau, which latter exploited the evocative power of formal qualities to an even greater degree.

More than anything else, with the Benson pavilion it appeared to be attempts at 'novelty' which elicited McColl's annoyance: the novelty of laying the tiles on the roof flat side by side (and thus allowing rain to come through them); the novelty of the treatment of the windows in the booth: 'These are apparently glazed in a metal framework of rather clumsy design, but on a nearer view it is discovered that the framework is in no way attached to the glass, which is simply an ordinary pane in front of it.'[107] In Glasgow itself, the 'malady' of Art Nouveau had numbered many victims:

> One finds old firms of cabinet-makers like Messrs. Wylie and Lochead, renowned in the past for sober and solid workmanship, breaking out into lurid and fantastic display. But the farther afield the disease travels the more acute becomes its virus. The Russian booths, with their monstrous decorations, made everything else appear quiet by comparison.[108]

The latter was a reference to the 'Russian village' which sported an agriculture pavilion with pale green and salmon pink walls and Indian red shingles; a mining pavilion with green shingles; a cubic style forestry building with 'warm light brown and buff' walls and 'grey-blue' shingles.[109]

Day found it impossible to take seriously such 'aggressively strange architecture' as the Russian exhibit, finding it ungainly and unacceptable to anyone who appreciated the 'logical development of

design out of given conditions'.[110] If it represented anything at all then it was 'the new art' but viewed through distorting Slavonic glasses. 'It is the mad imagining of the newest of new artists, in short an architectural nightmare.'[111] By contrast, McGibbon found the Russian section 'quite the most important display made by any foreign power',[112] and referred to the varied colouring as being 'quite harmonious', although he expressed disappointment at there being no carving, and at the fact that the possibilities offered by a colour scheme of unpainted wood had not been exploited (when later, the architect of the Russian Exhibition buildings, Shekhtel, was to be found 'propagandizing' the white lacquering of the Glasgow Style circa 1901 that he had earlier confronted on his visit to Scotland, Mackintosh had moved away from lacquering wood in this manner, to a more consistent presentation of 'natural' grains). *The Bailie* started out early in 1901 with characteristic sarcasm to ridicule the Russian builders who were at this stage involved in erecting their Pavilion. A Cartoon Supplement ('Russia at the Exhibition') had depicted the Russians as a sullen army of long-jawed characters, humourless, and involved to the point of fanaticism in setting up the construction. Accompanying captions read: 'The Russian Axe: The Workman's Principal Tool'; and 'Part of the Exhibit: Looks like a Gas Work?'[113] But by April it seemed that prejudice had given way to admiration:

> The Russian section, in the way of painting and decoration, puts all others in the shade. The style of ornament, quaint and, in appearance, occidental, and the beautiful harmony of colours is deserving of all praise. One has only to compare it with the painting and decoration of certain other of the erections on the grounds to see what depths of vulgarity the ordinary house-painter in this country descends.[114]

In one sense this is a surprising evaluation: that Day's 'architectural nightmare' of 'new art' should be considered quaint, stylish, and harmonious by this most chauvinistic of petit-bourgeois journals is deserving of comment. But if this aspect is unusual (and it could well have been conditioned by the factor of there being substantial commercial trade links between Scotland and Russia), what is not is the predictable mockery directed at local examples of design, through, on this occasion, invoking the image of the 'vulgar' house painter: an image contrived for the purpose of deflating the 'artistic' pretensions of certain local exponents of the 'decorative craze'.

The incorporation of aspects of the new decorative art forms into commercialism can be viewed from the vantage point of the contem-

porary advertising which accompanied the 1901 Exhibition. Processes of cultural fragmentation can be seen at work where only selected elements of the 'new' were integrated into commodity production. What now could be marketed along with the goods was an image of these products as embodying an inherently artistic meaning that was wholly contemporaneous. A washable water paint marketed under the name of Duresco since 1876 was used for the Exhibition buildings (Concert Hall, Russian Section, Irish Pavilion, etc.), and not only were the manufacturers (James Duthie and Co. of Glasgow and Dublin) able to boast that sixty tons of the paint had been used for the occasion, but they lost no time in capitalizing on the 'we are all artistic now' ethos, and in such a way as to present their product as a medium capable of satisfying the highest *artistic* requirements. Hence Duresco was claimed to be 'The Modern Equivalent of the Fresco of the Old Masters'; the contemporary association of white with modernity could make it 'The Paint of the Twentieth Century' specified by 'leading Architects', and recommended by 'Up-to-date Decorators' because it was 'Economical in Use, Artistic in Finish, Durable in Results'.[115] Is it merely coincidental that Mackintosh's return to 'natural' wood finishes took place after 1901? The Duthie company were, of course, by no means unique in playing up the artistic language. Copland and Lye, which, with the expansion of the range of customers for branded goods in Glasgow in the 1870s and 1880s, had established itself on the model of the large department store in 1878 (Pettigrew's followed in 1888 and Treron's in 1890), now advertised 'Reversible Art Carpets', 'Tapestry Carpets', and 'Inlaid Linoleums' ('The Floor Covering of the Future'). Pettigrew and Stephens, whose display at the Exhibition sported a stand designed by Mackintosh, who also designed exhibition stalls for Rae Brothers and Francis Smith's cabinetmaking firm, employed Aesthetic movement language ('the designs are exquisite') in describing their 'Magnificent Brussels Carpet Squares'. This firm formally opened its Sauchiehall Street warehouse, subsequent to 'elaborate structural alteration' to coincide with the start of the Exhibition. A wide pillar-supported entrance, marble staircases, stained-glass windows, 'effective' lighting, an elevator, and 'the most rapid cash service' were all incorporated. But perhaps most noteworthy was the inclusion of a Geddesian 'outlook tower' which incorporated a camera obscura, as did the original in Edinburgh.

When Lewis Day came to consider the show of carpets in the Kiosk of James Templeton and Co., he was moved to assert that 'Perhaps in the determined effort to meet the every want of retail trade, they [the Templeton company] allow themselves to be led sometimes in a direction which their better judgement must tell them is not the

way of art.'[116] What Day really meant was 'not the way of utility', since it is clear that his criticisms were directed against what he saw as a process which was compromising the functional in order to exploit public taste for an enhanced 'artistic' appeal in goods for the domestic interior. While conceding that carpets which had 'more the appearance of delicate tapestry than of carpet' were triumphs of manufacture, and although 'Flowers and arabesques could hardly be better painted in wools', Day was not restrained in expressing what he took to be the major error of this development: such carpets were unfit to be trodden upon, whether based upon historical or modern designs:

> That may be said to be rather the fault of the French style than of the Scottish manufacture. But a similar forgetfulness of the position to be occupied by carpets, is shown in designs more up-to-date. The latest thing in carpet design seems to be to plan it as if for hangings or wall-papers. Designers appear to be claiming a freedom from restraint which amounts to licence – Mr. Walter Crane himself giving the countenance of his name and authority to a practice more honoured, it seems to me, in the breach than in the observance.[117]

If Day was here emphasizing the ethics of functionalism/utilitarianism from his Arts and Crafts standpoint, then it is of the utmost significance that when it came to acknowledging the functionalist approach of Mackintosh, he took the path of portraying the latter's inventions as examples of the work of a stalwart individualist who had risked eccentricity in order to manifest his originality. Thus the severe simplicity of the Glasgow School of Art Stall, 'a sort of cage in which to confine a pair of lady bookbinders', was, in fact, designed

> to show how simply an erection of the sort may be built, the straight lines naturally suggested by carpentry construction being allowed to assert themselves, with no attempt at ornament beyond what is afforded by judicious distribution and proportion. A similar severity is to be observed in Mr. Mackintosh's permanent building for the Glasgow School of Art – planned apparently on lines nakedly utilitarian, yet everywhere revealing the marked individuality of the artist. His symbolism, as in the case of the ring and balls framing the name of the school (adjacent), is his own, and apparently for himself; he takes, at all events, no pains to make it intelligible to the mere Southerner. So imperturbably does he work on his own lines that to eyes unsympathetic it seems like affectation; but there is honestly no doubt as to the genuine-

ness of the artistic impulse. Whether it is quite wise in him to fol-
low it so unhesitatingly is another question – which time will
answer.[118]

When Day had, earlier in the year, described a house by George Wal-
ton shown at the Exhibition, he took this as being representative of
the work of the newer generation of Glasgow designers. At this point,
the aim of newness in design had not seemed to be a great problem.
He had found that 'There is throughout a determined effort to do
some new thing in design, and it is not often that it fails.'[119] Else-
where he had specified the two main ideas underlying the work
influenced by the Glasgow School of Art as being the determination
to be new, and an effort at simplicity.[120] But in comparing the Wylie
and Lochead exhibit (designed by Taylor, Logan, and Ednie, whose
names were suppressed at the time by the firm) with the traditional
furniture exhibit of Howard and Sons, Day revealed the kind of 'func-
tionalist' criteria that he was (for the most part implicitly) bringing
to bear. After the experience of newness, the first impression created
by the Howard exhibit was 'how dull the old work is! how often we
have seen it before! how well we know it! No! it does not strike one
at all: we pass it by.' But dullness and the homeliness that accompa-
nied it were to determine, so it seemed, the ultimate choices made.
The new, whilst undeniably striking, was not amenable to comfort.

> But if it should occur to us to question which is the more comfort-
> able, which is the more homely, which one would rather live with
> – the answer is not doubtful. The armchairs on page 240 are an in-
> vitation more cordial by far than any utterance of the new art.
> There is hope in that perhaps; in this there is satisfaction.[121]

Against these kinds of criteria the aesthetic–asceticism of a spare
modernist functionalism has failed before it has begun. But despite
the careful attempts to sound neutral when discussing the manifest
attempts at newness in Glasgow, Day was, in actuality prejudiced
from the outset. When writing on the subject of Art Nouveau in *The
Art Journal* in October 1900, he had expressed the view that, when the
English spoke of the 'New Art' it was with an inflection of irony, since
'It shows symptoms not of too exuberant life, but of pronounced dis-
ease.'[122] The same sentiments were expressed by him in 1901, in *The
British Architect* (June), and in *Macmillan's Magazine* (November).
Access to the press was clearly not a problem for this Arts and Crafts
traditionalist,[123] but it has to be said that Day's admiration for the
Howard furnishings even makes a nonsense of Arts and Crafts con-
cerns.

223

It is possible to discern here something of the divide between the taste patterns and correlated life-styles of the avant-garde and its intellectuals, and the bourgeoisie; a divide which would increasingly come to characterize twentieth-century capitalism. In recent years Bourdieu's empirically grounded work on class in France led to his establishing specific categories of 'intellectuals' and 'bourgeoisie'.[124] 'Intellectuals' (artists, lecturers, etc.) possess significant cultural capital but little economic capital. The 'bourgeoisie' (as distinguished from the 'new bourgeoisie' of private sector executives active, in particular, in areas such as finance, marketing, purchasing, design; and who possess both cultural and economic capital in significant quantities: and the 'new petit bourgeois' (service class) comprising those in occupations such as advertising and sales and in public service) are strong on economic capital but are weaker on cultural capital. The latter, with their 'material base, this-worldly satisfactions', are dependent upon the intellectuals for signs of distinction. But the limits to this dependence are determined by the fundamental divide separating these two groups within the 'dominant class'. This divide is expressed, according to Bourdieu, through the intellectuals' symbolic subversion, or reversal, of the rituals of bourgeois culture, and one form that this takes is the manifesting of 'ostentatious poverty': the intellectuals' tastes for functionalism/modernism in design are thus contrasted with the bourgeois attraction to the sumptuous and the indulgent.

Bourdieu's survey can help to shed some light on the turn-of-the-century situation we are examining. If Mackintosh may be viewed as an early modernist exponent of functionalism, an exemplar of intellectual taste, Day, while hardly fitting the description of the full-blown, opulence-consuming bourgeois, does represent something of the 'innocuous compromise' (Adorno) characteristic of the bourgeois taste which modernism was refusing to tolerate. However, it should be remarked upon that, where it is Day's reaction to those manifestations of the new art that could be described as being softened by Romanticism (the novelty of the 'pre-Raphaelite ideal' striven for with the Wylie and Lochead Pavilion, which was, incidentally, disliked by the Hungarians for its whimsy and exclusiveness when it was displayed in 1902 at the Iparmuveszeti Muzeum in Budapest) which focus his priorities and preoccupations, the really significant contrast inheres in his position *vis-à-vis* the 'nakedly utilitarian' work of Mackintosh with its aesthetic–asceticism and its architectonic qualities which make an expressive element of construction through the rejection of traditional and semi-traditional forms. It is here that the gulf between Day's desire to 'preserve the old amid the new',[125] and the uncompromising radical functionality

of Mackintosh is at its greatest. In highlighting the dispiriting experi-
ence of the old in the light of the new, Day, ironically for the ultimate
placing of his priorities, illustrates well the truth of Adorno's state-
ment that

> The only refuge the old has is at the vanguard of the new, not at
> the rear; it can be found in the interstices of the new, but it would
> be useless to expect the old to furnish continuity.... Works that do
> not live up to this principle immanently, that is in their own con-
> text, become inadequate.[126]

A solid bloc of opposition towards Art Nouveau, one which
viewed it as an essentially Continental style, had been established by
the Arts and Crafts movement by 1901. In their much publicized
judgements of new work, critics such as Crane and Day were able to
obstruct a full understanding of what was being signified through the
new form-language. In 1901 similar attitudes towards Glasgow
School work as those that were directed at the early paintings and
posters of The Four are to be found. The central avant-garde com-
mitment to modernism of the movement, in no sense compromised
but rather developed and continues to elicit hostility and misunder-
standing. Thus Lewis Day finds that Jessie King's 'strange treatment
of the human figure' employs 'a maze of sweeping lines, ornamental
indeed, but so altogether unintelligible, that you wonder how the art-
ist ever arrived at them'; and that Ann Macbeth employs a 'savage
type of ornament' of 'severe simplicity'.[127] Here Day is reacting to the
two-dimensional decorative approach characteristic of Art Nouveau
which has pattern predominating over traditional perspective; but it
is possible, in the light of the involvement of such avant-gardists as
Macbeth in forms of political radicalism, to read a wider meaning
into his use of terms like 'savage'. Significantly, he was unable to de-
cide on whether the work of the Glasgow School of Art (which he
found 'does not make the show one would have expected of it')[128] was
inherently individualistic or nationalistic.

A contrast which requires to be highlighted is that between the
'Glasgow Style' as manifested in the Wylie and Lochead Pavilion
(and, additionally, with Walton's work) and the rectilinear cubic
functionalism of Mackintosh. Speaking of the former, Juliet Kinchin
points out that 'For the modestly affluent, middle-class audience they
wished to attract, Wylie and Lochead could now offer a more dec-
orative and homely version of the experimental designs produced by
The Four in the 1890s – Mackintosh without the Spooks and
Ghouls.'[129] While this description convincingly relates the limited
acceptance of The Four's work to the period of reaction to the early

works, it has the effect of diverting attention away from the crucial area of contrast between their work and that of others, and between the aims of the avant-garde and those of commercialism. Under the auspices of Wylie and Lochead the team of Taylor, Ednie, and Logan aimed for a *mediation* between the modernist principles of Art Nouveau (as a style *and* an ideology) and the requirements of bourgeois taste, through a compromised 'tinkering' with the Glasgow Style as developed in the 1890s: Mackintosh sensuously tarted up and with greatly diminished asceticism. But Wylie and Lochead's commercial concerns represented a nonsense of Art Nouveau's anti-historicist aims. The company produced, alongside 'their' version of the Glasgow Style, still popular 'revivalist styles', and these were shown in their 'Royal Reception Rooms' at the exhibition (Louis XV Drawing Room; Jacobean Dining Room). Of The Four, Mackintosh in particular had moved on to develop a spare/ascetic cubic, rectilinear, geometric style, a new form of Art Nouveau which was commented upon in *Decorative Kunst* for its striking closeness to the style of the Viennese School. Significantly, the contrast between the (earlier) curvilinear and (later) cubic–constructivist permutations of Glasgow Style Art Nouveau was manifested at the 1901 Exhibition with Mackintosh's very different designs for commercial companies (Pettigrew and Stephens, Rae Brothers, Francis Smith) and the Glasgow School of Art respectively. Only the latter could be considered overtly constructivist. Since with construction, as Adorno puts it, 'Art takes on expression through frigidity',[130] the broad, unmodelled, cubic planes of Mackintosh's style in this the Viennese Secession's 'geometric' period, were more expressive of modern aims in the specific sense that the works are taken beyond their own functionalist language, and as a consequence, purpose itself is manifested as content. Purpose becomes the complement of aesthetic effect which is achieved through the medium of enhancing form. This was to realize the Art Nouveau ideals of combining form with content and the artistic with the functional-utilitarian for the 'total' work of art. On occasion, the one could over-balance the other, of course, as with certain objects of furniture which underplay (and compromise) practicality to the end of aesthetic effect. At any rate, it is these works of Mackintosh which demonstrate McGibbon's thinking with regard to the intertwining of the elements of symbolism, artistic design, and structuration. But when this approach is related to that of Ednie, Taylor, and Logan for Wylie and Lochead, we have, on the one hand, Art Nouveau, and on the other, a compromised commercialized version of it which was already assimilated to the eclecticism that Art Nouveau had set out to oppose ideologically and stylistically. While the form-language of geometric abstraction and tectonic constructivism in late Glasgow

Art Nouveau could be taken as reflecting a mass-producible com-
modity character, an 'artistic' autonomy was maintained which
placed these productions in a relationship of tension *vis-à-vis* com-
mercial imperatives and commodity markets. The team of Ednie,
Taylor, and Logan also developed simplified, less elaborate schemes,
clearly geared towards viable large-scale production. This involved
careful strategies to keep down costs. *The Studio*, when examining
the furniture included in a modern dining room and drawing room
designed by Taylor, executed by Wylie and Lochead, noted that it was
'inexpensive and unobtrusive – placed for a purpose, not for a
show'.[131] On the subject of Logan's furniture designs, the journal de-
scribed how he aimed 'at maintaining the architectural quality by
preserving extreme simplicity of form in the leading structural lines,
relieved in the secondary parts by ornamental detail'.[132] Reference
was made to the essential close relationship between the maker of
the design and the maker of the product, and in this respect, wrote
the anonymous contributor, 'no better instance could be adduced
than the successful enterprise of Messrs. Wylie and Lochead'.[133]

Chapter eight

# Conclusion
## The demise

Throughout the analysis we have been conducting, it became apparent to what degree experimentation and conscious control over technical procedures were important issues for the Glasgow avant-garde. These were apprehended as the means towards the emergence of new types of art. In tracing the career of the Mackintosh movement, we have illustrated something of the truth of the proposition that a dilemma for those seeking the new consists in the fact that what emerges *as new* is never integral or 'complete'. This helps to explain the significant changes which affected the form-language of Scottish Art Nouveau over a period of time. We also saw the kind of problems which resulted from the attempts to objectify the new within a cultural environment pervaded with traditional aesthetic norms. But the movement itself was never 'complete', and before 1914 it had dispersed. In this final chapter we will examine the main local and national (in the Scottish *and* the British sense) factors which had a crucial bearing upon the inability of the avant-garde to consolidate its position in Glasgow.

Commerce and heavy industry represented the mainstays of Glasgow's economy at the close of the nineteenth century. In terms of housing the enormous workforces required, shortage of land was a major problem: paradoxically, the poorest class occupied the most expensive land in and around the city centre. The housing layout, if such it could be called, reflected the economic morphology: moreover, it provided the most unfortunate consolidation of the non-existence of innovative concepts of large-scale environmental planning and/or design. In 1909 'A Special Correspondent' for the *Glasgow Herald* expressed his interest in how Vienna was attacking the problem of its slums, and at the same time made it clear that the major obstacle to progressive town planning in Glasgow lay with the

piecemeal nature of the planning activities within the city's housing sector.[1] Even if a proper scheme of town planning, along the lines of such as recommended by Geddes, had been capable of being implemented in Glasgow, and it was not, because of land values and the fragmented nature of land availability, patronage, and property ownership (as well as the scale of the latter), it is unlikely that the new movement would have been given much opportunity to be involved in it because (a) the aims of the movement were not adequately understood locally; (b) there was significant hostility towards it, it being portrayed as bizarre, effete, decadent, etc.; (c) the issue of potential costs for large-scale environmental transformation would have been a fundamental factor acting against it; and (d) there was disjunction between the artistic and technical spheres which was concretized in the institutional separation of art and architecture. In 1904 Horatio Bromhead of the Glasgow Institute of Architects articulated the argument that artistic–utilitarian synthesis in architecture was necessary for the avoidance of environmental disfigurement, but complained that such synthesis was not taking place in Glasgow. With hindsight it is possible to see that any avant-gardiste attempt to realize the fruits of a successful institutional combination of artistic and architectural/technical elements would still have had to confront the realities of Glasgow's economic morphology. But there were other obstacles also.

There appeared to be a woeful lack of understanding in Glasgow, not merely of what was actually required in the way of building, but of what was really taking place on the building front. In January of 1901, the *Glasgow Advertiser* informed its readers that 'Tenement and self-contained houses have been comparatively neglected, and preference given to building ground and public works.'[2] By April, an 'about-turn' on the issue of tenement building had become apparent: 'In what is being done in the way of building, whether on account of the burgh or on the part of individuals, as evidenced in the town hall, public baths, and tenement construction, an enterprising spirit prevails.'[3] The accelerated rate at which this 'enterprising spirit' had suddenly manifested itself should have evinced more than a little scepticism: in January it had been asked whether the 'disease' afflicting the volume of business during 1900 was general or confined to a district. The answer given was that 'An analytical study of the subjoined district table brings out the fact that, with the exception of Pollokshields, Queen's Park, and environs, the depression is common to the whole.'[4] This was undoubtedly true, and although the description here is of Glasgow, it was Glasgow's position within 'the whole' that was British capitalism which had, at this precise point in time, taken on a heightened significance. Considerable concern was

expressed in Glasgow, subsequent to the closing down of the 1901 Exhibition, over the withdrawal of 'over a million and a quarter of gold from the Bank of England'[5] to meet unexpected demands from Germany and France, because it was believed that such demands would continue into the future. Before the Exhibition actually began it had been anxiously stated, against a background of rapidly declining monetary value, that it was 'desirable money should not be allowed to fall much in value, so as to retain as much gold in London from going to the continent'.[6] In October *The Bailie* proclaimed that it went without saying that the 'hopeless state' of markets and the worsening state-of-affairs on an already inactive Stock Exchange were causing concern 'amongst capitalists and investors throughout the country',[7] and the *Glasgow Advertiser* asserted that it was evident that the Bank of England would 'require at once to take steps to obtain some control of the market, especially in view of our enormous indebtedness at the moment to the French market'.[8] This indebtedness was having the effect of fanning the flames of an already overheated anti-Continental feeling.

The Glasgow avant-garde did indeed foster a Scotto-Continental artistic style, but the ideological components underlying this nationalist *and* cosmopolitan style were of fundamental significance for the success or failure of the movement within the context of culture and class structure in Glasgow at that time. Notwithstanding factors such as the complex railway network connecting Glasgow with London since 1847 (fundamental to the commercial prosperity of the city), and with the remainder of Scotland by the 1880s, the city in the last quarter of the nineteenth century had continued to encapsulate what was essentially a local society, one considerably isolated culturally from British–national concerns. Even the large engineering, chemicals, and textiles firms, in the 1880s, reliant as they were upon world markets, were largely under the control of local capital subscription and local management. But around the turn of the century, Glasgow's industry was becoming increasingly controlled from London. Hence there was an intensified interest in the *British–national economy* which was focused upon dealings in the London Stock Exchange. Scottish businessmen were now establishing syndicates for capital export, credit, and trade, and were purchasing shares in foreign stock markets via the London market. Subsequent to the period when heavy industries were built up in the lowland regions of the country, the bourgeois class in Scotland, as a component within the system of British capitalism, and as a recipient of the benefits of that British imperialism which had transcended nation-state boundaries, wanted to compete with the Continent in markets for popular commodities. In this respect they desired the production of goods

manifesting a quality of design capable of meeting Continental goods on their own ground: only thus could the competitive potential of Scottish light engineering manufactures in world markets be enhanced. But competition involved also importation, and increasingly the latter was viewed as a threat to Scottish securities.

In 1901, a range of Glasgow workers in various occupations combined to restrict the importation of foreign-made joiner work, finishings, and suchlike, at the same time as slate quarry masters proposed the boycotting of foreign slates. These actions were denounced by George Herbertson at a meeting of the Architectural Craftsmen's Society, as being 'contrary to the spirit of Free Trade, which was the policy of this country'.[9] The limits to this 'policy' were to be found in British attitudes towards continental 'Free Trade' legitimacy. 'Even if we do not carry a commercial war into the camp of our enterprising Continental neighbours,' the *Glasgow Advertiser* broadcasted when spelling out the imperative necessity for institutionalized commercial education in Britain to match that already under way in Germany, Switzerland, America, France, Belgium, and Japan, 'we ought, in justice to ourselves, to prevent them working havoc in ours.'[10] Over the next decade foreign competition undermined heavy industry in Glasgow, with steel manufacture, ship and locomotive-building, and engineering seriously affected.

By the 1890s the economic and social advantages enjoyed by the Scottish bourgeoisie – many of which were to an extent disseminated, albeit unequally, throughout the social hierarchy – were inextricably connected to the economic, ideological, and political role of that class within British capitalism as a whole. New ideas grounded in a synthesis of 'genuinely' Scottish (such as Celtic ornamentation, or vernacular architecture) with contemporary continental cultural elements could not help but conflict with (a) the deferential relationship of the Scottish bourgeoisie to their counterpart in England; and (b) the ideology of British imperialism which, after the outbreak of the Boer War (1899), gave rise to increased widespread British–nationalist hostility towards the Continent. With regard to the latter point here, it was made clear by the popular Glasgow press that 1901 was not a time when the concerns of Geddes and his followers, the 'Geddemaniacs'[11] with 'amity between nations' (his major interest in the Exhibition alongside that of education), and the revival in a new form of Scotland's pre-1707 'Auld Alliance' with France, were likely to be appraised sympathetically. This was the year after the success enjoyed by Glasgow's avant-garde in Vienna (which was ignored by the Glasgow press) and a year before their involvement in cultural events at Turin and Moscow.

Against a background of introverted 'nationalism' in Scotland

(which for the most part took the form of carefully contained *kaily-airdism*:[12] the use of 'dialect' in the popular journals, for example, was never allowed to spill over into the articles, employing Standard English, on 'serious' issues such as the Stock Exchange or the art market), English Arts and Crafts, and English artists, designers, and architects, were lauded with praise and provided with commissions, while local practitioners were either given mediocre projects, or were ignored, slandered, and often portrayed as being inferior plagiarists of English ideas. Even William Young (1843–1910), the winner of the architectural competition for the design of the city chambers in George Square, Glasgow (1883–8), although born in Paisley, was a 'London Scot', an émigré who had moved south subsequent to having completed his architectural training in Glasgow. The architects James and Thomas MacLaren, Lorimer, Dunn, and Robert Watson, were either London Scots or were trained in London. In the sphere of cultural production overt nationalist ideology represented a kind of symbolic subversion, which carried with it the risk of possible disruption of the status quo. Only with the support among sections of the middle and lower middle classes for the Liberal Party's policy on home rule for Scotland did the issue of nationalism take on an overt form: and that form reflected, before anything else, Scottish support for the British political system, within a strategy implemented by a party desperately trying to combat the problem created for it by a fully formed Labour Party which had appropriated the support of large numbers of the ex-Liberal-voting working class.

The 1888 Exhibition in Glasgow was opened by the Prince and Princess of Wales, and Queen Victoria inaugurated the city chambers in the same year. Victoria was instrumental in fostering an image of the romantic Scottish highlands against a background of historic links between the Hanoverian monarchy and the Stuart dynasty. This made it respectable to be both a Scot and a loyal subject of the London-based monarchy and the empire: dimensions of British sovereignty which Victoria potently symbolized. But Victoria was also the 'mother' of the 'nation', and when Albert died she was popularly dubbed the 'widow of Windsor'. She thus epitomized a conservative family morality commensurate with the values on which the empire was built. In Glasgow, when the first exhibitions to include work by The Four were seized upon as providing evidence of a threat to public welfare, a widespread puritanical morality and fear of sensuality and spontaneity persisted in the city, and against this background the new artistic developments were interpreted as manifestations of Aesthetic movement opposition to the most revered aspects of the British character and way of life. Also, the sexual elements in the symbolism employed by The Four in their early works

232

were clearly perceived, although, characteristically, attention was not drawn to these in any explicit manner by commentators.[13] Considerable concern was expressed over the corrupting effects on the moral sense of women students in the Art School, of the requirement of drawing figures from the nude. To a striking degree France and Belgium were taken to be inherently amoral, and it appeared that this was nowhere more apparent than with their artistic productions. In respect of such attitudes in Britain, many of the 'artistic' were in the forefront. A certain William Kidston, who had visited and lectured upon the International French Exhibition of 1878, was years later referring to the French school of painting as being 'to a large extent meretricious and in bad taste, as well as lascivious in its character'.[14] Significantly, Kidston was looking to South Kensington for the hope of diffusing a taste for works of art displaying a specifically English sensibility throughout the provinces, by welcoming the forwarding of selections from the Museum there. Such morally grounded 'artistic' attitudes were often focused upon the activities taking place within the country's art schools. One of the pupils of the architect Norman Shaw (another London Scot), G. C. Horsley, who was officially connected with South Kensington, was outraged that at the National Exhibition of Student Work in 1885 the three studies of 'naked women' to be seen, the only such works on show, were all the products of female students: this showed, Horsley concluded, that in British art schools women were being 'trained at the public expense to assist in the degradation of their sex'.[15]

The popularity of an overt Scottish baronial 'style', either in architecture or in interior design (such as the interiors marketed by Wylie and Lochead), cannot be adequately understood without a consideration of Victorian/Edwardian novelty 'Scottishness', that is, a *mock-Baronial stylism*, as a manifestation of the Empire in which Scotland participated. This reached its peak with the Scottish Exhibition of National History, Art, and Industry in 1911. On this occasion all of the main buildings manifested pseudo-baronial stylism. To engender some historical credibility there was a 'Highland Village' and an 'Auld Toon', and authentic furniture and paintings were loaned from various famous collections. A loosely based reconstruction of Falkland Palace, employing steel frame with concrete 'shirt front', was erected as a 'Palace of History'. Relics of Scottish cultural history were absorbed into the most commercially ostentatious presentation of the Scottish-imperialist apparatus of tartanry. This meant that any anti-English significance attaching to the incorporated representation of the memory of Scotland's Auld Alliance with France (which anyway included an embarrassingly small number of exhibits) was severely curtailed.

As with the 1901 Exhibition, the newest ideas in Glasgow architecture were excluded, and the 1911 affair, on the eve of the First World War, demonstrated to what degree a banal 'nationalist' historicism mystifyingly emphasizing the status and power of Scotland's landed gentry was the current vogue. Glasgow's real wealth and power in this period, however, were more realistically reflected in the neo-classical monumentalism of the soaring commercial blocks built by the assurance companies and banks in the city centre.[16] The Exhibition of 1911, by which time Mackintosh was completing the Cloister Room and Chinese Room for Cranston's Ingram Street Tea-rooms, was thus as underwhelming an architectural experience as 1888 and 1901 had proven to be, with again the new directions that were being indicated here and there in the city, excluded from the grand event. The involvement of Mackintosh and the Macdonald sisters was restricted to the provision of the interior (Mackintosh) and menu card (Margaret Macdonald) for Cranston's 'White Cockade' Tea-room. The menu card for Cranston's Red Lion café was designed by Frances Macdonald. The predominating role of the Glasgow School of Art in developing the field of decorative arts, to the exclusion of industrial arts, was here forcibly demonstrated by the erection of two totally separate buildings – an Industrial Arts building and a building devoted to 'Decorative and Ecclesiastical Arts' – with the School figuring only in the latter.

With the Labour Party's representation in parliament from 1906 demonstrating forcibly where the political sympathies of the mass of the working class now lay, the Liberals were actively exploiting the nationalist feeling of those Scots and Irish who had helped to consolidate the party's success through their voting in the 1910 election. In Belgium, the Belgian Workers' Party associated Art Nouveau, as a progressivist movement, with the radical aims of the working class: the renewal of society as a political imperative was placed alongside that of the renewal of art and architecture. Nothing akin to this happened in Glasgow. Newbery's notion of a committee of public taste could be argued to derive directly from his knowledge of the Belgian Public Art Society which had its first International Congress in Brussels in September 1898. Newbery the polemicist was clearly concerned with the issue of encouraging the working class of Glasgow into an enhanced appreciation of art, but his publicly expressed attempts to diffuse knowledge of art among the mass of the citizens excluded any reference to the new movement or its significance. Diffusion thus gave way to diffuseness. One searches in vain through his populist outpourings in the local press, where the most pragmatic-sounding statements struggle to extricate themselves from a glutinous language of mystification, for something reminiscent of the

brief exposition contained within the article written for *The Studio* on the theory underlying the unified designs on show at Turin in 1902. In the former, Scottish Art Nouveau idealism is sometimes apparent, particularly where the concern with coherent 'wholes' is given articulation, but the consistent impression remaining is of a refusal to focus upon anything as concrete as the existence of an actual avant-garde group of Art Nouveau practitioners in Glasgow at the time. But Newbery obviously had difficulty in properly understanding the essentials of Art Nouveau. In 1902 he was unsparing in his criticism of Crane for failing to keep abreast of new artistic developments. Crane, in expressing the hostility of the contemporary Arts and Crafts fraternity, had overtly lampooned the 'malady' of Art Nouveau, and it is tempting to portray Newbery as being outraged at this on behalf of the Glasgow movement. However, Newbery's attempts to define the essence of the distinctive newness of the avant-garde's approach – with the aid of a description half-way between Geddes and Muthesius – were still made from within the Arts and Crafts fold; and in his own pleadings on behalf of Arts and Crafts *vis-à-vis* manufacturing industries he replicated the denunciation of commercialism which the Arts and Crafts ideologues of the 1890s used as a weapon against Art Nouveau style when they portrayed the latter as an essentially commercially oriented, and therefore vulgar, and despicable, fashion.

Thus Newbery, as a polemicist for the avant-garde, lacked the clarity of thought and firmness of understanding necessary for the presentation, within an easily assimilable framework, of the fundamental tenets of a movement attempting to break firmly with historicist eclecticism and develop a new visual ideology. There can surely be no more telling evidence in this respect, of the ideological gulf between Newbery and Mackintosh, than the former's reference to J. J. Burnet's recently completed (1900) pseudo-Baroque extension to his father's Savings Bank building in Ingram Street as 'an absolute work of art, and one of the most beautiful things in Glasgow';[17] or his expressed admiration for Alexander Thomson's classical-style Great Western Terrace ('there was no feature in it that could be taken away, and no feature that could be added').[18] Furthermore, although Newbery could agree with Mackintosh's expressed conviction that 'construction should be decorated, and not decoration constructed',[19] he was sufficiently contradictory to be able to express the opposite view, namely, that 'a designer took nature and constructed out of it ornament'.[20]

When the experimentation, spontaneity, and free creativity that were being encouraged in the Glasgow School of Art as early as 1891 were commended in the local press, it was on the basis of the recog-

nition that these alone could engender new ideas, and that new ideas were desperately needed in the production and marketing of desirable commodities. At the same time, the factor of new design ideas being too 'advanced' for current public taste was acknowledged. This focused the problem: in commercial terms new ideas and images were only viable so long as they were sellable in the form of new fashions. They must be 'understood' as representing the latest commodities within a commodity realm where the significance of the relationship between the old ('old fashioned') and the new was emphasized. Just enough 'newness' and the eliciting of interest and excitement were possible: too much, and there was hostile reaction. The impact that unintelligible works can have upon consciousness is not something desirable where commercial imperatives rule, and where taste and interest need to be 'manufactured', manipulated, and administered.

Institutionally, the introduction of an Arts and Crafts studio into the Glasgow School of Art, and the orientation of the School's material and mental activity around handicraft production (a move undoubtedly conditioned by the percentage of women attending the School),[21] while undeniably motivating an innovative period in decoration and the applied arts (with Glasgow School successes at Continental exhibitions appearing to consolidate the correctness of the move), led to a side-stepping of the problem of how to confront (and potentially initiate improvements in) contemporary manufacture and technology. An enclave fostering handicraft production and the utilization of expensive luxury materials, would, in following its own interests, ultimately hinder rather than facilitate a movement with its roots in the experience of urban modernity, and which desired the democratization of art and design. No contradiction is to be found in Mackintosh's extolling of the creative imagination, while at the same time welcoming technological process for the mass production of functional art objects. This was merely to acknowledge that a radical utilization of technology was ultimately commensurate with the Art Nouveau drive towards new meaning, which had begun by seeking meaningfulness in nature (Mackintosh was quite specific in his claim that the proof of the rightness of combining beauty with utility was to be found in the world which was external to the subject). In this way meaning derived from nature, and meaning derived from technology, were both justifiable, in opposition to the claim of the 'artistic' fraternity that meaning was necessarily inherent in the subjective dimension alone. Hence meaning was always rooted in the acknowledged nature of the *relationship* of the subjective to the objective: the dimension of mediation encompassing both human intentionality and the articulation of forms and forces emanating

from nature. The new visual ideology, as it emerged out of experimentation, and was subsequently developed in yet other new ways (and never to a point of ultimate completion), was something beyond, not only intentionality and nature, and thus the intentionality–nature dialectic, but, crucially, also the contemporary methods being employed in its production.

The concept of the total work of art – parts organically integrated into the whole: functional content in harmony with abstract aesthetic form – when hampered by the parameters of costly interior design, could not help but prove to be a liability when anything like commercial exploitation of it was attempted. This much is clear from a consideration of the experience of the Wiener Werkstätte. It was not for nothing therefore, that Wylie and Lochead were concerned to engender the means whereby the costs of their 'whole' rooms could be effectively reduced. But the all-embracing newness of Mackintosh's interiors, with their ascetic–aestheticism, was not something that this, or any other contemporary furnishing firm in Glasgow, wished to risk. Hence, wherever commercial exploitation of Art Nouveau modernity was attempted, it was accompanied by compromise on a number of levels. Commercialization also rendered the style susceptible to fashion, and to production for the middle class domestic interior. The 1890s style itself was 'softened' and the meaning of modern style was obscured (one of Wylie and Lochead's advertisements presented what was termed 'Tudor' style, and this incorporated Glasgow Style elements). This undermined the intention behind the rational modernist interiors of Ednie and Taylor, which was to teach about a new mode of living. The enduring qualities of Mackintosh's work are to be found in the latter's autonomy from pregiven conventions, and this had crucial implications at the time for its potential marketability. Muthesius recognized that Mackintosh–Macdonald interiors were estranged from the tastes, life-styles, and purchasing power of the public which denied them resonance. But this should not be taken as the final word on the failure of the movement.

Glasgow Art Nouveau embraced the ethos of the industrial manufacture of 'artistic' products, something of the mentality of Aestheticism with that orientation's desire to beautify life (even if it got no farther than the stylization of the domestic interior), many of the activities of the Arts and Crafts movement, and the practice of architecture within the public *and* the private spheres. If it 'contained a kind of self-frustration within itself' (to cite Schmutzler on the subject of 'the entire Art Nouveau movement'),[22] this was not merely the substance of its romantic nature making it shrink from the harsh reality of modern industrialization – it was certainly susceptible to

this – but also the frustration arising from the attempt to negotiate various entrenched socio-cultural spheres – manufacturing industry, the art establishment, the University (which contained the only 'intelligentsia' to speak of in Glasgow), the architectural élite. The real acid test of its success or failure to synthesize the ideas and stylistic elements which it considered most significant, and to integrate the results of imaginative creativity into contemporary society, that is, to *externalize* what Benjamin called the 'forces of interiority', would, of necessity, have been a practical and dynamic one. The partial and fragmented nature of its attempts to penetrate that society bear testimony to the power of the forces which it was opposing, and to the continuing influence of the conventions it was attempting to transform. By 1915 the very medium which had originally introduced Art Nouveau to Glasgow, namely the poster, appeared to represent the one remaining success of the venture to take art into the city: 'the cosmopolitan will feel – after a survey of the works, or reproductions on view, that, after all, there is a soupçon of truth in the Ruskin dictum that advertising – per poster, of course, – is nowadays the only living art.'[23] As a 'living art' it was inhabiting an environment full of the residues of dead artistic hopes.

In 1898 MacNair left Glasgow for Liverpool. In 1910 *The Bailie* commented upon the 'exodus of citizens from the city'.[24] Two years before, E. A. Taylor had moved with Jessie King to Manchester: in 1913 the Mackintoshes left the city: in 1918 Salmon complained that Glasgow was 'so ugly that the more there is the more's the pity'.[25] The most devastating end had come, to the already dispersing Glasgow Art Nouveau movement, with the First World War.

There can surely be no more potent evidence of the erroneous nature of the claim that Mackintosh had 'declined' even before he left Glasgow (with the alleged aid of an addiction to whisky) than the work executed subsequent to his having joined the exodus. Not only did the work commissioned by W. J. Bassett-Lowke demonstrate an assured style combining Viennese Secession with proto-Art Deco geometric forms, but, as Roger Billcliffe perceptively notes, many of the furniture items, 'with their clean lines and simple applied decoration would have been ideal for mass production'.[26] Of all the members of the Glasgow movement, by this stage, it was Mackintosh alone who had developed the inner dynamics of the potentially flexible Glasgow Style which had, after 1900, absorbed the lessons taught by the Viennese. If the old contradictions remained – advanced design but hand-crafted production employing traditional materials – this illustrates potently that architect–designers such as Mackintosh, in contrast to painters or sculptors, are never 'alone' before their work (he himself elaborated on this very point), and that, as a conse-

quence, the objects which they produce are not things in themselves (despite the most recent instances of their fetishization within 'postmodern' commodity society). The recent history of appreciation of their qualities – abstract, formal, structural, or whatever – should not be allowed to obscure what they signified through their antithesis to the conventionality apparent within their contemporary contexts: and that included their failure to effect on a significant scale the aesthetic/functional changes in social living which they themselves symbolized. The contradictions signified by Mackintosh's late work for Bassett-Lowke are highly revealing in that they pull into focus the nature of the difficulties confronted by Art Nouveau practitioners concerned to go beyond the constraints imposed by a system of workshop production. Traditional construction methods employed under Bassett-Lowke's direction ensured a quality of build which contrasted with that apparent in the furniture of the Glasgow period. However, the really significant relationship is to be found between, on the one hand, Mackintosh's practice of employing artistic activity and artistic form in the 1920s for objects capable of being mass-produced, and on the other, his practice of leaving technical problems of execution to the employees of a variety of local sub-contracted firms in the Glasgow period. In both cases, a central problem has to do with construction, but it is a problem for different respective reasons: in the Glasgow period, an urban-based, modern-type division of labour between the design stage and that of execution led to the production of poorly constructed end-products. In the Northampton context of the 1920s, the problem of poor construction was being solved, but at the cost (a term to be used advisedly in this context) of a work process involving closely controlled hand-crafted execution. In both cases, the limitations being imposed upon the design-to-execution process were fundamentally of a technical nature.

In considering Glasgow Art Nouveau as a movement motivated by what Madsen specified as the central idea underlying Art Nouveau style, that is, the 'idea of revitalizing industrial arts by a return to stricter aesthetic demands and a higher level of craftsmanship',[27] then consideration of the conditions of contemporary technology in Scotland for the facilitating of such a revitalizing process is of cardinal importance for our analysis. The phenomena of economic depression as these affected Glasgow within the context of Britain as a whole at the turn of the century, demonstrated a new depth of the city's dependence upon the British–national economy, with the correlate of restricted investment in new technologies for mass-production. Given the contemporary context of already restricted technological innovation in Britain, it is not surprising that Mackintosh's optimistic exhortations on the availability of cheaply priced,

mass-produced articles of artistic quality, should have been both prospective, and directed at Continental practitioners. Despite the course taken by the Wiener Werkstätte – and here, paradoxically, because of Hoffmann and Moser's worshipful attitude towards Morris and the Arts and Crafts movement, the emphasis placed upon craft production, albeit directed towards style and fashion, reflects vividly the English preoccupation with producing the best possible articles of high individual quality – the Continent at the beginning of the twentieth century was noticeably moving more swiftly in the direction of mass-production and large-scale output. These were being achieved, as was the increasing standardization of consumption patterns, through the adoption of new techniques of manufacture and methods of distribution. In purchasing hand-crafted products, those members of the Glasgow middle class who were attracted to, and who had little difficulty in affording, such products, were appropriating, not only the artefacts of an hypostatized, 'ideal' form of production, but also symbols that emanated from a sphere of activity which appeared to be characterized by ambivalence towards commercial interests, and (illusory) distance from the 'harsh realities' of contemporary urban society. Actually, those in Glasgow who followed Newbery in encouraging handicraft production were not so much opposing commercialism as what they believed was the debased 'taste' of the masses for ugly mass-produced goods. As Talwin Morris put it, 'The manufacturer callously meets the requirements of the shopkeeper, who in turn will declare with equal callousness that he is dictated to by the demands of his customer, and cannot afford to experiment.'[28] In the struggle for artistic experimentation therefore, appeal was made to the notion of the artist as craftsman, that is, an individual who combines the charisma and creativity of the artist with the craftsman's technical knowledge of tools and their capabilities. But the greatest difficulty in real terms was experienced in attempting to move beyond individualized methods of production which had come historically to characterize the 'autonomous' artist, in order to penetrate *contemporary* production external to the spheres of art. However, for all its inner contradictions, Glasgow Art Nouveau under Mackintosh was, from its inception, capable of firmly confronting technical developments for the mass production of merchandise: such was the depth of commitment to its ideal of the artist coming to determine the nature of the contemporary commodity form.

But in real terms there was no linking of the avant-garde with (a) a coherent critical intelligentsia capable of taking up a consistently oppositional stance; and (b) agencies capable of promoting the kind of technical developments that could facilitate the large-scale pro-

duction of goods manifesting artistic qualities. Ultimately, this was a situation compounded by the economic crisis at the turn of the century. In essence, avant-garde *theory* pre-dated a situation where artists/designers could combine with groups in possession of the kind of technological expertise necessary for the full actualization of the avant-garde endeavour. As it happened, the avant-garde were hampered by the parameters of their involvement with craft production, the only tenable 'productive' sphere open to it. Given the limited nature of this type of production – small output, high costs, restricted availability, etc. – alongside the factor of the inability of the Art School to penetrate manufacturing industries, there could be no real scope for the stimulation of market demands on anything like a significant scale. The production and sale of bric-à-brac represented an attempt to avoid confrontation with modernity, and the avant-garde suffered as a consequence of the lack of viable alternatives.

# Notes

## Chapter 1 The dialectics of modernity and modernism

1. J. Habermas, 'The Undermining of Western Rationalism', in *The Philosophical Discourse of Modernity*, F. Lawrence (trans.), MIT Press, Cambridge, Massachusetts, 1987, p. 139.
2. G. Simmel, 'Tendencies in German Life and Thought since 1870', *International Monthly*, No. 5, 1902, p. 93.
3. *Ibid.*, p. 177.
4. G. Simmel, 'Die Kunst Rodins und das Bewegungsmotiv in der Plastik', *Nord und Sud*, Vol. 129, 1909, II, pp. 189–96.
5. G. Simmel, 'Sociological Aesthetics', in P. K. Etzkorn (trans./ed.), *The Conflict in Modern Culture and other Essays*, New York, Teachers Press, 1968, p. 78.
6. M. Berman, *All That Is Solid Melts Into Air*, New York, Simon and Schuster, 1982, p. 17.
7. *Ibid.*, p. 24.
8. *Ibid.*
9. *Ibid.*, p. 36.
10. P. Anderson, 'Modernity and Revolution', *New Left Review*, 144, 1984, p. 112.
11. *Ibid.*, p. 102.
12. *Ibid.*
13. *Ibid.*, p. 103.
14. *Ibid.*, p. 113.
15. *Ibid.*, p. 105.
16. *Ibid.*
17. J. Habermas, 'Questions and Counterquestions', in R. J. Bernstein (ed.), *Habermas and Modernity*, Polity Press, 1985, p. 199.
18. *Ibid.*, p. 199.
19. *Ibid.*, pp. 200–1.
20. *Ibid.*, p. 201.
21. P. Bürger, 'Avant-garde and Contemporary Aesthetics: A Reply to Jürgen Habermas', *New German Critique*, 22, Winter, 1981.
22. F. Nietzsche, *Human, All Too Human*, R.J. Hollingdale (trans.),

Cambridge, Cambridge University Press, 1986, p. 101

23. S. Cheney, *Abstraction and Mysticism*, New York, Liveright Publishing Corporation, 1934, p. 315.

24. S. R. Guggenheim collection of non-objective paintings, exhibition catalogue, 8–28th. Feburary, 1937, Philadelphia, p. 8.

25. P. Eluard, lecture given at the New Burlington Galleries, 24th. June, 1936, reprinted in H. Read, *Surrealism*, Faber, 1936, p. 172.

26. *Ibid.*, p. 175.

27. H. van de Velde, 'Prinzipielle Erklarungen', in *Kunstgewerbliche Laienpredigten*, Leipzig, 1902.

28. R. Wagner, *Samtlich Schriften und Dichtungen*, Bd. 10, p. 211. Cited by J. Habermas in 'The Entry into Postmodernity: Nietzsche', *The Philosophical Discourse of Modernity*. See note 1 above.

29. F. Nietzsche, *The Birth of Tragedy and the Case of Wagner*, New York, 1967, p. 59.

30. R. Hayman, *Nietzsche: A Critical Life*, Quartet Books, 1981, p. 167.

31. Cited by H. F. Mallgrave, introduction to O. Wagner, *Modern Architecture*, Getty Center Publication Programs, 1988, p. 23.

32. *Op. cit.*, p. 81. See note 22 above.

33. F. Nietzsche, *The Gay Science*, W. Kaufmann (trans.), New York, Random House, 1974, p. 107. First published 1887.

34. *Ibid.*, p. 381.

35. F. Nietzsche, *Nachgelassene Fragmente*, September 1870–January 1871.

36. F. Nietzsche, 'The Wagner Case', W. Kaufmann (trans.), *Basic Writings of Nietzsche*, Modern Library Giants, 1968, p. 7.

37. Habermas, p. 87. See note 28 above.

38. J. Sallis, 'Dionysus – In Excess of Metaphysics', in D. F. Krell and D. Wood, *Exceedingly Nietzsche*, Routledge, 1988, p. 11.

39. F. Nietzsche, *Samtliche Werk. Kritische Studienausgabe*, G. Colli and M. Montinari (eds.), Berlin/New York, 1980, Vol. 5, p. 52.

40. F. Nietzsche, *On the Genealogy of Morals*, New York, 1968, p. 19.

41. F. Nietzsche, 'On the Advantage and Disadvantage of History for Life', *Untimely Observations*, Cambridge, 1980, p. 25.

42. Habermas, p. 95. See note 28 above.

43. F. Nietzsche, *Philosophy in the Tragic Age of the Greeks*. Unpublished.

44. Habermas, p. 96. See note 28 above.

45. *Ibid.*, p. 96.

46. Letter to Carl Fuchs, December, 1884.

47. Letter to Peter Gast, 21st. January, 1887.

48. Habermas, p. 94. See note 28 above.

49. *Ibid.*, p. 94.

50. J. Habermas, 'The Entwinement of Myth and Enlightenment: Horkheimer and Adorno', in *The Philosophical Discourse of Modernity*, p. 125.

51. W. Worringer, *Abstraction and Empathy: A Contribution to the Psychology of Style*, M. Bullock (trans.), Routledge and Kegan Paul, 1953. The references to Simmel appear in the foreword to the 1948 impression (pp. vii–xiii).

52. C. Schorske, *Fin-De-Siècle Vienna: Politics and Culture*, New York, Alfred A. Knopf, 1980, p. 235.
53. *Ibid.*, p. 235.
54. H. F. Mallgrave, p. 23. See note 31 above.
55. K. Varnedoe, *Vienna 1900: Art, Architecture and Design*, New York, Museum of Modern Art, 1986, p. 222.
56. Worringer, p. 15. See note 51 above.
57. *Ibid.*, p. 15.
58. *Ibid.*, p. 45.
59. *Ibid.*, p. 15.
60. *Ibid.*, p. 34.
61. *Ibid.*, p. 18.
62. *Ibid.*, p. 44.
63. *Ibid.*, p. 17.
64. *Ibid.*, pp. 16–17. Emphasis in original.
65. *Ibid.*, p. 18.
66. A. Riegl, *Spätromische Kunstindustrie*. Cited by Worringer, p. 21.
67. Worringer, pp. 23–4.
68. G. Simmel, *The Philosophy of Money*, D. Frisby and T. Bottomore (trans.), Routledge & Kegan Paul, London/Boston, 1978, p. 74.
69. M. Sahlins, *Islands of History*, Tavistock, 1985. See introduction.
70. C. Bell, *The Aesthetic Hypothesis in Art*, Chatto and Windus, 1914, p. 17.
71. O. Wagner, *Modern Architecture*, H. F. Mallgrave (trans.), Getty Center Publication Programs, 1988, p. 119.
72. E. Godoli, 'To the limits of a language: Wagner, Olbrich, Hoffmann', in F. Russell (ed.), *Art Nouveau Architecture*, Academy Editions, 1979, p. 248.
73. Introduction to *Mackintosh's Masterwork: The Glasgow School of Art*, W. Buchanan (ed.), Richard Drew, 1989, p. 10.
74. C. Baudelaire, 'The Painter of Modern Life', in *Selected Writings on Art and Artists*, New York and Harmondsworth, 1972, p. 403.
75. *Ibid.*, p. 435.
76. D. Frey, 'Otto Wagner, historische Betrachtungen und Gegenwartsgedanken', *Der Architekt*, XXII, 1919, pp. 1–9.
77. Introduction to W. J. Schweiger, *Wiener Werkstätte: Design in Vienna 1903–1932*, Thames and Hudson, 1984, p. 8.
78. *Ibid.*, p. 9.
79. *Ibid.*, p. 9
80. This letter is reproduced in T. Howarth, *Charles Rennie Mackintosh and the Modern Movement*, Preface to 2nd. edition, Routledge and Kegan Paul, 1977, pp. xxxviii–xxxix.

## Chapter 2 Modernism as avant-gardism

1. P. Bürger, *Theory of the Avant-Garde*, 2nd. edition, 1980, English translation by M. Shaw, Foreword by J. Schulte-Sasse, Minneapolis, Manchester University Press, 1984, pp. 95–6.
2. *Ibid.*, p. xxxvii.

3. *Ibid.*, p. 50.
4. *Ibid.*, p. xxxviii.
5. *Ibid.*, p. 46.
6. *Ibid.*, p. 22.
7. *Ibid.*, p. 90.
8. *Ibid.*, p. 54.
9. *Ibid.*, p. 50.
10. *Ibid.*, p. 41.
11. *Ibid.*, pp. 49–50.
12. *Ibid.*, p. 34. My emphasis.
13. *Ibid.*, p. 19. My emphasis.
14. *Ibid.*, p. 18.
15. J. Wolff, *Aesthetics and the Sociology of Art*, Allen and Unwin, 1983, p. 29.
16. Bürger, p. 70. See note 1 above.
17. *Ibid.*, p. 56.
18. *Ibid.*
19. *Ibid.*, p. 70.
20. *Ibid.*, pp. 72–3.
21. *Ibid.*, p. 72.
22. *Ibid.*, p. 80.
23. *Ibid.*
24. *Ibid.*, p. 79.
25. *Ibid.*, p. 82.
26. *Ibid.*, p. 40.
27. W. Benjamin, 'Paris: The Capital of the Nineteenth Century', in *Charles Baudelaire: A Lyric Poet in the Era of High Capitalism*, H. Zohn (trans.), IV – *Louis Philippe or the Interior*, New Left Books, 1973, p. 168.
28. *Ibid.*, p. 168.
29. W. Benjamin, *Das Passagen-Werk*, R. Tiedemann (ed.), Frankfurt, 1982, p. 232.
30. *Ibid.*, p. 236.
31. 'Paris', p. 168. See note 27 above.
32. S. T. Madsen, *Sources of Art Nouveau*, R. Christophersen (trans.), H. Aschehoug, Oslo, 1956, p. 222.
33. E. Grasset, 'L'Architecture Moderne jugée par Eugène Grasset', *L'Emulation*, Vol. XXI, 1896, p. 59.
34. Madsen, p. 229. My emphasis. See note 32 above.
35. W. Benjamin, 'Central Park', L. Spencer and M. Harrington (trans.), in *New German Critique*, No.34, Winter, 1985, p. 33.
36. *Ibid.*, p. 34.
37. *Ibid.*
38. *Ibid.*
39. *Ibid.*, p. 42.
40. M. Mikhaylov, 'Ist zu Wienerische', *Iskusstvo Stroitel' noe i Dekorativnoe*, 1903, p. 18.
41. *Aesthetics and Politics*, R. Taylor (trans. ed.), Verso, 1980, p. 118.
42. T. W. Adorno, letter to Benjamin, 2nd. August, 1935, *ibid.*

43. *Ibid.*
44. T. W. Adorno, *Aesthetic Theory*, C. Lenhardt (trans.), G. Adorno and R. Tiedemann (eds.), Routledge and Kegan Paul, 1984, p. 11.
45. *Ibid.*
46. *Ibid.*, p. 12.
47. *Ibid.*, p. 11.
48. *Ibid.*, p. 23.
49. *Ibid.*, p. 169.
50. *Ibid.*
51. *Ibid.*, p. 170.
52. *Ibid.*
53. *Ibid.*, p. 172.
54. *Aesthetics and Politics*, p. 119. See note 41 above.
55. *Aesthetic Theory*, p. 336. See note 44 above.
56. *Ibid.*, p. 336.
57. *Ibid.*, pp. 336–7.
58. *Ibid.*, p. 442. Bürger states that 'aesthetic experience is the positive side of that process by which the social subsystem "art" defines itself as a distinct sphere. Its negative side is the artist's loss of any social function' (p. 33).
59. *Aesthetic Theory*, p. 339. See note 44 above.
60. *Ibid.*, p. 381.
61. T. W. Adorno, 'Functionalism Today', J. O. Newman and J. H. Smith (trans.), *Oppositions*, 17, 1979, p. 34. Originally a lecture presented to the Deutsche Werkbund, Berlin, 23rd. October, 1965.
62. A. Loos, 'Ornament and Crime' (1898), in U. Conrads, *Programmes and Manifestoes on 20th. Century Architecture*, MIT Press, 1970. A. Loos, 'Architecture', in T. Benton, C. Benton, and D. Sharp (eds.), *Form and Function*, Grenada, Open University, 1975, p. 45.
63. A. Loos, 'Furniture for Sitting', *Spoken into the Void*, H. Damisch (trans.), Cambridge, MIT Press, 1981, p. 29.
64. A. Loos, *Architecture*. See note 62 above.
65. C. R. Mackintosh, *Lecture Delivered to a Glasgow Literary Society*, circa 1905, Hunterian Archive, University of Glasgow.
66. T. Morris, *Concerning the Work of Margaret Macdonald, Frances Macdonald, Charles Mackintosh and Herbert McNair: An Appreciation*, circa 1897, Glasgow Art Gallery and Museum Archive.
67. *Ibid.*, my emphasis.
68. C. E. Schorske, 'MOMA's Vienna', *New York Review of Books*, Vol.XXXIII, No. 14, 25th. September, 1986.
69. C. E. Schorske, *Fin-de-Siècle Vienna: Politics and Culture*, Alfred A. Knopf, New York, 1980, p. 209.
70. *Ibid.*, p. 84.
71. *Ibid.*, p. 85.
72. *Ibid.*, p. 87.
73. A. Loos, 'Die Potemkinische Stadt', *Ver Sacrum*, I, 1898, pp. 15–17.
74. Schorske, p. 73. See note 69 above.
75. *Ibid.*, p. 271.

76. *Ibid.*, p. 325.
77. *Ibid.*
78. *Ibid.*
79. 'MOMA's Vienna'. See note 68 above.
80. 'Glasgow Artists in Vienna: Kunstschau Exhibition', *Glasgow Herald* (1908), cutting in Glasgow School of Art Library.
81. *Fin-de-Siècle Vienna*, p. 362. See note 69 above.
82. *Ibid.*, p. 363.
83. R. Schmutzler, *Art Nouveau*, Thames and Hudson, 1978, p. 214.
84. Bürger, p. 63. See note 1 above.
85. D. Sternberger, 'Jugendstil, Begriff und Physiognomie', *Die Neue Rundschau*, Berlin, Vol. XLV, September, 1934, No. 9, p. 258.
86. F. Whitford, *Bauhaus*, Thames and Hudson, 1984, p. 26.
87. *Ibid.*
88. *Ibid.*
89. When Philipp Hausler, a graduate of the Vienna *Kunstgewerberschule*, became 'Chief of the General Management Directorate responsible for the central administration of all enterprises' in 1920, at Hoffmann's invitation – initially for the purpose of reorganization – he attempted to establish a viable economic basis for the Wiener Werkstätte. Under Hausler, who had been chosen by Hoffmann to be a collaborator in his own drawing office, the WW was to provide designs and large firms were to carry them out, under contract, for a percentage of the profits. Thus artists would be designing specifically for industrial production. Hausler's numerous connections with industry, a result of his own previous activities in supplying designs to workshops and industrial enterprises, facilitated the negotiation of a series of licensing agreements with industries, for example, Wolfram made stencils for mural decorations; Flammersheim and Steinmann made wallpapers; Berndorf manufactured cutlery. However, a quarrel with Hoffmann developed which, in conjunction with other contributory factors, ultimately led to Hausler being sacked: the latter's working towards a broadening of the base of the WW and for a degree of standardization of output conflicted with Hoffmann's predilection for uniqueness. See W. J. Schweiger, *Wiener Werkstätte: Design in Vienna 1903–1932*, London, Thames and Hudson, 1984.

**Chapter 3 Art Nouveau as a modern movement**

1. R. Schmutzler, *Art Nouveau* (trans. E. Roditi), Thames and Hudson, London, 1964, p. 276. Published in Germany in 1962 by Verlag Gerd Hafje, Stuttgart.
2. T. J. Clark, *The Painting of Modern Life*, Thames and Hudson, 1984, p. 7.
3. *Ibid.*
4. G. Gresleri, *Josef Hoffmann*, New York, Rizzoli, 1985, p. 14.
5. Schmutzler, p. 8. See note 1 above.
6. *Ibid.*, p. 10.
7. E. Michalski, *Die Entwicklungsgeschichtliche Bedeutung Des Jugendstils*,

Repertorium für Kunstwissenschaft, Berlin, Vol. XLVI, 1925, p. 135.
8. Schmutzler, p. 12. See note 1 above.
9. W. Pater, *The Renaissance*, Mentor, 1959, pp. 97–8.
10. R. Schmutzler, *Art Nouveau*, Thames and Hudson, 1978, p. 25.
11. J. R. Taylor, *The Art Nouveau Book in Britain*, Edinburgh, Paul Harris, 1966, 1980, p. 156.
12. P. Barker, 'Art Nouveau Riche', in P. Barker (ed.), *Arts in Society*, Fontana, 1977, p. 180.
13. S. T. Madsen, *Sources of Art Nouveau*, Oslo, Aschenhoug, 1956, p. 431.
14. *Ibid.*
15. Schmutzler (1964), p. 260. See note 1 above.
16. *Ibid.*, p. 272.
17. Schmutzler (1964), p. 274. See note 1 above.
18. E. R. Curtius, *Marcel Proust*, Berlin and Frankfurt am Main, 1952, p. 86.
19. Schmutzler (1964), p. 276. See note 1 above. See also Carter Ratcliff, 'Dandyism and Abstraction in a Universe Defined by Newton', *Art Forum International*, December, 1988: 'The dandy is entrepreneurial, but not in the right market. Accepting only the admiring glance as a token of exchange, he does no business of the proper bourgeois sort. For Charles Baudelaire, this withdrawal was no fault. Dispensing with the moral conventions that require disapproval of the dandy's aloofness, Baudelaire posed it instead as the first step toward "establishing a new kind of aristocracy, all the more difficult to break down because established on the most precious, the most indestructible faculties, on the divine gifts that neither work nor money can give" – among them, taste so refined that its judgements cannot be exploited for moral or utilitarian purposes. "An institution outside the law", dandyism challenges received standards with new ones calculated to discomfit, even to disrupt. The Baudelairean dandy is a recent ancestor of the 20th-century avant-gardist' (p. 82), Baudelaire quotations from *Le peintre de la vie moderne*, 1868, in *Oeuvres Complètes*, C. Pinchois (ed.), Paris, Editions Gallimard, 1976, 2:711, 709.
20. S. Diaghilev, 'Moskovie Novosti', *Mir Iskusstva*, 1903, No.3, p. 9.
21. Madsen (1956), p. 150. See note 13 above.
22. S. T. Madsen, *Art Nouveau*, Weidenfeld and Nicolson, 1967, p. 12.
23. K. Kraus, 'Heine und die Fölgen', *Auswahl aus dem Werk*, Munich, 1957, p. 190.
24. Madsen (1967), pp. 12–13. See note 22 above. Significant examples of these periodicals throughout Europe are *The Architectural Review* (London, 1896), *The Evergreen* (Edinburgh, 1895–7), *Kunst und Kunsthandwerk* (Vienna, 1898–1921), *Pan* (Berlin, 1895–1900), *La Réveil* (Ghent, 1891), *The Savoy* (London, 1896), *The Studio* (London, 1893), *Ver Sacrum* (Vienna, 1898; Leipzig, 1899–1903), *Ioventut* (Barcelona, 1900–3), *Mir Iskusstva* (St Petersburg, 1899–1904), *L'Art Moderne* (Brussels, 1881–1914), *L'Arte* (Rome, 1898–1901), *La Plume* (Paris, 1889–1913), *The Craftsman* (New York, 1901–16).
25. *Glasgow Herald*, 23rd. January, 1899.
26. B. Laughton, 'The British and American Contribution to *Les XX*,

1884–93', *Apollo*, November, 1967, p. 372.

27. *Ibid.*, p. 379.
28. *Op. cit.*
29. W. Crane, *Of the Decorative Illustration of Books Old and New*, London, 1896, p. 228.
30. H. R. Hitchcock, *Architecture: Nineteenth and Twentieth Centuries*, Baltimore, 1958.
31. A. M. Fern, *Art Nouveau*, Museum of Modern Art, New York, 1960.
32. Quoted in R. Melville, 'The Soft Jewellery of Art Nouveau', N. Pevsner and J. M. Richards, *The Anti-Rationalists*, Architectural Press, 1973, p. 143.
33. T. W. Adorno, *Aesthetic Theory*, Routledge and Kegan Paul, 1986, p. 192.
34. H. Bergson, *Time and Free Will*, Allen and Unwin, 1910, p. 12.
35. I. Zangwill, 'Without Prejudice', *Pall Mall Magazine*, January, 1895, p. 327.
36. See A. Defries, *The Interpreter Geddes: The Man and His Gospel*, Routledge, 1927: 'One of the messengers of light, with whom Geddesians are in sympathy, is M. Bergson, whose delightful style is widely popularizing some of the very conceptions of life they have been trying to express and put in place of the established mechanical ones. Of course, William James and Stanley Hall – both friends of Geddes for a good many years – were essentially pioneers of the same movement' (pp. 303–4).
37. P. Geddes and J. A. Thomson, *The Evolution of Sex*, Walter Scott, 1889, p. 312.
38. With his Edinburgh Summer School Geddes viewed himself as being involved in the active process of reuniting the hitherto segregated studies of art (and literature) and science by organizing them into an integrated cultural whole. The separation of these studies, he held, had been engineered by institutions such as the schools and universities which had fragmented knowledge by breaking it up 'into particles unconnected with each other or with life'. Geddes thus acknowledged a nexus of institutionalized agencies fostering their own ideological view of knowledge construction.
39. 'To find an object of reverence, we must be able in some way or other to rise to an original source of life, out of which this manifold existence flows, and which in all this variety and change never forgets or loses itself. A world of endless determination is a prosaic world, into which neither poetry nor religion can enter. To rise to either, we must find that which is self-determined, – we must have shown to us a fountain of fresh and natural life. When we have found that, the multiplicity of forms, the endless series of appearances, will begin to take an ideal meaning, because we shall see in them the Protean masks of a Being which is never absolutely hidden, but in the perishing of one form and the coming of another is ever more fully revealing itself.' E. Caird, *Hegel*, William Blackwood, 1883, pp. 113–14.
40. H. von Hofmannsthal, *Der Dichter und diese Zeit*, in M. Gilbert (ed.),

*Selected Essays*, Oxford, 1955, p. 133.
41. N. Pevsner, *Pioneers of Modern Design from William Morris to Walter Gropius*, New York, Museum of Modern Art, 1949, p. 105.
42. L. Hevesi, *Acht Jahre Sezession: Marz 1897–Juni 1905*, Wien, 1906 (Reprint 1984, Klagenfurt).
43. T. Howarth, *Charles Rennie Mackintosh and the Modern Movement*, Routledge and Kegan Paul, 1952, second edition 1977, p. xxxi.
44. Cited by Pevsner (1949), p. 105. See note 41 above.
45. Madsen (1956), p. 431.
46. D. Chapman-Huston, *The Lamp of Memory*, Skeffington and Son, 1949, p. 125.
47. T. Morris, *Concerning the Work of Margaret Macdonald, Frances Macdonald, Charles Mackintosh and Herbert MacNair: An Appreciation*, unpublished article, circa 1897, in Kelvingrove Museum and Art Gallery.
48. *Op. cit.*, p. 31. See note 43 above.
49. E. Sekler, 'The Stoclet House by Josef Hoffmann', in D. Fraser *et al.* (eds), *Essays on the History of Architecture Presented to Rudolf Wittköwer*, Pitman, 1967, p. 231.
50. Taylor, p. 20. See note 11 above.
51. *Ibid.*, p. 19.
52. '... the loftiest order of art selecting only the loftiest combinations is the perpetual struggle of humanity to approach the gods. The great painter or architect embodies what is possible to man it is true – but what is not common to mankind.' C. R. Mackintosh, *Paper on Architecture*, 1893.

'Art is the flower – Life is the green leaf. Let every artist strive to make his flower a beautiful living thing – something that will convince the world that there may be – there are – things more precious – more beautiful – more lasting than life. But to do this you must offer real living – beautifully coloured flowers – flowers that grow from but above the green leaf – flowers that are not dead – are not dying – not artificial – real flowers springing from your own soul – not even cut flowers – you must offer the flowers of the art that is in you – the symbols of all that is noble – and beautiful – and inspiring – flowers that will often change a colourless cheerless life – into an animated thoughtful thing.' C. R. Mackintosh, *Seemliness*, 1902. Mackintosh Archive, University of Glasgow.

53. *Evening Times*, 5th. February, 1895.
54. M. Sturrock Newbery, *The Costume Society of Scotland*, Bulletin 5, 1970.
55. *Op. cit.*
56. G. Naylor, *The Arts and Crafts Movement: a Study of its Sources, Ideals and Influence on Design Theory*, Studio Vista, 1971, p. 169.
57. *Ibid.*, p. 124.
58. Taylor, p. 66. See note 11 above.
59. *Op. cit.*, p. 240. See note 1 above.
60. *Ibid.*, p. 240.
61. *Ibid.* An anonymous contributor to *The Scotsman* in 1979 wrongly attributed the Glasgow Style rose motif to Talwin Morris: 'His [Talwin

Morris'] paper [*Black and White* in London] featured the work of
Charles Ricketts and Walter Crane and his own tautly wrought designs
often headed articles. The Glasgow "rose" first blossomed on one of his
Blackie's book covers in 1893, and his interest and influence would have
certainly helped Mackintosh's circle out of the Celtic other-world of
love-lost spooks into the mature work illustrated in his book.' *The
Scotsman*, 27th. October, 1979. Morris' earliest designs for Blackie's
certainly used stylized floral motifs (along with whiplash lines) but he
appears not to have incorporated the distinctive 'rose' until after he
purchased the Mackintosh watercolour panel *Part seen, imagined part*
(which includes this motif) at the 1897 Arts and Crafts Exhibition
Society exhibition. Gerald Cinamon remarks of one of Morris' first
Blackie designs in 1894 that 'The binding is covered in *art nouveau*
whiplash lines. On the front cover is a decorated panel and lettering not
unrepresentative of fussier gothic design of an earlier decade.' 'Talwin
Morris, Blackie and the Glasgow Style', *The Private Library*, Vol. 10:1,
Spring, 1987, p. 7.

62. H. Muthesius, 'Mackintosh's Art Principles', *Haus Eines Kunstfreundes*,
Darmstadt, 1902.
63. R. Macleod, *Charles Rennie Mackintosh*, Hamlyn, 1968, p. 33.
64. *Ibid.*, p. 31.
65. J. Sturrock Newbery, 'A Memory of Mackintosh', Mackintosh Archive
(MA), University of Glasgow.
66. *Ibid.*
67. *Glasgow Herald*, circa 1907, 'Glasgow Artists in Vienna: Kunstschau
Exhibition', cutting in Glasgow School of Art Library.
68. M. Battersby, *The World of Art Nouveau*, Arlington, 1968, p. 126.
69. H. van de Velde, *Renaissance im Kunstgewerbe*, Berlin, Neue Ausgabe,
1901, p. 63.
70. E. Godoli, 'To the Limits of a Language: Wagner, Olbrich, Hoffmann',
in F. Russell (ed.), *Art Nouveau Architecture*, Academy Editions, 1979,
p. 244.
71. *Ibid.*
72. Cited by E. Sekler in *Josef Hoffmann*, Princeton University Press, 1985,
p. 54. Translated by the author (German version 1978).
73. Cited by P. Selz in P. Selz and M. Constantine, *Art Nouveau*, New York,
Museum of Modern Art, 1959, p. 20.
74. Godoli, p. 244. See note 70 above.
75. For an account of Benjamin's distinctions between *Erlebnis* and
*Erfahrung* and of the different types of memory possible with the
continuity embodied within *Erfahrung*, see I. Wohlfarth, 'On the
Messianic Structure of Walter Benjamin's Last Reflections', *Glyph*,
No.3, 1978, pp. 148–212.
76. Schmutzler (1978), p. 212. See note 10 above.
77. Schmutzler (1964), p. 239. See note 1 above.
78. Macleod, p. 43. See note 63 above.
79. *Ibid.*, p. 38.
80. Howarth expresses the view that 'Miss Cranston raised the tea-room

business in Glasgow from the level of mundane commercialism to that of a profession, if not a fine art' (p. 123). Yet with the flotation of Cranston's Tea-rooms Limited in 1905 the *Glasgow Advertiser and Property Circular* made no reference to Miss Cranston's role: 'Mr. Stuart Cranston's name as an expert tea-taster has long since made his Tea Saloons world-famous. The success attending his various enterprises has been phenomenal.' *GAPC*, 31st. October, 1905.

81. *Op. cit.*, p. 267.
82. *Ibid.*, p. 267.
83. *Ibid.*, p. 268.
84. P. Vergo, *Art in Vienna 1898–1918: Klimt, Kokoschka, Schiele and Their Contemporaries*, Phaidon, 1975–81, p. 64.
85. *Op. cit.*, p. 269.
86. *Ibid.*, p. 270.
87. Godoli, p. 244. See note 70 above.
88. Sekler, p. 40. See note 72 above.
89. *Deutsche Kunst und Dekoration*, Vol. III, 1898, pp. 197–219.
90. Special number of *The Art Journal*, ed. D. Croal Thomson, London, 1901, p. 112.
91. *The Studio*, Vol. XXI, 1900, p. 114.
92. Cited by Sekler, p. 36. See note 72 above.
93. *The Studio*, Vol. XXII, 1901, pp. 261 ff.
94. *Op. cit.*, p. 40. See note 72 above. Eckart Muthesius remarks that 'his work in Vienna seems, more than elsewhere, to have given Mackintosh opportunities to discuss with others the ideas of compression of form.' Foreword to *Mackintosh's Masterwork: The Glasgow School of Art*, Richard Drew 1989., p. 10.
95. G. Daniel, 'Decorative Arts', in Selz and Constantine, p. 102. See note 73 above.
96. 'An Interview with Mr. C.F.A. Voysey', *The Studio*, Vol.1, 1893, p. 233.
97. *Glasgow Herald*, 2nd. November, 1911. My emphasis.
98. P. Selz, Introduction to *Art Nouveau*, p. 9. See note 73 above.
99. H. Bergson, p. 17. See note 34 above. Emphases in original.
100. Lecture delivered before the National Association for the Advancement of Art, 1889: Transaction of the Art Congress, Edinburgh, 1889, pp. 202–20.
101. H. van de Velde, 'Prinzipelle Erklarung', *Kunstgewerbliche Laienpredigten*, Leipzig, Hermann Seemann, 1902, p. 188.
102. *Op. cit.*: 'It is imagination which has taught man the moral implication of colour, line, sounds and scents. At the beginning of the world it created analogy and metaphor.'
103. P. Gauguin to his friend Schuffenecker, 14th. August, 1888; quoted in J. Rewald, *Post-Impressionism from Van Gogh to Gauguin*, New York, Museum of Modern Art, 1956, p. 196. Revised edition, London, 1978.
104. F. Orton and G. Pollock, 'Les Données Bretonnantes: La Prairie de la Representation', *Art History*, Vol. 3, No. 3, September, 1980. E. Verhaeren, 'Le Salon des Indépendants', *La Nation*, reprinted in *L'Art Moderne*, 5th. April, 1891.

105. *Ibid.*
106. Selz, p. 54. See note 73 above.
107. Khnopff was invited by the art critic and novelist Joseph Péladan to exhibit with the latter's *Ordre de la Rose et Croix Catholique du Temple et du Graal* in 1892, and he subsequently became a regular contributor, as did Jean Delville, the symbolist artist invited by Newbery to teach painting at the Glasgow School of Art. In the studio of his house on the Avenue de Course (no longer extant), Khnopff had an altar dedicated to Hypnos upon which was inscribed 'on n'a que soi' (one has but oneself). This sported lapis lazuli blue glass by Tiffany. Hoffmann may have played some role in the design of this house which was built in 1900. The interior was reminiscent of Hoffmann's manner and Khnopff was in Vienna around 1898, at which time he could have become personally acquainted with Hoffmann.
108. *The Studio*, Vol. XI, 1897, p. 227.
109. *Ibid.*, p. 228.
110. T. Morris, *Concerning the Work of Margaret Macdonald, Frances Macdonald, Charles Mackintosh and Herbert MacNair: An Appreciation*, unpublished article, circa 1897, in Kelvingrove Art Gallery and Museum, Glasgow.
111. C. E. Schorske, 'MOMA's Vienna', *New York Review of Books*, Vol. XXXIII, No. 14, September, 1986.
112. Howarth, p. 145. See note 43 above.
113. N. Pevsner, 'Charles Rennie Mackintosh', *Il Bacone*, Milan, 1950. See also N. Pevsner, *Studies in Art, Architecture and Design*, Thames and Hudson, 1968, where it is claimed that Mackintosh 'discovered the necessity and the possibilities of abstract art in his wall-panels several years before Picasso and Kandinsky had begun their efforts to liberate art from nature, and he discovered abstract metal sculpture of a transparency in which outer and inner space are made to merge when Moholy Nagy was only eleven, and Alexander Calder five' (p. 175).
114. Howarth, p. 27. See note 43 above.
115. *Ibid.*, p. 30.
116. *Ibid.*, p. 31. My emphasis.
117. *Ibid.*
118. G. Gresleri, *Josef Hoffmann*, New York, Rizzoli, 1985, pp. 10–11.
119. C. R. Mackintosh, Paper on Architecture, 1893, MA.
120. *Ibid.* At the first exhibition of *La Libre Esthétique*, in February 1894 in Brussels, van de Velde delivered his lecture *L'Art Futur* in which he stressed the relationship between all of the arts and the potentiality of a transformation of the environment for a healthier form of contemporary living. In the first issue of *Deutsche Kunst und Dekoration* (May 1897) Alexander Koch insisted that all artists, architects, sculptors, painters, technical artists, should be integrated, through their work, towards a 'larger whole'.
121. *Ibid.*
122. C. R. Mackintosh, Lecture delivered to a literary society, circa 1905, MA.
123. P. Geddes, *An Analysis of the Principles of Economics*, Proceedings of

the Royal Society of Edinburgh, XII, 1884. Reprinted by Williams and Norgate, 1885.

124. P. Geddes, *Edinburgh Summer Meeting, Prospectus*, 1895.

## Chapter 4 The European context

1. H. van de Velde, 'Extracts from his Memoirs 1891–1961', *Architectural Review*, September, 1952, p. 146.
2. Asserted by van de Velde in 1897. Cited by F. Whitford in *Bauhaus*, Thames and Hudson, 1984, p. 23.
3. 'Extracts', p. 148. See note 1 above.
4. B. Colt de Wolf, 'Municipal Art in Belgium', *The Art Journal*, 1901.
5. *Ibid.*
6. Alexander Paterson, who was an ardent admirer of Viollet-le-Duc's attempts to rationalize domestic architecture, described how the principles of heredity continued markedly in art 'as in every department of human life'. Architects took from the general evolution of nature, claimed Paterson, a concern over which [architectural] type should be followed in going beyond 'the feverish borrowing from every foreign source which has marked recent years'. This process of selection had become, to some extent, conscious and individual, and it involved the judicious employment of knowledge of past styles. As did Mackintosh, Paterson applauded the apparent contemporary 'healthier return to the study of national type' as representing the evolutionary outcome of 'the slow growth of the national styles during the earlier centuries of development'. Lecture on 'Domestic Architecture' in Glasgow Corporation Galleries for Glasgow School of Art: Architectural Section. Reproduced in *Glasgow Property Circular*, 3rd. December, 1895.
7. *The Scotsman*, 14th. January, 1908.
8. 'The Principles of Ornament and Decoration', lecture in the Technical Institute, Dundee, circa 1894. Cutting in Newbery Scrapbook (NS), Mitchell Library, Glasgow.
9. W. Gropius, *Concept and Development of the State Bauhaus*, 1924.
10. 'Belgian Artists in England', *The Studio*, Vol. 64, 1914, p. 200.
11. J. Delville, *The New Mission of Art: A Study of Idealism in Art*, F. Colmer (trans.), Francis Griffiths, 1910, p. 125.
12. Cutting from unknown newspaper in NS, Mitchell Library, Glasgow.
13. *The Scotsman*, 5th. Feburary, 1889.
14. Address at 52nd. Annual Meeting of Glasgow School of Art, 1895. Reproduced in Annual Report, 1896.
15. R. Billcliffe, *The Glasgow Boys: The Glasgow School of Painting 1875–1895*, John Murray, 1985, p. 300.
16. F. Newbery, Introduction to D. Martin, *The Glasgow School of Painting*, G. Bell and Sons, 1897, p. xv.
17. *Ibid.*, p. xx.
18. 'It is curious to note how most of the great triumphs of Art have been won in cities, and in cities too, whose life was oftentimes of the busiest and most complex description .... And at this end of the nineteenth

century, in the midst of one of the busiest, noisiest, smokiest cities, that, with its like fellows, make up the sum total of the greatness of Britain's commercial position, there is a movement existing, and a compelling force behind it, whose value we cannot yet rightly appraise or whose influence is not yet bounded, but which, both movement and movers, may yet, perhaps, put Glasgow on the Clyde into the hands of the future historians of Art, on much the same grounds as those on which Bruges, Venice, and Amsterdam find themselves in the book of the life of the world.' *Ibid.*, pp. xii–xiv.

19. P. Bürger, *Theory of the Avant Garde*, M. Shaw (trans.), Manchester University Press, 1984, p. 41.
20. P. Geddes, 'The Sociology of Autumn', *The Evergreen: A Northern Seasonal*, 1895.
21. P. Geddes, *John Ruskin, Economist*, Edinburgh, William Brown, 1884.
22. F. Newbery, 'How to Popularize Our Art Galleries and Museums', two articles for *Glasgow Evening News*, 6th. December, 1905. The influence of pre-Raphaelitism on Glasgow works is apparent with the Rossetti-like figures in David Gauld's illustrations for *Lays of Middle Age and Other Poems* (1889). As Billcliffe points out, 'the first imaginative works which Mackintosh produced, a series of watercolours beginning in 1892, draw quite clearly on Gauld's interpretation of Pre-Raphaelite imagery' (*op. cit.*, p. 266).
23. *Ibid.*
24. *Glasgow Herald*, 20th. December, 1909.
25. G. Gresleri, *Josef Hoffmann*, New York, Rizzoli, 1985, p. 8.
26. R. Billcliffe. See note 15 above.
27. Hornel's painting *Pigs in a Wood* (1887) can be taken as marking the beginning of the Glasgow School's preoccupation with colour, pattern, and design, here presented in a composition without a horizon or other perspective-indicating landmarks. The ornamental predisposition is emphasized by the treatment of varying textures in the depiction of trees, leaves, shrubs, undergrowth. With increased awareness of the function required of materials, the properties of materials, and of methods and forms of execution emerging with Art Nouveau, natural forms such as leaves and shrubs, in being treated more and more in a consciously decorative manner, would become increasingly abstracted, symbolic, and ultimately metamorphosed.
28. Billcliffe, p. 39. See note 15 above.
29. 'Glasgow finds it hard to face the critics of its acrid atmosphere. Recent experience has sorely tried the patience of the most loyal citizen, who feels acutely that the adage "where there is smoke there is money" is a poor shield against condemnation of the poisonous gloom whose horrors are in recent memory. But the city may well be proud of having created an atmosphere of its own, one in which the arts flourish with amazing vigour.' *Glasgow Herald*, 16th. December, 1909.
30. A journalist who visited the 1901 Exhibition presented (in characteristic-ally 'humorous' fashion) the following account: 'One of the very artistic exhibits was a large show-case, filled in a promiscuous manner with

knives, forks, and spoons. It was certainly a grand conception, and
reflected greatly on the mind which originated it. Then I was greatly
moved by the ease and grace with which an overtaxed City Father
pocketed the humble threepenny-bit for brushing boots – no, no, hats;
the dress and deportment of the nymphs of the confectionery corner;
the smiles and rouge of the ditto in the – section; and the abundant bar
accommodation with the handsome and costly fitting. There was also
the Press Club! All testified to the influence of the Glasgow School of
painters on our public life of every day.' 'The Exhibition: My First Visit',
*The Bailie*, 23rd. October, 1901.

31. *Glasgow Herald*, March, 1888, cutting in *Newbery Scrapbook*, Mitchell
    Library, Glasgow.
32. *Op. cit.*, p. 30. Over twenty years later, this decorative approach conti-
    nued to characterize the work of Hornel and Henry.
33. 'The Glasgow School in America', article in *Glasgow Evening Times*, 14th.
    November, 1895.
34. *Ibid.*
35. *Ibid.*
36. H. Obrist, 'Wozu über Kunst Schreiben?', *Dekorative Kunst*, Vol. 5, 1900,
    p. 190.
37. In 1887 Lavery became acquainted with Whistler, who, by this time, was
    President of the Royal Society of British Artists. The two men
    remained friends throughout the 1890s.
38. A. Mackworth, 'The Relation of the Easel Picture to Decorative Art',
    *The Art Journal*, 1901.
39. L. F. Day, 'Decorative and Industrial Art at the Glasgow Exhibition:
    Second Notice', *The Art Journal*, 1901, p. 241.
40. C. Cooke, 'Fedor Osipovich Shekhtel: An Architect and His Clients in
    Turn-of-the-Century Moscow', *Annals of the Architectural Association
    School of Architecture*, No.5. C. Cooke, 'Shekhtel in Kelvingrove and
    Mackintosh on the Petrovka', *Scottish Slavonic Review*, No.10, 1988.
41. E. A. Taylor, 'Charles Rennie Mackintosh: A Neglected Genius', *The
    Studio*, Vol. CV, no. 483, 1933, p. 348.
42. H. Muthesius, 'The Glasgow Art Movement', *Dekorative Kunst*, Vol. 9,
    1902, p. 194.
43. In *Das Englische Haus* Muthesius described how, for the Scottish
    movement, the design of the room was but the beginning for the design
    of the whole house. That is to say, interior design and exterior
    architecture were organically connected through this work.
44. Muthesius, p. 194. See note 42 above.
45. *Ibid.*, p. 198.
46. *Ibid.*
47. *Ibid.*, p. 215.
48. H. Muthesius, 'Die Ausstellung der Wiener Secession', *Dekorative Kunst*,
    Vol. 7, 1901, p. 180.
49. *Ibid.*, p. 181.
50. *Evening Times*, 15th. December, 1909.
51. P. Jullian, *Dreamers of Decadence*, R. Baldick (trans.), New York,

Praeger, 1971, p. 208.
52. 'Glasgow – A Model Municipality', *Fortnightly Review*, Vol. 63, 1895, p. 608.
53. For a description see A. Gomme and D. Walker, *Architecture of Glasgow*, Lund Humphries, 1968, p. 222.
54. *Glasgow Advertiser and Property Circular (GAPC)*, 6th. December, 1898.
55. *GAPC*, 22nd. August, 1899.
56. *Buildings of Special Architectural or Historical Interest*, Scottish Development Department, 1985.
57. T. Howarth, *Charles Rennie Mackintosh and the Modern Movement*, Routledge and Kegan Paul, 1952–77, p. 256.
58. *Ibid.*, pp. 257–8.
59. G. Larner and C. Larner, *The Glasgow Style*, Paul Harris, 1979, p. 3. This 'flowering' of the decorative arts in Glasgow had a restricted life-span and it cannot really be said to have lasted much beyond 1910. Indeed 'late' Glasgow Style, of immediately before and after the 1914–18 War, is restricted to embroideries (the pupils of Jessie Newbery and Ann MacBeth), stained glass, hand-painted pottery (Jessie Keppie, Elizabeth Watts), decorative watercolours (Annie French, Cecile Walton, Meg Wright), book illustration, and beaten metal mirror frames and wall sconces (Margaret Gilmour, Mary B. Henderson): in short, primarily two-dimensional work, by then stylistically undistinctive.
60. *Ibid.*, p. 1.
61. *Ibid.*, p. 20.
62. *Ibid.*, p. 19.
63. 'Stylish Glasgow', *The Scotsman*, 27th. October, 1979.
64. *The Glasgow Style 1890–1920*, Department of Decorative Art, Glasgow Museums and Art Galleries, 1984, p. 6.
65. *Ibid.*, pp. 6–8.
66. *Ibid.*, p. 36.
67. 'Die Schottische Kunstler', *Dekorative Kunst*, Vol. 2, No. 2, 1899, p. 49. My emphasis.
68. A. Gomme and D. Walker, *Architecture of Glasgow*, Lund Humphries, 1968, p. 215.
69. K. B. Hiesinger, *Art Nouveau in Munich: Masters of Jugendstil*, Prestel/Philadelphia Museum of Art, 1988, p. 23.
70. J. A. Lux, *Das Neue Kunstgewerbe in Deutschland*, Leipzig, 1908, p. 144.
71. H. Muthesius, 'Die Kunst Richard Riemerschmid', *Die Kunst*, Vol. 10, 1904.
72. *Ibid.*, p. 283.
73. L. Hevesi, *Altkunst – Neukunst: Wien 1894–1908*, Vienna 1908, p. 220.
74. Cited by P. Jullian, p. 85. See note 51 above.
75. H. Muthesius, *The English House*, J. Seligman (trans.), New York, Rizzoli, p. 51.
76. *Ibid.*, p. 51.
77. H. Muthesius, 'Neues Ornament und Neue Kunst', *Die Kunst*, Vol. 4, 1901, p. 350.
78. *Dekorative Kunst*, Vol. 9, 1902, p. 215.

*Notes*

79. J. Kinchin, 'The Wylie and Lochead Style', 'Aspects of British Design 1870–1930', *Journal of the Decorative Arts Society*, No. 9, 1985, pp. 9–10.
80. *Op. cit.*, p. 262. See note 57 above.
81. B. Rauecker, *Das Kunstgewerbe in Munchen*, Stuttgart, 1911, p. 18. Cited by Hiesinger, p. 22. See note 69 above.
82. H. Muthesius, 'Art and Machine', *Dekorative Kunst*, Vol. 9, 1902, p. 141.
83. Cited by G. Bollenbeck, 'Stilinflation und Einheitsstil', *Stil*, H. U. Gumbrecht and K. L. Pfeiffer (eds), Suhrkamp, 1986, p. 226.

**Chapter 5 The Scottish ideology**

1. Referred to in a letter from Philip Mairet to W. A. Murray Grigor, 2nd. March, 1967, Mackintosh Archive (MA), University of Glasgow.
2. T. Howarth, *Charles Rennie Mackintosh and the Modern Movement*, Routledge and Kegan Paul, 1952, p. 255.
3. Letter by Hoffmann sent by Max Welz to the members of the *Wiener Werkbund* in March, 1933 on the occasion of *Werkbund* events. Reproduced in E. Sekler, *Josef Hoffmann*, Princeton University Press, 1985, p. 498 (Appendix 15). My emphasis.
4. Cutting from unidentified newspaper in Francis Newbery's personal press-cutting book, Mitchell Library, Glasgow. My emphasis.
5. R. Macleod, *Charles Rennie Mackintosh*, Hamlyn, 1968, p. 154.
6. *The Bailie*, 1918. Cited by A. Gomme and D. Walker, *Architecture of Glasgow*, Lund Humphries, 1968, p. 277.
7. *The Studio*, Vol. XXXIII, 1904, p. 222. My emphasis.
8. R. Billcliffe, *Mackintosh's Furniture*, Lutterworth Press, 1984, p. 18.
9. M. H. Bailie Scott, 'On the Characteristics of Mr. C. F. A. Voysey's Architecture', *The Studio*, Vol. XLII, No. 175, October, 1907. In his *Houses and Gardens*, George Newnes, London, 1906, Scott has this to say on the subject of exhibition rooms for firms in Berlin and Dresden: 'It appears to be a growing custom with the principal furniture firms in Germany to invite representative architects to contribute to such periodical exhibitions, *and in these it has been Mr. Mackintosh and myself who have represented the British section.*' My emphasis, pp. 235–6.
10. C. R. Mackintosh, *Literary Society Lecture* (LS) in MA.
11. A. McGibbon, 'Medieval Architecture', lecture reproduced in *Glasgow Advertiser and Property Circular*, 30th. October, 1894.
12. *Ibid.*
13. 'Wagner war mit Mackintosh und van de Velde personlich bekannt': H. Geretsegger und M. Peinter, *Otto Wagner 1841–1918: Unbegrentze Grossstadt Beginn der Modernen Architektur*, Residenz Verlag, Salzburg, 1964 DTV, 1980, p. 24. See also C. M. Nebehay, *Ver Sacrum 1893–1903*, Deutscher Taschenbuch Verlag, 1979, p. 194.
14. O. Wagner, *Modern Architecture* (trans. H. F. Mallgrave), Getty Center for the History of Art and the Humanities, 1988, p. 91. First published as *Moderne Architektur*, Vienna, 1895.
15. G. Semper, *Kleine Schriften*, Berlin, 1884.

16. *Modern Architecture*, p. 91. See note 14 above.
17. LS.
18. Eugène Grasset, the French symbolist painter and decorative artist who adopted the Art Nouveau style in the 1890s, asserted that 'Art has been born precisely from the need *to clothe the purely useful (sic) which is always repugnant and horrible.*' 'L'Architecture Moderne Jugée par Eugène Grasset', *L'Emulation*, Brussels, Vol. XXI, 1896, p. 59. Emphasis in original. Grasset was interviewed in 1904 by Newbery and three other of the governors of the Glasgow School of Art in their search for a new Professor of Design and Decorative Art. Whatever the reasons, he was not appointed.
19. LS.
20. LS. 'There never was more flagrant nor impertinent folly than the smallest portion of ornament in anything concerned with railroads or near them.' J. Ruskin, *The Seven Lamps of Architecture*, London, New York, 1907 edition, p. 122. 'Will a single traveller be willing to pay an increased fare to the South Western, because the columns are covered with patterns from Niniveh ?' *Ibid.*, p. 129.
21. C. R. Mackintosh, *Paper on Architecture* (PA) in MA.
22. G. Simmel, 'Space and the Spatial Structures of Society', *Soziologie*, 5th. edition, Duncker and Humblot, Berlin, 1968.
23. LS. 'It is a mere fanciful analogy that is drawn between shady avenue and vaulted aisle – between the human skeleton and the iron construction concealed in a building; and the source and standard of true architecture is found in man himself ...' McGibbon, 1894. See note 11 above.
24. F. Walker, 'Mackintosh and Art Nouveau Architecture', in C. J. Carter (ed.), *Art, Design and the Quality of Life in Turn of the Century Scotland (1890–1910)*, Proceedings of Symposium Duncan of Jordanstone College of Art, Dundee, 1985, p. 63.
25. C. R. Mackintosh, *Critique of Ruskin's 'Stones of Venice'*. My emphasis. Some of the arguments in this paper were purloined by Mackintosh from a review, written by H. H. Statham, which appeared in *The Builder* in 1888.
26. *Glasgow Herald*, 16th. December, 1909.
27. C. R. Mackintosh, *Scottish Baronial Architecture* (SBA) in MA.
28. LS.
29. *Dekorative Kunst*, VII, 1ff. My emphasis.
30. Cited by A. Gresleri, *Josef Hoffmann*, New York, Rizzoli, 1985, p. 21.
31. LS.
32. Gresleri, p. 9. See note 30 above.
33. Sekler, p. 19. See note 3 above.
34. C. R. Mackintosh, *Elizabethan Architecture* (EA) in MA.
35. LS.
36. *Ibid.*
37. Annual Prize Distribution, Council of RIBA, 1905. Cutting from unspecified newspaper, Glasgow School of Art Library.
38. LS. My emphasis.

39. *Ibid.* My emphasis.
40. D. Hume, *An Inquiry Concerning Human Understanding*, Collier Books, 1962, p. 162.
41. C. R. Mackintosh, *Seemliness* in MA. My emphasis.
42. LS.
43. *Ibid.* My emphases. Edward Caird, when writing on Kant's aesthetics, emphasized that,

    in the perception of beautiful forms, inventiveness was apprehended as being combined with underlying principles, but that the latter were not easily specifiable: '... we do not ascribe beauty to a rectangular figure, such as a geometrical diagram, which thrusts upon us a definite conception of the law of its construction, and so brings the imagination under visible restraint. *We recognize beauty only in forms in which there is an appearance of free play, and yet a secret order with which we are pleased though we cannot define it*' (*The Philosophy of Immanuel Kant*, Vol. 2, Glasgow, James Maclehose and Sons, 1889, p. 401. My emphases). It will be seen, in considering this description, that, from Mackintosh's point of view, the 'laws' of construction for true architecture were to be *manifested through* this hitherto 'secret' order, the latter acknowledged by Caird as being an essential component of aesthetic responses.
44. *Op. cit.* My emphasis.
45. PA. My emphasis.
46. LS.
47. *Seemliness*. My emphasis.
48. *Ibid.*
49. *Seemliness*.
50. *Ibid.*
51. *Ibid.* My emphases.
52. *Glasgow Herald*, 22nd. February, 1906.
53. *Seemliness*.
54. H. F. Lenning, *The Art Nouveau*, The Hague, Martinus Nijhoff, 1951, p. 7.
55. *Seemliness*.
56. All these sections are from *Seemliness*. My emphases.
57. F. Walker, *Mackintosh and Art Nouveau Architecture*, in C. J. Carter (ed.). See note 24 above. My emphasis.
58. PA.
59. The significance of Spencer for Scottish Art Nouveau theory was made apparent by Mackintosh in 1893. Two years previously a collection of essays by Spencer had appeared which addressed some themes that would have been of undeniable interest for the Glasgow avant-garde. The acknowledgement by Spencer of asymmetry as a central element within indigenous vernacular and 'castellated' architecture appears to point in the direction of a late Art Nouveau concern with a non-organic form language embodying asymmetry, at the same time as it locates this element in the building of the past, where it is taken to be some kind of cultural representation of the asymmetry apparent in nature: 'Of the

alleged connexion between inorganic forms and the wholly irregular and the castellated styles of building, we have, I think, some proof in the fact that when an edifice is irregular, the *more* irregular it is the more it pleases us. I see no way of accounting for this fact, save by supposing that the greater the irregularity the more strongly are we reminded of the inorganic forms typified, and the more vividly are aroused the agreeable ideas of rugged and romantic scenery associated with those forms.' H. Spencer, 'Architectural Types', in *Essays: Scientific, Political, and Speculative*, Vol. II, Williams and Norgate, 1891, p. 377.

60. *Seemliness*. My emphasis.
61. *Ibid*. My emphasis.
62. G. Naylor, *The Arts and Crafts Movement: A Study of its Sources, Ideals and Influence on Design Theory*, Studio Vista, 1971, p. 188.
63. Unspecified Glasgow newspaper, August, 1897. Cutting in Glasgow School of Art Library.
64. LS.
65. *Ibid*.
66. J. Hoffmann, 'Simple Furniture', *Das Interieur*, II, 1901.
67. E. Sekler, 'The Stoclet House by Josef Hoffmann', in D. Fraser *et al.* (eds), *Essays on the History of Architecture Presented to Rudolf Wittkower*, Pitman, 1967, p. 239.
68. See for example *Glasgow Property Circular*, 28th. May, 1895, 'The Glasgow School of Art at Melrose'.
69. LS.
70. *Ibid*.
71. *Ibid*.
72. F. Newbery, *The Future of Art*, Lecture 1895, cutting from unspecified newspaper, Glasgow School of Art Library.
73. LS.
74. *Ibid*.
75. *Ibid*.
76. *Ibid*.
77. J. Hoffmann, 'My Work', Lecture given on 22nd. February, 1911: excerpts transcribed from lecture manuscript by E. Sekler, Appendix 7, p. 488, my emphasis. See note 3 above.
78. P. Bürger, *Theory of the Avant-Garde*, Manchester University Press, 1984, pp. 41–2.
79. Gresleri, p. 9. My emphasis. See note 30 above.
80. PA.
81. *Ibid*. 'How truly language must be regarded as a hindrance to thought, though the necessary instrument of it, we shall clearly perceive on remembering the comparative force with which simple ideas are communicated by signs.' H. Spencer, 'The Philosophy of Style', in *Essays: Scientific, Political, and Speculative*, Vol. II, Williams and Norgate, 1891, p. 335.
82. On this point see Introduction to M. Sahlins, *Islands of History*, Tavistock, 1985.
83. H. Muthesius, *The English House*, J. Seligman (trans.), New York,

Rizzoli, 1979, p. 61. My emphases.

84. J. Ruskin, *The Two Paths*, Blackfriars, p. 151.
85. *The Pall Mall Budget*, of 15th. October, 1885, referred to this original article and a cutting of it from the former appears in Newbery's personal scrapbook.
86. C. E. Schorske, *Fin-de-Siècle Vienna: Politics and Culture*, Alfred A. Knopf, New York, 1980, p. 325.
87. Cited by Sekler. See note 3 above.
88. E. Caird, *Hegel*, William Blackwood and Sons, 1883, pp. 149–50. For Scottish Hegelianism, the crucial sphere for the mediation of thought and feeling, and of subject and object, was that of the integration of imagination and intellect: 'Knowledge is essentially *communicable*; it is what holds good for every subject equally, what is true *for* consciousness in general, and therefore what is true *of* the object. And knowledge depends on the agency of the imagination and understanding, working together in a certain harmonious way: the former combining the manifold of sense, the latter bringing the manifold so combined under the unity of thought. Now, there is, in the case of each different object, a certain proportion or balance of these faculties which is most suitable for knowledge, and which we are capable of feeling as a stimulus to their activity. And this feeling must be as communicable as the knowledge which is the result of such activity.' E. Caird, *The Critical Philosophy of Immanuel Kant*, Vol. 2, Glasgow, James Maclehose and Sons, 1889, p. 400.
89. Walker, p. 56. See note 24 above.
90. *Ibid.*, p. 55.
91. *Seemliness*.
92. *Ibid.*
93. PA.
94. The phrase 'Scottish Peculiarities' was used in a letter from Hoffmann to Howarth dated Vienna, 20th. December, 1947. 'He [Mackintosh] seems to us a deliverer from dead styles – a founder of new forms and an impressive renovator of Scottish peculiarities.' T. Howarth, *Charles Rennie Mackintosh and the Secessionist Movement in Architecture*, Glasgow University Thesis No. 935, 1949.
95. R. Macleod, *Charles Rennie Mackintosh*, Hamlyn, 1968, pp. 37–8.
96. W. R. Lethaby, *Architecture, Nature and Magic*, Duckworth, 1956, p. 16. With this work Lethaby attempted to clarify the meaning and content of his ideas as expounded in *Architecture, Mysticism and Myth*. Certain of his comments make it clear that he considered the earlier work to have been misread in some quarters.
97. Cited by C. E. Schorske, 'Schnitzler und Hofmannsthal', in *Wort und Wahrheit*, XVII, May, 1962.
98. Sekler, p. 238. See note 67 above.
99. PA.
100. Sekler, p. 24. See note 3 above.
101. PA.
102. *Ibid.*

103. *Ibid.*
104. *Ibid.*
105. Naylor, p. 187. See note 62 above.
106. *Fünfzig Jahre Deutscher Werkbund.*
107. *Op. cit.*
108. *Ibid.*
109. PA.
110. LS.
111. O. Jones, *The Grammar of Ornament*, London, 1856, p. 4.
112. PA.
113. *Seemliness.*

## Chapter 6 The institutional context

1. On the issue of setting up a school in Glasgow, the London Council reported in 1843 that 'a memorial was received from the principal municipal authorities, merchants, and manufacturers, of that city [Glasgow], applying for a portion of the Government funds pursuant to the resolutions of a large public meeting on the 4th. of March, which was unanimously of opinion that Schools of Design are well calculated to advance the interests of our manufactures connected with the art of design, and to improve the general taste of the people, and which stated that, the establishment of a School of Design had long been felt to be a desideratum in Glasgow; and that annual subscriptions for its maintenance, during three years, had already been obtained, to the extent of £300. Under these circumstances, Glasgow appeared to have peculiar claims on the consideration of the Council, as forming, in conjunction with Paisley, a centre of various manufactures.' *Third Report of the Council of the School of Design, 1843–44.*
2. H. Muthesius, *The English House*, New York, Rizzoli, 1979, p. 161. Ruskin complained that 'the pre-Raphaelites are all more or less affected by enthusiasm and by various morbid conditions of intellect and temper' ('The Unity of Art', in *The Two Paths*, London, Blackfriars, p. 70).
3. *Ibid.*, p. 161.
4. *Annual Report of the Glasgow School of Art and Haldane Academy*, year ending July, 1884.
5. Cutting from unspecified newspaper (1904) in Glasgow School of Art Library.
6. *Annual Report*, 1884.
7. *Ibid.*
8. *Op. cit.*
9. *Annual Report*, 1884.
10. J. Ruskin, *A Joy for Ever*, George Allen, London, 3rd edition, 1893, p. 221.
11. *Ibid.*, p. 229.
12. *Modern Painters*, Vol. III, Part IV, Ch.X, pp. 14–15.
13. H. Spencer, *Education*, Williams and Norgate, 1878.

# Notes

*Notes*

14. W. Benjamin with A. Lacis, *Programme for a Proletarian Children's Theatre*, S. Buck-Morss (trans.), *Performance*, 5, March, 1973, p. 30.
15. H. Spencer, *Education*, p. 80. See note 13 above.
16. *Ibid.*
17. C. R. Mackintosh, *Seemliness*, 1902. Lecture notes in Hunterian Archive, University of Glasgow.
18. Cited by P. Geddes in *John Ruskin, Economist*, Edinburgh, William Brown, 1884, p. 3.
19. J. Ruskin, *Lectures on Art*, Lecture I, 1870, cited by K. Clark, *Ruskin Today*, Penguin, 1967, p. 213.
20. *Glasgow School of Art Head Master's Report*, 1885.
21. P. L. Waterhouse, *The Story of Architecture Throughout the Ages*, Batsford, 1902, p. 255.
22. 'Idealists are always producing more or less formal conditions of art ... they seek for the pleasure in art, in the relations of its colours and lines, without caring to convey any truth with it ... You will find that the art whose end is pleasure only is pre-eminently the gift of cruel and savage nations, cruel in temper, savage in habits and conception ... when you examine the men in whom the gifts of art are variously mingled, or universally mingled, you will discern that the ornamental, or pleasurable power, though it may be possessed by good men, is not in itself an indication of their goodness, but is rather, unless balanced by other faculties, indicative of violence of temper, inclining to cruelty and irreligion.' J. Ruskin, *The Unity of Art*, pp. 59–61. See note 2 above. What disturbed Ruskin about idealism was that it allegedly led to the kind of absorption in the imagination which he saw as ultimately opposing the 'facts and forms' of nature. As a consequence, artistic form, in reflecting the 'doleful phantoms' of the inner world, engendered meaningless fragmentation of colour and flowings of line.
23. *Glasgow School of Art Annual Report*, 1885.
24. *Op. cit.*
25. *Glasgow Evening News*, May, 1895, 'Glasgow School of Art: A Flourishing Institution'.
26. *Ibid.*
27. *Ibid.* In 1894, *Quiz* was remarking that Newbery knew, as well as anyone, 'the limitations of ... [South Kensington] as a factor in the art education of the country'. 'Character Sketches', No. 52, *Quiz*, 6th. December, 1894.
28. *Glasgow School of Art Annual Meeting*, 1893.
29. *Glasgow Evening News*, May, 1895.
30. F. Newbery, *Art and Commerce*, Lecture in Glasgow Corporation Galleries, 1896.
31. *Glasgow School of Art Annual Report*, 1899.
32. *Op. cit.*
33. *Glasgow School of Art Annual Report*, 1893.
34. *Ibid.*, p. 7.
35. S. Macdonald, *The History and Philosophy of Art Education*, University of London Press, 1970, p. 364.

36. *Glasgow School of Art Annual Report*, 1899.
37. *Glasgow Herald*, date unknown, 'The Sloyd Association: Conference on Educational Handwork'. Cutting in Glasgow School of Art library.
38. *Ibid.*
39. *The Studio*, Vol. XIX, 1900, p. 53.
40. Cutting from unknown newspaper (1894) in Glasgow School of Art Library.
41. *The Studio*, Vol. XIX, 1900, p. 51.
42. *Glasgow Evening News*, 16th. November, 1894. My emphasis.
43. *Glasgow Herald*, 10th. November, 1894. My emphasis.
44. C. R. Mackintosh, *Seemliness*. See note 17 above. My emphasis.
45. *The Studio*, Vol. XIX, 1900, pp. 48–56.
46. F. Newbery, 'Art and Personality', *Glasgow Herald*, 25th. December, 1896.
47. *Ibid.*
48. *Glasgow School of Art Annual Report*, 1899.
49. *The Builder*, 2nd. August, 1845. My emphasis.
50. Cutting from unknown 1894 newspaper in Glasgow School of Art Library.
51. *Ibid.*
52. J. Stanley Little, 'Maurice Greiffenhagen and his Work', *The Studio*, Vol. IX, 1897, p. 239.
53. *Ibid.*, p. 241.
54. Glasgow newspaper, 3rd. August, 1892, title unknown. Cutting in Glasgow School of Art Library.
55. *Glasgow Herald*, January, 1891.
56. Newspaper cutting in Newbery Scrapbook, Mitchell Library, Glasgow.
57. I. Spencer, *Walter Crane: His Work and Influence*, Thesis No. 4280, Glasgow University.
58. *The Studio*, Vol. 26, No. 114, 1902. My emphasis.
59. *Ibid.*, p. 252.
60. *Ibid.*, pp. 253–4.
61. H. F. Lenning, *The Art Nouveau*, The Hague, Martinus Nijhoff, 1951, p. 20.
62. W. Pater, *The Renaissance: Studies in Art and Poetry*, Mentor, 1959, p. 97. Published 1873.
63. *Ibid.*, p. 158.
64. R. Schmutzler, *Art Nouveau*, Thames and Hudson, 1978, p. 209.
65. E. Caird, *Hegel*, William Blackwood and Sons, 1883. The world was an organic unity, but this did not mean, Caird stressed, that the world as a 'whole' should be interpreted on the analogy of organisms such as the living body, plants or animals. Lacking thought or consciousness, such organisms did not represent a unity *for itself*. An ideal or self-determining principle found its final form and expression only in self-consciousness, where subject was unified with object.
66. Macdonald, p. 177. See note 35 above.
67. F. Newbery, 'How to Popularize Our Art Galleries and Museums', two articles written for the *Glasgow Evening News*, 4th. December, 1905.
68. *Ibid.*

69. F. Newbery, 'The Weft of Art in the Warp of City Life', Lecture to members of the Glasgow and West of Scotland Branch of the Teachers' Guild. Cutting from unspecified newspaper in Newbery Scrapbook, Mitchell Library, Glasgow.
70. *The Studio*, Vol. 26, No. 114, 1902, p. 253.
71. Newbery 1905. See note 67 above.
72. *The Studio*, Vol. XXVI, 1902, p. 97.
73. This included work by the Mackintoshes, the MacNairs, James Salmon, J. Gaff Gillespie, Macbeth, Beveridge, Phoebe Traquair, Jessie Newbery, Margaret de Courcy Lewthwaite Dewar, and Agnes Bankier Harvey.
74. Mentioned in letters from Josef Olbrich to Claire Morawe, 10th. May, 1902 and 11th. May, 1902, Private Collection. Cited by R. J. Clark in 'Olbrich and Mackintosh', in P. Nuttgens (ed.), *Mackintosh and His Contemporaries in Europe and America*, John Murray, 1988, p. 106.
75. *Glasgow Herald*, 27th. February, 1902, 'Turin Decorative Art Exhibition'. Although both Traquair and Beveridge exhibited embroideries and needlework in the Scottish section at Turin, neither of them is mentioned in *Glasgow School of Art Embroidery 1894–1920* by F. C. Macfarlane and E. F. Arthur, Glasgow Museums and Art Galleries, 1980.
76. *Ibid.*
77. F. Newbery, 'The International Exhibition of Decorative Art at Turin: The English Section', *The Studio*, Vol. 26, No. 114, p. 254.
78. 'Architecture Teaching at the Glasgow School of Art', *Glasgow Property Circular*, 6th. August, 1895.
79. *The Studio*, p. 254. See note 77 above. Ironically, Wilhelm Scholermann had already praised Crane for the very characteristic which Newbery claimed was absent from Crane's Turin contribution, namely an architectonic sense of design. W. Scholermann, 'Walter Crane', *Zeitschrift für Bildende Kunst*, 1897, Vol. 8, pp. 81–2.
80. *Glasgow Herald*, 3rd. September, 1910.
81. *Glasgow Herald*, 20th. November, 1907.
82. Letter headed 'The Artless University' (a). *Glasgow Herald*, 18th. January, 1907.
83. Letter headed 'The Artless University' (b). Cutting from unspecified newspaper circa 1907 in Glasgow School of Art Library.
84. *Ibid.*
85. *The Studio*, Vol. XIX, 1900, p. 53.
86. W. Pater, *The Renaissance*, p. 158. See note 62 above.
87. 'Principal Caird on Art', cutting from unspecified newspaper (November, 1886) in Newbery Scrapbook, Mitchell Library, Glasgow.
88. C. R. Mackintosh, *Seemliness*. See note 17 above.
89. J. Caird. See note 87 above.
90. C. R. Mackintosh, *Untitled paper on Architecture*, 1893, Hunterian Archive, Glasgow University.
91. E. Caird, *The Critical Philosophy of Immanuel Kant*, Glasgow, James Maclehose and Sons, 1889, p. 410.
92. Cited by N. Pevsner, *Pioneers of Modern Design*, New York, Museum of

Modern Art, 1949, p. 9. Morris quotations from *The Collected Works of William Morris*, xxii, p. 42, xxii, p. 173, xxii, p. 47 et seq.
93. J. Caird. See note 87 above. My emphasis.
94. C. R. Mackintosh, *Seemliness*. See note 17 above.
95. P. Geddes, 'The Sociology of Autumn', *The Evergreen: The Book of Autumn*, 1895.
96. Letter from A. Drysdal, 123 Hospital Street, Glasgow, to the *Glasgow Herald*, 6th. April, 1891.
97. *Architectural Review*, Vol. 9, 1901, p. 243.
98. *Burlington Magazine*, XVI, January, 1910 (part 1), and February, 1910 (part 2). Originally published in *L'Occident*, September, 1907. Emphasis in original.
99. Committee minute, 11th. January, 1892.
100. F. Newbery, lecture 'Art and the University', *Glasgow Herald*, 10th. May, 1907. My emphasis.
101. *Glasgow Herald*, 16th. December, 1909.
102. *Ibid.*
103. *Ibid.*
104. 'Universities and Art', cutting from unspecified newspaper in Newbery Scrapbook, Mitchell Library, Glasgow.
105. *Ibid.*
106. *Ibid.*
107. *Glasgow School of Art Annual Report*, December, 1885.
108. *The Studio*, p. 255. See note 77 above.
109. *Ibid.*, p. 256.
110. F. Newbery, 'Art and its Relation to Handicraft', circa 1890. Cutting from unspecified newspaper in Newbery Scrapbook, Mitchell Library, Glasgow.
111. F. Newbery, 'Art in Relation to Technical Education', *Evening Times*, 12th. April, 1893.
112. Cutting from unspecified newspaper (1894) in Glasgow School of Art Library. My emphasis.
113. *Glasgow Herald*, 13th. January, 1910.
114. *Ibid.* The term 'tricky' had been employed by *Quiz* on the occasion of its reviewing the Glasgow School of Art Club Exhibition, when it condemned the 'ghoul like' designs of the 'Misses Macdonald': 'the landscapes were, for the most part, "tricky", but here and there were evidences of honest endeavour'. *Quiz*, 15th. November, 1894.
115. Quoted in G. Sutton, *Artisan or Artist: A History of the Teaching of Art and Crafts in English Schools*, London and New York, 1967, p. 199.
116. *Glasgow Herald*, 21st. December, 1909.

## Chapter 7 Dissemination and reception

1. Glasgow's main organs of leisure communications in the Art Nouveau period were *The Bailie*, *Quiz*, and *Saint Mungo*. *The Bailie* survived into the 1930s, whereas the other two 'folded' in the 1890s.
2. *Quiz*, 26th. September, 1895.

3. *Quiz*, 28th. February, 1895.
4. *Quiz*, 9th. May, 1895. The Wilde trials (and conviction) on charges of 'homosexuality' began at the Old Bailey on 3rd. April, 1895. Public interest was reflected in the court being filled to capacity.
5. *Quiz*, 13th. June, 1895.
6. *The Studio*, Vol. 21, 1901, p. 262.
7. *Glasgow Herald*, 23rd. January, 1899.
8. P. Hankar, 'Exposition D'Art Appliqué, Mai 1895', *L'Emulation*, Vol. XX, 1895.
9. Copied into Minutes of Committee, Glasgow School of Art, 5th. May, 1897.
10. *Saint Mungo*, 11th November, 1897.
11. *Evening Times*, 5th. February, 1895.
12. 'Glasgow School of Art: A Flourishing Institution', *Glasgow Evening News*, 22nd. May, 1895.
13. P. Geddes, 'The Sociology of Autumn', *The Evergreen: A Northern Seasonal*, 1895, p. 37.
14. *Ibid.*, p. 35.
15. *Ibid.*, p. 37.
16. P. Geddes, *The Evergreen*, Part IV, Winter 1896–7, p. 155.
17. D. Frisby, *Fragments of Modernity: Theories of Modernity in the Work of Simmel, Kracauer and Benjamin*, Polity Press, 1985, p. 82.
18. H. Muthesius, Introduction to *Design for an Art Lover's House*, Darmstadt, 1902.
19. D. Chapman-Houston, *Dreamers in the Moon*, Typescript in Mackintosh Archive (MA), University of Glasgow. The studio was in the house at 6 Florentine Terrace (later Southpark Avenue).
20. *Ibid.*
21. 'A Memory of Mackintosh', Hunterian Archive, University of Glasgow.
22. *North British Daily Mail*, 9th. November, 1894.
23. Cited by S. Weintraub in *Beardsley*, Pelican, 1972, p. 113.
24. *Glasgow Herald*, 10th. November, 1894.
25. Cutting from unknown newspaper in Newbery Scrapbook, Glasgow School of Art Library.
26. *Glasgow Herald*, 16th. November, 1894.
27. 'The New Woman in Art', letter from 'A Gossip', cutting from unknown newspaper in Newbery Scrapbook, Mitchell Library, Glasgow.
28. E. King, *The Women's Suffrage Movement in Scotland*, People's Palace, 1979.
29. *The Bailie*, 17th. November, 1909.
30. 'How to be a "New Woman"', *Quiz*, 13th. September, 1894.
31. *Quiz*, 15th. November, 1894.
32. *Quiz*, 28th. February, 1895.
33. C. Ratcliff, 'Dandyism and Abstraction in a Universe Defined by Newton', *Art Forum International*, December, 1988, p. 84.
34. *Glasgow Advertiser and Property Circular*, 30th. July, 1901.
35. These were: *A Dream* and *Mother and Child* (Margaret Macdonald), and *The Dew* and *Ysighlu* (MacNair).

36. T. Howarth, *Charles Rennie Mackintosh and the Modern Movement*, Routledge and Kegan Paul, 1952, pp. 24–5.
37. *Glasgow Evening News*, 17th. November, 1894.
38. *Op. cit.*, p. 26.
39. *Op. cit.*, p. 25. More recently Howarth has implied a Freudian interpret-ation of the work of the Macdonalds which draws attention to the kind of erotic content which Adorno welcomed in Art Nouveau: 'The powerful sexual overtones in Margaret's craftwork and painting, and especially in that of her sister Frances, are not only obvious, but seem to be unique among women artists at the turn of the century; they deserve closer analysis than is possible here.' 'Charles Rennie Mackintosh: The Internal Reality of Buildings', in P. Nuttgens (ed.), *Mackintosh and his Contemporaries in Europe and America*, John Murray, 1988, p. 45.
40. *Op. cit.*, p. 26.
41. T. Adorno, *Aesthetic Theory*, Routledge and Kegan Paul, 1984, p. 29.
42. *Ibid.*, p. 30.
43. *Ibid.*, p. 31. Bram Dijkstra comments on the symbolism of sleep-as-death as employed by Frances Macdonald in her painting *The Sleeping Princess* (which appeared in *The Yellow Book*, Vol. X, July, 1896, p. 177): 'The fairy tale of the sleeping beauty ... inevitably came to be seen as symbolic of woman in her virginal state of sleep – her state of suspended animation and, as it were, death-in-life. In late nineteenth-century art representations of the sleeping beauty proliferated. Often the artists would make it a point to show the "deathlike" quality of the virgin's sleep. Frances Macdonald's "The Sleeping Princess" could just as easily have been labelled "Ophelia", since this princess seems to be floating in a watery grave rather than to be merely sleeping.' B. Dijkstra, *Idols of Perversity: Fantasies of Feminine Evil in Fin-de-Siècle Culture*, Oxford University Press, 1986, pp. 61–2.
44. *Ibid.*, p. 31.
45. *Op. cit.*
46. *Op. cit.*
47. Adorno, p. 31. See note 41 above.
48. A. Defries, *The Interpreter Geddes: The Man and his Gospel*, George Routledge and Sons, 1927, pp. 204–5.
49. *Ibid.*, p. 205.
50. *Ibid.*, p. 193.
51. *Ibid.*, p. 194.
52. *Ibid.*, p. 195.
53. *Ibid.*, p. 192.
54. *Glasgow Herald*, March, 1888.
55. Cutting from unspecified 1894 newspaper in Glasgow School of Art library.
56. *Glasgow Herald*, 22nd. November, 1861.
57. T. Armstrong, *A Memoir 1832–1911*, Glasgow School of Art Library.
58. C. R. Mackintosh, *Seemliness*, 1902, lecture notes in Hunterian Archive,

University of Glasgow.

59. O. Wilde, 'The English Renaissance of Art', in D. Stanford (ed.), *Writing of the 'Nineties From Wilde to Beerbohm*, Everyman, 1971, p. 23.
60. Wilde to Coquelin, star of the Comédie Française, in *ibid.*, p. xvii.
61. 'A Week With the Jim-Jammers', *Saint Mungo*, 2nd. December, 1897.
62. J. H. Muir (composite pseudonym for James Bone, Archibald Hamilton and Muirhead Bone), *Glasgow in 1901*, William Hodge, 1901, p. 139.
63. *Ibid.*, pp. 139–40.
64. N. Pevsner, 'Sources of Art in the 20th. Century', *The Listener*, 8th. December, 1960.
65. *Time*, 16th. Feburary, 1953. Author not specified.
66. *The Builders' Journal*, August, 1900.
67. F. Newbery, 'The Weft of Art in the Warp of City Life', 1902. Newspaper cutting in Glasgow School of Art Library.
68. 'How a Commercial City May be Beautified', *Glasgow Herald*, 1903.
69. *Glasgow Herald*, 7th. April, 1904.
70. *Ibid.*
71. *Ibid.*.
72. 'The Bounding Girl', *Glasgow Evening News*, 10th. November, 1900.
73. Letter to William Davidson, 7th. April, 1933. Hunterian Archive.
74. Letter to William Davidson, 31st. March, 1933. Hunterian Archive.
75. J. Meier-Graefe, *Entwicklungsgeschichte der Modernen Kunst*, Vol. II, Stuttgart, 1904–5, p. 620.
76. A. McGibbon, 'The Glasgow International Exhibition, 1901', Part One, *The Art Journal*, 1901, p. 129.
77. The General Manager of both the 1888 and 1901 Exhibitions was Henry Anthony Hedley, a native of South Africa, whose official connection with exhibitions began in 1883 when he was appointed Assistant General Superintendent of the London 'Fisheries' Exhibition. This was followed by the 'Healtheries' (1884) and the 'Inventions' (1885) exhibitions in which Hedley occupied the same post. He was manager of the Edinburgh Exhibition in 1886 (profits £15,000). See 'Men You Know', *The Bailie*, 3rd. July, 1901.
78. L. F. Day, 'Decorative and Industrial Art at the Glasgow Exhibition', First Notice, *The Art Journal*, 1901, p. 215.
79. McGibbon, p. 130. See note 76 above.
80. P. Geddes,'The Sociology of Autumn', p. 30. See note 13 above.
81. *Ibid.*, p. 30.
82. P. Geddes, *The Evergreen: A Northern Seasonal*, 'The Book of Autumn', 1895 (Prefatory Note).
83. *The Art Journal*. See note 78 above.
84. *Glasgow Advertiser*, 21st. May, 1901.
85. *Glasgow Advertiser*, 30th. April, 1901.
86. *Glasgow Advertiser*, 30th. July, 1901. My emphasis.
87. *Ibid.*
88. *Ibid.*
89. *Ibid.*
90. S. T. Madsen, *Sources of Art Nouveau*, R. Christophersen (trans.), Da

Capo Press, 1975–80, p. 274. First published in Oslo in 1956.
91. *The Art Journal*, p. 132. See note 76 above.
92. *Ibid.*, p. 220. My emphasis.
93. *Architectural Review*, 'The Artistic Side of the Glasgow International Exhibition', Vol. 10. 1901.
94. *The Bailie*, 23rd. October, 1901.
95. Reported in *The Bailie*, 3rd. July, 1901.
96. *The Art Journal*, p. 188. See note 76 above.
97. Cited by H. Lenning, *The Art Nouveau*, The Hague, Martinus Nijhoff, 1951, p. 63.
98. Madsen, p. 64. See note 90 above.
99. Cited by P. Jullian, *The Triumph of Art Nouveau: Paris Exhibition 1900*, Phaidon, 1974, p. 100.
100. *Ibid.*
101. *Op. cit.*, 'Bing's Art Nouveau auf der Welt-Ausstellung, Paris 1900', *Deutsche Kunst und Dekoration*, Vol. VI, 1900, p. 558.
102. K. E. Osthaus, 'Henry Van de Velde', *Die Neue Baukunst*, I, p. 8.
103. Cited by Lenning, p. 55. See note 97 above.
104. *Op. cit.*, 30th. July, 1901.
105. *Architectural Review*, Vol. 10, 1901, 'The Artistic Side of the Glasgow International Exhibition' (Part Two), 'Some Critical Observations on the Same Subject', p. 54.
106. W. Gaunt, *The Aesthetic Adventure*, Pelican, 1957, p. 255.
107. *Architectural Review*, p. 54. See note 105 above.
108. *Ibid.*, p. 54.
109. 'Glasgow International Exhibition: Part One', *The Studio*, Vol. XXIII, no. 99, 1901.
110. Fourth Notice, *The Art Journal*, p. 302.
111. *Ibid.*
112. *Ibid.*, p. 220.
113. *The Bailie*, 20th. Feburary, 1901.
114. *The Bailie*, 24th. April, 1901.
115. *Glasgow Advertiser and Property Circular*, 21st. May, 1901.
116. Third Notice, *The Art Journal*, p. 277.
117. *Ibid.*
118. *Ibid.*
119. Second Notice, *Ibid.*, p. 240.
120. *Ibid.*, p. 242.
121. *Ibid.*
122. L. F. Day, 'L'Art Nouveau', *The Art Journal*, October, 1900, p. 295.
123. Madsen asserts that 'Lewis Day was possibly one of the leading designers of the 1880s and 1890s, although he has no original contribution to make in his simple and rather traditional designs' (p. 274).
124. See P. Bourdieu, *Distinction: A Social Critique of the Judgement of Taste*, Routledge, 1984.
125. Adorno, p. 33. See note 41 above.
126. *Ibid.*, p. 33.
127. L. F. Day, Fourth Notice, *The Art Journal*, p. 299.

*Notes*

128. *Ibid.*, p. 299.
129. J. Kinchin, 'The Wylie and Lochead Style', in 'Aspects of British Design 1870–1930', *Journal of the Decorative Arts Society*, No. 9, 1985, p. 5. In a review of exhibits at the eighth exhibition of the Vienna Secession in November, 1900, the *Neue Freie Presse* referred critically to the work of the Scottish group in such a way as to bring together descriptively the elements of modernism, symbolistic imagery, and 'simplicity' that were apparent: 'The foreign "moderns" already debauch. Opulently they indulge in pretended simplicity ... prehistoric magic images, hiding-boxes of the sorcerer, furniture for fetishes.' Cited by E. F. Sekler in 'Mackintosh and Vienna', *Architectural Review*, CXLIV, December, 1968, p. 455.
130. Adorno, p. 65. See note 41 above.
131. 'A Glasgow Artist and Designer', *The Studio*, Vol. XXXIII, 1904, p. 222.
132. 'A Glasgow Designer: The Furniture of Mr. George Logan', *The Studio*, Vol. XXX, 1903, p. 202.
133. *Ibid.*, p. 201.

## Chapter 8 Conclusion: the demise

1. 'The Town Beautiful', *Glasgow Herald*, 23rd. December, 1909.
2. *Op. cit.*, 15th. January, 1901.
3. *Glasgow Advertiser and Property Circular (GAPC)*, 16th. April, 1901.
4. *GAPC*, 15th. January, 1901.
5. *GAPC*, 29th. October, 1901.
6. *GAPC*, 26th. March, 1901.
7. *The Bailie*, 30th. October, 1901.
8. *GAPC*, 29th. October, 1901.
9. *GAPC*, 26th. November, 1901.
10. *GAPC*, 3rd. June, 1902.
11. The term 'Geddemaniacs' appeared in *Quiz*, 23rd. January, 1896.
12. 'Kailyairdism' or 'kailyardism' refers to a travestied, fantasized, small-Scottish-town-mentality oriented sub-nationalism which was to a considerable extent created through the literature (for an English readership) of émigré Scots such as Barrie, Cronin, and Gibbon. Even the 'realist' Gibbon was published initially by Welwyn Garden City publishers, and his portrayal of the 'workers' movement' was far from the reality of contemporary forms of urban-based working-class political organization.
13. Talwin Morris attempted to draw attention away from this aspect of the early work with his defensive comment on MacNair's pastel paintings that the 'entire absence of any suggestion of the sensuous [the very term employed by Howarth in his description of MacNair's work] in his treatment of subjects passionate in motive, is pleasantly conspicuous'. T. Morris, *Concerning the Work of Margaret Macdonald, Frances Macdonald, Charles Mackintosh and Herbert MacNair*, unpublished article circa 1897, in Kelvingrove Art Galleries, Glasgow.
14. Formal Opening of the Fine Art Exhibition in connection with the

Helensburgh School of Art, reported in Helensburgh newspaper, 6th. September, 1882.
15. Paper read at the Church Congress in 1885. Cutting in Newbery Scrapbook, Mitchell Library, Glasgow.
16. These included the Phoenix Assurance building, St. Vincent Street, by A. D. Hislop (1913); Northern Insurance building, St. Vincent Street, by J. A. Campbell (1908); Edinburgh Life Insurance, St. Vincent Street, by J. A. Campbell (1906); Commercial Bank, St. Enoch Square, by A. N. Paterson (1906).
17. F. Newbery, 'The Weft of Art in the Warp of City Life', *Glasgow Herald*, 1902.
18. *Ibid.*
19. '... construction should be ornamented, but ornament should never be constructed'. Newbery at fortnightly meeting of Ruskin Society of Glasgow: lecture on 'Art and its Relation to Handicraft' (circa 1890). Cutting in Newbery Scrapbook, Mitchell Library, Glasgow.
20. F. Newbery, Lecture on 'The Principles of Ornament and Decoration' given in the Technical Institute, Dundee, circa 1896. Cutting from unspecified newspaper, Newbery Scrapbook, Mitchell Library, Glasgow.
21. The *Glasgow Evening News* on 25th. February, 1913 presented a short article entitled 'Women and Their Work: Mrs. Fra H. Newbery' which demonstrated that the question of the Art School's role in catering to the kind of craft activities (embroidery, enamelling) perceived as being actually or potentially the preserve of working women had been carefully scrutinized in the early 1890s (Jessie Newbery's embroidery classes were begun in 1894): 'It is largely owing to Mrs. Newbery's incentive that so many students of the Art School have found their metier in the making of patterns, having learned that it is better to be a first-class designer than a mediocre dabbler in paint. By teaching, Mrs. Newbery showed the method to the earliest girl students of design, and she was also able to demonstrate by example that there was a very real outlet and demand for work of this class which came well within the sphere of the woman worker, and provided for her a congenial employment into which it was possible to throw her personality, and which would absorb her interest as well as providing a profitable means of existence.'
22. R. Schmutzler, *Art Nouveau*, Thames and Hudson, 1978, p. 213.
23. 'Glasgow School of Art Exhibition of Posters', *Glasgow Herald*, 22nd. October, 1915.
24. *Op. cit.*, 7th. September, 1910.
25. Cited by A. Gomme and D. Walker, *Architecture of Glasgow*, Lund Humphries, 1968, p. 277.
26. R. Billcliffe, *Mackintosh Furniture*, Cambridge, Lutterworth Press, London, Cameron Books, 1984, p. 198.
27. S. T. Madsen, *Sources of Art Nouveau*, New York, Da Capo, 1975 edition, p. 432.
28. *Concerning the Work of Margaret Macdonald, Frances Macdonald, Charles Mackintosh and Herbert MacNair.* See note 13 above.

# Bibliography

1. Primary sources (archival).
2. Contemporary writing (books, articles).
3. Secondary literature (after the period studied).

## Primary sources

Archive of House of Fraser and its Subsidiary and Associated Companies 1818–1986 (compiled by Alison Turton, Company Archivist, March 1987), The Archives, University of Glasgow.

Blackie, Walter and Sons, Catalogues 1870–1913.

Morris, Talwin, 'Concerning the Work of Margaret Macdonald, Frances Macdonald, Charles Mackintosh and Herbert MacNair: An Appreciation', unpublished article, circa 1897, Kelvingrove Art Gallery and Museum.

Glasgow School of Art Annual Reports.

Glasgow School of Art books of press cuttings.

Glasgow School of Art Prospectuses.

Keppie, Henderson Archives, Glasgow.

Walter MacFarlane's Architectural Iron Work catalogues, vols. I and II, circa 1911.

Mackintosh Archive, Hunterian Gallery, University of Glasgow. Extant material by C. R. Mackintosh:
   (a) Lecture on Scottish Baronial Architecture (1891).
   (b) Lecture on Elizabethan Architecture (early 1890s).
   (c) Paper on Architecture (1893).
   (d) *Seemliness* (1902).
   (e) Lecture given to a Literary Society (circa 1905).
   (f) Critique of Ruskin's *Stones of Venice* (date unknown). Copied from a review which appeared in *The Builder* in 1888.

Minutes of the Glasgow City Improvement Committee, Strathclyde Regional Archive.

Notes on Municipal Work: City Improvements Dept, Glasgow Corporation, 1899.

Francis Newbery's personal press-cuttings book, Glasgow Room, Mitchell Library, Glasgow.

A number of newspapers and journals were consulted for contemporary reportage relevant to the area of analysis. These included: *The Bailie, Daily Record, The Exhibition Illustrated 1901, Glasgow Advertiser and Propery Circular, Glasgow Herald, Glasgow Evening News, Glasgow Evening Times, Madame, Property, Quiz, Saint Mungo, The Scotsman.*

## Contemporary writing

Anonymous, 'A New Art Movement in Glasgow', *Quiz*, 10th. December, 1896.

Anonymous, 'The Glasgow School in America', *Glasgow Evening Times*, 14th. November, 1895.

Anonymous, 'The Artistic Side of the Glasgow International Exhibition', *Architectural Review*, Vols. 9 and 10, 1901.

Anonymous, *The Exhibition Illustrated*, 22nd. June, 1901.

Anonymous, 'A Glasgow Designer: The Furniture of Mr. George Logan', *The Studio*, Vol. XXX, 1903.

Anonymous, 'Glasgow School of Art Club', *The Studio*, Vol. XV, 1899.

Anonymous, 'Some Work by the Students of the Glasgow School of Art', *The Studio*, Vol. XIX, 1900.

Anonymous, 'Studio Talk' (Talwin Morris), *The Studio*, Vol. XXII, 1900.

Anonymous, 'First International Studio Exhibition', *The Studio*, Vol. XXIV, 1901.

Anonymous, 'The Glasgow International Exhibition', *The Studio*, Vol. XXIII, 1901.

Anonymous, 'Annual Exhibition, Glasgow School of Art', *The Studio*, Vol. XXIV, 1902.

Anonymous, 'The International Exhibition of Modern Decorative Art at Turin: the Scottish Section', *The Studio*, Vol. XXVI, 1902.

Anonymous, 'An Interview with Mr. C. F. A. Voysey', *The Studio*, Vol. I, 1893.

Anonymous, 'Vienna Arts and Crafts', *The Studio*, Vol. XXI, 1900.

Anonymous, 'Woman as an Architect', *Daily Chronicle*, 19th. August, 1909.

Ashbee, C. R., *Craftsmanship in Competitive Industry*, Campden, 1908.

Ashbee, C. R., *Should We Stop Teaching Art?*, London, 1911.

Bate, Percy, 'The Work of David Gauld', *Scottish Art and Letters*, 1903.

Bergson, Henri, *Time and Free Will*, London, Allen and Unwin, 1910.

Bosanquet, Bernard, *A History of Aesthetic*, Swan Sonneschein and Co., 1892.

Buschmann, P., 'Belgian Artists in England', *The Studio*, Vol. 64, 1914–15.

Caird, Edward, *Hegel*, William Blackwood and Sons, 1883.

Caird, Edward, *The Critical Philosophy of Immanuel Kant*, Glasgow, James Maclehose and Sons, 1889.

Charles, Ethel, 'A Plea for Women Practising Architecture', *The Builder*, Vol. 82, 1902.

Crane, Walter, *Of the Decorative Illustration of Books Old and New*, London, 1896.

Davidson, T. Raffles, *Pen and Ink Notes at the Glasgow Exhibition*, London, 1888.

Day, Lewis F., 'L'Art Nouveau', *The Art Journal*, October, 1900.

Day, Lewis F.,'Decorative and Industrial Art at the Glasgow Exhibition', Five Notices, *The Art Journal*, 1901.

Delville, Jean, *The New Mission of Art: A Study of Idealism in Art*, F. Colmer (trans.), London, Francis Griffiths, 1910.

Denis, Maurice, 'Cézanne', *Burlington Magazine*, Vol. XVI, January 1910.

Diaghilev, Sergei, 'Moskovie Novosti', *Mir Iskusstva*, No. 3, 1903.

Donaldson, G., 'Gift of "New Art" Furniture for Circulation', *The Magazine of Art*, Vol. XXV, 1900.

Fisher, Garrett, 'Glasgow – A Model Municipality', *Fortnightly Review*, Vol. 63, 1895.

Frey, Dagobert, 'Otto Wagner, Historische Betrachtungen und Gegenwartsgedanken', *Der Architekt*, Vol. XII, 1919.

Geddes, Patrick, contributions to *The Evergreen: A Northern Seasonal*, published in the Lawnmarket, Edinburgh, by Geddes and colleagues, in London by T. Fisher Unwin, and in Philadelphia by J. B. Lippincott and Co., 1895–7 (four volumes).

Geddes, Patrick, 'An Analysis of the Principles of Economics', *Proceedings of the Royal Society of Edinburgh*, No. XII, 1884.

Geddes, Patrick, *Edinburgh Summer Meeting, Prospectus*, 1895.

Geddes, Patrick, *John Ruskin, Economist*, Edinburgh, William Brown, 1884.

Geddes, Patrick, 'On the Conditions of Progress of the Capitalist and Labourer', No. 3, *The Claims of Labour* Lectures, Edinburgh Cooperative Printing Society, 1886.

Geddes, Patrick, and Thomson, J. Arthur, *The Evolution of Sex*, Walter Scott, 1889.

Gerard, Alexander, *Essay on Taste*, London, 1759.

Grasset, Eugène, 'L'Architecture Moderne Jugée par Eugène Grasset', *L'Emulation*, Vol. XXI, 1896.

Hankar, Paul, 'Exposition d'Art Appliqué, Mai 1895', *L'Emulation*, Vol. XX, 1895.

Hevesi, Ludwig, *Acht Jahre Sezession März 1897 – Juni 1905*, Vienna, 1906.

Hevesi, Ludwig, *Altkunst – Neukunst: Wien 1894–1908*, Vienna, 1908.

Hoffmann, Josef, 'Simple Furniture', *Das Interieur*, II, 1901.

Hoffmann, Josef and Moser, Koloman, *The Work Programme of the Wiener Werkstätte*, Vienna, 1905.

Hume, David, *Philosophical Works*, T. H. Green and T. H. Grose (eds), London, 1875.

Jones, Owen, *The Grammar of Ornament*, London, 1856.

Khnopff, Fernand, Review of the Vienna School of Arts and Crafts Exposition, *The Studio*, Vol. XXII, 1901.

Konody, P. G., *The Art of Walter Crane*, London, 1902.

Lethaby, William Richard, *Architecture, Mysticism and Myth*, Percival and Co., 1892. Reprinted, with an introduction by Godfrey Rubens, by the Architectural Press, 1975/76.

Little, J. Stanley, 'Maurice Greiffenhagen and his Work', *The Studio*,

Vol. IX, 1897.

Lux, Joseph A., *Das Neue Kunstgewerbe in Deutschland*, Leipzig, 1908.

McGibbon, Alexander, 'The Glasgow International Exhibition, 1901', *The Art Journal*, 1901, pp. 129–32 and pp. 219–22

McGibbon, Alexander, 'Medieval Architecture', *Glasgow Advertiser and Property Circular*, 30th. October, 1894.

Mackworth, Audley, 'The Relation of the Easel Picture to Decorative Art', *The Art Journal*, 1901.

Martin, David, *The Glasgow School of Painting*, Introduction by Francis H. Newbery, Bell and Sons, 1897.

Mikhaylov, M., 'Ist zu Wienerische', *Iskusstvo Stroitel'noe i Dekorativnoe*, 1903.

Miller, Fred, 'Women in the Art Crafts', *The Art Journal*, 1896.

Morris, William, *Collected Works*, London, 1915.

Mourey, Gabriel, 'Round the Exhibition: IV Austrian Decorative Art', *The Studio*, Vol. XXI, 1901.

Muir, James Hamilton, *Glasgow in 1901*, William Hodge, 1901.

Munro, Neil, *Erchie*, circa 1904.

Muthesius, Hermann, 'Art and Machine', *Dekorative Kunst*, Vol. 9, 1902.

Muthesius, Hermann, 'Die Ausstellung der Wiener Secession', *Dekorative Kunst*, Vol. 7, 1901.

Muthesius, Hermann, 'The Glasgow Art Movement', *Dekorative Kunst*, Vol. 9, 1902.

Muthesius, Hermann, *Haus Eines Kunstfreundes* (introduction), Darmstadt, 1902.

Muthesius, Hermann, 'Die Ästhetische Ausbildung der Ingenieurbauten', *Zeitschrift des Vereins Deutscher Ingenieure*, 53, No. 31, 1909.

Muthesius, Hermann, 'Die Kunst Richard Riemerschmid', *Die Kunst*, Vol. 10, 1904.

Muthesius, Hermann, 'Neues Ornament und Neue Kunst', *Die Kunst*, Vol. 4, 1901.

Muthesius, Hermann (?), 'Die Schottische Kunstler', *Dekorative Kunst*, Vol. 2, No. 2, 1899.

Newbery, Francis H., 'An Appreciation of the Work of Ann Macbeth', *The Studio*, Vol. XXVII, 1902.

Newbery, Francis H., 'The International Exhibition of Modern Decorative Art at Turin: the English Section', *The Studio*, Vol. XXVI, No. 114, 1902.

Newbery, F. H., 'How to Popularize Our Art Galleries and Museums', two articles for *Glasgow Evening News*, 1905.

Newbery, F. H., 'Art and the University', *Glasgow Herald*, 10th. May, 1907.

Obrist, Hermann, 'Wozu über Kunst Schreiben', *Dekorative Kunst*, Vol. 5, 1900.

Osborne, Max, 'Bing's Art Nouveau auf der Welt-Ausstellung, Paris 1900', *Deutsche Kunst und Dekoration*, Vol. VI, 1900.

Osthaus, K. E., 'Henry Van de Velde', *Die Neue Baukunst*, Dresden, 1906.

Pater, Walter, *The Renaissance: Studies in Art and Poetry* (1873), Mentor Books, 1959.

Paterson, Alexander N., 'Domestic Architecture', *Glasgow Advertiser and Property Circular*, 3rd. December, 1895.

Peacock, Netta, 'The New Movement in Russian Decorative Art', *The Studio*, Vol. XXII, 1901.

Pennell, Joseph, 'A New Illustrator: Aubrey Beardsley', *The Studio*, Vol. 1, September, 1893.

Poppenberg, Friedrich, *Das Lebendige Kleid*, Berlin, 1910.

Redgrave, R., and Redgrave, S., *A Century of Painters*, Smith, Elder, 1866.

Ruskin, John, *Collected Works*, Cook and Wedderburn (eds), London, 1903–12.

Ruskin, John, *A Joy for Ever*, George Allen, London, 1893 (3rd. edition).

Ruskin, John, *The Seven Lamps of Architecture*, London, New York, 1907. Originally published in 1849.

Ruskin, John, *The Two Paths: Lectures on Art and its Application to Decoration and Manufacture*, London, Blackfriars (undated). Originally published as *Lectures on Art* in 1870.

Scott, M. H. Bailie, 'On the Characteristics of Mr. C. F. A. Voysey's Architecture', *The Studio*, Vol. XLII, 1907.

Scott, M. H. Bailie, *Houses and Gardens*, George Newnes, 1906.

Sedding, John D., *Art and Handicraft*, Kegan Paul, Trench, Trubner and Co., 1893.

Singer, Hans W., 'Arts and Crafts in Dresden', *The Studio*, Vol. MCMIV, 1904.

Spencer, Herbert, *Education*, Williams and Norgate, 1878.

Spencer, Herbert, *Essays: Scientific, Political, and Speculative*, Williams and Norgate, 1891.

Spencer, Herbert, *Sociology*, New York, Appleton and Co., 1892.

Taylor, J., 'A Glasgow Artist and Designer: the Work of E. A. Taylor', *The Studio*, Vol. XXXIII, 1904.

Taylor, J., 'Modern Decorative Art at Glasgow', *The Studio*, Vol. XXXIV, 1906.

Taylor, J., 'The Glasgow School of Embroidery', *The Studio*, Vol. L, 1910.

Van de Velde, Henry, *Kunstgewerbliche Laienpredigten*, Leipzig, Hermann Seemann, 1902.

Wagner, Otto, *Modern Architecture*, translated and with an introduction by H. F. Mallgrave, Getty Center for the History of Art and the Humanities, 1988. Originally published in Vienna in 1895.

Waterhouse, P. Leslie, *The Story of Architecture Throughout the Ages*, Batsford, 1902.

White, Gleeson, 'Some Glasgow Designers and their Work', four parts, *The Studio*, Vols. XI–XIII, 1897.

Wolf, B. Colt de, 'Municipal Art in Belgium', *The Art Journal*, 1901.

Zangwill, Israel, 'Without Prejudice', *Pall Mall Magazine*, January, 1895.

## Secondary literature
### (subsequent to the period being studied, that is, post-1914)

Adorno, Theodor W., *Aesthetic Theory*, C. Lenhardt (trans.), G. Adorno and R. Tiedemann (eds), Routledge and Kegan Paul, 1984. First published in Germany in 1970.

Adorno, Theodor W., 'Functionalism Today', J. O. Newman and J. H. Smith (trans.), *Oppositions*, 17, 1979.

Adorno, Theodor W., *Prisms: Cultural Criticism and Society*, London, Neville Spearman, 1967.

Aldcroft, Derek H., and Richardson, Harry W., *The British Economy 1870–1939*, Macmillan, 1969.

Amaya, Mario, *Art Nouveau*, Dutton Vista, 1966.

Anonymous, 'Jessie M. King Scottish Book Illustrator', *The Scottish Book Collector*, August, 1987.

Barker, Paul, 'Art Nouveau riche', in P. Barker (ed.), *Arts in Society*, Fontana/Collins, 1977.

Barr, Alfred H. Jnr., *Defining Modern Art*, New York, Harry N. Abrams, 1986.

Battersby, Martin, *The World of Art Nouveau*, Arlington Books, 1968.

Beazley, Elisabeth, and Lambert, Sam, 'The Astonishing City', *Architects' Journal*, May, 1964.

Bell, Quentin, *The Schools of Design*, Routledge and Kegan Paul, 1963.

Benevolo, Leonardo, *History of Modern Architecture*, H. J. Landry (trans.), Routledge and Kegan Paul, 1966. First published in Italy in 1960.

Benjamin, Andrew, 'Derrida, Architecture and Philosophy', 'Deconstruction in Architecture', *Architectural Design*, Vol. 58, No. 3/4, 1988.

Benjamin, Walter, 'Central Park', *New German Critique*, No. 34, Winter, 1985.

Benjamin, Walter, *Charles Baudelaire: A Lyric Poet in the Era of High Capitalism*, Harry Zohn (trans.), NLB, 1973.

Benton, Tim, 'Arts and Crafts and Art Nouveau', in Frank Russell (ed.), *Art Nouveau Architecture*, Academy Editions, 1979.

Benton, T., Benton, C., and Sharp, D. (eds), *Form and Function*, Grenada, Open University, 1975.

Berman, Marshall, *All That Is Solid Melts Into Air: The Experience of Modernity*, New York, Simon and Schuster, 1982, Verso edition, 1983.

Bernstein, Richard J., *Habermas and Modernity*, Polity Press/Basil Blackwell, 1985.

Billcliffe, Roger, *The Hill House*, National Trust for Scotland, 1985.

Billcliffe, Roger, *Mackintosh Furniture*, Lutterworth Press, 1984.

Billcliffe, Roger, *The Glasgow Boys: The Glasgow School of Painting 1875–1895*, John Murray, 1985.

Billcliffe, Roger, and Vergo, Peter, 'Charles Rennie Mackintosh and the Austrian Art Revival', *Burlington Magazine*, No. 896, Vol. CXIX, November, 1977.

Bird, Elizabeth, 'Ghouls and Gas Pipes: Public Reaction to Early Work of The Four', *Scottish Art Review*, Vol. XIV, No. 4, 1975.

Boardman, Philip, *Patrick Geddes: Maker of the Future*, Introduction by Lewis Mumford, Chapel Hill, University of California Press, 1944.

Boardman, Philip, *The Worlds of Patrick Geddes, Biologist, Town Planner, Re-Educator, Peace-Warrior*, Routledge and Kegan Paul, 1978.

Bourdieu, Pierre, *Distinction: A Social Critique of the Judgement of Taste*, Routledge and Kegan Paul, 1984. First published in Paris in 1979.

279

Buchanan, William (ed.), *Mackintosh's Masterwork: The Glasgow School of Art*, Richard Drew, 1989.

Buddensieg, Tilmann, and Rogge, Henning, *Industriekultur: Peter Behrens and the AEG, 1907–1914*, Iain Boyd Whyte (trans.), with contributions by G. Heidecker, K. Wilhelm, S. Bohle and F. Neumeyer, Cambridge, Massachusetts, MIT Press, 1984. Originally published by Gebr. Mann Verlag, Berlin, 1979.

Bürger, Peter, 'Avant-garde and Contemporary Aesthetics: A Reply to Jürgen Habermas', *New German Critique*, 22, Winter, 1981.

Bürger, Peter, *Theory of the Avant-Garde*, Michael Shaw (trans.), Foreword by Jochen Schulte-Sasse, 'Theory of Modernism Versus Theory of the Avant-Garde', Manchester University Press/University of Minnesota Press, 1984 (originally published Frankfurt, 1974).

Cage, R. A. (ed.), *The Working Class in Glasgow 1750–1914*, Croom Helm, 1987.

Campbell, Joan, *The German Werkbund*, Princeton University Press, 1978.

Carter, Christopher J. (ed.), *Art, Design and the Quality of Life in Turn of the Century Scotland (1890–1910)*, Proceedings of Symposium Duncan of Jordanstone College of Art, Dundee, 1985.

Chapman-Huston, Desmond, *The Lamp of Memory: Autobiographical Digressions*, Skeffington and Son, 1949.

Cinamon, Gerald, 'Talwin Morris, Blackie and the Glasgow Style', *The Private Library*, 3rd. Series, Vol. 10:1, Spring, 1987.

Clark, Kenneth, *Ruskin Today*, John Murray, 1964.

Clark, T. J., *The Painting of Modern Life: Paris in the Art of Manet and his Followers*, Thames and Hudson, 1985.

Conrads, V., *Programmes and Manifestoes on 20th. Century Architecture*, MIT Press, 1970.

Cooke, Catherine, 'Fedor Osipovich Shekhtel: An Architect and his Clients in Turn of the Century Moscow', *Annals of the Architectural Association School of Architecture*, No. 5.

Cooke, Catherine, 'Shekhtel in Kelvingrove and Mackintosh on the Petrovka: Two Russo-Scottish Exhibitions at the Turn of the Century', *Scottish Slavonic Review*, No. 10, 1988.

Cooper, Jackie (ed.), *Mackintosh Architecture: The Complete Buildings and Selected Projects*, foreword by David Dunster, introduction by Barbara Bernard, Academy Editions, 1977/1984.

Davey, Peter, *Arts and Crafts Architecture*, Architectural Press, 1980.

Defries, Amelia, *The Interpreter Geddes: The Man and his Gospel*, George Routledge, 1927.

Department of Decorative Art, Glasgow Museums and Art Galleries, *The Glasgow Style 1890–1920*, 1984.

Dijkstra, Bram, *Idols of Perversity: Fantasies of Feminine Evil in Fin-de-Siècle Culture*, Oxford University Press, 1986.

Donnelly, Michael, *Glasgow Stained Glass: a Preliminary Study*, Glasgow Museums and Art Galleries, 1981.

Eidelberg, Martin, and Herion-Giele, Suzanne, 'Horta and Bing: An Unwritten Episode of L'Art Nouveau', *Burlington Magazine*, No. 896,

Vol. CXIX, November, 1977.

Ellmann, Richard, *Oscar Wilde*, Hamish Hamilton, 1987.

Fraser, Douglas, Hibbard, Howard, and Lewine, M. J. (eds), *Essays on the History of Architecture Presented to Rudolf Wittkower*, Pitman, 1967.

Frisby, David, *The Aesthetics of Modern Life: Simmel's Interpretation*, Paper presented to the Culture Section at the American Sociological Association Annual Meeting, San Francisco, August, 1989. Copy supplied by the author.

Frisby, David, *Fragments of Modernity: Theories of Modernity in the Work of Simmel, Kracauer and Benjamin*, Polity Press, 1985.

Garner, Philippe (ed.), *Encyclopedia of Decorative Arts 1890–1940*, Quarto/Phaidon, 1978.

Gaunt, William, *The Aesthetic Adventure*, Pelican, 1957.

Gibb, Andrew, *Glasgow: The Making of a City*, Croom Helm, 1983.

Godoli, Ezio, 'To the limits of a language: Wagner, Olbrich, Hoffmann', in Frank Russell (ed.), *Art Nouveau Architecture*, Academy Editions, 1979.

Gomme, Andor, and Walker, David, *Architecture of Glasgow*, Lund Humphries, 1968.

Goodman, Nelson, *Problems and Projects*, Hackett, 1972.

Gordon, George (ed.), *Perspectives of the Scottish City*, Aberdeen University Press, 1985.

Gray, R. Q., 'Religion, Culture and Social Class in Late Nineteenth Century and Early Twentieth Century Edinburgh', in G. Crossick (ed.), *The Lower Middle Class in Britain*, Croom Helm, 1977.

Gresleri, Giuliano, *Josef Hoffmann*, New York, Rizzoli, 1985.

Griffiths, John, 'Deconstruction Deconstructed', 'The New Modernism: Deconstructionist Tendencies in Art', *Art and Design*, Vol. 4, No. 3/4, 1988.

Groundwater, John M., *The Glasgow School of Art Through a Century*, Glasgow School of Art, 1940.

Groussard, Jean-Claude, and Roussel, Francis, *Nancy Architecture 1900*, Office Du Tourisme de la Ville de Nancy, 1976.

Gunther, G., and Hielscher, K., *Kunst und Produktion*, Munich, Hanser, 1972.

Gusevich, Miriam, 'Decoration and Decorum, Adolf Loos's Critique of Kitsch', *New German Critique*, No. 43, Winter, 1988.

Habermas, Jürgen, *The Philosophical Discourse of Modernity*, F. Lawrence (trans.), Cambridge, Massachusetts, MIT Press, 1987.

Halliday, R., *The Lost Pearls: A Review of the Art Nouveau Architecture of Mackintosh's Contemporaries at the Turn of the Century*, B.A. Dissertation, Glasgow School of Art.

Hardy, William, *A Guide to Art Nouveau*, Quartet/Apple Books, 1986.

Hauser, Arnold, *The Social History of Art*, Routledge and Kegan Paul, 1951.

Hellier, Henry, 'Odd Man Out', *Scottish Art Review*, Vol. XI, No. 4, 1968.

Hiesinger, Kathryn Bloom, *Art Nouveau in Munich: Masters of Jugendstil*, Philadelphia Museum of Art/Prestel-Verlag, Munich, 1988.

Hillier, Bevis, *Posters*, Spring Books, 1969/1974.

Hitchcock, Henry Russell, *Architecture: Nineteenth and Twentieth Centuries*,

Baltimore, 1958.

Howarth, Thomas, *Charles Rennie Mackintosh and the Secessionist Movement in Architecture*, Glasgow University Thesis No. 935, 1949.

Howarth, Thomas, *Charles Rennie Mackintosh and the Modern Movement*, Routledge and Kegan Paul, 1952. Second Edition, 1977. Paperback edition, 1990

Jullian, Philippe, *Dreamers of Decadence: Symbolist Painters of the 1890s*, Robert Baldick (trans.), Praeger, 1971. Originally published as *Ésthetes et Magiciens*, Paris, Librairie Academique Perrin, 1969.

Jullian, Philippe, *The Symbolists*, Phaidon, 1973.

Jullian, Philippe, *The Triumph of Art Nouveau: Paris Exhibition 1900*, Phaidon, 1974.

Kallir, Jane, *Viennese Design and the Wiener Werkstätte*, New York, George Braziller, London, Thames and Hudson, 1986.

Kellet, John R., *Glasgow: A Concise History*, Blond, 1967.

Kinchin, Juliet, 'The Wylie and Lochead Style', *Aspects of British Design 1870–1930: Journal of the Decorative Arts Society*, No. 9, 1985.

Kinchin, Juliet, and Kinchin, Perilla, *Glasgow's Great Exhibitions*, White Cockade, 1988.

Krell, David Farrell, and Wood, David, *Exceedingly Nietzsche: Aspects of Contemporary Nietzsche-Interpretation*, Routledge, 1988.

Larner, Gerald, and Larner, Celia, *The Glasgow Style*, Edinburgh, Paul Harris Publishing, 1979.

Lees, Andrew, *Cities Perceived: Urban Society in European and American Thought, 1820–1940*, Manchester University Press, 1985.

Lenning, Henry F., *The Art Nouveau*, The Hague, Martinus Nijhoff, 1951.

Lethaby, William Richard, *Architecture, Nature and Magic*, Duckworth, 1956. Originally written as a series of articles for *The Builder* in 1928.

Lockett, Terence A., *Collecting Victorian Tiles*, Antique Collectors' Club, Baron Publishing, 1979.

McCully, Marilyn (ed.), *Homage to Barcelona*, Arts Council of Great Britain, 1986.

MacDonald, Stuart, *The History and Philosophy of Art Education*, University of London Press, 1970.

Macfarlane, Fiona C., and Arthur, Elizabeth F., *Glasgow School of Art Embroidery 1894–1920*, Glasgow Museums and Art Galleries, 1980.

Macleod, Robert, *Charles Rennie Mackintosh*, Hamlyn/Country Life Books, 1968. Revised version *Charles Rennie Mackintosh: Architect and Artist*, Collins, 1983.

Madsen, Stephan Tschudi, *Art Nouveau*, Weidenfeld and Nicolson, 1967.

Madsen, Stephan Tschudi, *Sources of Art Nouveau*, R. I. Christophersen (trans.), Oslo, H. Aschenhoug and Co., 1956. Reprinted in World University Library, Weidenfeld and Nicolson, 1967.

Mairet, Philip, *Pioneer of Sociology: The Life and Letters of Patrick Geddes*, Lund Humphries, 1957.

Masini, Lara-Vinca, *Art Nouveau*, Thames and Hudson, 1984.

Maxwell, Sir John Stirling, *Shrines and Homes of Scotland*, London, 1937.

Micklethwait, Brigid, and Peppin, Lucy, *Dictionary of British Book*

*Illustrators: The Twentieth Century*, London, John Murray, 1983.

Morton, Henry Brougham, *A Hillhead Album*, H. B. Morton/University Press, Glasgow, for the Trustees of the Late Charles A. Hepburn, 1973.

Murotani, Bunji (ed.), 'Charles Rennie Mackintosh', *Process Architecture*, No. 50, August, 1984.

Nairn, Tom, *The Break-Up of Britain: Crisis and Neo-Nationalism*, Second, Expanded Edition, NLB/Verso, 1981. First published by NLB, 1977.

Nairn, Tom, 'Old Nationalism and New Nationalism', in G. Brown (ed.), *The Red Paper on Scotland*, EUSPB, 1975.

Naylor, Gillian, *The Arts and Crafts Movement: A Study of its Sources, Ideals and Influence on Design Theory*, London, Studio Vista, 1971.

Nietzsche, Friedrich, *Complete Works*, Oscar Levy (ed.), New York, Russell and Russell, 1964.

Nietzsche, Friedrich, *The Gay Science*, W. Kaufmann (trans.), New York, Random House, 1974.

Nietzsche, Friedrich, *Human, All Too Human*, R.J. Hollingdale (trans.), Cambridge, Cambridge University Press, 1986.

Nuttgens, Patrick (ed.), *Mackintosh and his Contemporaries in Europe and America*, John Murray, 1988.

Olsen, Donald J., *The City as a Work of Art: London, Paris, Vienna*, Yale University Press, 1986.

Orton, Fred, and Pollock, Griselda, 'Les Données Bretonnantes: La Prairie de la Représentation', *Art History*, Vol. 3, No. 3, September, 1980.

Osthaus, K. E., 'Henry Van de Velde', *Die Neue Baukunst*, Vol. 1, 1906.

Pevsner, Sir Nikolaus, *Pioneers of Modern Design from William Morris to Walter Gropius*, New York, Museum of Modern Art, 1949.

Pevsner, Sir Nikolaus, 'Sources of Art in the 20th. Century', *The Listener*, 8th. December, 1960.

Pevsner, Sir Nikolaus, *Studies in Art, Architecture and Design*, Thames and Hudson, 1968.

Pevsner, Sir Nikolaus, and Richards, J. M. (eds), *The Anti-Rationalists*, Architectural Press, 1973.

Powell, Nicolas, *The Sacred Spring: The Arts in Vienna 1898–1918*, Studio Vista, 1974.

Reekie, Pamela, *The Mackintosh House*, Hunterian Art Gallery, University of Glasgow.

Rewald, J., *Post-Impressionism from Van Gogh to Gauguin*, New York, Museum of Modern Art, 1956.

Russell, Frank, *Art Nouveau Architecture*, Academy Editions, 1979.

Sahlins, Marshall, *Islands of History*, Tavistock, 1985.

Schmutzler, Robert, *Art Nouveau*, Edouard Roditi (trans.), Thames and Hudson, 1964. First published by Verlag Gerd Hafje, Stuttgart, 1962.

Schmutzler, Robert, *Art Nouveau*, revised and abridged edition, Thames and Hudson, 1978.

Schorske, Carl E., *Fin-de-Siècle Vienna: Politics and Culture*, New York, Alfred A. Knopf, 1980.

Schorske, Carl E., 'MOMA's Vienna, Vienna 1900: Art, Architecture and Design', review of an exhibition at the Museum of Modern Art, New

York, 3rd. July–21st. October, 1986, *New York Review of Books*, 25th. September, 1986.

Schweiger, Werner J., *Wiener Werkstätte: Design in Vienna 1903–1932*, Thames and Hudson, 1984.

Seaton, Christopher, 'Scottish Publishing and its Reaction to Art Nouveau', in C. J. Carter, *Art, Design and the Quality of Life in Turn of the Century Scotland (1890–1910)*, Proceedings of Symposium Duncan of Jordanstone College of Art, Dundee, 1985.

Sekler, Eduard F., *Josef Hoffmann: The Architectural Work, Monograph and Catalogue of Works*, trans. by the author (catalogue trans. by John Maass), Princeton University Press, 1985. German edition 1978.

Sekler, Eduard F., 'Mackintosh and Vienna', *Architectural Review*, CXLIV, December, 1968.

Selz, Peter, and Constantine, Mildred (eds), *Art Nouveau: Art and Design at the Turn of the Century*, New York, Museum of Modern Art, Doubleday, 1959.

Spencer, Isobel, *Walter Crane: His Work and Influence*, Thesis No. 4280, Glasgow University.

Spencer, Isobel, 'Francis Newbery and the Glasgow Style', *Apollo*, October, 1973.

Tafuri, Manfredo, 'Am Steinhof: Centrality and "Surface" in Otto Wagner's Architecture', *Die Kunst Des Otto Wagner*, Akademie der Bildenden Künste, Vienna, 1984.

Taylor, E. A., 'A Neglected Genius: Charles Rennie Mackintosh', *The Studio*, Vol. CV, 1933.

Taylor, John Russell, *The Art Nouveau Book in Britain*, Edinburgh, Paul Harris, 1966/1980.

Taylor, Ronald (ed.), *Aesthetics and Politics*, Verso, 1977.

Tillyard, S. K., *The Impact of Modernism*, Routledge, 1987.

Van de Velde, Henry, 'Extracts from his Memoirs', *Architectural Review*, September, 1952.

Varnedoe, Kirk, *Vienna 1900: Art, Architecture and Design*, New York, Museum of Modern Art, 1986.

Vergo, Peter, *Art in Vienna 1898–1918: Klimt, Kokoschka, Schiele and their Contemporaries*, Phaidon, 1975/1981.

Vergo, Peter, *Vienna 1900: Vienna, Scotland and the European Avant-Garde*, National Museum of Antiquities, Scotland, Edinburgh, Her Majesty's Stationery Office, 1983.

Waissenberger, Robert, *Vienna 1890–1929*, New York, Rizzoli, 1987.

Walker, David, 'Mackintosh's Early Works', in N. Pevsner and J. M. Richards, *The Anti-Rationalists*, Architectural Press, 1973.

Walker, Frank, 'Mackintosh and Art Nouveau Architecture', in C. J. Carter (ed.), *Art, Design and the Quality of Life in Turn of the Century Scotland (1890–1910)*, Proceedings of Symposium Duncan of Jordanstone College of Art, Dundee, 1985.

Walker, Frank, 'National Romanticism and the Architecture of the City', in G. Gordon (ed.), *Perspectives of the Scottish City*, Aberdeen University Press, 1985.

Whitford, Frank, *Bauhaus*, Thames and Hudson, 1984.
Windsor, Alan, *Peter Behrens: Architect and Designer*, Architectural Press, 1981.
Wohlfarth, Irving, 'On the Messianic Structure of Walter Benjamin's Last Reflections', *Glyph*, No. 3, 1978.
Wolff, Janet, *Aesthetics and the Sociology of Art*, Allen and Unwin, 1983.
Wordsall, Frank, *The Disappearing City*, Glasgow, 1981.
Wordsall, Frank, *The Tenement: A Way of Life*, Chambers, 1979.
Worringer, Wilhelm, *Abstraction and Empathy: A Contribution to the Psychology of Style*, M. Bullock (trans.), Routledge and Kegan Paul, 1953.

# Index

absolute construction 38
abstract chromaticism 88
abstract dynamism 54–5, 85
*Abstraktion und Einfuhlung* 17
Adorno, Theodor W. 15, 36–43, 47,
    48, 49, 59, 200, 201, 202, 224,
    225, 226
aesthetic illusion 13
Aestheticism 26–34, 40, 49, 50, 53,
    55–6, 64, 82, 95, 98, 142, 153,
    154, 172, 179, 180, 190–5, 201,
    205, 206
aestheticization of thought 175, 194
Ahlers-Hestermann, Friedrich 62
Alexandre, Arsène 74
Anderson, Perry 7, 8
anti-historicism 54, 56
anti-naturalism 182
architectural influences, on
    decorative arts 102
architectural principles 63, 114, 122,
    123–6, 149
Armstrong, Thomas 164, 165, 168,
    204
art, as institution 27, 28, 117
art carpets 221, 222
Art Deco 45, 238
Art Nouveau journals 57, 248
Art Workers' Guild 170
Arts and Crafts aesthetics 83
Ashbee, Charles R. 64, 72
Auld Alliance 233
authenticity in architecture 148, 149
avant-garde work of art 31, 32

Baltus, Georges 129
Barker, Paul 54
Basset-Lowke, W.J. 71, 238, 239
Bastien-Lepage, Jules 91, 92
Baudelaire, Charles 9, 23, 24, 53,
    77, 248
Bauhaus 24, 25
Beardsley, Aubrey 56, 61, 63, 66,
    70, 71, 76, 196, 197, 199, 201-2
Beerbohm, Max 55
Behrens, Peter 132
Belcher, John 123, 124
Belgian Art Schools 89
Belgian Workers' Party 90, 234
Bell, Clive 22
Benjamin, Walter 34–6, 39, 49, 70,
    158, 202, 238
Bergson, Henri 59, 60, 70, 76
Berman, Marshall 22, 261
Bernard, Emile 77, 183
Billcliffe, Roger 92, 95, 238
Bing, Samuel 57
Blake, William 52, 65
book decoration/illustration 171, 191
Bosanquet, Bernard 183–4
Bourdieu, Pierre 224
Brahms, Johannes 15, 36
British–national economy 230
Brown, Baldwin 154
Brown, Ford Madox 65
Brussels Academy of Fine Arts 129
bureaucracy 44, 201
Bürger, Peter 21, 26–33, 35, 39, 48,
    49, 93, 131

286